IVORIES

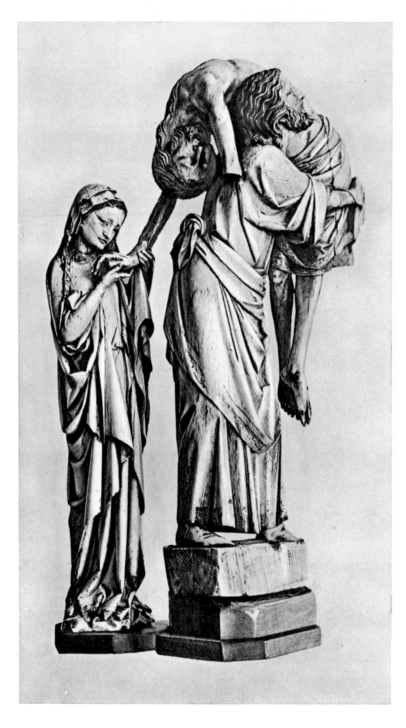

Part of Group: "The Descent from the Cross."
French, end of Thirteenth Century.

IVORIES

by ALFRED MASKELL F.S.A.

CHARLES E. TUTTLE CO.: PUBLISHERS
Rutland, Vermont *Tokyo, Japan*

Representatives
Continental Europe: BOXERBOOKS, INC., *Zurich*
British Isles: PRENTICE-HALL INTERNATIONAL, INC., *London*
Australasia: PAUL FLESCH & CO., PTY. LTD., *Melbourne*

Published by Charles E. Tuttle Co., Inc.
of Rutland, Vermont & Tokyo, Japan
with editorial offices at
Suido 1-chome, 2-6, Bunkyo-ku, Tokyo

© *1966 by Charles E. Tuttle Co., Inc.*

Library of Congress Catalog Card No. 66–20572

First edition, 1966

PRINTED IN JAPAN

PUBLISHER'S FOREWORD

FIRST published in 1905 in Methuen's famed series *The Connoisseur's Library*, Alfred Maskell's *Ivories* has long been one of the definitive works for antiquarians, collectors, and connoisseurs of this fascinating art.

Sculpture in ivory has always been intimately involved with a study of world art in all ages. It is to ivory's durability and comparatively small intrinsic value that we owe the uninterrupted preservation of traditions from classic times to the renaissance. Ivory apart, there are no authentic records of the history of art during the Dark Ages, from the fifth to the eleventh centuries. Only from ivory can we compile a chronological history of the manners and customs, domestic arts, costume and daily life of those times, as nearly every other source of information relies on conjecture. Therefore a knowledge of ivory sculpture is necessary for a thorough comprehension of world art through the centuries.

The author, Alfred Ogle Maskell, F.S.A. spent a lifetime in the appreciation of the arts, and has written other books on wood-sculpture, engravings, and aquatints, as well as contributing to many art magazines. He was also the founder and editor of the art magazine *Downside Review*.

For many years Mr. Maskell was unofficial consultant to the South Kensington Museum, London, and represented the Museum at International Exhibitions in Munich, Brussels, and Moscow. His taste and great knowledge were responsible for Lord Brassey's private collection

which later became the Indian Room Museum, Park Lane, London.

Because of the lack of publications in the English language devoted to ivory sculpture, it is a decided pleasure to make available once again a scholarly work that has so well deserved its reputation.

PREFACE

IVORY sculpture has long formed an interesting subject in literature, and the examples to be found in the great national and private collections throughout the world, though not numerous, have, it may be said, a special importance not inferior to those of any other department of the world's art. The estimation in which they are held arises from various causes. First from their comparative rarity, next because practically all examples of importance and their whereabouts are known, and lastly from their intrinsic beauty, and from the fact that they not only constitute an epitome, as it were, of the world's art from the earliest times down to at least the period of the renaissance, but because they form almost the sole links in the chain of examples of artistic development during the many centuries when, in other directions, this makes almost total default.

The literature concerning carvings in ivory, especially the dissertations upon such an important section as the consular diptychs, is voluminous, and includes the names of the most distinguished archæologists and critics, going back almost to the sixteenth century, in days when the study of the fine arts received less attention than it does now. But, generally speaking, it deals with special divisions, and we have no connected accounts of the progress of ivory carving throughout the world's history.

In submitting the present work I can hardly pretend, within the limits assigned, to have treated such

a vast subject fully in all its ramifications. Volumes might be written upon any one of its divisions or chapters, so that, although apparently covering a large extent of ground, this work still remains but little more than a sketch. I propose to advance no theories on disputed questions, to enter into no speculations except those which may have a general human interest. In a subject of such universal application omissions must be innumerable. If, therefore, I can only claim to produce a sketch, at least I may hope that it will not be considered a hasty one, and that any merit it may possess may be estimated, as sketches should be, by the judgment I may have exercised in leaving out, as much as by including, and by thus presenting, in a certain way, a complete picture.

In describing particular examples I have endeavoured to confine my references, as far as possible, to objects which are easily accessible and may be seen in our great national collections—the South Kensington Museum, the British Museum, the Mayer Collection at Liverpool, and the Wallace Collection. It would be impossible to include all the ivories which have claims on our attention. Doubtless, every great museum and private collection contains many admirable, and sometimes unique, examples. Still, it may be said that the four institutions just mentioned provide ample material to cover every point of interest which might arise.

As a general rule, I have taken, as a standard, the value of ivory carvings from the point of view of their beauty, and the place they occupy in the history of art, and I have endeavoured to confine the treatment of the subject solely to the case of ivories. It may be said with regard to certain characteristics of style or decoration that they are not peculiar to ivory, but that similar fashions and themes are common to the various arts. That is so, but it would not only be tedious to be constantly noticing analogies of treatment and making

researches into origins, but to do so would be to extend this book to an unreasonable length. No one can dispute the mutual interchange between the different arts : how they act and react on each other, and give and take, or, it may be said rather, persistently borrow and assimilate. Naturally, in our ivories, we shall find at times similar subjects treated in ways with which we may be elsewhere familiar, but it will be unnecessary to call attention to such coincidences, except in cases where they are particularly striking.

Few references to authorities and no footnotes have been added. The latter are often tiresome, and it is hoped that the extended bibliography at the end of this book will serve the purpose of those who desire to inquire further. I have not unnaturally been guided to a considerable extent, as regards ancient and mediæval ivories, by the introduction to Mr. William Maskell's Catalogue of Ivories in the South Kensington Museum, for I could go to no better authority. Great use has been made, also, of Westwood's Catalogue of "Fictile Ivories" in the same museum ; but while availing myself of the excellent collection of casts, I have endeavoured to see, wherever possible, every original to which reference is here made. The exceptions are not many, or of importance, and, in such instances, the casts are, for most practical purposes, equal to the ivories themselves. The latter have, no doubt, in several cases changed hands in late years, and while care has been taken to follow their vicissitudes, it has not been possible always, perhaps, to avoid error in this respect and to state correctly the present owners. These instances are, however, few, and concern examples which are only incidentally mentioned.

An endeavour has been made to present the subject in such a manner as to avoid the character which it might otherwise have—of a merely descriptive catalogue. For this purpose it is hoped that the incidental remarks concerning the use of the various objects

mentioned may not be without interest. Some, perhaps, may not see the value, for example, of discoursing on the liturgical use of diptychs, may think it trespassing on the province of the liturgiologist, and that a statement of the mere fact would suffice. Such particulars, however, may help to brighten the description and add to the interest which on this account is attached to them. So also with regard to pastoral staves, to which some general references are made. The difficulty has been to refrain from adding more of the same kind. I can only trust that the line has been fairly drawn, and that what may not be new to all may be new to some.

A. M.

15th January, 1904

CONTENTS

CONTENTS

LIST OF THE PLATES

[15]

LIST OF THE PLATES

[16]

LIST OF THE PLATES

IVORIES

IVORIES

CHAPTER I

INTRODUCTORY

THE use of ivory as a decorative material has been so universal in the history of civilisation, it is so intimately connected with almost every other substance employed in the production and adornment of beautiful objects, that a close and systematic consideration of its various applications would seem to involve the study of the whole world's art in all ages. Not only would this be the case with regard to that which is, in the strictest sense, sculpture in ivory, but we shall find that even the graphic arts cannot be excluded ; for in the decoration of ivory, the subjects carved or engraved upon it, and the practical use to which many of the objects which will come under our notice were destined, will insensibly lead us to consider endless illustrations of the manners and customs of mankind from the earliest periods of which we possess any written account. Nay, more, we shall have to go back to a period in prehistoric ages when it may almost be said that the only records are graphic ones, carved or incised on this very material which is to occupy our attention.

It will be a surprise to many, perhaps, to find that

ivory has played so important a part in our civilisation;
but though the principal aim of the present work will
be the consideration of the decorative application of
this material, the commercial uses in the more common
necessities of our daily life will not be altogether ex-
cluded. It will enter into our plan also to include
bone and horn where these substances are employed,
as we shall often find them, in a similar manner to
elephant or true ivory. With regard to horn, the use
of stags' horn is meant. It was, at one time, a com-
mon substitute for ivory, which it greatly resembles,
in the inlay and decoration of firelocks, crossbows, and
similar weapons. Bone was much employed in Italy,
probably on account of the scarcity of ivory, and was
worked with no less care and with little loss of effect.

Within the limits assigned to us we can scarcely
hope to do more than endeavour to call attention to the
more important among the many examples—decorative
or purely useful—which have come down to us, and are
preserved in the museums and private collections of
the world; but in touching ever so lightly on these
objects, and in endeavouring to increase their interest
by connecting them with the uses — religious and
secular—to which they were devoted, the importance of
the subject can hardly fail to be appreciated.

Multitudinous are the applications which ivory is
made to serve. It would be easier, almost, to enumerate
amongst the industrial arts those in which it has played
no part than those in which it forms the principal
attraction. Nor is this surprising if we consider the
intrinsic beauty of the material, its comparatively
lasting nature, the brilliancy of the polish, and the
peculiar delicacy of the colour, whether we may prefer
this to rival the purest white of the finest marble, or,
on the other hand, to be of that semi-transparent
mellow tint with which it is more generally associated.
Little wonder, then, that, from the most distant times,

the eastern peoples of Asia and Africa, which furnish the raw material in abundance, should have excelled in the working of ivory, and in applying it to the most noble purposes of utility and decoration.

Strictly speaking, the term ivory is confined to the tusk of the elephant, and for commercial purposes to that of the male elephant. In Africa both males and females furnish good-sized tusks, but in India females scarcely any at all, and not all males. When elephants are kept in captivity the tusks are shortened occasionally, but the produce is not so valuable as when in the wild state. As a chemical substance ivory may be placed between bone and horn. It is not so brittle as bone, and is of a closer nature, and does not splinter so much when broken. Being more fibrous, it cannot be torn. The substance is very dense, the pores close and compact, and filled with an oily or waxy solution, which contributes to the beautiful polish, and renders it more supple and amenable to the tool of the worker than is, for example, the refractory nature of marble.

The composition of ivory is essentially equivalent to that hard, bony substance of which most teeth are principally formed. It may be said to consist of an organic matrix richly impregnated with calcareous salts, and permeated with an immense number of exceedingly fine tubes, starting from the pulp cavity, and radiating outwards in all directions. In elephant ivory these tubes are placed very close together, and it is to the regularity with which they are disposed, their number, their small size and frequent curvature, that ivory owes its fine grain, its almost perfect elasticity, and the characteristic appearance of network resembling engine-turning by which we are accustomed to distinguish it. In bone the tubes, or blood passages, are larger and of a coarser and less fibrous structure. Scientifically, to quote the language of Professor Owen, in his lecture before the Society of Arts in 1856, "the

name ivory is now restricted by the best anatomists and physiologists to that modification of dentine or tooth substance which in transverse sections or fractures shows lines of different colours or *striæ* proceeding in the arc of a circle, and forming by their decussations minute curvilinear lozenge-shaped spaces." As a matter of fact, almost everyone is aware of these peculiar markings, and is accustomed to be guided by them in determining, for instance, whether the handles of cutlery are ivory or imitation.

Elephants' tusks are the upper incisor teeth which are prolonged and attain enormous development, some teeth measuring as much as eight to ten feet, and weighing 150 lbs., or even 180 lbs., each. The curvature is sometimes equal to half a circle from the root to the extreme point. The teeth are hollow to about half-way up, being formed by layers deposited on a vascular pulp after the manner of teeth generally. When in the most perfect condition ivory should appear, if recently cut, of a mellow, warm, transparent tint, almost as if soaked in oil, and with very little appearance of grain or fibre. The oil dries up considerably by exposure. Asiatic ivory is of a denser white than African, less close in texture, not so hard under the tools, and not susceptible of so fine a polish. The usual distinction between the various qualities is that of African or Asiatic. But perhaps a better and more useful one would be that of transparent and opaque.

The finest and most beautiful kind is exported from Pangani, on the east coast of Africa, in the neighbourhood of Zanzibar. It is known as green ivory, and is probably collected from the whole stretch of country from here to the Gaboon in French Congo on the west coast. Throughout this part of Africa this green or guinea ivory prevails, and is esteemed for its transparence and the light-yellow or pale-blonde tint distinguishing it, which bleaches after a time. Other

kinds, on the contrary, which are whiter, become yellow with age. It is very hard, very heavy, and of a fine grain. Cape ivory is softer, sometimes yellowish, sometimes of a dead white. That of Senegal and Abyssinia is very similar, but not so perfect, and is less valuable. There are several varieties of East Indian ivory, which, as a rule, is very white indeed. The most esteemed comes from Ceylon, and is of a pale rosy white. That from Siam resembles it. Bombay ivory is inferior.

The African elephant is a distinct species from the Asiatic, and some of the Asiatic elephants of the larger islands of the Indian Archipelago form again a strongly marked variety. Generally speaking, it may be said that most ivory imported into Europe comes from Africa. Some is Asiatic, but much which is shipped from India is really African, coming by way of Zanzibar to Bombay. The best is from near the equator, gathered in stores by natives, and brought down to the coast by traders who collect it. An excellent recent account of elephant hunting in the most fertile ivory district of the world is that given of his expedition by Mr. E. S. Grogan in his *Cape to Cairo*. In his opinion the elephant is rapidly becoming in the greater part of Africa a thing of the past. The rate at which it is disappearing is appalling. Ten years ago elephants swarmed in places such as the country of the British South Africa Company, where now not one is to be found. Years of persecution have driven the survivors north to the Congo forests and the Mivern swamps. There, and principally in the Toro country, in the vicinity of Ruwenzori and on the upper Nile, immense herds still exist. The prevailing type of tusk differs considerably, ranging from the thick and heavy ones of the Toro district to those of the smaller elephants, which are long and thin, in M'boga. The writer of the work whose opinion we have just quoted expresses himself severely on the licensing system which prevails

in British Africa, and the wanton destruction of elephants which results from it.

When we consider the enormous drain on the supply of ivory in Africa alone, which has been going on for centuries, it is indeed surprising that the source has not long since been exhausted. The whole question is one which cannot fail to excite astonishment. To begin with, the mere number of elephants which roam over these territories is almost beyond calculation, and the supply of food which they must require is enormous. Literally, almost, they represent a forest of ivory tusks, and it is not a forest which can be periodically cut down and allowed to renew itself by growth from the same roots. Every pair of tusks represents a slain elephant. At the periodical sales of ivory in London parcels of a hundred tons and more are put up to auction. In the year 1900 the importation amounted to 11,757 cwt., which represented 60,000 tusks, and a value, in its rough state, of over half a million sterling. For billiard balls alone the sales of one of the great London firms are nearly 10,000 tusks a year. In 1888 the importation into Antwerp from the Congo amounted only to 36,400 kilos, say 1,000 cwt. In 1902 the Congo furnished to the same port 380,000 kilos. The prices at this market ranged for sound tusks from 22 to 25 francs a kilo, and for ball tusks from 28 to 38.25 francs. The greater part came from the Congo, but Senegal, Angola, Gaboon, Abyssinia, the Cameroons, Zanzibar, and other places contributed about 40,000 kilos. There were imported besides to Antwerp in 1900 340 kilos of hippopotamus, 22 kilos rhinoceros' horns, and a number of curiosities.

Although, strictly speaking, the term ivory is only applied to the tusk of the elephant, we shall have to consider other kinds and other varieties. In very early periods of the earth's history elephants were

much more widely spread over the globe than in later times. A true elephant roamed in countless herds over the temperate and northern parts of Europe, Asia, and America. This was the species known as the mastodon or mammoth, whose remains have been discovered in various countries, including our own island, for example, in Essex and off Dungeness. So late as the year 1903 a very fine skeleton was unearthed in Kent. Even Australia, Professor Owen tells us, appears to have had its huge proboscidian ivory-producing quadruped. Great indeed has been the number of species now extinct, and as they were free from the hunter, the quantity of the valuable material of ivory that has been formed and has perished must be beyond calculation.

Mammoth tusks have been found in Siberia in enormous quantities since the beginning of the eighteenth century. The exploitation of the immense deposits—for, owing to the climatic conditions, the ivory has been preserved in a perfect state—forms at the present day a considerable industry. These deposits exist throughout Russia, but principally in the neighbourhood of the Lena and other rivers discharging into the Arctic Ocean. The attempt to explain the vast accumulations—the skulls and entire skeletons of elephants, rhinoceros, bisons, and other extinct pachyderms which fill mysteriously the frozen soil—is a subject of very wide interest. They are cemented together by débris of all kinds, by fossil wood and branches of trees brought down by the inundations, for centuries, of the great rivers, or as if at one particular period some frightful cataclysm had overwhelmed a vast extent of country, and sweeping everything before it, had collected and driven together in one tangled mass, gathering its accumulations as it proceeded, every living object which then existed in the greater part of northern Europe. For nearly two centuries these vast deposits of antediluvian animals

have been worked for the ivory which they contain. The store appears to be as inexhaustible as a coal-field, and it may be that when the supply of African ivory ceases, as some day it surely will, we shall be indebted to these mines for a source upon which we can still draw for this beautiful material.

The mammoth was a distinct species of elephant, as may be seen from the skeletons and remains preserved in the museum of the academy at St. Petersburg. It was a hairy animal, protected in this way by a shaggy coat against a very different climate from that in which his African brother has lived and flourished. Complete bodies have been found in a perfect state of preservation, exposed by the breaking up of the ice in summer, or subsequently washed down by floods. Sometimes the ivory has become entirely disintegrated into a chalk-like matter. The tusks are longer and more slender than those of the African elephant. They have a bolder and more extensive curvature, approaching closer together at the root, and spreading out laterally, like two great scythes, in the same horizontal plane, instead of forwards and upwards. Some have been found of enormous development—as long as twelve feet and weighing 200 lbs. Holtzapfel tells us of one cut up in England for piano keys which weighed 186 lbs. A mammoth tusk quite recently found on the island of New Siberia, in the Arctic Ocean, off the shores of Siberia, measuring thirteen feet long and two feet in diameter in the thickest part and 220 lbs. in weight, is now in the American Museum, New York.

Other considerable sources of ivory from which come many of the examples which we shall presently consider are the teeth of the hippopotamus and the tusks of the walrus. Hippo ivory is denser, and has a closer grain than elephant ivory, and as the tusks are hollow, there is little solid material. It is consequently

available only for small work. It is also of a purer white, not liable to split, and of a texture which may be called something between ivory proper and pearl shell. Morse, or walrus, ivory is from the long tusks which hang perpendicularly downwards from the upper jaw of the sea-cow, troops of which exist along the icy coasts of the north seas. It was used by oriental nations—by the Persians almost exclusively for sword grips—and we shall find it frequently employed for early chessmen and Scandinavian caskets. It is even now an important part of the trade of Archangel. The single tooth, or defence, of the narwhale supplies also a fine description of ivory. It is rarely worked, as it is generally kept as a curio in its natural condition.

In reviewing the art of sculpture in ivory, we shall have to notice first the work of a very remote period. We shall pass from the days of the Assyrian empire, of the civilisation of ancient Egypt, of Greece and of Rome, to early Christian times. From the establishment of Christianity and the domination of the Roman empire in the west, and in Byzantium, we shall come to the centuries of pre-gothic and gothic art, and, finally, we shall trace the decline from the golden age of the renaissance through the rococo period down to our own day. Of the practical and commercial uses of ivory in more modern times it will not be necessary to say very much. It is for the most part restricted in this way to cutlery handles, walking-sticks, umbrellas, fans, combs, paper-knives, chess and draughts men, billiard balls, and other applications, in none of which, unhappily, is any call made for the exercise of artistic talent.

The history of ivory carving goes back to the most remote antiquity. Centuries before the Christian era we can point to examples in the days of the earliest dynasties of Assyria and Egypt. Earlier still than these far distant days we shall be confronted with the

artists—for so we may call them—of those prehistoric epochs which we are accustomed to term the stone or bronze ages. It will not be by conjecture merely, but with actual examples in our hands, that we shall commence the chain, and pass from a period of which no written history exists to such comparatively modern times as those of which the records are the Holy Scriptures, and we shall be able to illustrate the allusions and records by objects in ivory discovered amongst the mounds and ruins of the cities which are there mentioned.

Ivory seems to have held an honoured place in the adornment of the palaces of the great in all ages, for the rich inlay of the ceilings and walls, and for the making of even small objects of decorative use to which the most renowned artists did not disdain to apply their skill. The whiteness and purity of this beautiful material fitted it to be a distinctive ornament of royal dignity, and especially was it appropriate for the thrones and sceptres of rulers and potentates. There seems to have been a passion for its employment. The Roman senate sent to Porsenna a throne of ivory, as, indeed, in our own times we find a great Indian prince sending on the occasion of the exhibition of 1851 an ivory throne to Queen Victoria. For musical instruments, such as the lyre, for chariots, harness, beds, chairs, tables, and other costly articles of furniture, ivory was extensively employed. A celebrated car in the museum at Florence has the linch-pins tipped with ivory. Even in its natural condition the unworked tusk formed part of the offerings in temples. The cover of a small ivory box in the Louvre is inscribed with the name and royal tablet of Merien-ra, found in the upper line of the tablet of Abydos, and attributed to the fifth dynasty. In the time of Thothmes III. ivory was imported in considerable quantities into Egypt in boats laden with ivory and ebony from Nubia

and Abyssinia. Hence, as Herodotus tells us, came most of the ivory used in Egypt, though their elephants were originally from Asia. And, again, we learn from Diodorus Siculus that these Ethiopians brought to Sesostris ebony and gold, and the teeth of elephants and twenty large tusks, as tribute to the Persian king. So plentiful was it, according to Pliny, that the natives used it for door-posts, fencing and stalls for cattle, as, in fact, the horrible things from Benin in the British Museum show that they still continue to do. In Greece the trappings of horses were studded with ivory (*Iliad*, v. 584), the bosses of shields and the handles of keys (*Odyss.*, xxi. 7). The chryselephantine statues made by Phidias and his contemporaries were renowned, and we shall have occasion again to refer to them later on. Over and over again in nearly all the classical writers allusions abound.

The Hebrews knew the elephant from its ivory only, which was an important article of commerce. In their days a great traffic was carried on with Assyria, and as Assyrian conquests extended, vast quantities were poured in for the adornment of the palaces of their luxurious cities. The Scriptures teem with references to the use of ivory, to its beauty and value, and the high esteem in which it was held. It was indeed "a noble substance for noble works." Most familiar of all is the reference to the great ivory throne, overlaid with pure gold, made for King Solomon by the skilled workmen of Hiram, king of Tyre—"there was not the like made in any kingdom"—and we learn that the ivory came by the caravans of Dedan. "The men of Dedan were thy merchants; . . . they brought thee for a present horns of ivory and ebony" (Ezek. xxvii. 15). "Once in three years came the navy of Tharshish, bringing gold, and silver, ivory, and apes, and peacocks" (1 Kings x. 22). And, again, "the company of the Ashurites made thy benches of ivory, brought out of the isles

of Chittim" (Ezek. xxvii. 6). And, then, the ivory house which Ahab made, and horns of ivory and ebony (Ezekiel), and "those that lie on beds of ivory" (Amos vi. 4). Many are the poetic allusions to its beauty and smoothness and brightness. In the Song of Solomon the "ivory overlaid with sapphire," and the expression "Tower of ivory," still used daily in the litany of the Catholic Church.

When we consider the thousands of vases of fragile materials, especially those of the finest periods of Greek art which have been preserved to us, and are now spread throughout the museums of Europe, it is curious that there should be comparatively so few remains of the less fragile ivory. The reason may be that though in itself it was of no great intrinsic value, it was destroyed for the sake of the precious metals or other materials with which it was associated. Of Roman work before the time of Constantine examples of importance are so scarce that they might almost be counted on the fingers. We shall note, however, amongst these few some very celebrated pieces, one of them, in the museum at Kensington, perhaps the finest in existence, a typical example of the diptychs for private purposes of the third century. The British Museum possesses many small fragments of no little interest in relation to domestic habits of the time of the Roman empire, and, from time to time—though certainly such occurrences are of extreme rarity—small objects of the period of the Roman occupation of our country turn up in barrows and other excavations. A notable instance is that of the plaque and the ivory mask found at Caerleon. But if up to the fourth century such things are scarce, from that date onward the chain of examples is unbroken, and it would be impossible to estimate their value too highly, either as regards the history of art, or as pictures and sources of information.

INTRODUCTORY

Of the classical period we have works of stone and marble in abundance, and then the Christian sarcophagi continue the line, and bring us down to the fourth or fifth century. From that time, for five or six hundred years, the history of art shows default. In England, for instance, we have only in sculpture the figures in church architecture, and of these nothing earlier than about the twelfth century.

Apart from any intrinsic beauty which our ivories may possess, there is nothing more striking than the manner in which they permit us to fill the void in the illustration of the development of art which occurs in these centuries of unrest and strife which we are accustomed to term the dark ages—from about the fifth to the tenth or eleventh centuries after Christ—and to supply for those times the complete absence of monumental sculpture, and the default in every description of learning and art. It is to the durability and comparatively small intrinsic value of this semi-precious material that we owe the uninterrupted preservation of types and traditions from classic times to the renaissance. During the long period of time which elapsed from the decline of the Roman empire in the fifth century to the beginnings of the gothic revival, about the eleventh or twelfth, a thick veil covers the history of art in central Europe. Of these ages little exists except a small number of miniatures in illuminated manuscripts, and a certain quantity of objects in the precious metals, fortunate survivors of the melting-pot. For at least four hundred years it may be said that, ivories apart, we really possess no authentic records. Buildings and the vast quantities of works of sculpture which they contained have been for the most part destroyed. But during these same ages ivory carvings have come down to us in considerable quantities. From these, almost alone, are we able to compile a chronological table of the progress and

history, of the manners and customs, the domestic arts, the costume and daily life of those times. Nearly every other source of information is closed, and we are left to mere conjecture.

One of the most important periods in the history of ivory sculpture—and incidentally, therefore, in the history of art generally—will be that of the connection of the great empires of the east and west; of Rome and of Constantinople; and the natural influence exerted by the art of the east upon that of the west will form not the least interesting subject of our observation. In the eastern empire, under the happy influences of the long and glorious reign of Justinian (A.D. 527–63), a considerable manifestation of artistic talent went on, and maintained at that time, and for long after, the authority of classic models and traditions. About the middle of his reign, however, ivory sculpture shows marked evidence of decadence, and the decline becomes still more marked two centuries later, when iconoclastic troubles and the spirit of abhorrence in which all sorts of images and their designers and workers were held arose. The destruction of works of art of all kinds by Christian iconoclasts, under the Emperor Leo in the eighth century, was furious and unsparing, and the persecution lasted a hundred years. The greatest excesses were, of course, in the east. For this reason the west benefited, for many works of art were transferred thither for their preservation, and in this way new models were available, and a devotion to, and culture of, art followed, which caused the foundation of new schools, and the naturalisation of the workmen and refugees, who found shelter and employment amongst new surroundings. To this infusion of exotic ideas we owe the style which we term Byzantine. At the period of its highest development in the eastern empire—from the time of Basil the Macedonian, who restored the use of images in the

eighth century, up to the most prosperous times of
the empire in the eleventh—it was natural that as the
best artists of Constantinople emigrated to the west,
Italy, Germany, France, and England should be in-
fluenced, and borrow largely from them. In the east
artistic culture degenerated, disquiet, wars, and general
unrest prevailed, the emperors had no time to attend
to the arts, and at last, in 1204, came the sack of the
imperial city itself, and doubtless the destruction of
incomparable treasures.

For wealth of detail and for their exquisite beauty
of expression it will be to the sculptures in ivory of the
gothic art of the thirteenth, fourteenth, and fifteenth
centuries that we shall turn with the greatest interest,
not only to those examples of religious art which were
so touchingly conceived and executed, but also to the
many objects of domestic use and ornament which will
bring home to us in a vivid manner the most intimate
details of the life, the religion, the costumes, amuse-
ments, and habits of the people.

Up to about the fourteenth century the influence of
the Church was predominant in all matters relating to
art. Religion formed the chief interest of people's
lives. All that was most beautiful and costly in
material was applied to the decoration of sacred
edifices and the shrines connected with them. Art
was the monopoly of religion, and, so far, at least,
as our immediate subject is concerned, it would be
difficult to find a dozen examples of decorative sculp-
ture during the long lapse of time from the days of
Constantine almost up to the twelfth century the sub-
jects of which are other than sacred ones. Innumer-
able are the objects for private devotion and for use in
the services of the Church, to which, in a succeeding
chapter, considerable space will be devoted. Prominent
amongst such things, the statuettes and groups of the
Virgin and her divine Son stand out almost as a class

apart. Naturally, and yet not realistically treated, it would be hard to exceed the grace and beauty, the refinement, and absolutely religious and Christian feeling which are manifested in many of these admirable figures. There is a certain mannerism about them, no doubt, but they are full of suggestion and delicacy. It is not to be wondered at that the evolution of religious idealism through many centuries found its highest expression in work which was done not for sordid reasons but from the enthusiasm of true piety. From such motives came the creation of a spiritual type, the noble expression of innate and fervent devotion. Nor, again, are the simplicity, the absolute life and vigour of movement of these figures the only things which will call for our admiration. Charming also is the elegance of treatment in the expression of the draperies. They are not wholly realistic, not wholly conventional, not a copy of classical methods, for in all probability it would be rarely that the artist had access to actual models—they are, rather, an evolution and adaptation from examples of the finest periods of Greek art filtered through Byzantine mannerisms to the type which distinguishes the work of gothic times.

One of the most controverted questions concerning these delightful objects of the thirteenth and fourteenth centuries is, in many cases, that of their country of origin. Any nationality does and may claim them, and though we shall often find some difficulty in being absolutely precise and certain, still the inquiry itself and the attempt at solution have attractions of their own which add to our interest. It will be admitted that in these periods the preponderance of French work is very great. We hardly ever come across a piece of the highest class to which French origin is not, rightly as a rule, attributed. But we must remember that there was in those days, as there is now, a considerable interchange of artists between the

various countries. In the fourteenth and fifteenth centuries Flemish artists, especially, worked for the courts of Savoy, and were to be found elsewhere also. There will always be a certain distinction between the work which imported labour produces from its own genius and that which it forms under the direction of native artists or to suit the tastes of its patrons. There must be also a give-and-take and mutual appreciation of styles. We shall be aided, however, in many cases by a certain accepted type of form or expression, not necessarily the national type of the country concerned, but one which has become the usual and favourite one. So also with the disposition and flow of the draperies. The actual costume of the period will not always be decisive of the date or even the nationality, but the treatment of it will have generally a style or *cachet* of its own which will form for us a not unreliable guide.

Not only as to dates and countries do difficulties exist, but it is also not easy always to diagnose transitions of style, for instance, from romanesque to gothic.

In default of the names of the actual artists who executed these beautiful works—for, perhaps with one exception, the identity of no single one has come down to us—it is interesting to speculate on the probable manner in which they were produced. When we consider the comparatively large number which still exist, it is evident that they must have been made in considerable quantities. Were there factories or studios, so to speak? Were there numbers of specialists, each for his own particular class of work? May we not take it that every monastery had its workshop for carvings in ivory in the same way as to this day, in Russia, we find that numberless small woodcarvings and paintings are produced? Was it, perhaps, sometimes the distraction, in his leisure moments, of what we should now call the amateur; or of the

villager, during the long winter evenings, as again we find in Russia amongst the small farmer class? We must recollect that a feeling for art was more universal in those days, and also how the Church and everything connected with its devotions and its teachings entered into the daily and hourly life of every member of the community. There were practically no books, except those on religious subjects, and then only for the wealthy; no other pictures, except religious ones which, for the most part, were in the costly illuminated manuscripts. Such things, then, as these small tablets, these diptychs and triptychs, and portable shrines, were the literature of the people, or at least the text-books from which they were taught. They were, it may be said, the illustrated catechisms of the time, and could be read and understood as the hieroglyphics of Egypt were read.

In the series of ivory carvings we find if not every, at least every principal, event of the Old and New Testaments. Doubtless they were used for instruction as well as ornament, and, in this way, when the art of reading was an accomplishment of the few, would have formed, for centuries, the Bible of the unlearned.* And when we consider the extensive range of subjects selected, it is not unreasonable to conclude that nothing of the Scriptures which was

* The question of the condition of learning in the later middle ages is important and interesting. The references made above must therefore be considered as generally applicable only to the mass of the people. It is unquestionable that monasteries, convents of nuns, and other religious houses, were hives of learning, and books were by no means rare within their precincts. On the contrary, every great ecclesiastical establishment throughout Christian Europe possessed its own library, and books were copied in vast numbers. The duty of teaching the people the rudiments of their faith in the vulgar tongue, and of providing books for the purpose, was enforced on all priests. It has been said, indeed, that taking into account the relative population of England during the two periods, there were more people who could read two hundred years before the Reformation than two hundred years after. No one has testified more ably to the position of this important question than such an unprejudiced writer as Dr. Maitland, in his valuable work, the *Dark Ages* (see also *Monumenta Ritualia*, Oxford edition, III. li.).

valuable for instruction was withheld from the people. Many favourite subjects are repeated over and over again, and the same traditions of types preserved. Many were the legends, also, that the artists seized upon; very popular the life of the Virgin, and touching indeed the representation of her death. The more these beautiful scenes are studied the more their fascination grows upon us. Not unfrequently the holy personages—with the exception always of our Lord Himself—are in the costumes of the period. Added to this are the charm, the simplicity, and, as it must be conjectured, the deliberately chosen conventionalism of the manner in which the pictures are executed. If to the unaccustomed eye there may appear, at first sight, a grotesque exaggeration of proportions and a wanton distortion of perspective, the aim is distinctly decorative, the arrangement of the composition is always harmonious and true to the rules of balance.

Until about the end of the thirteenth century religious subjects alone exercised the imagination of the artists, but in the fourteenth the influence of the romantic literature of the period began to assert itself, and its illustration became almost as general as had been that of religious legends and scriptural stories. Deeds of chivalry, scenes of the chase or of the tournament-field, characters from the mediæval chronicles and romances so popular in those days, form now the texts. Thus we are able to follow, for a time, the more ordinary story of human life in its most familiar aspects, and in reviewing the best examples of ivory work applied to objects of domestic use—to arms and armour, and the furniture of the house or of the table—we shall have vividly brought before us the costumes, manners, sports and amusements of the most interesting period of the middle ages. In the decoration of caskets, and especially of mirror cases, there is one subject of

frequent occurrence which will lead us to consider a very important class of ivory carving. This is the illustration of people playing chess or draughts. In all times of which examples of chessmen have come down to us ivory seems to have been naturally the favourite material of which the figures were made. Their history is therefore entitled to special consideration, and an important chapter will be allotted to it.

The period of the renaissance and the return to classical ideas bring us in contact with a time when we shall have to look at sculpture in ivory with feelings other than those by which we have till then been guided. Whatever may have been the glory and magnificence of the many forms of art of that time, it must be admitted that that of ivory carving declined. With rare exceptions, from one cause or another, it became neglected. We may still be able to find examples which can hold their own with other artistic productions, but in a general way we shall have to admit the decadence. There is a loss of that high feeling, simplicity, and delicacy which had characterised the work of earlier periods. There is instead a banality in subject and in treatment, and, finally, as we approach our own times ivory carving is no longer worthy to be classed as a fine art. It becomes a trade, and is entirely in the hands of the mechanic of the workshop. Of the revival in the twentieth century, of which signs were shown in the last decade of the preceding one, some account will be given.

CHAPTER II

PREHISTORIC IVORIES

SOME comparatively recent discoveries in the habitations of the cave-dwellers of prehistoric ages in the department of the Dordogne in France, and also in Switzerland, enable us to begin our notices of carvings in ivory at so remote an epoch in the history of the world, that we cannot assign to these objects a more precise date or period than the conjectural ones given by geologists to the earliest inhabitants of the earth of which any traces have been found.

About the middle of the last century a systematic investigation of the cave-dwellings in the neighbourhood of Périgord was carried out by distinguished palæontologists, and their discoveries included a certain number of worked fragments of bone and ivory, not only scratched on or engraved with patterns, such as are often found on the implements and ornaments of uncivilised races, but actually chiselled and incised with designs of a description which it is impossible to avoid characterising as absolutely artistic in conception and execution.

It is especially in the valley of the Vesère, a tributary of the Dordogne, that these remains exist in the greatest abundance. In it and in some of its lateral branches have been found the resting-places of those early inhabitants of the earth whom we are

accustomed, from want of data, to group in a general manner as of the stone, bronze, or iron ages. And these peoples, as we shall presently see, may add yet another classification, for without any pretensions to be precise in scientific phraseology, we may allude to them as of the reindeer age. The rivers in the Dordogne run in deep valleys, cut through the calcareous strata. Overhanging the villages and the smiling plains of cultivated land of the present day are picturesque cliffs which abound in the small caves, called *grottes*, which were formerly the dwellings of the interesting people whose handiwork we shall presently consider.

The investigations of the geologists who have carried on the excavations have resulted in the discovery of a vast number of objects, ranging from the skulls and skeletons of the inhabitants themselves to their implements of domestic use, their ornaments, their arms, and weapons of the chase. With all of these, of course, we shall not be directly concerned, but amongst them there are fragments of reindeer horn and of tusks of the mammoth. These animals, in those early times, had not entirely disappeared from southern Europe, and it is the ornamentation on the bone and ivory fragments which will arrest our attention in a striking manner.

The principal caves which have been investigated are at Les Eyzies and La Madelaine, about eighteen miles from Périgord, in Dordogne. At these two places worked ivory has been met with; at Laugerie Basse a portion of the pelvis of the elephant itself, and in all three a quantity of fragments of various bones and horns and other remains, including those of the mammoth, reindeer, great bear, great Irish deer, auroch, and horse, cut in various shapes, engraved in outline, and chased with figures of animals of extraordinary vigour of execution. The question of the co-existence

of man with the reindeer and mammoth in these southern regions is, of course, of the highest importance in our efforts to place a limit of time in respect to the earliest period of man's appearance on earth. We have evidence of this appearance in the heaps of the bones of these animals cracked for the marrow which they contained, and in the traces on them of the hand of man as he cut away the skin and flesh to serve in his primitive cooking. Further than this, it is still more interesting to find engraved or chased in relief on the horn of the reindeer most spirited representations of the animal itself. An actual sculpture of an elephant in reindeer horn was found in 1864 in the neighbourhood of Périgord, and the evidence that it was modelled from life is unmistakable. There are the thick legs with large flat feet, the trunk, the mouth, and the tusks. A cast from the original is in the Musée de St. Germain at Paris.

Amongst these fragments certainly the most striking of all is a piece of a reindeer's antler representing the head and shoulders of an ibex, carved with a life and understanding of art which a sculptor of the finest period might envy. There are other examples of sculpture amongst these remains, but quite as astonishing are the incised drawings or sketches on ivory and horn or bone and on pieces of slate. An example of the latter is a group of reindeer. It is nothing more than a sketch, drawn with a free hand, but it is executed with such strength and precision, the forms, the gaits, and the characteristics of the animals are given with such life and truth to nature, that the whole question of cultivation in art seems to be raised. The intuitive knowledge of these primitive peoples, who in other respects perhaps were not removed from those of our race whom we are accustomed to call savages, can be compared only to those natural geniuses who from time to time appear—for instance, as musical prodigies

[43]

—and astonish us by their mastery and innate comprehension of that which for others, however gifted, requires years of training and cultivation. Again, when we consider the evolution of art through the ages of which we possess records, it must surely be admitted that its highest expression is after all a convention, and not a direct imitation of nature. Yet here we find at a remote period of man's existence on earth—we cannot speak of it as man's history, for we have no history—this uncultivated savage instinctively adopting a convention, a system, a mannerism which no previous evolution could have led up to! It may be conceded perhaps that, surprising though it might be to find the imitative faculties of primitive man so developed as to admit of perfection in modelling in the round in some plastic material, still our admiration and astonishment would not be so excited as when we are led to examine these examples of absolutely clever and artistic sketching. For it is hardly necessary to point out that the engraved outlines—drawn with such precision on a hard and unyielding substance—are not sketched as a child would draw them, nor even in the manner which a sailor uses when he engraves figures of men and women, ships and animals, in outline, on sea-horse teeth. They are drawn by the hand of a genius, who, in his way, had nothing to learn, but from whose work his fellow-artists, uncounted generations later, could derive much profit.

Very characteristic indeed are these extracts from the note-books of our primitive ancestors. Take, for example, the huge form and gait of the mammoth, the graceful and alert bearing of the reindeer. There is no mistaking them for an instant. More than this, but of less particular value from the point of view of art, in the specimen of the ibex carved in reindeer horn we have a representation which is so precise and true that naturalists are able to distinguish the species, and

to assign it to the ibex of the Alps rather than to that of the Pyrenees. Again, it must be remarked that these chiselled examples are not servile imitations in the round; they are conceived with the highest feeling of delicacy and restraint.

It may be that these early artists sometimes chose by preference some more plastic and more perishable material, but, happily for us, they worked also in the hard, unyielding medium of bone and ivory. Happily, for it must be considered also that if we have had by chance preserved to us these few instances, it is extremely probable that they represent many more in the history of a people who undoubtedly, whatever their method of life might have been, whether or no they existed under conditions which to us would seem to indicate extreme discomfort and barbarism, must still have possessed more than the elements of refinement and of practical culture. Who, then, were they? What do we know of them, or what can we deduce from the investigations of geologists? Do more things perhaps lie buried, whose discovery will increase our knowledge, and tell us more distinctly something which may reconcile so many apparent inconsistencies? And what an hiatus is there in the history of art between the epoch of the cave-dwellers and those later days, even the days of the civilisation of Egypt and Assyria, which are still far distant from us, and which we reasonably are accustomed to associate with remote ages!

It is interesting also to remark that until the finest periods of Greek art, excepting in the days of the splendour of Assyria and ancient Egypt, we have no records of representations of animals and animal life. Half-civilised nations might carve ornaments of fretwork, spirals, and the like, such as we find up to the present time in the work of the savages of the south seas, but at the best such work was confined to outline. And so

[45]

these—the earliest in our history of carving in ivory—
are the earliest also in the history of cultured and
thoughtful art: these pictures, these records, earlier
than the cylinders and tablets of Assyria, which with
infinite pains and learning have been deciphered and
explained to us. But the drawings and sculptures
which we are now considering need no deciphering.
So far as art and delineation are concerned they tell
their own story, though they may fill us with wonder
and leave us vainly guessing at the condition and
period of civilisation and the history of mankind with
which they are associated.

As to the possible date of these objects all informa-
tion of which we are possessed is vague indeed, and
we must content ourselves with conjecture and hypo-
thesis. The geologist alone, from his investigation of
the changes which have taken place in the earth itself,
and the palæontologist from the examination of human
remains and the remains of the now extinct animals
which at one time roamed in countless numbers over
these regions, can deduce some shadowy period in the
distant ages of a far-off antiquity in comparison with
which the building of the earliest of the pyramids would
seem, as it were, almost of our own time.

There are evidences that these cave-dwellers lived
a fairly easy life. The quantities of remains of bones
of deer, wild boar, birds and fish, show that food was
plentiful, and they had little other occupation besides
that of the chase. They had ample leisure to occupy
themselves with works of pleasure and amusement, and
we may suppose that they began first with the fabrica-
tion of the simple tools and weapons—the adzes, spears,
harpoons, and fish-hooks—which they required for the
ordinary purposes of domestic life. They would natur-
ally then proceed to give these things more varied and
ornamental shapes, and finally to decorate them by
engraving and chiselling in relief. The profusion of

reindeer was so great that one must imagine they scarcely went further for their principal food, and the bones and antlers furnished them with sufficient material for implements of all kinds. We find also many instances of the teeth of animals, such as the horse, auroch, wolf, bear, and others, besides the reindeer, used as ornaments, as we may surmise from the holes drilled in them for suspension. Finally, true ivory, both from the ordinary elephant and the mammoth, was within their reach, and probably in abundance.

The investigations and deductions of geologists appear then to place this reindeer age at the highest antiquity of all the prehistoric ages. It is of course evident that the climate of those times was very different from that which characterises southern Europe in our own epoch, and it is not unreasonable to suppose that as the climate altered the inhabitants found themselves gradually compelled to migrate, as the conditions of existence became incompatible with those to which they had previously been accustomed. Doubtless the movement was very gradual and must have taken ages to accomplish, but there appears to be a considerable amount of evidence—at least, there has been some speculation—to connect the cave-men of Périgord with the Esquimaux of northern Europe. The identity of the form of the weapons, fishing and other implements, the absence of pottery, the accumulation of animal remains in one spot, the small stature of the people, as shown by the skulls and skeletons which have been found, and other indications seem to point to their having been driven northwards, together with the fauna — the mastodons, grizzly bears, and reindeer. All this, however, is naturally pure conjecture, a matter of palæontological inquiry. It is unnecessary for our purpose to investigate the question and to attempt to be precise as to the possible period of remote antiquity when this people existed. It will suffice that it was at

[47]

a very early time indeed; an age which was certainly long before the days of the cradle of civilisation in Egypt.

It is not without reason that we insist so strongly, and endeavour to enforce the realisation of the extreme antiquity of these objects. Reference has already been made to the remarkable manner in which the void in the history of art is for several centuries almost entirely filled by the examples of carvings in ivory which have come down to us. Not less interesting is it to be able to refer to these solitary examples of the art of probably the earliest prehistoric times, and that these records should be of comparatively so fragile and perishable a material. But we may remember that under certain conditions—of frost especially—ivory and bone are capable of almost indefinite preservation. It is entirely a matter of the surroundings. While, for example, the ivories discovered in the excavations of ancient Nineveh have been transformed in most cases into the semblance of decayed or fossilised wood, ebony or basalt, the tusks of the mammoth still lie embedded in their icy Siberian prison-houses, as fresh and perfect as in the days when the animals ceased to exist.

The first of these interesting finds in the Dordogne caves which we shall describe is the slab of mammoth ivory discovered at the Madelaine, now in the museum of the Jardin des Plantes. It is somewhat more than nine inches in length, of irregular shape, and un-fortunately was broken at the time of the excavation. It was, however, shown soon afterwards to the eminent palæontologist, Dr. Falconer, who at once recognised in the outline engraving on its smooth surface the head of an elephant. The trunk and eye and ear are evident at first glance, and, in the surrounding vertical lines, the indication of a distinct species, that of the shaggy or hairy mammoth, is apparent. It is, of course, little more than a rough sketch, probably made in an

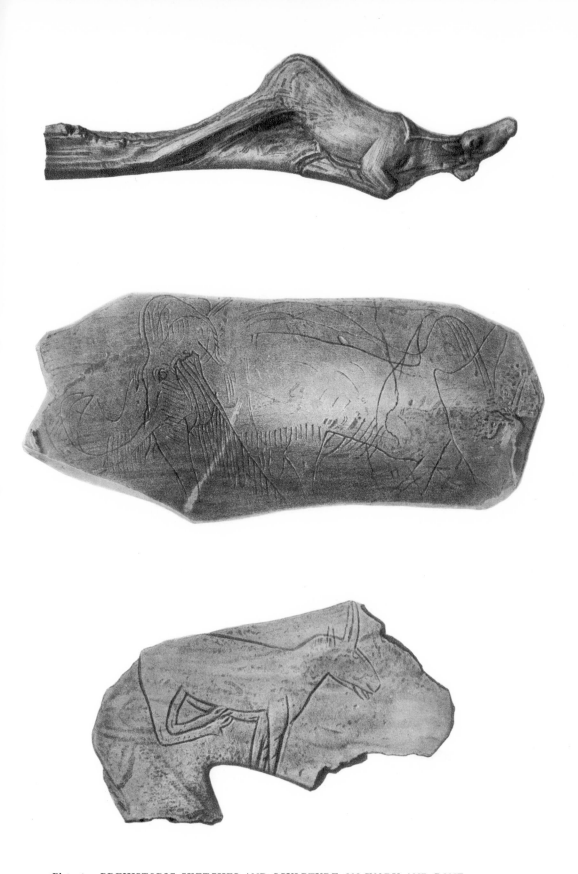

Plate 1. PREHISTORIC SKETCHES AND SCULPTURE ON IVORY AND BONE

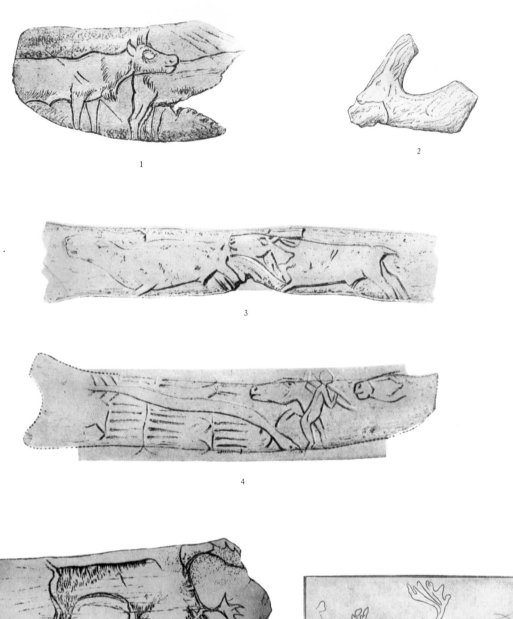

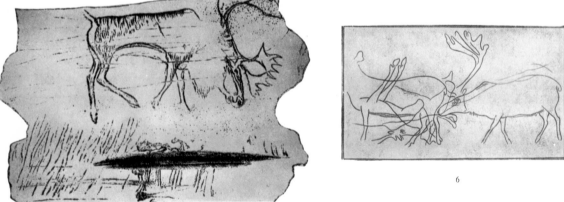

Plate 2. PREHISTORIC SKETCHES ON BONE, IVORY AND SLATE

1, 3, 4. FROM THE DORDOGNE. 2. IBEX, CARVED IN REINDEER HORN. 5. FROM THAINGEN. 6. SKETCHES ON SLATE

idle moment without any intention of creating anything for subsequent use, but even in such beginnings one cannot help recognising a certain force of interpretation which is extremely striking. The group of reindeer which forms the next illustration is one of the remarkable examples of intuitive artistic spirit, to which allusion has been made. It is drawn, it is true, on a piece of slate, and is therefore connected in an indirect manner only with our subject, but as the examples in bone and ivory are necessarily few, it may not be improper to supplement them with instances of similar artistic skill by the same workmen. Here, again, the figures are incised in outline, partly finished, and mixed up together in precisely the same manner as a modern artist would mix up thumb-nail sketches in his sketch-book. It is impossible to help marvelling at the truth to nature displayed in the lithe and agile form of these animals, their characteristic gait, the majesty of their antlers, the plumpness of their well-fed bodies, and the clever touches, as restrained as in any work of modern times, in the indication of the hair in the nostrils and dewlap.

Another example, still more remarkable, perhaps, was found in some habitations of cave-dwellers at Thaingen, near Schaffhausen, in Switzerland. It is engraved on reindeer horn and represents in a remarkably truthful manner, and with extraordinary spirit, a reindeer browsing. The animal, in this case, seems poor and thin, rather tucked up, as it may be said, and even a pool with grass growing at the edges and with reflections in the water are represented. This celebrated sketch is now in the Rosgarten Museum, Constance.

On another slab from the Dordogne we have the outline of a glutton, in which from the point of view of fidelity to nature no fault could be found by a naturalist. It is not, we believe, incorrect to say that

[51]

the fact of the existence of this particular species at the period of the cave-dwellers has for proof solely this remarkable picture. Other animals are represented, carved or chased on bears' teeth, and portions of deer antlers. Such, for instance, are a bear's tooth with a representation of a seal, and another with a fish engraved upon it, in which we recognise without question a pike. The teeth are bored for suspension as ornaments, and when we consider the distance from the sea at which these people lived, one cannot help wondering with regard to the seal how they became acquainted with such an animal.

The most interesting of all these examples, artistically, is the reindeer's antler carved with the head and shoulders of an ibex. Instances of human figures are not numerous, if indeed more than one is known. This is the shoulder-blade of a reindeer, found in the Madelaine caves. On one side is scratched or incised the figure of a woman, naked, and wearing a necklace and bracelet. On the other side of the bone is the outline of a horse's head. Casts of this and of many others are in the British Museum. Many originals are in that of St. Germain-en-Laye.

CHAPTER III

IVORIES FROM THE RUINS OF NINEVEH
AND OF ANCIENT EGYPT

FROM the consideration of the interesting examples of the work of our prehistoric ancestors, we must allow the lapse of a number of centuries which it is impossible to express in figures and pass to a period of time which is still remote and indistinct in the annals of our race, and yet not so absolutely hidden in obscurity as to prevent our assigning dates which may be approximately correct, say, within a few hundred years or so. We shall find ourselves concerned principally with those African and Asiatic countries where the early nations of the world developed a civilisation perhaps unequalled in splendour and in the encouragement of the arts of decoration. Of these nations almost our entire knowledge comes from the sculptures and treasures discovered in the ruins of cities buried and hidden from sight for centuries, whose very names and histories are unknown, and from the gorgeous burial-places of the great rulers and princes of the dynasties which governed these lands. It is to Egypt and Assyria that we now come, and happily the remains of the wonderful magnificence of their ancient peoples have come down to us, it may be said in profusion.

Many museums abound with splendid examples of the gold and silver work, the jewellery, the vases, the sarcophagi, the statues and figures, the bracelets, neck-

laces, earrings and other ornaments of dress, the furniture and objects of domestic use of those days, some of them indeed of such high artistic value that they could only have belonged to very great personages or monarchs. Naturally we could hardly expect to find instances of works of art in such a fragile material as ivory in any very considerable quantity, and it is not a little surprising that so much has survived the destruction of the buildings amongst the ruins of which they have been discovered. Enough, however, remains to give us a very good idea of the estimation in which this material was held for decorative purposes, and to form a link in the chain of the history of art which, so far as ivory is concerned, will scarcely be broken for a single century from these ancient days to our own times.

It will be necessary to consider Egyptian art in ivory incidentally, rather than as a separate subject. As a matter of fact, with regard to Egypt it must be allowed that there is not sufficient material at hand to justify our doing otherwise. But the collection of examples now preserved in the British Museum, resulting from the discoveries made by Layard, in his well-known excavations of the site of the great city of Nineveh, have a peculiar interest of their own, and may well be considered to form a class apart from other isolated specimens found here and there, and unconnected with any particular historical event.

Of very early Egyptian works in ivory we have still preserved in the museums of London, Paris, and Cairo, examples of the earliest of the dynasties—of times which go back before the days of Solomon, before the age which saw the building of the pyramids of Ghizeh, before the days of Abraham, possibly, perhaps, before the building of the great Step Pyramid. For the erection of Solomon's temple was about a thousand years before Christ, the time of Abraham again about

a thousand years farther back, and the building of the Step Pyramid some centuries again still more remote. We have evidence that the ancient Egyptians were skilled workers in ivory, which they obtained in large quantities from Ethiopia. Sometimes they were content with carving it, sometimes it was engraved with designs and figures in outline filled in with black mastic. Of these two methods there are two extremely interesting examples, supposed to be castanets, or clappers of some kind, in the museum of the Louvre. One of them, preserving the curve of the tusk, is carved with a head in relief, and ends with a beautifully modelled hand tapering to the extreme point. The other is the plain curved tusk incised with rudely drawn figures.

The British Museum possesses two daggers inlaid and ornamented with ivory, which are of the time of the Pharaoh of the Exodus, that Pharaoh whose actual features every traveller can contemplate and recognise to-day, as he stands imprisoned in his glass case in the museum at Cairo. And in the Louvre are a quantity of objects in ivory and bone—small vases, toilet boxes, spoons—the handle of one of which is a naked female figure—and other things, amongst them a box of plain form and simple decoration, which is inscribed with a prænomen attributed to the fifth dynasty, perhaps nearly four thousand years before Christ.

The date of many of these objects brings us to somewhere about the same period as that of the Assyrian ivories now in the British Museum. Where chronology is somewhat vague, and where we insensibly speak and think of four or five centuries or so, or even more, as almost a negligible lapse of time, it is as well to get hold of some tangible idea concerning the antiquity of these fragile articles. When we consider how very fragile they are, and how quickly perishable under ordinary circumstances, it is astonish-

ing that any at all should have survived the fall of
buildings and the action of fire which probably in the
first place caused their burial in the ground, and next
the action of the earth itself during the ages which
elapsed before their discovery.

The history of Assyria is almost entirely wanting.
Very rare, indeed, are the references to this great
empire in early writers. From one or two, such as
Diodorus Siculus or Eusebius, we have a few casual
remarks, but it is remarkable that anything in the
shape of a connected history should absolutely fail to
have been transmitted to us. Still a certain amount
of historical information may be said to have been
put together, and from it we may gather that the great
city of Nineveh arose about two thousand years before
the Christian era. In the Scriptures we find (Gen. x. 11)
that out of the land of Shinar "went forth Asshur
and builded Nineveh," and there, too, was Nimrod,
the mighty hunter before the Lord. A thousand years
or so later the prophet Jonah appears in the city and
foretells its destruction, and about 840 B.C. the great
king Sardanapalus is said, in a fit of madness, to
have shut himself up in his palace and destroyed it
and himself by fire. And so time went on until
Nineveh itself, after the expeditions of Sennacherib,
was rased to the ground, under Nebuchadnezzar II.,
about 650 B.C., and for a space of nearly three thousand
years the only traces of its existence were the mounds
and heaps of débris covering the site of some ancient
city, which our countryman, the great explorer Layard,
at length unearthed in our own days. From his
excavations, principally, come the stupendous mono-
lithic monuments, which we are able to wonder at and
admire in our national museum. These and a quantity
of other monuments and works of art of the highest
interest, together with the famous cylinders, hundreds
of which have been learnedly and patiently deciphered,

are the only real books and records which we possess of these ancient peoples.

The huge mounds under which the ruins of Babylonia had been buried for many centuries had long excited the curiosity of travellers, but nothing systematic appears to have been attempted in the way of exploration until early in the nineteenth century, when the first to engage in a serious examination was Mr. Rich, the political resident of the East India Company at Bagdad, who began his excavations on the supposed site of Nineveh, opposite the modern city of Mosul, about the year 1820. He was followed about twenty years later by Layard, whose discoveries amongst the ruins of Babylon, of course, far exceed any others in importance.

The so-called mound of Nineveh occupies a rectangular area of about nine hundred yards long by eighteen hundred wide; within were discovered the remains of five edifices—palaces, temples, and tombs. The first great finds were some immense chambers walled with slabs of gypsum covered with sculptured representations of battles, sieges, and the like. For twenty-five centuries at least they had been hidden from the eye of man. During that time where had been spacious halls and kingly palaces nothing had been visible but portions of ruins and huge mounds of earth. As the ages passed the earth accumulated; over and over again the plough passed over, crops grew and were gathered and replaced, and no suspicion existed of what remained beneath the ground.

It is not, of course, within our province to do more than allude in passing to the marvellous and gigantic monuments—the winged bulls, the representations of the triumphs of Sennacherib and his predecessors, which Layard unearthed. The examples of ivory carvings from Nineveh exhibited in the British Museum number some fifty important pieces, besides

those which, either being duplicates or too much decayed and fragile for exhibition, are stored away in cases. They were found for the most part all together, in the excavation of the great north-west palace, at Nimroud, the largest and most ancient building discovered, and the most interesting portion of the ruins. When the workmen came across these fragments they were deeply embedded in the soil, to which they adhered so closely that it was only with extreme care, and in many cases with the aid of a penknife, or some other small instrument, that they could be detached and cleaned without falling to pieces. Not only so, but the action of the earth, and in some cases the effect of fire from a conflagration at the time of the destruction of the palaces had so decomposed them, that many separated into flakes or fell into powder. The action of the external air would no doubt before long have completed their destruction, when it occurred to their discoverer to restore to them the gelatinous matter which had dried up in the course of centuries. This was done with a very gratifying measure of success by boiling them in a solution of gelatine dissolved in alcohol, so that some of them have almost completely regained their pristine beauty. For the most part, however, the ivory has so entirely changed its nature that a casual observation would lead one to ascribe them to quite different materials.

After all, the forms remain very fairly perfect, so far as their fragmentary character may be considered, and one can hardly, in fact, regret the curious changes which have happened, so beautiful—in the same way as with the iridescence of ancient glass—have these fragments become. It is possible, perhaps, that some may owe their colour to dye or to other artificial colouring, but as a rule the probability is that the action of fire is responsible for the change in nature. Some pieces are hardly to be distinguished from ebony,

others resemble basalt, slate, fossilised wood, sandstone, wax, or even possess almost the iridescence of opal. In this connection it may be interesting to recall the opinion of the learned chemist, Professor Church, to whom a tiny bit of inlay, resembling turquoise, from a gold armlet discovered on the Oxus, was submitted for analysis. He says: "I tested the fragment for phosphoric acid and found it, but could detect no copper, to which element turquoise owes its colour. But there are other blue mineral phosphates. So I turned my attention to the best known of these, namely, odontolite or fossil turquoise, which is really mammoth ivory coloured blue naturally by vivianite or iron phosphate." We learn, then, that mammoth ivory may be, by lapse of time and through surroundings, converted into a gem, and the question is suggestive in many ways. Fossil or blue ivory is sometimes found in commerce, and is used occasionally in the manufacture of jewellery. It is evidently the result of the tusks of antediluvian mammoths buried in the earth for thousands of years, during which time they have become slowly penetrated with the metallic salts, which have given them the peculiar blue colour, allowing them to be used as turquoises.

The examples of ivory in this collection consist of a number of plaques, which formed, probably, portions of the decoration of thrones or couches, fragments of winged sphinxes, small thin slabs, simply engraved in outline, the head of a lion, portions of the bodies of bulls, and other animals, flower and scroll work, and a considerable number of human heads, hands, legs, and feet. In most cases these heads would appear not to have formed parts of complete figures, but to have been affixed to pedestals, or to have been portions of the decorative frieze of some piece of furniture.

The wealthy Assyrians were noted for excessive luxury in the rich adornment of their dwellings. Doubtless

it was particularly to them that the inspired prophet referred when he said that there was "no end of the store and glory out of all the pleasant furniture." On a sculptured slab in the British Museum and on his cylinders we have had deciphered the campaigns of Sennacherib described by himself. He enumerates the spoil which he carried away when he overthrew King Hezekiah and shut him up in Jerusalem: "thirty talents of gold, eight hundred talents of silver, precious stones, ivory couches, ivory furniture he sent to my court at Nineveh as tribute." And if the few precious fragments which have come to us are suggestive, can we not imagine the wealth of ivory decoration displayed in the inlay of ceilings, beams, and panellings, in the mouldings and architraves of the gates and doorways of the palaces, in the chairs and couches, tables and cabinets, and other furniture? We may be certain that in the decoration of these and many other things ivory was used as an ordinary veneer or inlay in the manner which afterwards spread far westwards, and became so popular under the name of tarsia work. Its exquisite whiteness and peculiar sheen were contrasted, not only with wood, but also with gold and silver, and even with the more sombre tones of bronze and iron. Very often, indeed, we find the fragments mixed up with the débris of wood and other material. Evidently many of them have formed portions of thrones or of footstools of thrones—in fact, it might not be very difficult with their aid to construct a possible reproduction of such a magnificent piece of furniture. Then, again, in one or other of the museums already mentioned we have examples, in a more or less complete state, of arms, such as daggers or sword handles, sceptres, decorations of the wheels or pole-heads of chariots, musical instruments, toys, and small domestic articles.

The most interesting, says Layard in his great

1

2

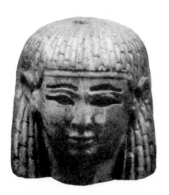

3

Plate 3. IVORIES FROM THE RUINS OF NINEVEH

1. FRAGMENT FROM THRONE, NIMRUD. 2. PANEL WITH CARTOUCHE. 3. EBONY-LIKE HEAD

work on Nineveh, amongst the pieces forming the collection in the British Museum, are the remains of two small tablets. One of them is almost perfect. The other panel, unfortunately much injured, represents two sitting figures, each holding in one hand the Egyptian sceptre or symbol of power. Between the figures is a cartouche containing a name or words in hieroglyphics, and surmounted by a feather or plume such as is found in monuments of the eighteenth and subsequent dynasties of Egypt. The chairs on which the figures are seated, the hieroglyphics, and the feather were enamelled—if the term is applicable, and it may be—with a blue substance let into the ivory, and the whole ground of the tablet, as well as the cartouche and part of the figures, was originally gilded. Now in this treatment of the ivory, after the manner of enamelling, by digging out the ground in cells and compartments, and filling in these compartments whether with a coloured composition, or, as is extremely probable in other cases, with actual jewels or semi-precious stones, a question arises of considerable importance in connection with the analogy of such a method with a very usual and beautiful art in ancient Egyptian jewellery. It is, in fact, doubtful whether the origin of this fashion may not be traced to Assyria, and that it was thence adopted later in Egypt. The inference cannot, of course, be absolutely drawn from the fragments which are now before us, but it may be remarked that though many of the finest pieces from Nineveh, and especially this cartouche tablet, have a decidedly Egyptian character, yet there are certain peculiarities which may lead to the supposition that although the motive may have been copied or taken direct from Egyptian sources, the method of application was due to native workmen. It is true that the inlay in these cases is a composition or colouring matter resembling lapis lazuli, but the idea is the same, and until we can be more precise as to the

date of these objects the question may perhaps remain an open one.

It is not to be denied, with regard to a considerable number of them, that they were importations, and it is impossible to question the purely Egyptian character of the designs. We cannot, therefore, reasonably assert that all these plaques are of Mesopotamian origin, or deny that some are not only Egyptian in style but also in workmanship. To ascribe their origin to all the importations would be a matter of considerable difficulty, bearing in mind the various foreign sources to which artistic work in ancient Assyria, with the varied commercial relations of that great empire, might be assigned. The important part played by Egypt, at least, may be taken for granted, both in the actual importation of works of art, and in the influence exerted by its style on the native workmen. And with regard to other countries, undoubtedly a considerable quantity of Indian ivory must have entered Mesopotamia by caravan and land routes, by the Persian Gulf, from Chaldea and Arabia, and from Africa also by way of Egypt—some in its raw state, some already partly prepared for application in the way of veneer. We know also, both from the sculptured reliefs on the monuments of Nineveh, representing captives or tribute-bearers bearing tusks, and from actual finds, such as the elephant tusks which Layard discovered in one of the palaces, that ivory was brought in a rough state into the Assyrian capital. At the same time there are many other examples with figures and ornaments of purely Assyrian character, for instance, the horned tiara, the winged robes, the guilloche border, the daisy-shaped rosette repeated over and over again, or the honeysuckle ornament in various forms and developments. Then, again, though certain motives, such as the solar disc, the plumes surmounting the cartouche, the sphinx, the palmette, or the lotus,

[63]

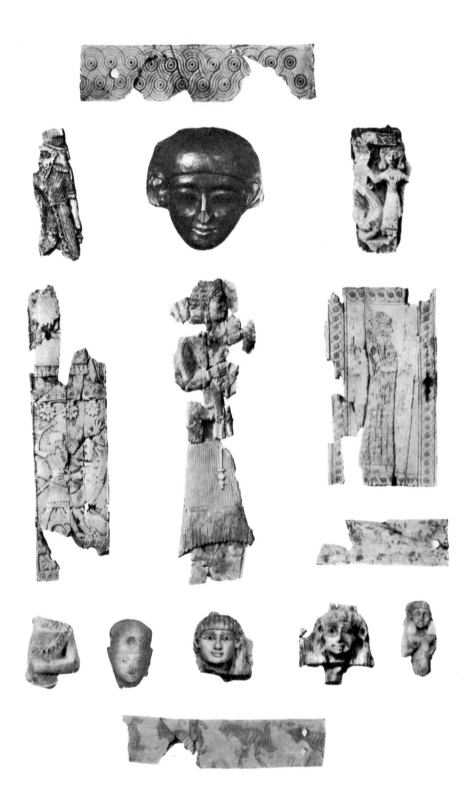

Plate 4. IVORIES FROM THE RUINS OF NINEVEH

might have been borrowed from Egypt, and were so, no doubt—especially in the times about seven centuries before Christ, when the Assyrians invaded and occupied it—still, it is often adaptation rather than borrowing, and to the adaptation the Assyrian might have added his own peculiarities. May we not, for example, see an instance of such adaptation in the fragment with the winged sphinx in the British Museum, of which we give an illustration?

In the great fragment with the cartouche the figures of the women are clearly Egyptian in their dress, attitude, and faces. Not only so, but the tablet bears a legible, and not purely ornamental, hieroglyphic, which has been read as Auben Ra, perhaps the name of a dynasty. It is, of course, possible that the style of this hieroglyphic may not be purely Egyptian, but an imitation by native artists. But though the preparation for inlay in cells in the wings of the sphinxes seems to be in the Egyptian manner, the bodies of the animals and the general treatment of the lotus-flower decoration are somewhat different from what we should expect in fine specimens of purely Egyptian work.

The question of origin is always one which it is difficult to settle satisfactorily on the evidence only of national styles. It is easy to imagine that an ornament may be the result of an order given by a great personage of one country to a workman of another who would often be following instructions, or might endeavour to infuse some of the characteristics into his work of the nation for which it is destined. Or a foreign workman long settled in another country, though assimilating the tastes of his adopted home, would naturally preserve a good deal of the style of his own nationality. We find such instances over and over again in the arts of all nations. At the same time, though, as the wise man said, there is nothing new under the sun, it is always interesting to endeavour to fix the earliest

examples of any particular fashion or style. And even in this small collection of ivories from Nimroud we are able to point to an indubitable instance of the invention of the Assyrian in that most graceful ornament commonly called the honeysuckle, which was known to their refined taste certainly two or three centuries before it passed, under various forms and adaptations, from Persia to the Greeks, and was extensively used by the latter during the highest periods of their incomparable art. Another favourite with the Assyrians was the guilloche design, that simple and effective intertwining of bands and circles. We find it on their monuments, embroidered on the robes of the personages depicted, on the decoration of chariots, of arms, on the walls and friezes.

Yet again, illustrated on these ivories, is the volute, which is universal in Assyrian and Chaldean art. We have it, for example, in a plaque carved with a figure of a man standing and grasping a lotus stem. In this arrangement is to be traced also that peculiar symbolical device which has so much interested orientalists, viz. the tree of life. The fondness of all oriental nations of antiquity for this symbol, and for the particular curves composing it, which may be seen over and over again in the various adaptations of the device, is very remarkable, and its relation with the history of art and the development of the earliest forms of religion in the east meet the observer at every turn, sometimes in the most unexpected connections.

The very early specimens of ancient art which these Assyrian ivories, prepared for inlay, offer us the opportunity of studying, open up therefore the interesting questions of the origin and evolution of *cloisonné* enamel, which appears in its earliest stages to have consisted in the inlay of coloured stones or of pastes and other compositions used without the action of firing. The fashion of inlaying brooches, rings, brace-

lets, necklaces, and other ornaments with precious stones spread gradually to the west, and we find numerous examples throughout Germany, Scandinavia, Italy, and England, up to the ninth or tenth centuries. We are enabled to trace this system of imbricated ornament in its passage from Assyria and Egypt across the Asiatic and European continents, and to observe the manner in which it was adapted by various nations, especially by barbaric tribes, as in the case of the Scythians, where we find turquoises and cabochon-cut stones set in cells dug out of the solid metal. The fashion of inlay in ivory was not uncommon. It is probable that gold and silver were used, and there are traces of the inlay, if not of precious stones, at any rate of such semi-precious material as lapis lazuli. Possibly also the process was reversed and the ivory set—or let in—to bronze, silver, or gold, as the case might be, and as a matter of fact, we have an instance of this on a small scale in the case of a Roman bronze head found at Veii. Few examples in ivory other than those of Nimroud have come down to us. Amongst these few there is, however, an ivory dagger-sheath inlaid with small squares of amber found by Padre Garrucci in an Etruscan pre-Christian tomb at Veii; and, again, at Hallstadt, some sword handles have been found inlaid with ivory.

The practice seems to have travelled on through Russia and Scandinavia, through France and Spain, Italy and Germany, till it died out completely. It is an art which must be admitted to be one of the most difficult of all the arts which can be used without danger of vulgarity. Barbaric magnificence may be satisfied with it in its crudest forms, but for a cultivated taste a measure of restraint is required, of which possibly none since the times of Greek art at its best have been capable. To the Japanese, almost alone in their marvellous originality, have the inlay and mixture

of various substances of opposite character occurred in modern times until quite recently. When we come, in a succeeding chapter, to examine their work, we shall find occasion to note their use of the inlay and combination with ivory of gold and silver, coral and mother-of-pearl.

Some stress has been laid on the hypotheses connecting these ivory fragments with the art of inlaying, because it is pleasing in an account of the application of ivory to the industrial arts to be able to point at so early a stage to an association which is of a very high importance. It is right, without pursuing the subject further, to mention analogous cases of similar inlay with pastes or coloured glass in tiles and other objects of pottery and porcelain in ancient Egypt, and also the mixture of these materials with ivory for the decoration of coffins and mummy cases.

Where all is vague in the history of so flourishing, but so little known, a people as the Assyrians, it is impossible to estimate too highly the value of the smallest indications which tend to throw light on their civilisation, their manners, arts and customs, but to attempt to be in any way precise as to the date of these interesting ivories is impossible. In many cases, as already pointed out, the forms and styles of art are very distinctly Egyptian, but we are met with puzzling anomalies and peculiarities in the character of these styles. At the date generally assigned to the foundation of Nineveh, that is to say, about 2000 B.C., the arts had already attained to a high state of perfection in Egypt, but a lapse of time amounting to at least a thousand years—a very long period, indeed, in the history of the world—must be allowed before we reach the earliest period at which authorities have ventured to place the date of the fabrication of the ivories, if we may take this to be about the time of the twenty-second dynasty, or 980 B.C., and, again, a further interval of three or

four hundred years, if we accept the latest possible date —according to Layard—as 634 B.C.

From recent explorations in Egypt, such, for instance, as those of Professor Flinders Petrie and Drs. Grenfell and Hunt at Abydos, a certain number of fragments of sculpture in ivory have naturally resulted. Some small objects from the old temple site at Abydos were exhibited at the University College, Gower Street, in 1903. Amongst them were several fragments of small figures, for the most part of animals —dogs, bears, and lions, one of the latter having eyes of chalcedony. The most interesting is a small statuette of an aged king, wearing the crown of upper Egypt, and what appears to be a robe of thick quilted stuff with a well-defined pattern. Another is a torso of a naked woman surprisingly well modelled.

Concerning the dates of these pieces, it would be difficult to be anything like precise, and, in any case, it is a question for Egyptologists to decide. The earliest temple was probably anterior to the first dynasty—that is to say, before the time of Menes, the first king of Egypt—and it was in a chamber of this temple that the ivories were discovered. In that case they might be some two thousand years older than the Nineveh fragments. They were found here amongst a mass of waste and rubbish which had been thrown together with many other disused temple figures, ornaments, and débris of furniture. Their condition resembles that of the ivory fragments from Nineveh in the British Museum, and, in fact, in most cases they are in the same way hardly to be recognised as ivory. But there was evidently a large deposit of ivory objects in this chamber, much, however, in such a state as to prevent their recovery. Sometimes there would be little more than mere yellow paste, or a little heap of grains or needles, lying in a hollow in the clay. Sometimes the form and the nature of the material

of a statuette could be discerned, but without hope of successful extraction. The most perfect pieces were treated in a similar way to those discovered by Layard. The lime and salt incrustations were removed with vinegar and with dilute hydrochloric acid, and the ivory was then soaked in gelatine, melted stearine, or beeswax. Later on, on arrival in London, it was boiled in wax to increase the consistency.

CHAPTER IV

CONSULAR DIPTYCHS AND OTHER ANCIENT GREEK AND ROMAN IVORIES

COMPARATIVELY a very small number of
Greek and Roman carvings in ivory have come
down to us earlier than the earliest of the
consular and other important classical diptychs and
plaques, to which considerable attention will presently
be devoted. Of Greek art at its finest period scarcely
anything exists to which we can refer with any
certainty, though it can hardly be doubted that ivory
work could not have been neglected, and we have,
therefore, to deplore the absolute loss of countless
examples, which must, at one time, have abounded.
Ivory would seem to be a medium, in which the
refined taste of the great sculptors of Greece must have
delighted; but there remain to us but the records, to
which allusion has already been made, for instance, in
the pages of Pausanias and in the references which we
find so frequently in the great poetic writers. The
chryselephantine statues of Phidias and Praxiteles will
receive attention in a subsequent chapter.

There can be little doubt that for a thousand
years at least before our era, ivory would have occupied
the attention of a succession of sculptors throughout
all the flourishing nations of Africa and Asia, as well
as in Italy. Unquestionably, the demand for its use
must have been very great in the decoration of palaces,

for furniture, arms, and numberless objects of domestic use which were so lavishly adorned in those luxurious days. Not the least among the losses which we have to regret must be that nothing has been preserved in ivory to compare, for example, with the charming Tanagra groups and statuettes, which, though executed in a much more fragile material, may yet be seen in comparatively large numbers. To say that there is nothing left of the most glorious ages of art which the world has ever seen is perhaps too sweeping, but even remembering that a few very beautiful objects of possibly Greek workmanship have been discovered in Etruscan tombs at Chiusi, Palestrina, and Calvi, the exceptions are so rare that the void remains practically unfilled. In the tombs of the Scythian kings of the Crimea, which yielded up such a multitude of treasures of Greek and Greco-Scythian art workmanship in the precious metals, dating from the time of the highest civilisation of Greece, we can point to nothing, save a few fragments of thin pieces or veneers of ivory which ornamented some domestic object, perhaps a couch or throne, or, as some think, a lyre. These are, so far as they go, precious and remarkable, but even to them we can hardly assign an earlier date than the third century before Christ. They bear exquisite designs and groups of figures in outline, and are similar in many respects to the slabs of ivory with outline designs in the Nineveh collection of the British Museum. Like these, too, the ivory is much decomposed, and of a greyish colour resembling wood, which, until recently, the Hermitage fragments were supposed to be.

The few examples of importance of classical work before the Christian era, or about that time, are mostly in the great museums of the Vatican, Naples, the Louvre, and Cluny. In the Cluny Museum is a very beautiful and rare statuette of Penthea, possibly of the

third century. It is fifteen inches in height, of very white ivory, the head covered by a veil. She holds in the right hand a *thyrsus*, in the left a mirror. The most important in Italy include finds in Etruscan and other tombs, in some cases the work of more eastern countries, and of high antiquity.

A fine head of a woman, found in 1878, at Vienne, during the excavations of the site of the ancient Roman theatre, is of considerable interest. It is very large, almost half life-size. For some time it was thought to be wood, and a paper was read upon it, and upon the extreme rarity of carvings in wood of the Roman epoch. The interior is hollow, with an opening in the back, and it appears to have served as a jewel-case. It is now in the Museum, Vienne.

The finds in the Etruscan tombs at Chiusi and Calvi, if few in number, are of extreme importance, as some of them are probably Greek work of a very fine period, perhaps of the fourth century B.C. A head of a gorgon, with the eyes inlaid with gold, has the appearance of a button or other ornament of a woman's dress. There were other fragments, heads of horses and of lions, portions of mirrors and caskets, and a large bust of a woman, all full of character, and equal in execution to any similar work in sculpture of the best times of Greek art.

The earliest in England to which we can refer is an Etruscan tablet in the Liverpool collection. It is of bone, probably at one time forming part of a casket, and bears a representation of Diana and the Mænalian stag. There are also in the same museum one or two tablets and a fragment of a scent-box. In the Gem Room of the British Museum there is an ivory handle of a mirror in a very fine style of art of perhaps the seventh century B.C., with a representation of Arimaspes slaying the Gryphon, and another, similar, but much decayed. There is also an ivory draught-box, with a

[73]

most spirited representation of a deer hunt. Nor can a mention be omitted of one very famous figure, the Tragic Actor with his mask—Greek work of the second or third century, which came lately to the city of Paris with the rest of the magnificent Dutuit collection.

The examples of Roman classical work in ivory of the first three centuries (omitting for the present the diptychs) in the British and South Kensington Museums are limited to a number of small objects, for the most part of domestic utility. We find among them, however, some remarkably beautiful Greek and Roman fragments — statuettes, heads, busts, cupids, masks, medallions, plaques, parts of friezes, and so on. In addition there are caskets, toilet-boxes, combs, hair-pins, dolls, back-scratchers, styles for writing on wax tablets, dice of several kinds (some very large), knuckle-bones, spoons, and a number of small objects. *Tesseræ*, or admission tickets to the theatre or circus—such as, with relation to the opera, we still call a "bone"—are not uncommon, some of them numbered, others carved with human figures, or with such subjects as a hand, a prawn, etc. Many of these things call for description in detail and for illustration, but we must take them as a whole and view them for their interest in regard to the daily life of those times. It is interesting to note again, as in the case of the Nineveh ivories, the dis-integration and discoloration which is so varied and unaccountable. A curious example is an ivory in its primitive condition, viz., a horse's tooth, which appears almost to be turning into fossil turquoise.

A certain number of ivory fragments of the time of the Roman occupation of our country naturally turn up in barrows from time to time—such things as combs or small statuettes. Of the latter there are, in the British Museum, a figure of a boy and another of Hercules, probably knife-handles. They were dug up at Chesterford about 1855. Ivory and bone combs

have been found in London and Lincoln, at Great Watering, Essex, York, Berkshire, and other places, and are now in the Guildhall and British Museums, and there are the somewhat important pieces discovered at Caerleon, already referred to. Objects in ivory relating to Roman occupations of other countries are not more common. Among them a parazonium, or parade dagger, plain, but the sheath and handle entirely of ivory, found in a tumulus in Belgium is interesting. It is now in the museum at Brussels.

A Greco - Roman necropolis was discovered at Sakkara in 1882, and soon after a Romano-Coptic one at Akmin, containing many fragments of various sorts, ornaments, stuffs and embroideries of the men and women who had inhabited Memphis at the commencement of the Christian era. It must have been used for centuries, and the finds included small ivory crosses with arms of equal length, evidently intended to be worn, and some ivory plaques with figures of St. George and St. Michael, devotional objects of the early Coptic Christians of the fifth to the eighth century.

But if we have to lament the defaults in the chain of examples in the history of art, as illustrated by carvings in ivory, during so long a time, and at a period when, in other directions, it is continued so fully and with such magnificence, on the other hand, the chain can be again picked up in a series of the highest importance and historical interest which begins about the third century of our era. From that time onwards until the present day it continues unbroken. Not only so, but while now it is the turn of every other description of art industry to make total default for a period of five or six centuries—nay, it is hardly an exaggeration to say for almost double that lapse of time—we are indebted to sculpture in ivory for enabling us to make good the hiatus, and to lift the veil which

during that long period covers the history of art throughout the whole of central Europe.

The most important of these monuments of sculpture are the diptychs and triptychs, which for many centuries were used for various practical purposes, and amongst these the most interesting—for their historical associations, at least—and the earliest in point of date are those known as consular diptychs.

Generally speaking, any object doubled or folded in two is a diptych, but the name is more particularly associated with a kind of note-book for inscribing memoranda, or other documents, in a peculiar manner, by indenting the thin surface of wax, with which the leaves were covered, by means of a sharp metallic instrument termed a style.

Books in early days were composed, as a rule, of long strips of vellum rolled on a couple of wooden or ivory rollers when not in use. They were, naturally, costly to produce, and confined to works of considerable length and importance. For memoranda, letters, and documents of various kinds, whether ephemeral or to be kept as records, the custom continued for many centuries of using these waxen-covered tablets, which were usually folded at least twice, and then termed diptychs, or if they consisted of three or more leaves, were called triptychs or polyptychs.

In the case, then, of a diptych, the inner parts of the pair of tablets were slightly hollowed out, leaving a raised margin to hold a very thin layer of wax, the surface of which was coloured, usually black or green, so that the letters scratched upon it with the metallic style might appear white and be easily legible. The tablets themselves were, for ordinary use, of wood of a more or less costly kind and decorated or undecorated; of a more valuable material, usually of ivory, for the wealthy, or for important purposes. A number of such tablets joined together was termed a codex. For

letters the edges of one side were pierced, so that they might be fastened together with a cord and sealed, and with the broad end of the stylus the characters already written might be smoothed over and obliterated, and the surface thus made again ready to be written on. Legal documents, wills and deeds, were almost always on such tablets, and from their use we have probably now such terms as style of writing, indenture, codex, and *tabula rasa*, or, as we should say, to make a clean slate. The custom, clumsy though it may appear to be, has persisted down to very recent times. It could be shown, in fact, that it has not even at the present day completely died out, and we shall have occasion to notice very particularly, in their proper place, the religious and secular objects of this kind which were in use in mediæval and earlier times.

But there are special diptychs of the days of the Roman consulate and empire of more than passing interest, and of an historical value which it would be difficult to estimate too highly. We call them consular diptychs, and though the whole of the series of these historical monuments amounts in number to less than fifty examples, covering a period of scarcely more than three hundred years, yet their teaching value, and the instruction we can derive from them, is of the highest importance. Any question of their artistic value apart, it cannot be forgotten that it is to the work of the ivory sculptor alone that we are indebted for the materials which confirm the written history, and throw light upon subjects which might otherwise remain obscure.

On the establishment of the Roman republic, after the abolition of royalty and the expulsion of the Tarquins in the year 509 B.C., the highest dignitaries in the state were the consuls, who were two in number and elected annually. Their power was at first very great, and equal to that of the kings whom they had superseded. The office continued, with some variations,

for the very long period of more than a thousand years, lasting even through the time of the emperors, though under them the consular power was considerably diminished, and, in fact, became almost entirely honorary, retaining, however, a great deal of pomp and ceremony. The emperors themselves eventually took into their hands the consular dignity, conferring it on others or assuming it themselves, and it was in this condition during the period of time—from the middle of the third to the middle of the sixth centuries —which we shall find illustrated in the series of ivory diptychs that up to the present have been discovered.

During the whole of the long period that the system lasted the office of consul was attended with great pomp and dignity. The consul himself presided in the senate and at public solemnities, such as the pageants and games in the circus, so dear to the Roman people. He administered justice, and never appeared in public without extraordinary state and splendour, and attended by the twelve lictors carrying the fasces, and even when the office became a mere title, it was still the most exalted position in the state.

In connection with the high office of these chief magistrates a popular custom was that by which the consular periods served as a measurement of time. In this way Roman chronology was an epitome of Roman history—a method more congenial to the Roman taste than the dry abstraction of figures. Thus, instead of referring to a particular year, one would have said, for example, in the consulship of Cicero or Caius Antonius. Much importance, therefore, attached to the register of consuls—the *Fasti*, as they were called—a register increasing annually by two names. Some marble tablets, in fact, dug up in the forum in Rome in the sixteenth century contain a list of the consuls and other officials for a period of nearly five hundred years. We are thus able to assign to the consular diptychs a

certain date, and as mere documents there can be no question of their extreme historical importance.

Ordinary writing tablets were usually of a handy shape. A common term for them was *pugillares*, because they could be conveniently held in the hand, and, as may readily be imagined, they were very frequently used for elegant presents in much the same way as similar things are at the present day. Consular diptychs, however, and other diptychs made to commemorate special events, were much larger, measuring generally about twelve inches in height by five or six in width, and correspondingly thick and massive. The fashion appears to have been prevalent of sending these magnificent ivory tablets as presents on the occasions of great family events or celebrations, such as a marriage, a coming of age, or the like, and doubtless it was of importance that the ivory should be of the finest description and of the largest size that it was possible to procure. In a similar manner new consuls, on their appointment, caused a number of such diptychs to be made for presentation to the emperors and to their equals and subordinates on the day of their entering upon their office. The size, excellence of workmanship, and value of material, of course, would vary according to the rank of the recipient. If intended for officials, or others of the very highest position, they would be of fine ivory, carved by the best artists of the time, and perhaps mounted in gold; for others bone, rudely carved and roughly finished, would suffice, and these, possibly, were turned out by the dozen, or hundred, like modern photographs. Some of these tablets or diptych-leaves are of extraordinary dimensions, again arousing our wonder as to the manner in which such very large pieces of ivory could have been produced. It is evident that the size and beauty of the material added considerably to their value.

The Emperor Theodosius (A.D. 380) divided the

Roman world into the two independent states of the West and of the East, the consuls being retained, one always nominated at Rome, the other at Constantinople. Their joint names designated the years, and when these officials ceased to exercise any real power, they still continued to hold their former state, and inaugurated their periods of office by magnificent games, feasts, and presents to the senators. It was, in fact, under Theodosius in the fourth century that the presenting of ivory diptychs by any but the consuls was forbidden. The law was precise: "This also we prescribe: that it shall not be lawful for any but the regular consuls to give away golden caskets or ivory diptychs. In public ceremonials the caskets shall be of silver, and the diptychs of some other material."

Consular diptychs, then, were composed of two leaves joined together by hinges or other methods of fastening, the inner surfaces containing wax for the purpose of inscribing the history of the consul and of his predecessors, and of their achievements and dignities. The outer parts of the covers were profusely decorated, being as a general rule carved in relief with a figure of the consul himself and with representations of games and combats in the circus, the release or manumission of prisoners or slaves, the distribution of bread and money to the populace, and other incidents of official life. Sometimes, however, the only decoration consisted of ornaments and inscriptions, with perhaps the bust of the new consul in a medallion. The most important are those in which the consul is represented at full length, clothed in his gorgeous official robes, or sitting in the curule chair, one hand uplifted and holding the *mappa circensis*—the folded piece of white cloth—as if in the act of giving the signal for the games in the circus to begin.

The consular costume was of extraordinary richness, both in material and ornament. It appears to

have followed that worn by victorious generals in earlier days on the occasion of triumphs. As we may observe from these diptychs, it consisted of a long under-garment with long and narrow sleeves, a shorter embroidered tunic, striped with purple or embroidered with palm leaves, and having shorter and wider sleeves and a richly ornamented toga, stiff with embroidery in gold and precious stones. It was the custom for many centuries to ornament every kind of garment with stripes of cloth and with fringes of purple colour, the breadth of the stripes being commensurate with the rank of the wearer. The tunic was merely a strip of material just long enough to wrap once round the body below the arms, sometimes girdled, but for senators and consuls usually ungirdled. In addition to the above was the very important ornament of rank termed the *clavus*, a strip which crossed each shoulder and fell before and behind to the bottom of the tunic. These details of costume are of no little importance: it is interesting also to note that from them are derived many of the important parts and variations of ecclesiastical costume; indeed, it has been thought by some that the dress of the chief dignitaries of the Church in early days was identical with that of the consuls.

We have next the curule chair, or official seat of the magistrature, a magnificent piece of furniture usually decorated, as represented in these diptychs, with lions' heads and terminal figures, which were very possibly of ivory. The footstool was of one or two steps, and an important part of the chair which is prominently shown in these ivories is the cushion on which the consul is seated, because a cushion on ceremonial occasions was permitted only to persons of considerable dignity. The consul carries in his hand the consular staff or sceptre, surmounted, as we see on many of the diptychs, either by a figure of Victory or by a bird with outstretched wings—sometimes an eagle, some-

times a dove. There is still existing in the treasury of
the cathedral of Aix-la-Chapelle a sceptre which consists
of a slender ivory rod with two large plain bosses, one
near the bottom, one on the top; on the latter is a
dove with expanded wings. This sceptre is tradition-
ally considered to have belonged to Charlemagne. It
may possibly have been at an earlier time a consular
staff.

The consul is usually represented standing in the
case of western diptychs, seated in those of the eastern
empire; but we have examples, as in that of the Consul
Boethius (487 A.D.), where on one leaf he is seated,
on the other standing. The remaining part of the
decoration of the upper portion of the leaf on which
the consul is represented consists, as a rule, of
supporting allegorical figures, usually of Rome and
Constantinople, pillars with Corinthian capitals, gar-
lands, and medallions, and sometimes, after the
establishment of Christianity, a plain cross is intro-
duced. The name of the consul is carved across the
top of the leaf, and the inscription includes his style
and titles, often running across both leaves of the
diptych, and, as a rule, expressed by the formula, "Vir
illustris comes domesticorum equitum et consul ordi-
naris," signifying that he was commander of the body-
guard of the emperor, and of full consular dignity.
These inscriptions are often in very contracted forms,
for the artist was limited as to space, and was compelled
to express a great deal by means of initial letters and
symbols only. They are not always, therefore, ab-
solutely intelligible, and some remain still undeciphered,
or, at least, are open to various interpretations. The
lower part of each leaf of the diptych is, generally, a
separate panel, containing the representation of shows
or combats.

The earliest consular diptych which we have to
consider is important for two especial circumstances.

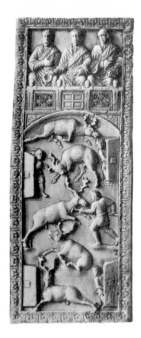

1

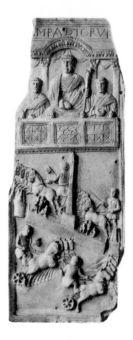

2

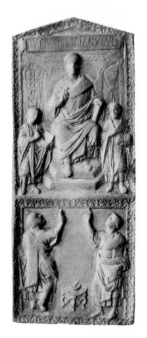

3

4

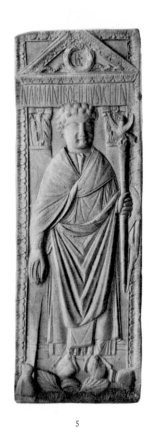

5

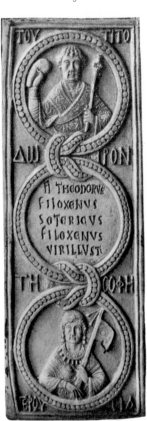

6

Plate 5. CONSULAR DIPTYCHS

1. M. J. PHILIPPUS. A.D. 248 2. UNKNOWN. THIRD CENTURY? 3. RUFIUS PROBIANUS. A.D. 322

4. JUSTINIANUS. A.D. 516 5. BOETHIUS. A.D. 487 6. PHILOXENUS. A.D. 525

First it is, in the opinion of many, the most beautiful and interesting example of its kind in existence, and next, we are fortunate enough to possess it in one of our national collections, that of the Mayer Museum at Liverpool. On the other hand, it must be allowed that doubts have been expressed concerning its admission into the series of consular diptychs, and certainly in the absence of any inscription, it is not possible to give a positive opinion. But if, as may be, it is not strictly a consular diptych, still it has many points of resemblance, and we have on it undoubtedly the representation of a consul assisting at a combat with beasts in the circus. Possibly this splendid piece formed a panel of a cabinet, or of some other article of furniture, or was, perhaps, the half of an ordinary writing tablet. The ivory measures about eleven and a half inches by nearly five, and is in an unusually good state of preservation. The subject represented is a combat between men and stags. In the upper part three personages are seated in a latticed gallery over-looking the circus, one of them holding a cup (perhaps a prize), another the *mappa circensis*. The workman-ship is most spirited, the movement of the stags, especially of one dying in the foreground, is extremely fine, and equal to anything of the period of which we have examples.

We have here given to us a very vivid idea of the way in which such combats were carried out. The men engaged are dressed in belted tunics and in trousers confined at the knees and ankles, or, in the case of one of them, in what looks much more like the modern knickerbocker and woollen stockings. He is armed with a spear, with which he is despatching an animal, and means of escape are provided—of which three other men are availing themselves—in the shape of revolving doors. On one of these doors a figure of a man has been added, with what idea it is not easy to

imagine. Throughout, the attitudes and expressions, the life and movement of both men and beasts, are admirable. With regard to the great personages represented, as the consul is not seated in the middle, the central figure would appear certainly to be an emperor, and the conjecture is that we have here the emperor Marcus Julius Philippus, with whom his youthful son was associated as consul in the year 248 A.D., the year of the thousandth anniversary of the foundation of Rome. We take this plaque, then, to be a leaf of the diptych of the consul Marcus Julius Philippus. It is described by *Millin* (1808), and in his time was in the possession of M. de Roujoux at Macon.

The next example is one leaf of the so-called consular diptych of Marcus Aurelius Romulus Cæsar (308 A.D.), and is in the British Museum. We have here, again, a question of disputed attribution, and there is only the uninscribed evidence of the tablet itself. The subject represented is of some personage who is being carried in a car drawn by elephants towards a funeral pile. Above the pile is the apotheosis of the youthful Cæsar, Aurelius Romulus, who is being transported to Heaven in a chariot with four horses. There is a monogram, the letters of which have been interpreted to represent the above - named consul. Whatever it may be, this plaque has little to recommend it in design and execution, and it cannot but be regretted that the consular series is practically unrepresented in our national collection.

The leaf of a diptych of the third or fourth century in the Biblioteca Quiriniana at Brescia has at the top an inscription, ". . MPADIORUM," in Roman capitals. The two first letters, which are missing, are supposed to complete the word *Lampadiorum*, and the piece has therefore been attributed to the consul Lampadius of the middle of the sixth century. The interest is in the subject, in which we have again three figures in con-

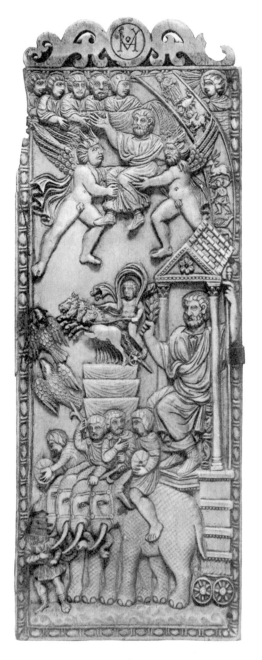

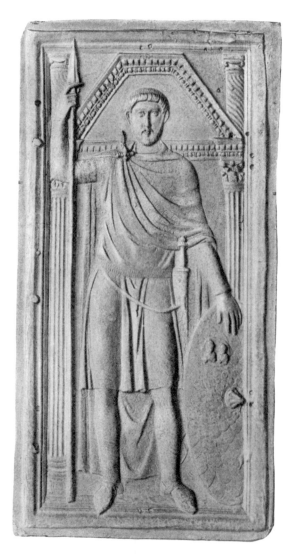

1

2

Plate 6. CONSULAR DIPTYCHS

1. MARCUS AURELIUS. A.D. 308 2. VALENTINIAN. A.D. 380

sular robes, with sceptre and *mappa circensis*, looking down from a latticed gallery on the games in the circus, in the arena of which a chariot race of four quadrigæ is in progress. The execution is skilful, and without venturing to complete and interpret the mutilated inscription, it may not be altogether unreasonable to assign the origin to the third century, whether as a consular or as merely a commemorative tablet.

We come next to the complete diptych of the Consul Rufius Probianus (322 A.D.), two leaves, now forming the covers of a MS. in the Royal Library, Berlin, and here we begin to be on surer ground. Both leaves are almost identical, and the subject and treatment deserve particular attention. The consul, who is seated, is not clad in his embroidered robes, and holds on his knees a long scroll inscribed, "*Probiane floreas,*" which we may suppose has just been addressed to him. He is attended on either side by a scribe who is making entries in a book with a style; beneath is a panel in which are represented two personages, possibly priests, standing on either side of a small altar, and pointing upwards. The top of the leaves is of an arched, or pointed, shape, and the panels containing the subjects are surrounded by elegant, floriated borders. The inscription across the top of the two leaves is "RVFIVS PROBIANVS VC VICARIVS VRBIS ROMAE." Altogether this diptych differs in style and other important particulars from the most usual fashion of the series.

We arrive now at the period of the recognition and protection of Christianity under Constantine the Great, in the first years of the fourth century, but the diptych of Anicius Probus (406 A.D.) is the first after that recognition to which we can refer. Both leaves are in the treasury of the cathedral of Aosta. On each we have represented the emperor (Honorius) instead of the consul; his head is surrounded by a circular

nimbus, and on the *labarum* which he holds in his hand is inscribed "IN NOMINE X̄P̄Ī VINCAS SEMPER."

Of the succeeding diptych, that of Flavius Felix (consul 428 A.D.), one leaf only, in the National Library in Paris, exists. And even here we are not yet clear regarding disputes, for it has been ascribed by more than one writer to Felix Gallus, whose consulate was nearly a century later. The full-length figure of the consul is represented, occupying the whole of the tablet. He stands between drawn-back curtains, clad in his rich robes and holding the sceptre. The execution is somewhat rude, yet vigorous, and not without merit, and it would appear to be a portrait. The edge of the leaf has a border of egg-and-leaf moulding, and what remains of the inscription gives the name of the consul. There is still the possibility that the missing leaf, at one time in the collegiate church of St. Junien in the diocese of Limoges, may be found, for it was lost or stolen during the French revolution. It is figured in *Gorius*. The complete diptych formed the binding of a life of a bishop of Limoges, written in 1461 by Jean Courtois, canon of St. Junien.

Much dispute of the commentators attends the next example, but at least it must be admitted to be one of the finest and most interesting of the series. The diptych of Monza (in the treasury of the cathedral of that city) is complete with its two leaves, and has been assigned to various personages—consular, imperial, and royal—and to dates ranging from the end of the fourth to early in the seventh centuries. But without venturing to decide a question upon which such learned writers as Gori and Pulszky have so widely differed, we may allow ourselves to be led away by the fine execution and beautiful design of this diptych, and instead of attributing it to such an age as the seventh century, when art had perhaps reached the time of its lowest expression, we may follow, perhaps, more safely Old-

field, who assigns it to the Emperor Valentinian II. (380 A.D.). Molinier thinks it to be the diptych of the consul, Stilico, about 400 A.D., and that he himself is represented on one half; on the other his wife Serena, daughter of Honorius, and their son Eucharius. On the first leaf we have represented a noble lady holding a branch of laurel; by her side there stands a youthful figure in a toga, his right hand raised, as it were, in benediction, a book in his left, and these two are supposed by Oldfield to be Valentinian II. and his mother Justina. On the second leaf is a full-length figure of a youthful warrior, clad in an embroidered tunic, over which a cloak of the same rich material, fastened on one shoulder with a fibula, falls behind him nearly to the ground. The tunic is belted, and to the belt is attached a dagger in its sheath. With one hand he holds erect a spear, the other rests on an oval, decorated shield. The background is arcaded between Corinthian pillars. The head, with hair falling over the forehead and close-cropped beard and moustache, is admirable in beauty and expression. Altogether it can hardly be denied that amongst all our classical diptychs, not excluding even the non-consular ones, we have few finer examples than this of Monza.

The two leaves ascribed to Flavius Ætius (454 A.D.) in the treasury of the cathedral at Halberstadt we may take to be of that consul and general successful in the defeat of the Huns of Attila. They include representations of numerous personages and allegorical figures. Amongst the latter are those of Rome, helmeted and bearing a spear and globe, and of the eastern empire with rays as of the sun round the head. There are also prisoners, male and female, one of the latter suckling a child. The attribution to Flavius Ætius is doubtful, and has been contested.

We come now to the diptych of Manlius Boethius (487 A.D.) at Brescia, the first of the eastern empire,

on one leaf of which the consul is seated, on the other standing. Under the feet of the consul lie palm branches, money-bags, and silver basins, prizes in the games of the circus. The inscription on one leaf "NARMANLBOETHIVSVCETINL," on the other "EXPPPV- SECCONSORDETPATRIC," is unusually obscure, and has given rise to a host of interpretations, and a volume of no less than two hundred pages was edited by Hagenbuch, in 1738, containing a number of learned essays on this diptych alone. The three times repeated "P" and the twice-repeated "C" have been held to mean three times prefect and twice consul. At the same time words with a quite different meaning have been associated with them, and in point of fact the question is still open to the exercise of the ingenuity of anyone.

We take next the diptych of Consul Flavius Theodorus Valentinianus (505 A.D.) at Berlin, which presents several peculiarities. The centre of each leaf is occupied with a bust of the consul, holding his sceptre and the mappa, within a wreath of elegant design; above and below is floral scroll-work, recalling somewhat the honeysuckle pattern, and at the bottom we have for the first time the two youths emptying sacks containing money, palm leaves, and other prizes for the games, which we shall find later several times on these diptychs. Most remarkable are the medallions beneath the inscription, in which, between the busts of the emperor and empress, is a bust of our Lord with a cruciferous nimbus.

Of the consul Areobindus (506 A.D.) eight examples are extant. The two leaves at Lucca, both alike, are our first instance of a consular diptych with ornaments, a monogram, and the inscription only; both leaves at Zurich have the seated figure of the consul, and beneath are combats of men and lions in the arena. One leaf is in the Basilewski collection, and another,

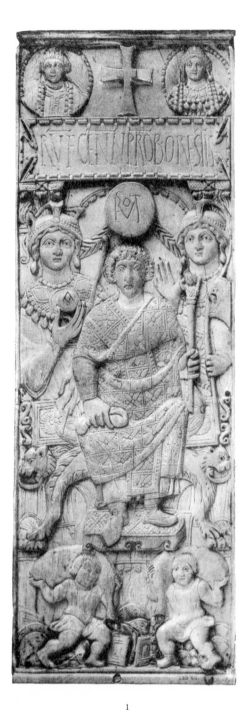

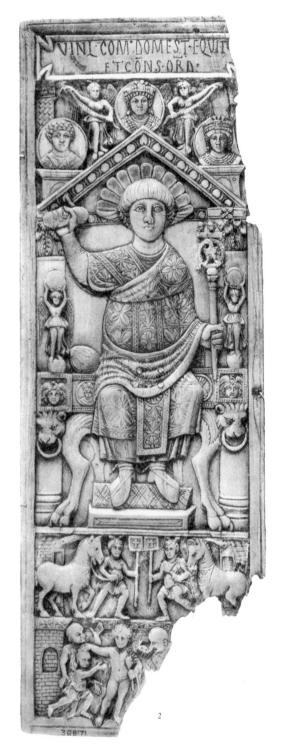

Plate 7. CONSULAR DIPTYCHS

1. ORESTES. A.D. 530　　　　　　　　　2. ANASTASIUS. A.D. 517

probably the companion leaf, is in the Cluny Museum at Paris.

The Liverpool Museum possesses the next diptych, that of Flavius Clementinus (513 A.D.). Within the leaves is the incised liturgical inscription to which reference will be made in a succeeding chapter.

The diptych of Petrus Sabatius Justinianus (516 A.D.), of which one leaf is at Paris, consists of ornament only, in the shape of a wreath, within which is an inscription which gives us for the first time a record of a presentation, for we read that the consul offers "these presents, though small in value, ample in honours." Both leaves were in the *Trevulzi* at Milan, and the right-hand leaf is now in the Sigismond Bardac collection, Paris.

Of the first diptych of Flavius Anastasius (517 A.D.), formerly known as the diptych of Bourges, there are two leaves at Paris, and of a second diptych, one leaf is in Berlin, the other in the museum at South Kensington. Part of another leaf—a fragment of the lower portion —at one time in the collection of the Vicomte de Janzé, is probably of the same consul. The character of them all is similar, and perhaps the most generally characteristic of all the consular diptychs which we possess. The youthful magistrate had probably strong sporting tastes, for beneath the usual figure of the consul we have on all these leaves a number of varied representations of scenes and combats in the circus, the more remarkable and interesting as it is to these ivory sculptures alone that we are indebted for so many pictorial details. The lower part of one leaf gives us a portion of the arena itself, with the heads of the spectators peeping over the barriers. A very spirited fight with bears is in progress. Two of the combatants are hoisted up out of the way in baskets, another escapes by throwing a somersault with a pole, and two more are in the act of suddenly closing the protective

revolving doors. In the South Kensington leaf the lower panel is in two divisions. In the upper portion two servants lead each a horse, whose legs are plainly bandaged precisely as in the case of racehorses in our own times; their heads are decorated with long peacocks' feathers. The lower corner of the leaf is unfortunately broken and missing, and we can only discern one part of a scene, in which a man has a live crab hanging from the end of his nose, and is evidently not enjoying the situation. From indications elsewhere this appears to refer to some kind of game like diving in a bowl with the mouth for crab apples, in this case the live crab being the object. The association is curious, but it may be the explanation. A remarkable ornament on this and later diptychs appears behind the head of the consul. It is in the form of a shell, and has given rise to much discussion, some taking it to be a kind of *nimbus* or glory. It is more likely to be architectural, but in any case presents difficulties. The leaf at South Kensington is of excellent workmanship, and were it not for the fractured and missing corner, is in remarkably good condition. The complete diptych, now divided between Berlin and Kensington, was formerly in the church of St. Lambert at Liège, and known as the Leodiense diptych. A very notable forgery, to which we shall have occasion to refer later on, was imposed upon the authorities of the Brussels Museum about the year 1864.

The subjects on the other leaves include combats with lions and tigers, the manumission of slaves, the parade of racehorses, acrobatic feats, in which women and children appear, juggling with balls in the air in the fashion which is as old as the hills, and with which we are still familiar.

We may pass over the next four examples of the Consul Probus Magnus (518 A.D.) with the remark that the consul is represented with the usual accompani-

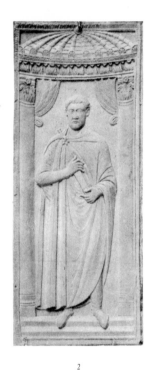

1

2

3

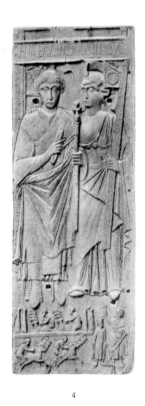

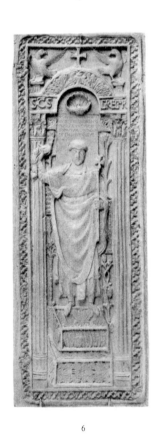

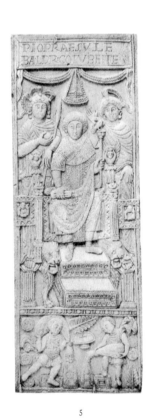

4

6

5

Plate 8.　CONSULAR DIPTYCHS

1. AREOBINDUS.　A.D. 506　　　2. UNKNOWN (NOVARA)　　　3. PHILOXENUS.　A.D. 525

4. BASILIUS.　A.D. 541　　　5. UNKNOWN (PALIMPSEST)　　　6. UNKNOWN.

ments of boys emptying sacks of coins, wreaths, dip-
tychs, and money-bags.

The diptych of Philoxenus (525 A.D.), both leaves at
Paris, and one, doubtful, in Liverpool, are a variation
of the ordinary theme. We have here three circles
formed by the interlacing of an ornamented fillet; in
two of these is a bust—one of the consul in his robes,
the other an allegorical one of the eastern empire, and,
again, there is a dedication: " I, Philoxenus, the consul,
offer this gift to the wise senators." It may be re-
marked that the inscriptions on this diptych are in
Latin and in Greek, and that we are now in the sixth
century, in the full splendour of the Byzantine empire
at Constantinople—at a time when, however, sculpture
in ivory had certainly declined in the east to a very
marked degree. A like inscription in Latin—"+ MVNERA
PARVA QVIDEM PRETIO SED HONORIBVS ALMA (*sic* for
ampla) +"—occurs on the diptych of Petrus Justinianus
(516 A.D.). The design on this is of admirable sim-
plicity—a very beautiful circular wreath of palm leaves
in the centre, within which is the inscription. At the
top is a label with the title, and in the angles are
rosettes of foliage.

The diptych of Philoxenus at Paris is known as the
diptych of Compiègne, because it was given by Charles
the Bald in the ninth century to the church of St.
Corneille at Compiègne.

The museum at South Kensington has yet another
example of consular diptychs. It is that of Rufinus
Orestes (530 A.D.), and resembles the diptych of
Clementinus at Liverpool. It is not, however, in any
way equal in careful execution to the Anastasius diptych
in the same museum. It was formerly in the Museum
Septalianum at Milan.

We come now to the last of the consular diptychs
which can be absolutely identified, and it is, at the
same time, the diptych of the last representative of

the consular line. It is that of Basilius, who was consul of the east in 541 A.D. One leaf of this diptych is in the Uffizi at Florence, the upper portion of the other in the Brera at Milan. The consul is represented in the usual way, in his official robes, a peculiarity being that a portion of the embroidery of these shows a figure of himself in a chariot. At the bottom of one leaf is a chariot race and the manumission of a slave. The inscription running across both leaves is "ANIC FAVST ALBIN BASILIVS VC ET INL EXCOM DOM PAT CONS ORD." There are, of course, a certain number of unidentified leaves, and portions of leaves, of consular diptychs in various collections, with which, for the moment, it is hardly necessary to concern ourselves. We shall, in the next division of our subject, refer more particularly to the use which in all probability a considerable number of classical ivories, especially diptychs, were subsequently made to serve, and may then notice some examples of the practice.

The subject of consular diptychs has formed for a very long time a special study. Folios, indeed, of learned dissertations have been written upon them, amongst which the work of the erudite Gori, published so long ago as 1759, is perhaps the most elaborate, and other well-known treatises are those of Wiltheim, Lenormant, Pulszky, Wyatt, and Westwood.

The line of consuls up to the last consul of Rome (Decimus Paulinus, 534 A.D.), and Basilius, the last of the eastern empire, had continued for nearly a thousand years; and of this lapse of time our ivory records may be said to embrace the period from the first half of the third (probably not long after the custom began) to the middle of the sixth century. It will be seen, then, how interesting and valuable these historical documents are, more especially when we consider the dearth of contemporary pictures of events and personages in other developments of art. We find in them, of course,

a variety of treatment and various degrees of excellence. The decline of art was rapid and persistent during the three centuries after the birth of Constantine the Great, and it may readily be admitted that in general these works have no pretensions to a high artistic value, and, a few exceptions apart, the consular diptychs show a deplorably low condition of technical excellence. The same types were repeated with little variation. In the case of portraits, for instance, though perhaps faithful to a certain extent, they are, as a rule, heavy and wanting in spirit. For all that, they are in a way astonishingly truthful and remarkable when we consider the general condition of decadence to which art had everywhere fallen.

One must imagine that the artists worked from such classic models as they were able to procure, but it was in most respects but a rude imitation, with too much striving after exactitude in such details as costume and furniture. When left to themselves there was a sublime indifference to all ideas of perspective, and in the scenes, for instance, in the circus, or incidents in the life of the consul, they were content to pile one event on the top of another, and to be absolutely careless as to the relative proportions of the figures introduced. At the same time we should remember that the excellence of some of the examples which have come down to us must lead to the conclusion that possibly numbers of others of equal merit have perished, and that the commoner things were, in many cases, probably turned out, as it were, in factories, and distributed broadcast. We see, in fact, represented what are evidently diptychs poured out of sacks, by boys, on the ground.

It may be mentioned here as not a little curious and suggestive that, although our series embraces a period of nearly three centuries after the introduction of Christianity, we find on these diptychs that anything

approaching Christian emblems or allusions is extremely rare, so rare that it is confined to an occasional plain cross, to the figure of our Lord on the diptych of 505 A.D., and to one inscription.

It is interesting to note that all existing consular diptychs being known, and, without exception, preserved in national museums, or in the treasuries of cathedrals, few, if any, will ever come into the open market. What the value of one might be, should another example by good fortune be discovered, would be an interesting matter, in more than one sense, for speculation. Gori, in his *Thesaurus*, remarks on the possibility of such an occurrence. He says that a suspicion prevailed in his time that in the wealthiest church treasuries of Spain, whither gifts flow from almost every part of the world, many things of this kind are hidden, never yet made known, because never hitherto cared about or sought for. But nearly a hundred and fifty years have passed since his learned Latin treatise was written, and it is doubtful whether a single example has been added to those that were then known. A statuette or figure of a consul of the fifth or sixth century in the British Museum remains to be noticed, from the Fountaine collection. The consul is seated in the curule chair, clad in a toga and cloak, which are not embroidered in the usual way we see them in the diptychs. The cloak is fastened by a brooch on the right shoulder; the hair arranged in curls over the forehead. The attitude and expression are natural, not vacant and staring, as in most diptychs.

Of Roman diptychs, or writing tablets, we have also some important non-consular ones, scarcely inferior in historical value, and more beautiful as works of art. The earliest specimens are of a comparatively good period of Roman art, and we probably owe their preservation to the custom which prevailed amongst the Roman emperors, high officials, patricians, and

other persons of distinction, of sending valuable objects of this description as presents on occasions of public or private rejoicings, in the same way, as we have seen, the specially consular ones were distributed. They were sent, amongst others, to persons of rank in the various provinces of the empire, and in this way they often remained in the countries to which they came, or, as we shall see, were adapted to ecclesiastical purposes, and were preserved in the treasuries of the cathedrals. Martial, in the Apophoreta, describes in detail such presents given by a host to his guests, amongst them wooden and ivory books; and we learn that the wooden ones were covered inside with wax; but of the ivory he says that in order that the weak eyes of the recipient should not be troubled by reading on the dull waxen surface, the white ivory should be painted on in black letters. And, again, in the Latin poet of the fourth century, Claudian, we read in his verses in praise of a consul: "Then Diana gathers together the lithe panthers and other wonders of the south, and huge tusks, which, cut with steel into tablets and gleaming with gold, engraved with the illustrious name of the consul, are circulated among great and small; and the great wonder of the Indies, the elephant, wanders about in tuskless shame." Doubtless, these large and cumbersome pieces, valuable for the size and beauty of the ivory of which they were made, besides being sculptured in many cases by the best artists of the time, were used rather as ceremonial presents than as note-books for practical use. They would have been sent by the rich on occasions of marriages, perhaps recoveries from illnesses, and the like, and we may consider them as the sumptuous envelope of a letter. They were ceremonious times, and such a custom may be compared to that of old Japan, or of other oriental countries, and to the elaborate and costly boxes in which letters and presents were frequently sent. But

we can do little more than conjecture for whom, or on what occasions, these tablets or diptychs may have been made; the dates of those we have are uncertain, and the inscriptions puzzling. Nor are they all of the kind destined for use as writing tablets. Some are decorative tablets, or plaques pure and simple.

Amongst these Roman ivories we have two or three which may be ascribed to the second or third centuries, before the decline in art had set in, and happily the finest of these examples of an age of which so little art work of any kind has come down to us, are preserved in the British, South Kensington and Liverpool museums, each of which possesses a specimen, which, for design and workmanship, is perhaps unequalled elsewhere. The three pieces to which we refer are the Bellerophon, the Æsculapius and Hygieia, and the Bacchante diptychs.

The half of the Roman diptych of the third century —the *diptychon Meleretense*—representing a Bacchante, is in the museum at South Kensington. The tablet measures eleven and three-quarter inches in height by nearly five inches in width, a fine piece of ivory, though not so large as some others in existence, which have given rise to much surprise concerning the method by which they were obtained. The condition is fairly perfect, allowing for portions of the border which have been broken off and are missing, and for vertical cracks in the surface of the ivory which do not, however, detract from its beauty. Part of one of the forefingers has been broken off, probably in recent times, but has been restored. The subject is a figure of a woman, apparently a priestess, making offerings before a small altar on which a fire is burning. She is clothed in a long tunic falling to the feet, over which is another garment not quite so long, part of which is caught up and thrown over the left shoulder. The manner in which the drapery is expressed, the folds,

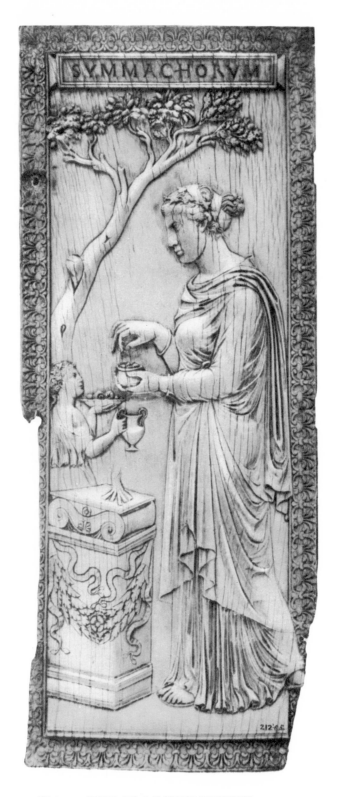

Plate 9. LEAF OF A ROMAN DIPTYCH

THIRD CENTURY

the elegance, and the indications of the form beneath are of a style for which we should certainly have to go back to the best periods of Greek art to find a parallel. She wears a plain bracelet on each wrist, and her hair is bound with a fillet, with which ivy leaves are intertwined. On the other side of the altar a girl clad in a tunic which falls off one shoulder and is girdled at the waist, her hair being also bound with a wreath of ivy, bears a two-handled vase and a bowl, which apparently contains fruit as offerings for the altar. The altar itself is of an early classical type, a low double cube, decorated with garlands and fillets, and scrolls of the Ionic order forming the top. An oak tree, with leaves and acorns of the most refined conception and execution, is in the background, and above this, on a plain tablet, we have the word "SYMMACHORVM," part of the inscription, the remainder of which is on the other leaf of the diptych. The priestess herself appears to be dropping incense on to the fire on the altar from a small box which she holds in one hand. One sandalled foot appears as she approaches the altar, and part of the other just over-steps the bordering of the plaque. The figure is most graceful and imposing, and the attitude and expression of the face are full of reverence. The narrow orna-mental border, which is somewhat sunk in semi-oval section, is remarkably pure and elegant in its repeated conventional floral design. Altogether this beautiful leaf impresses one with the feeling that it is in the style at least of the best examples.

There is a remarkable difference between the design and workmanship of such works as this, and it may be said, too, the other examples with classical subjects, compared with the best consular diptychs of the same period, especially when we consider the figures. In the former the artist would certainly have had classical models of the finest periods which he could copy faith-

fully, and he could at least reproduce, for instance, the flow of the garments and the general style and expression of the faces. In the latter, he was tied down to the necessity of giving a minute and detailed representation of the decorated official robes of the period which the bad taste of that time exacted, as it does to-day from the photographer, and of providing also something in the nature of a portrait, and so was thrown on his own resources, and had to invent for himself. The borders, in the few cases in which we find them on the consular diptychs—for example, in that of Probianus (A.D. 322), which is almost identical with that of the priestess diptych—are evidently copied from older designs. However all this may be, the man who executed this important work, whatever might have been his inspiration, was a great artist.

The other leaf of this diptych fortunately still exists, and is in the Cluny Museum at Paris. Both pieces were found in 1860 at the bottom of a well at Moutier-en-Der, in France, and had at one time formed the doors of the reliquary of St. Berchaire, formerly in the monastery of that place. The two learned Benedictines, Martène and Durand, who, in 1717, made their famous "Voyage littéraire," describe and figure them, and we gather that they were at this time in perfect condition. The Paris leaf is now much injured.

The Paris leaf also represents a priestess at an altar, holding two torches. The corresponding tablet to that on the Kensington leaf bears the word "NICOMACHORVM." The complete inscription, unfortunately, gives us little clue regarding the origin of the diptych, or for whom it was made. It has been conjectured that it may have contained a copy of a marriage contract between two great patrician families, or possibly have been an offering from members of these families to some temple. The name Symmachus occurs amongst the list of consuls, but the date of the consulship of Quintus

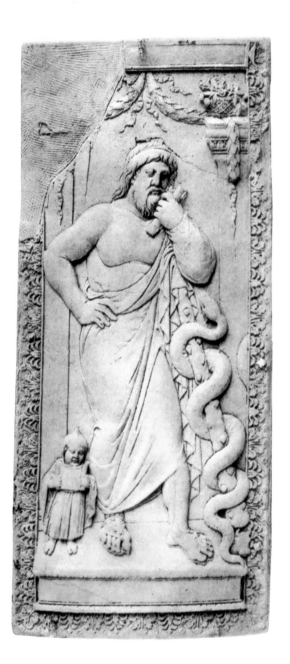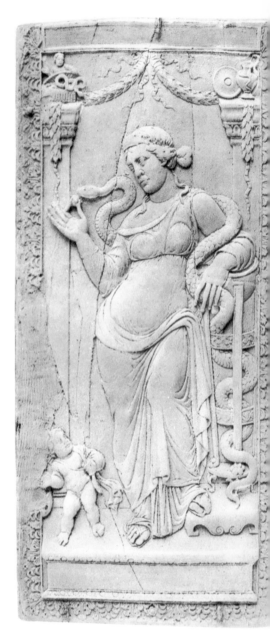

Plate 10. DIPTYCH. ROMAN

THIRD CENTURY

Aurelius Symmachus is 392 A.D., and we cannot place the production of so fine a work at so late a date.

The diptych formerly in the Fejérváry collection, and now, through the munificence of Mr. Mayer, in the museum at Liverpool, disputes in the opinion of some, with whom it would be difficult to agree, the precedence for artistic value amongst the classical diptychs of this period. It is also of the third century, and measures nearly an inch more in height and width than the fine piece just described. On one leaf Æsculapius is represented standing erect and leaning on a thick club, round which a serpent is twined. He wears a fillet, binding his long hair which falls over his shoulders. He is bearded and sandalled, and his figure is partly draped. A small figure of Telesphorus, the genius of recovery from sickness, stands near him, reading a scroll, and on pilasters on either side of the two figures hang, and are placed, baskets of flowers and wreaths. The left-hand leaf represents Hygieia leaning her left arm on a tall tripod, creeping up the supports of which from the ground is a serpent, which, coiling round her shoulders, presents its head to be fed by her with her right hand. The drapery of the figure is clinging, revealing the form beneath. At the feet of Hygieia a little cupid holds his bow. There are pilasters and garlands as in the other leaf, and from a basket on the top of one pilaster a small figure allows a serpent to escape. On the top, as well as on the Æsculapius leaf, is a tablet, and also on the pedestal on both ; but, unfortunately, there are, now at least, no inscriptions. Both leaves of this diptych were engraved in 1805 by the Italian engraver, Raphael Morghen. Of his work four states exist, one (the proof before all letters) being extremely rare. The ivories are undoubtedly fine specimens, but how different, for instance, is the treatment of the hands of the Hygieia from the delicate and masterly pose and execution of those of the

priestess in the South Kensington tablet! Passeri, in his learned treatise, *Thesaurus Veterum Diptychorum*, has a long dissertation on this diptych, which he fully describes and engraves. It was, in his time (1759), in the Gaddio Museum at Florence.

The plaque in the British Museum, which completes the three examples of the art of imperial Rome at the time when that art—at its highest, perhaps, under Trajan and Adrian, in the early part of the second century—had scarcely felt the decline which afterwards occurred, is not inferior to the two others which we have grouped with it. In this admirable specimen, which is executed in open work, we have represented the combat between Bellerophon and the chimæra. Bellerophon, on a winged horse, is killing this lion-like, monstrous animal with a spear, which he thrusts into its mouth. A considerable authority is inclined to defer the date of this piece to the fourth, rather than to the third, century. In that case we may take it that even at so late a date there were artists who had not lost their purity of feeling, or their skill in execution.

We cannot accord the same praise to the diptych of the fourth, or more probably the fifth, century, of which the two leaves are in the treasury of Monza, though as an undoubtedly—from many points of view—very fine piece of work, we are willing to include it amongst the examples to be described of Roman classical art. One leaf of this diptych represents a female figure playing on the lyre with a plectrum. It is possibly a portrait of a Roman patrician lady. On the other leaf we have a philosopher, with an entirely bald or shaved head, sitting among his books, scrolls from a box at his feet, and a writing style in one hand. The upper part of his robe is open, showing his chest and arms bare, and certainly the drapery is well expressed, and the attitude and anatomy of the figure, as well as the vigour and naturalness of the face, are

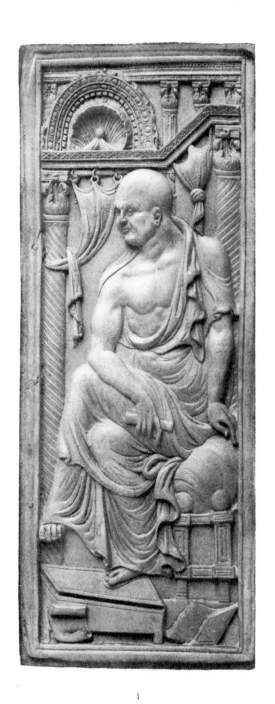

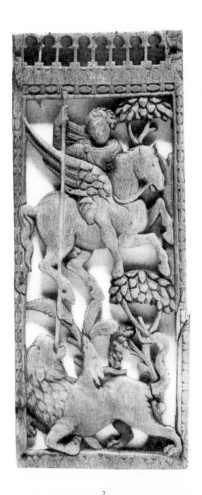

Plate 11. 1. LEAF OF ROMAN DIPTYCH (MONZA). 2. PLAQUE (BELLEROPHON)
3. FRAGMENT OF CONSULAR DIPTYCH

very striking. But the architectural and other details are poor, and the perspective is quite extraordinary. The dimensions of the ivory are large, the leaves measuring nearly fourteen inches in height.

A diptych, also of large dimensions, which formerly served as the binding of " The Office of the Circumcision" in the library at Sens—and is now in the National Library at Paris—is an example of a style of art of the third century of quite another description. On these leaves Bacchus with his wine cup and the *thyrsus*, and Diana Lucifera in a car drawn by prancing bulls, are mixed up with a sea goddess and a number of other figures, to which it would be difficult now to assign a meaning. More remarkable and worthy of notice is the diptych in the Basilewski collection. Both leaves are almost absolutely identical—a most careful reproduction of one from the other. They show in a surprising manner—throughout the whole extent of each leaf from top to bottom—combats in the circus of men and wild beasts. They are in somewhat high relief, of very careful execution, and surrounded by an unusually simple border in the Greek style of fret and ovule. For many other diptychs at one time in Roman, Florentine, and Venetian collections — amongst them the " Riccardianum " diptych — we must refer to Passeri's and Gori's learned dissertations. The engravings of them, though not perhaps very accurate, are full of interest, especially in cases where the originals have since suffered damage. Finally, we may mention the fragment of a cup in the museum of South Kensington, Roman work of the second century representing a sacrificial procession. Before, however, leaving this part of our subject, we cannot pass by without notice, amongst the examples of classical Roman work, some cylindrical boxes or pyxes which are to be found in various collections. The earliest of these is in the museum at Zurich, work which may be attributed

to any date from the first to the fourth century. The subjects illustrated upon it, as well as on others in the cathedrals of Zanten and of Sens, are wholly mythological scenes, the stories of Venus and Adonis, Bacchanalian groups, and the like.

LIST OF KNOWN CONSULAR DIPTYCHS

Name of Consul.	Date. A.D.	Description.	Dimen. Inches.
Marcus Julius Philippus	248 .	One leaf in the Mayer Museum, Liverpool; three officials presiding at games in the circus	$11\frac{2}{3} \times 4\frac{3}{4}$
Doubtful . .	3rd to 6th c.	One leaf at Brescia; inscription "(La)mpadiorum"; chariot races	$11\frac{1}{2} \times 4\frac{1}{2}$
* Marcus Aurelius Romulus Cæsar	308 .	The Gherardesca; one leaf in British Museum; an apotheosis	
Rufius Probianus .	322 ?.	Both leaves at Berlin; consul seated; priests below	$11\frac{4}{5} \times 5$
* Anicius Probus .	406 .	Both leaves at Aosta; consul or emperor standing	
Flavius Felix . .	428 .	One leaf at Paris (Library); consul standing between curtains	$11\frac{1}{2} \times 5\frac{1}{2}$
Valentinian II. .		Both leaves at Monza; a noble lady and a warrior	13×6
*Flavius Areobindus	434 .	Both leaves at Milan; bust of consul in a circle	
Flavius Asturius .	449 .	Part of one leaf at Darmstadt; consul seated	7×5
Flavius Aetius .	454 .	Both leaves at Halberstadt; consul standing; releasing prisoners	$11 \times 5\frac{3}{4}$
Manlius Boethius .	487 .	Both leaves at Brescia; consul seated on one, standing on the other	$13\frac{1}{2} \times 5$
Rufius Achilius Sividius	488 .	One leaf, medallions, and foliage; Paris (Library): formerly at Seminary of Gerunda, Valais	
Flavius Theodorus Valentinianus	505 .	Both leaves at Berlin; bust of consul, scrolls, boys emptying sacks of prizes; Molinier attributes to Justinus (540 A.D.)	13×5
Flavius Dagalaiphus Areobindus	506 .	One leaf in Basilewski collection; consul seated; circus games; inscription "FL. AREOB. DAGAL"	

* Casts of all the above, except those marked with an asterisk, are in the Kensington Museum. The dates given are usually of the first assumption of the dignity, though several consuls held the office for a long period; for instance, Basilius, from 541 to 565.

Name of Consul.	Date. A.D.	Description.	Dimen. Inches.
Flavius Dagalaiphus Areobindus	506 .	Both leaves at Lucca; cornucopiæ, vines, and baskets of fruit; the first diptych	13¼ × 4¾
,, ,,	506 .	Two leaves at Zurich; consul seated; combats in circus	13 × 5
,, ,,	506 .	One leaf similar, in Cluny Museum: formerly at Dijon	
* ,, ,,	506 .	Both leaves; circular medallions; foliage; bust of consul; monogram. Milan (Trevulzi) formerly in Possente collection, Fabriano	
* ,, ,, ?	506 ? .	One leaf in Louvre; similar to foregoing; on the back Adam and Eve in Paradise, animals, satyrs, etc.	
* ,, ,, ?	506 ? .	Both leaves in Museo Civico, Bologna; bust of consul in medallion; rosettes; formerly in basilica of San Gaudenzio, Novara	
* ,, ,,	506 .	Like that at Zurich; one leaf in museum, Besançon	
Flavius Taurus Clementinus	513 .	Both leaves in the Mayer Museum, Liverpool; consul seated; figures of Rome and Constantinople on either side; boys emptying sacks; liturgical inscription	15 × 5
Anthemius . .	515 .	Molinier mentions a diptych of this consul as formerly at Limoges, but now lost	
Flavius Petrus Justinianus	516 .	One leaf at Paris; wreath of palm leaves; "MVNERA. PARVA"; one leaf in Bardac collection; both leaves in Aymard collection, Le Puy?	15 × 5¼
,, ,,	516 .	Both leaves at Milan; duplicate of preceding	
Unknown .	5th c.	Two leaves at Paris; lozenge-shaped ornament	13½ × 5
Flavius Anastasius, Paulus Probus Pompeius	517 .	Both leaves at Paris; the diptych of Bourges; consul seated; combats in circus on one leaf; manumission of slaves, and three female figures on the other	14 × 5⅓
,, ,,	517 .	One leaf at Berlin; similar to first leaf of preceding; combats in circus	14¼ × 5
,, ,,	517 .	The other leaf of the preceding in Kensington Museum; races in circus; man caught by crab; the second diptych	14¼ × 5
,, ,,	517 .	Lower part of one leaf at one time in Janzé collection, Paris; acrobats in circus	4 × 5
Flavius Probus Magnus	518 .	One leaf at Paris (Library); consul seated; Rome and Constantinople; boys emptying sacks of prizes	14¾ × 5

Name of Consul.	Date. A.D.	Description.	Dimen. Inches.
Doubtful . .	6th c.	One leaf, bone, in Mayer Museum, Liverpool; similar to preceding; inscribed "Baldrico," etc.; rough execution; ascribed to Fl. Probus	14 × 5¼
Flavius Probus Magnus	518 .	Part of one leaf at Paris; similar to the preceding, but wanting the label on top and the bottom compartment; careful execution	10⅓ × 5¼
,, ,,	518 .	One leaf in Basilewski collection; similar to the preceding: of walrus bone	
Doubtful . .	?	Part of one leaf, at Milan (Brera), as above; wanting label and lower portion; consul older, bearded; fine execution; figd. Gorius II., pl. iii.	10⅓ × 5¼
*Flavius Anicius Justinianus Augustus	519 .	One leaf at Vienna; figured *Gorius* II., pl. iii.	
Flavius Theodorus Philoxenus	525 .	Two leaves known as the diptych of Compiègne, in Paris; three circles of ornamented ribbon, with busts	15 × 5½
Flavius Theodorus Philoxenus ?	525 ?.	One leaf in Mayer Museum; lozenge-shaped ornament; bone	12¼ × 4½
,, ,,	525 .	Both leaves at Milan (Trevulzi); lozenge with tablet in centre; circles in angles with inscriptions	
* ,, ,,	528 .	One leaf at Paris (Library); formerly at Autun. See *Millin*	
Rufinus Gennadius Probus Orestes	530 .	Both leaves in Kensington Museum; similar to the diptych of Flavius Clementinus	13 × 4⅔
*Flavius Strategius Apion	539 .	Both leaves; bust of consul; in chapter-house, Oviedo. See *Hübner*	
Anicius Faustus Albinus Basilius	541 .	The first leaf at Florence; consul standing; chariot race and manumission of a slave	13½ × 5
,, ,,	541 .	Upper part of the other leaf of above at Milan; seated figure of Victory	8 × 5
Unknown . .	6th c.	Palimpsest in Kensington Museum; consul seated; on the reverse, scenes in the Passion; the lower part of leaf, treated in the same way, is in British Museum	
,, . .	5th c.	Two leaves in cathedral of Novara; consul standing	12½ × 5½
,, . .	6th c.	One leaf, bone, in Mayer Museum; bust of consul within a foliated disc	12½ × 5⅛
,, . .	6th c. ?	Two leaves, palimpsestically treated, or partly so, at Monza; "DAVID REX" and "S̄C̄S GREGOR"; consul sitting on one, standing on the other leaf	14½ × 5½
* ,, . .	5th or 6th ?	Part of one leaf at Bologna University Museum; consul standing	6½ × 3

Name of Consul.	Date. A.D.	Description.	Dimen. Inches.
* Unknown . .	5th or 6th	Consul seated; below, combats of men and animals in circus; museum at Bourges, formerly in the cathedral	
* ,, . .	5th or 6th	One leaf in Vatican (formerly Barberini); bust of consul; rosettes	
* ,, . .	6th	Fragments made into cover of a MS. in Munich library; a consul standing and another personage	
* ,, ,,	6th	One leaf in chapter house at Prague; consul seated; palimpsested in eleventh or twelfth century and converted into St. Peter; head tonsured, sceptre turned into key, beard added	

CHAPTER V

EARLY CHRISTIAN IVORIES

THE transition from pagan times to those which connect them in ivory carving with examples of Christian art—of that art which, for so many centuries from now onwards, governed in its religious forms the whole system of decorative illustration throughout the world—is hardly perceptible, so intimately are the two periods interwoven. We shall cast a glance at the early Christians while yet they remained a persecuted race, compelled to remain in hiding, to conceal their rites and ceremonies, and to veil under mysterious symbols the pictorial expression of their most sacred sentiments. During all this period of more than three centuries pagan and imperial Rome had been extending its conquests and increasing its magnificence under the first of its emperors, and under the conjoined rule of emperor and consul; and at last, in the first years of the fourth century, suddenly— almost before our eyes, as we review history briefly—at one blow, or like the change of scene in dissolving views, paganism disappears, and gives place, under Constantine the Great, to the teaching of Christianity, which from thence onwards, almost to our own times, was to be the mainspring of the world's progress.

We have already been occupied with examples of pagan sculpture in ivory, illustrated by the diptychs of the consuls, and the other paraphernalia of the wealthy

Roman patrician, and we must now hark back, as it were, to notice shortly some things in the history of persecuted Christianity while it was still taking refuge in the catacombs of Rome, to pick up the thread again at a time when, under the protection of the emperors, it was openly displaying that Christian art, which from modest beginnings was destined to form the glory of succeeding centuries.

Interesting as it is, and full of material regarding the history of art generally, it would be beyond the limits of our subject to follow the development of Christianity in the early centuries, and we shall endeavour to steer clear of all considerations, except those which touch in a sufficiently direct manner the art in ivory, with which we are principally concerned. There were, no doubt, as early as the second century, considerable numbers of Christians in various parts of the Roman empire, not only in Palestine, but wherever the doctrines had been spread by the apostles and by the missionaries sent out by them to teach all nations. By the time of Constantine, and certainly a century later—say, about the middle of the fifth century—Christianity, under official protection, would have made itself known, and acquired adherents throughout Italy, France, Spain, on the north coast of Africa, and along the whole of the Mediterranean. From Palestine itself it had naturally passed through Syria into Egypt, Abyssinia, and Armenia, and reference has been made in a preceding chapter to Coptic Christianity and the remains therefrom. After the earliest days, however, our principal concern will be with the work and influence of that part of the Roman territories which we know under the name of the Byzantine empire, whose magnificent capital was Constantinople, and whose style, which spread rapidly throughout the west and influenced that of all other countries, we call by the almost generic term of Byzantine art. We shall, how-

ever, leave it for a moment and return to some general considerations concerning early Christian methods.

The catacombs of Rome and the great Christian sarcophagi unfortunately yield no direct examples of carvings in ivory to which we can refer, but the similarity in subject and style of execution between the reliefs on these sarcophagi and the paintings and other work of the catacombs, compared with that of the early sculptors in ivory, is striking and interesting. The reliefs on the marble sarcophagi are the earliest Christian sculptures which have come down to us. Their relation to the pagan art of the period is naturally very intimate, and in connection with sculpture generally is of the highest interest to consider.

In all early Christian art we can hardly fail to be struck at once with the fondness for symbolism and poetic imagery, the avoidance of direct and realistic representations, and a tendency to hide in allegory mysteries of religion which, either from excess of reverence or from fear of persecution, it hesitated to exhibit too openly. The invention of types and the mystical signification assigned to certain incidents, to certain animals, birds, beasts, and natural products generally, seem to have been a perfect passion. Pictorial art, and especially the arts of sculpture, restricted themselves to modest attempts at such allegorical and mystical representations. They aimed rather at a symmetrical arrangement of the decorative display in which the incidents lay concealed, and we certainly find a marvellous aptitude for balance in composition, and the maintenance of an equilibrium which is seldom disturbed or irregular. Besides, this leaning towards symbolism was natural to the character and feeling of early Christian teaching. It had itself suffered in the days of persecution, when concealment was necessary; it had not forgotten also the idolatrous worship of pagan times, and feared to fall into the same errors;

and for this reason the pictorial representation of actual scenes had hardly suggested itself as an adjunct to the new and simple religion. The Christians of the west must also naturally have borrowed from the eastern cradle of their faith the oriental love for mysticism, the fondness for poetical imagery, and the adaptation of marvellous tales.

We shall not find in our ivory sculpture, perhaps, all the various symbols which, in their simplest forms, prevailed so commonly in the representations on the sarcophagi, the mural paintings, the glass, and other decorations of the catacombs. But we shall see carried down for many centuries and recurring under various forms and adaptations such familiar symbolism as that represented by the figure of the good shepherd, the ship, the fish (one of the earliest emblems of our Lord, expressed as an anagram in the letters forming in Greek the words Jesus Christ, Son of God, the Saviour), the anchor, the serpent, the monogram of Christ, ☧, known as the Chi Rho, and the well-known symbols of the evangelists. With such things as these, even complete events in the Old Testament, such as the visit of the three angels to Abraham, typical of the Trinity, had symbolical meanings attached to them. Symbolism, in short, was a popular and well-understood science. As before remarked, also, there was often in the early days a tendency to shirk the representation of the human figure and incidents connected with it, and to use, in preference, such symbols as doves, peacocks, the sun and moon, lambs, crosses, the hand of the Almighty issuing from a cloud, festoons of vines, from which the juice of the grape flows into cups or chalices, and the like. In one case twelve lambs, representing the twelve apostles, are so labelled, but as a rule the imagination and previous knowledge suffice.

In the middle ages a certain form of symbolism connected with animal life of all kinds—birds and

beasts of fabulous and imaginative forms—became an absolute rage. But besides the deep and hidden meanings with which they were associated, no doubt the decorative forms into which they could be twisted appealed strongly to the artist of those days, who was ever on the look-out for methods of combining quaint imagery with some underlying teaching. Nor can we forget the satirical spirit of the time, which loved to disguise in animal forms the human qualities which it was its pleasure mildly to castigate.

Doubtless the origins of the imagery and decoration drawn from natural history came from various sources, and the evolutions were progressive. Traditions from pagan times, and acquaintances with classical writings such as those of Aristotle and Pliny, early treatises on symbolism, and an exaggeration of the marvellous tales of eastern travellers filtering slowly as they made their way through Byzantium to the west, and gathering on their paths fresh accretions and adaptations, will account to some extent for the use of certain forms, the absolute interpretation of which must ever remain matter for conjecture. We cannot even be certain of the real origin of such an apparently obvious symbolism as that which is now universally accepted in connection with the crook or pastoral staff.

But for the science of animal imagery we have more means at our disposal by which we may be enabled to follow the evolution of the subject. They exist in the literature which is known under the name of Bestiary, and it is to such works—little known, perhaps—as the *Bestiaire d'amours* of Richard de Fournival, the *Speculum Naturale* of Vincent de Beauvais, or the *Speculum Ecclesiæ* of Honorius of Autun, that we should have to go if we wished to understand and appreciate the subtlety of a science which was popular and general, both in its religious and its secular aspects.

The natural history of animals was little understood,

the most absurd misconceptions prevailed concerning such of the fauna of the eastern world as were known to the artists of the west only through the medium of works such as those we have mentioned, and by the tales of the rare travellers whose veracity there were no means of contradicting. And, as a matter of fact, in all probability, scientific accuracy presented no charm. We need only recall the rhinoceros, the hippopotamus, and the elephant of the time of Dürer and his school, to note how long the feeling persisted.

The presence of animal imagery, and to this must be added the vegetable kingdom, will follow us for many centuries of our review of ivory carving, and it is for this reason that it is spoken of here in general terms. We should be carried too far, later on, should we attempt to dwell upon each individual instance. We shall find, often and prominently, the lion as the emblem of Christ, and, in another connection, typical of the evil spirit who goeth about like a roaring lion, seeking whom he may devour. Again, the eagle soaring to the sun and recovering, in his old age, his youthful vigour by gazing at the source of light and life. Very frequently, also, there will be presented to us, especially in the crooks or pastoral staves of bishops, the serpent or dragon with various meanings attached, the ram, the lamb, the cockatrice, the basilisk, and other emblems. Or again, the whale, which, amongst other attributes, will be seen in our carvings typifying the very jaws of hell itself. Countless are the forms of strange fantastic animals, all, no doubt, having attached to them some subtle signification, lost to us now in many cases, but at one time familiar.

Very quaint was the natural history of the lion which commended itself to our mediæval forefathers. It was said that in order to baffle his pursuers he was accustomed to obliterate his footsteps by lashing his tail, that he slept with his eyes open, that the cubs

were born dead and came to life again on the third day by being breathed upon by their sire. It is not difficult to imagine the symbolism which might be evolved from each of these characteristics.

We may now pass at once to some early Christian ivories. Unhappily we are unable to go back beyond the time of Constantine, and after his time, or after the establishment of the empire at Constantinople, we shall find ourselves merged at once in full Byzantine art, which we shall treat to a great extent as a whole, without attempting, for some centuries at least, to discriminate between work which may have been made for the east itself, imported from thence to the west, or made in the west either by immigrant artists or absolutely under the influence of the Byzantine style. In reviewing religious art of the centuries dominated by the dual empire of the east and west, we must bear in mind the force that religion exercised in those days, and how it was the mainspring and the all in all of human existence. Every action of life sprang from it, every detail of domestic economy was practically governed by it. There was no other literature and there was no other art.

There are several cylindrical pyxes in various collections, the most important, perhaps, being that of the fourth or fifth century, now in the museum at Berlin. It is of the usual shape, a section of the elephant's tusk carved all round with figures in high relief. The Saviour is represented, young and beardless, seated on a throne with a cushioned seat, his right hand raised in benediction in the western manner. Near him are seated, on curule chairs, St. Peter and St. Paul, and the other ten apostles stand around. In another group St. John holds a scroll, and in another we have the sacrifice of Abraham interrupted by an angel, and the hand of the Almighty issuing from a cloud. The draperies, the expressions and attitudes of the figures,

and the grouping, are equal to the work on the finest sarcophagi of the fourth century. This admirable piece is said to have been found by some peasants in a village on the Moselle. In passing, it is interesting to compare it with a very well-known gold relic casket of Buddhist workmanship, in the British Museum, found late in the last century in Cabul. The resemblance is striking. The casket has quite the form of part of a tusk, and the figures chased on it are under arches of Christian character, the figures themselves recalling at once those of the apostles.

There are several other ivory pyxes of western Christian workmanship, carved with various biblical subjects in the style of the sarcophagi. A statuette in bone of the Good Shepherd, of the early Christian period, in the Basilewski collection, is unique, for we shall have no ivory statuettes to refer to for a very long period, and it has also a remarkable resemblance to two marble statuettes in the museum of St. John Lateran, Rome, which for this subject are themselves also of extreme rarity.

We may pass next to four small plaques in the British Museum, which present many points of considerable interest. These plaques measure each about four inches by three, representing in very high, almost full, relief several events in the history of our Lord, and especially the crucifixion, of which, if not the earliest known representation, it is at least one of the very earliest.

As to the date of these plaques it is impossible to be precise, and we must content ourselves with the wide margin of, perhaps, as much as three hundred years — say, from the fifth to the eighth century. They have many points of resemblance—more than this, one may say of absolutely identical feeling in the subjects, costume, and treatment—with the scenes on the great sarcophagus in the museum of St. John

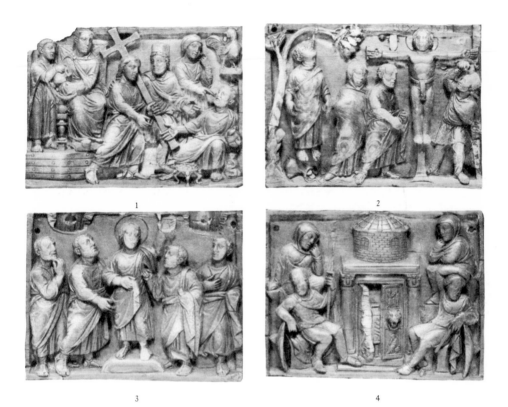

1

2

3

4

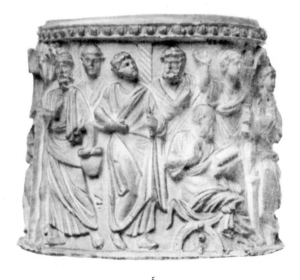

5

Plate 12. EARLY CHRISTIAN IVORIES

1 TO 4. PANELS OF CASKET. SEVENTH CENTURY. 5. PYXIS. FIFTH CENTURY

Lateran, which is of the fourth century, but even this does not help us, for as before observed, the similarity between early ivory carvings and the sculpture of sarcophagi is remarkable and frequent, and the style might have been copied during a long period of years. But we may safely accept the authority which gives us the seventh century as the most probable, and even then the representation of the crucifixion will remain the earliest in existence, for the next—again in ivory—is on the panel of a Carlovingian book cover, of the eighth or ninth century, in the Liverpool Museum.

On the first of these four plaques we have what some take to be the dispute with the doctors in the temple; in the next Christ is carrying His cross, Pilate washes his hands, the cock crows, Peter denies his Master, while the maid-servant mockingly points her finger at him; in the third our Lord is hanging on the cross; and the fourth is the visit of the two Marys to the open sepulchre.

With regard to the first plaque the subject seems, rather, to represent the incredulity of St. Thomas. If this be so, a curious question is involved. Clearly the doubting apostle raises his hand towards the *left* side of our Lord, who is fully clothed, and there appears to be a deep fold or slit in his garments. Still, it must be admitted that the fold in the garment may be an accidental one, or subsequently added. Now in nearly every early representation the wound in our Saviour's side is on the right side, except in the panel of the crucifixion in this series. In this panel the soldier Longinus is represented thrusting vigorously with his spear towards the left side of Christ. The spear is now nearly broken off, but the attitude remains. Time has given to the ivory of these plaques a pleasant dark chestnut or mahogany colour.

Rude and conventional as the design and execution of these pictures may be, naïve in the extreme and

contrary to our present ideas of the necessity of proportion and perspective, there are yet a truth and force about them which are remarkable. From those unaccustomed to work of this character they will at first attract little attention—perhaps excite a smile—but if we take the trouble to examine them and honestly try to enter into the spirit of the artist, we shall find feelings of sympathy and admiration insensibly grow upon us, as they will grow in the case of many another example of an art which, at first sight, appears only to be grotesque, till we come to love such pictures and their touching tenderness, and we wonder no longer at the teaching value, and the influence which they must have exercised in the devout ages when faith existed.

In those early days the face and figure of the Saviour were idealised. Instead of the suffering expression, which was adopted much later on, He is usually represented as very youthful and smiling. It is true that before long we find sometimes a more aged and bearded type, but it is still full of manly beauty, with no realistic indications of the sufferings of the Passion. Remark the figure of our Lord in the second of these plaques as He is dismissed by Pilate. He goes, as it were, cheerfully, nor can we say that He did not do so. It is different, indeed, from the harrowing type, the revelling in the horrors of the sacred event to which the realism of artists of later times unfortunately accustomed us.

So, again, with the other sacred personages represented. They are men and women, and yet not realistic; idealised, and conformed to certain conventionalised characteristics by which we readily recognise them at first glance. Those who conceived in the earliest times these types and representations knew too well themselves what persecution was and the sufferings of the martyrs, and so they chose in preference the cheerfulness of youth, and declined to excite compassion by agonising

details. There is no suggestion of actual portraiture. In the case of the Virgin, for instance, we find her always as a woman of the people. Often, as in the numerous early representations of the visit of the angel at the annunciation, she is spinning at a distaff. There were no exaggerated ideas of crowns and diadems, and star-bespangled robes. The poetry is not yet of the type which puts a lily into her hand. Nor have we even arrived at the times of the tender feelings which imagined and executed those wonderfully charming statuettes and figures with which the ivory sculptor will delight us as no other sculptor ever did, when we come to consider them in that period of the highest devotional feeling, the thirteenth and fourteenth centuries.

Up to the fourth century, at least, no types of portraiture had become established, but from about that time certain apocryphal documents made their appearance, from which artists drew their inspirations, which were gradually accepted, and became so far stereotyped that we are influenced by them even at the present day. Putting aside the traditional portrait of our Lord, which developed and asserted itself as time went on, it is certain that from the oriental capital came the change from the early type which represented Him as a gentle shepherd or as a youthful teacher of a mild and un-assuming expression, in which the human element was not forgotten, but, on the contrary, emphasised, and gave Him to us glorified, with all the attributes of a potentate, clothed in gorgeous robes, enthroned on a magnificent throne sparkling with gold and jewels. His disciples and apostles, too, at one time plain, simple men, became invested with the character of rulers and seated on the curule chair. In many of our early ivories St. Peter is represented with curly hair and a short curly beard; St. Paul, on the contrary, is always bald, and has usually a long beard. Doubtless in both cases there is good traditional authority.

 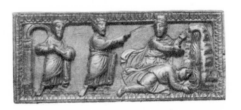

1

2

Plate 13. 1. LEAF OF THE DIPTYCH OF RAMBONA 2. PANELS

SEVENTH CENTURY

In the plaques in the British Museum representing the Passion the Jews are shown in the almost invariable manner continued to the fourteenth century at least, in which we find them depicted not only in ivory carvings, but in the sculptures on the sarcophagi which the ivories so much resemble, that is to say, with flat caps something like carpenters' brown-paper caps. In the one representing the crucifixion our Lord is nailed to the cross with the arms fully extended at right angles to the body, the head erect with no sign of suffering. Judas is hanging on the branch of a tree close by, and the Virgin and the beloved disciple are approaching the cross. There is no scabellum, or rest for the feet, and there is no sign of the thieves' crosses. In the next representation, in point of date, of the crucifixion, with which we are acquainted—the Liverpool panel of the eighth or ninth century—the cross bears the full inscription in Roman capitals, the body of Christ is suspended in the same position, and again without a scabellum, and our Lord's head is still without a nimbus (there is a trace of one in the British Museum plaque, an easily made addition). At the top on either side are busts representing the sun and moon. Such figures are very frequent, nearly always weeping, or, rather, conventionally so to be taken from the manner in which the hands are held up to the faces.

Another early representation, the well-known leaf of the diptych of Rambona, in the Vatican, of the ninth century, is marked by several peculiarities. The Saviour's body is so attached that it appears hardly to be suspended. More correctly speaking, perhaps, the upper part is above the points of suspension. The head has a cruciferous nimbus, and on the short arms of the cross are inscribed "MVLIER EN" and "DISSIPVLE ECCE," referring to the figures of the Virgin and St. John beneath. At the top is a bust of the Saviour, the right hand raised in the act of benediction, the third finger

inclined to the thumb. The allegorical figures of the sun and moon are again represented, holding torches, and at the foot of the cross is what appears to be a most incongruous addition, a figure of a large wolf suckling two children, with the inscription, " ROMVLVS ET REMVLVS (*sic*) A LVPA NVTRITI." Does it mean that He conquered Rome, the capital of the universe?

Allusion has already been made to the manner in which nearly all the important events of the Holy Scriptures were drawn upon to supply instruction by their illustration in the ivory carvings which have come down to us without a break from at least the time of Constantine to the sixteenth century. The number of distinct biblical scenes or episodes often included within the limited area afforded by a single slab of ivory is surprising. Not only so, but, to take as an example, the front of a book cover of the ninth century in the Bodleian Library, in this case the plaque measures but eight inches by five, and a considerable portion of the centre is filled by a figure of our Lord Himself. Yet in the border surrounding the central figure fifteen scenes in the life of Christ are represented in a marvellously distinct manner, each event occupying a separate compartment about an inch square. Such plaques are by no means uncommon, and we shall refer later on to one of the most beautiful ivories in existence —a piece of the fourteenth century in the British Museum—unsurpassed in the treatment of such a microscopic epitome.

A favourite subject above all others was, naturally, the nativity of our Lord, and we may take here a typical instance of a not unusual manner. It is a plaque of Rhenish workmanship of the eleventh century, in the museum at Cologne. Very naïve, indeed at first sight grotesque, is the method of treatment of this and similar works. The birth of Christ takes place within a fortified and battlemented enclosure with towers at

equal distances. The crib itself is an erection of a like
architectural character, through the windows of which
two oxen thrust their heads and gaze upon the Holy
Child. The holy Virgin is stretched upon a bed upon
the ground, and near by St. Joseph keeps watch and
guard. In the upper part are the angels and the star,
and, beneath, the shepherds in attitudes of astonishment
look up to the sky and interrupt their occupation of
watching their sheep. However naïve may be the con-
ception, however apparently uncultured the manner of
the execution, still with all this one cannot but acknow-
ledge the earnestness and the entirely devotional feeling
of the artist who was able to infuse so much expression
into the figures of this great event. Untaught, working
from no pictures or other models to guide him, he evolved
these things from his own conscious devotion. The in-
dividual figures are well designed, the drapery is excellent,
the expression on the faces, to those who are accustomed
to the spirit of these things, is admirable in its suggestive-
ness, and yet there are the incongruity of the surround-
ings, the absolute disregard of perspective, which shock
at first sight. One is almost inclined to ask—though
with no idea of depreciation—whether the artist who
worked in this way did not first make up a little model,
after the manner of toy bricks and figures, and then set
to work to copy the whole on the flat with such crude
ideas of drawing as would occur to him. An almost
identical plaque of walrus ivory is in the Kensington
Museum (No. 144'66), and the type of workmanship is
characteristic of a good deal of Carlovingian work of
the period.

We shall take one more instance of early western
work before we turn to the examples of purely Byzantine
art, and to the outcome of the influence of that school
from its foundation in the capital of the eastern empire.
There are two tablets of the sixth century, or earlier,
probably parts of a book cover, in the art museum at

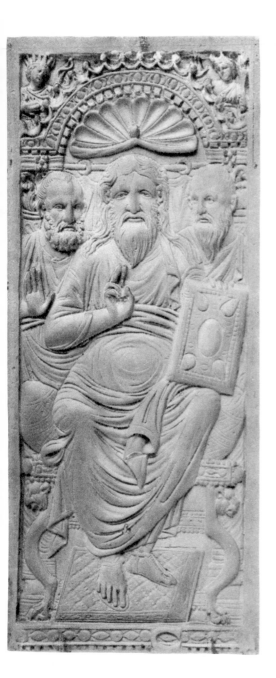
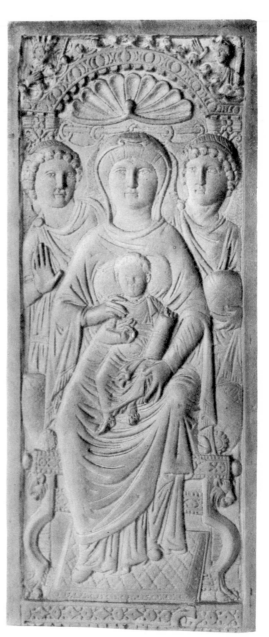

Plate 14. BOOK COVERS. ITALIAN

SIXTH CENTURY

Berlin which are remarkable from several points of view. They are plaques of fine ivory, such as we are accustomed to in diptychs, nearly twelve inches in length by five in width, possibly at one time longer, if, as we surmise, a portion has been cut off from the bottom of one at least. Of the first plaque we need say no more than that our Lord is represented, quite unusually as more than middle-aged, without a nimbus, sitting on a curule chair, and in the act of benediction. On either side are the busts of SS. Peter and Paul, and the architectural background is similar to that on the other portion of the book cover. On the second plaque the subject is treated in a manner which entirely recalls many of the consular diptychs. If, as it is taken to be, it is an example of Christian art, we have here a singular instance of the persistence of pagan forms and accessories in the representation of religious subjects. We have, therefore, to look at it from two points of view, and were it not that the design and execution are remarkably fine, it might possibly be regarded as curious without attracting much further attention. An imperial figure of a woman is seated in a curule chair which has the lion-headed legs, and is furnished with the usual cushion of honour and footstool. She is clothed in a toga-shaped garment, and her head is covered with a large veil, which spreads over her shoulders and hangs down low, bordered with a fringe. Beneath the veil the hair is either covered with a close-fitting sort of cap, or, as is more likely, is dressed in a roll and ornamented with fillets. Between her knees she holds a child, whose right hand is raised in the ordinary manner of benediction, the third and fourth fingers joined to the thumb, and in his left hand is a rolled-up scroll or book. Behind stand two attendants, attired in tunics, with cloaks fastened on the shoulder by a brooch, one of whom bears a globe. The background is architectural, with the large shell-ornament

common to several of the consular plaques, and above, in the angles, are two small busts representing the sun and moon in the usual manner. We have thus described this piece, without any reference to its religious character, because, although we are undoubtedly to accept it as the representation of the Virgin and the Holy Child, it is an interesting example of a transition period, when the artist could adapt pagan forms and methods to the representation of the holiest subjects and yet keep absent from his work the slightest spark of a devotional ideal. Doubtless, towards the middle of the sixth century, and even later, down to at least the twelfth, the ancient classical robes were still copied— the Virgin wears a tunic and chlamys, the apostles, or saints, as in the casket in the Bargello, Florence, togas —but in such a piece as the present one it is not the costume only, but the posing and arrangement of the figures, above all, the expression of the faces, which is so wanting in any indication of religious feeling. It might well be the representation of some great empress with her child on her lap. The expression of the face of the Virgin is bold almost to effrontery, that of the Holy Child is stern, and He looks more like a small grown-up person with decided features. On the other hand, the faces of the angel attendants (for angels they are, as shown by the indications of wings) are charming, their attitudes protective, and in wondering admiration of the Child in His mother's lap. As a classical piece, there is a majesty about it, a grandeur of feeling, and an excellence in design and execution which compel our admiration. But when we associate it with religious ideas it becomes almost repulsive. Nothing, however, is more interesting than to compare such various forms of treatment, as we find, on the one hand, exemplified in such a plaque as this, and, on the other, in the examples of naïve simplicity and rude execution so frequent in the religious work of the same period. Or

we may take, for instance, a plaque in the collection of
M. de Bastard (figured in Didron, *Annales*, vol. xvii.
p. 63), which has more in common with the one we
have just been considering. In this the Virgin is again
seated on a gorgeously decorated throne, but her ex-
pression is noble and simple, and without mannerism.
The Holy Child is properly invested with infantile
charm. Both figures are nimbed, and the draperies,
in form and in arrangement of the folds, carry one on
rather to the graceful methods of the fourteenth century,
than to the stiffness of the Byzantine fixity of type. So
also do the little figures of angels in the corners of the
plaque.

CHAPTER VI

BYZANTINE IVORIES

IT is time now to turn our attention to Byzantine art in general, and to the admirable examples of sculpture in ivory, and to select a few at least of the finest and most typical pieces.

The popular idea of Byzantine art represents something which is characterised by a kind of grotesque form of stiffness and angularity; monotonous and gloomy, with an affected position of the figures which, to use an accepted expression that has almost become classical, " hold themselves like this and hold themselves like that." It is usually supposed that, from its very birth, rules and regulations were laid down, and never departed from, by which it was condemned to suffer an immobility which gave it one uniform and stereotyped character. It is associated with a kind of barbaric magnificence, an overloading of colour, a lavish and vulgar profusion of gold and silver, gems and jewels, gorgeous tissues, and an exaggeration of oriental splendour. It has its enthusiasts, its apologists, and its detractors. There are those who see the influence of Byzantine art in the art of every other nation under the sun, who ascribe that origin in some way more or less direct, at least, to every work of importance of the middle ages, who will hardly concede that any country could have done its borrowing in art—and what country has not? —without the help of this intermediary. On the other

hand, there are those who decline to see the results of Byzantine teaching, to whom the mere hint of such an ascription acts like the proverbial red rag to a bull, for there are politics in art as well as elsewhere which arouse corresponding passions. There is, of course, truth on both sides, and these disputes are not without their usefulness. A good deal of the misconception no doubt often arises from the fact that much work was done by Greek artists who migrated at various epochs, and settling in the west engrafted the types and methods of the country of their birth on those of the country of their adoption, and working often under the direction of native artists, or to suit the tastes of their employers, naturally assimilated and made use of forms and inspirations which their new surroundings could hardly fail to suggest. On the other hand, the contrary influence was happily rare, for the results of the borrowing by the east from the west—in the arts certainly—have ever been disastrous.

In that part of the east which afterwards became the great province of the Roman empire, and later on the capital of the most important division of its dual government, Greek civilisation and influence were, at the beginning of our era, predominant. But at that time the arts had been for long in a state of decadence, though the monuments of their highest period of excellence still remained, probably, everywhere in great abundance. It was a restless age; the peoples were harassed by foreign invasions, overrun everywhere by hordes of barbarians, and themselves almost entirely occupied by the greed of conquest and expansion. Still, when conquered by Rome, schools of art existed, and a national form asserted itself. Then came the epoch of the introduction and protection of Christianity under Constantine the Great, and the conquests and extension of his dominions even to the shores of the Bosphorus, upon which, in the year 328 A.D., he fixed his choice for the foundation of the capital of

his eastern province, which was to become seventy years later the Byzantine empire. The ambition of Constantine was to make his new city, which he renamed Constantinople, unrivalled for splendour and magnificence amongst all the cities of his own or ancient days. What wonder if he filled it with the artistic spoil of ages gathered from all parts of the east; that Athens, and Antioch, and Smyrna, and all the great marts and settlements were made to yield up their chefs-d'œuvre and riches for its adornment! Treasures and costly material were brought from Rome. In return Greek workmen, no doubt, travelled to the capital, and were settled and employed there to introduce into the west the arts in which they excelled. Most important of all were the coincident protection and official recognition of Christianity, which had the effect, no more, no less, of a revolution. Persecuted till then, now all of a sudden the Christian religion finds itself in favour, and very active indeed must have been the preparations amongst all classes of artists to provide for the calls which the requirements of the new faith would have made upon them.

In ivory sculpture the first to arrest our attention will be a superb leaf of a diptych—one of the earliest monuments of Christian art after the recognition of Christianity by Constantine—which can be worthily ranked with the finest work of pagan times. When we consider that the Christian religion had hardly been relieved from persecution and officially recognised at the time when this diptych was made—for we cannot be positively contradicted if we place the date of it so early even as the end of the fourth century—it is certainly of the most pleasing interest to be able to assign to sculpture in ivory and to a Christian subject the honour of representing the condition of art at that important period. It is the commencement of those types of figures and ornamentation which we shall see later on developed in such various ways, now in a high state

of perfection, then again decadent and sinking, now wholly devoted to, and imbued with, the spirit of religion, at another period showing signs of a return to the antique spirit; in one form almost proscribed for a time during the reign of hatred towards imagery of all sorts, then again sending out its artists and workmen to every corner of the then known civilisation; at again another time being influenced by the invasion of crowds of western strangers when the expeditions of the crusades poured them by thousands and hundreds of thousands into the east. Now up, now down, all such vicissitudes cannot have failed to have had a marked influence on the art which, through them all, preserved its peculiar characteristics and originality. For Byzantine art is undoubtedly original.

Making allowances for the influences of Greek art, Constantinople, from her geographical position and from her political and commercial relations with the powerful monarchies of the farther east — especially with Persia—was bound to borrow, and she did so, frankly. Thus, in the very characteristic ornamentation, which we find so frequently, of complicated interlacings of foliage and fruit intermixed with birds and animals of all kinds—known and unknown—she found inspiration in the work which is so typical and universal in India and Persia. But, naturally, where religion and its histories were concerned she was left to her own resources, and her originality is then incontestable. She found that the belief and symbolism, and even the legends which grew up, were laid down dogmatically. How, then, could an appearance of repetition be prevented? A following of certain methods became almost a dogmatic necessity in itself. This would seem to be almost inevitable, much as in ecclesiastical art of the present day, not only in imagery, but in the adornment of the altar and the vestments of the ministers, some forms of the most debased description—we need

not hesitate to say, of the most blatant vulgarity—are not only tolerated, but in the eyes of some it is almost equivalent to heresy to raise objections to them.

The fixity of type in Byzantine religious iconography —at least, in the popular imagination—has already been alluded to. Doubtless there is much foundation for the idea, but it is due, perhaps, more to the exaggeration of the practice in later years. The religious art of the Greeks from the first tended to be governed by laws as precise as dogmas. Little was left to the fancy or invention of the artist. In course of time the form of the head, the proportions, the attitudes, and the attributes were rigidly fixed by tradition, and the same indications over and over again were faithfully represented. All this is more remarkable, however, in painting than in sculpture, and it need not, therefore, concern us so much in our consideration of the ivories. Probably, also, these rigid rules were more peculiar to the later days of the Greek Church after its separation from the western, and as a matter of fact, our examples of Christian sculpture in ivory in the east will not be many after the tenth century, and after the twelfth will be confined to one or two of the very few of Russian origin which are to be found.

If we can trace similarities and influences, if from every aspect it may not have been a spontaneous creation, if it did not itself originate those marvellous combinations of foliage and imagery, if it borrowed, as we know it did, from Persia, Byzantine art knew also how to adapt and assimilate what it found of value to the inspirations of its own genius. The passion for harking back to the remotest possible beginnings of this or that system of art, the search for absolute originality which is often carried to extremes, and of which the results must always remain contestable, are matters with which we need hardly concern ourselves. Neither will it be necessary, in connection with our

ivory carvings, to allude to those points in other divisions of art in which Byzantine artists may have failed to reach the purest and highest form. Our aim will be to endeavour to select for comment and illustration the most admirable examples of ivory sculpture and those which will the most readily appeal to the imagination.

It is necessary to allude shortly to events which had —as they could not have failed to have—a disastrous effect on the arts in general. It is surprising that the latter should have been able to withstand, as well as they did, the disordered state of the empire, the wars and disasters from the time of Justinian (527 A.D.) to the commencement of the eighth century. In fact, there were everywhere—in literature, in art, and in the state of the people, and of domestic habits—signs of decadence and of ruin. Happily, however, for the arts, the Church was predominant, and under her protection they were enabled to continue to develop themselves in security. Suddenly arose the disastrous spirit and the mad fury of iconoclasm, a repudiation and a violent dislike to everything in the shape of imagery. Upheld by the emperors themselves, the frenzied fanaticism of the instigators of the new crusade attacked with fury what they considered to be idolatry. Above all, religious imagery excited their anger and opposition. In the year 726 A.D. images were suppressed entirely by edict of the Emperor Leo. Re-established in 754, they were again doomed to disappear for a few years about 830. It is unnecessary to follow at length the history of iconoclasm. Those days passed away, but we can imagine their effect, not only on the treasures of pagan art which remained, but also, and principally, on religious imagery. Not even at the time of the destruction of churches and religious houses in England at the Reformation could the excesses and violences committed have been paralleled. As in England, statues and shrines were defaced and destroyed, and the frescoed and painted walls

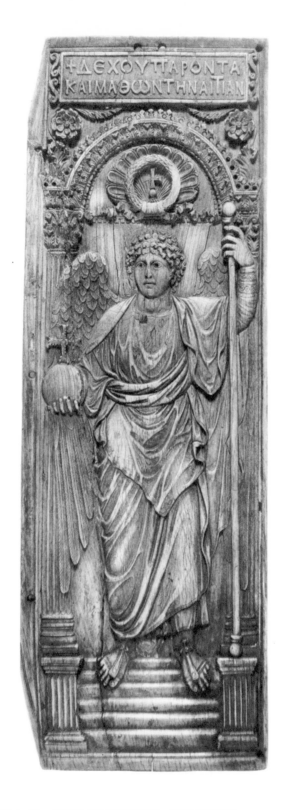

Plate 15. LEAF OF DIPTYCH. BYZANTINE

FOURTH CENTURY

of religious edifices covered with limewash. To this day, as is well known, actual sculpture is prohibited in the Greek church. One would imagine that a revival of secular art and a return to antique models would have taken place, but it is, on the contrary, not until the ninth and tenth centuries that we find a tendency in this direction strongly manifested. This is, however, more in evidence in the paintings and miniatures of these epochs. The examples in ivory work are not very numerous, although there are some very important instances, such as the Veroli casket in the South Kensington Museum, which we shall notice presently.

If we ascribe the very celebrated leaf of a diptych in the British Museum, representing an archangel, to so early a date as the fourth century, it is not that we do not recognise the divergence of opinion on this point amongst commentators, especially foreign ones. But there are equally good authorities, with whom it is satisfactory to be in agreement, who do not hesitate to claim for this superb work a place amongst the earliest productions of Christian art after the recognition of Christianity by Constantine, and who hold the opinion that there are no examples of carvings in ivory of the fifth or sixth centuries, or, in fact, of any later period, which can compare with it in excellence of design and workmanship. The ivory itself is of unusual size and quality, one of the largest known, measuring sixteen and a quarter inches in height, by five and a half inches wide. It is undoubtedly part of a writing tablet, for the back is hollowed for the reception of wax, but the other leaf is unfortunately lost. It is curious that for such an important piece no records are in existence to tell us when or in what way it came into the possession of the British Museum. Nothing would be more interesting than to know something of its previous history, and of the locality where it has been so carefully preserved, as its condition shows it must have been, during

so many centuries. We should be glad, indeed, to have positive proof that this beautiful ivory is really, as there are grounds for surmising, identical with the "Angelus longus eburneus" of a book cover among the books brought to England by St. Augustine, which is mentioned in a list of things belonging to Christchurch, Canterbury, in 1321 (given in Dart, *App.*, p. xviii).

Nearly the whole of the field of this large piece of ivory is occupied by the figure of an angel or archangel —we may take it to be the latter from the emblem of sovereignty in the form of an orb surmounted by a jewelled cross which is held in one hand—standing erect on the uppermost of a flight of six steps beneath an arch of rich design which rests on two columns with Corinthian capitals. Beneath the arch is the shell ornament, which we have frequently noticed in the consular diptychs, and a wreath of leaves tied with a fillet, within which is a small orb and cross. The angel is robed in a tunic and mantle, which fall round him and from his shoulders, draped in excellent taste and of a rare elegance. The wings are widely spread with beautifully disposed feathers, of admirable design, falling down on either side of the body nearly to the sandalled feet. In the left hand the angel holds a long rod tipped at top and bottom with a small ball, a not unusual attribute in Byzantine designs. Most remarkable is the character of the head and face, the hair curled in a mass of thick small curls, the neck solidly placed, the eyes frankly open, and the whole expression full of vivacity and nobility of demeanour, without a suspicion of stiffness or mannerism. The label on the top of the plaque has the inscription in Greek capital letters which we may read, so far as it is completed, "Accept this gift, and having learned the cause," the remainder being, no doubt, on the missing leaf. We can hardly doubt that the Byzantine artist who executed this fine piece must have known and followed, but without slavish imitation,

[141]

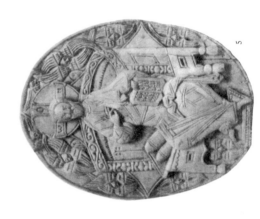

Plate 16.　　1. PYXIS　　SEVENTH CENTURY

2. PLAQUE. BYZANTINE
NINTH CENTURY

3, 4, 5. PLAQUES. BYZANTINE
TWELFTH CENTURY

some work of great excellence of pagan times. An interesting detail is that the back surface, prepared for the wax, has upon it, written in ink, in characters of the seventh century, a prayer, but only the opening words are still legible. Time has considerably discoloured the ivory, but this is not a condition that we should care to alter; rather may we look on it in the light in which we regard the patina of ancient bronzes.

With the archangel diptych may be classed, perhaps, the elegant vase in the British Museum of a very pure style, of which an illustration is given. The date is not easy to be precise about; a century, perhaps two, or even three, later than the diptych. The detached ivory ring which surrounds the foot is curious. Possibly it was for attaching a veil to be thrown over the vase, as it may be conjectured that it must have served some very sacred purpose, though we have no means of forming any idea what this may have been.

Still of an early period, though possibly two centuries later than the archangel diptych, we come next to the beautiful casket known as the Brescia casket, Italian work of the fifth or sixth century, preserved in the Quiriniana Library at Brescia. So covered with ornament and scenes and a multiplicity of detail are the ivory plaques, which compose the top and sides of this casket, that we shall be content with describing the front. The style is quite classical, and forms an extremely important example. A row of five busts in medallions runs along the top, the centre one, of our Lord, showing Him of a youthful type, the hair thick and combed straight over the forehead, with long curls at the sides. On either side of the lock-plate are, respectively, Jonah thrown overboard from a vessel manned by rowers, and partly swallowed by a great fish; and again, the great fish, whose body is in huge coils of very decorative character, casting him upon the shore. Then we have the Saviour, youthful and

charming in expression, with the Magdalen, who kneels before Him, reading from a long scroll, which He holds extended before Him, to three disciples on either side; and again, as the Good Shepherd standing beneath an arch, the sheep near by, but a wolf approaching, and the hireling who fleeth. The scenes below are charming little figures, with the story of Susannah and the elders, and Daniel with the lions.

That the artist had classical models—Greek, it may be, of the finest epoch—it is impossible to doubt. One might almost name the works recalled, were it not that one might fear being accused of too easily seeing resemblances and recognising sources of inspiration, and, besides, there is here no question of mechanical following. Such details as the placing and grouping of the little flock of sheep; the management of the curtains in the scenes with the apostles; the scroll beneath, and the whole arrangement and movement in the scenes in the lower panel, are examples of decorative treatment, balance, and harmony, to which special attention should be directed. They are the keynotes of the charm which so many works of the kind of the highest character are capable of giving to those who rightly look at them. For the rest the delicacy of workmanship is remarkable, and perhaps we may say of this piece, as we should wish to say of much other work in ivory, that it is an instance of the singular appropriateness of this material to such a class of design. Neither marble nor terra-cotta, for example, could be used to express so much on a small scale with equal delicacy. Some woods might suffice, but we should miss the peculiar brilliancy and elegance which the white ivory is able to give.

Throughout the remainder of the plaques we have admirably arranged groups, and scenes from both the Old and the New Testaments. It may be interesting to note that on the five pieces forming the top and four

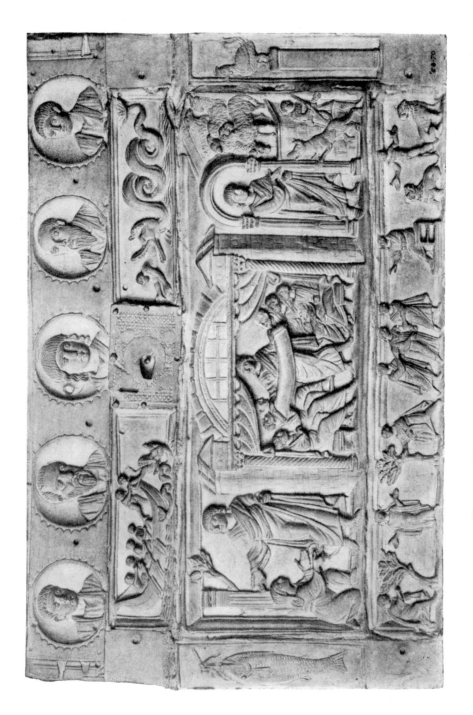

Plate 17. PANEL OF THE "BRESCIA" CASKET

FIFTH CENTURY

sides of the casket, measuring each, on an average, eight or nine by eight to twelve inches, we have no less than forty-one distinct scenes or incidents represented. There is hardly one which does not present points, for comparison, of interest to the student of the evolution of Christian iconography. It may be noticed that, although the narratives carry us on so far into the history of the Passion as our Lord being led before Pilate and Pilate washing his hands, with one or two other incidents connected with it, there is no representation of the crucifixion, or even of the way of the cross. We must content ourselves with calling attention to the equally fine work, of the same date, in the book cover in the treasury of the cathedral of Milan. It would be impossible to omit this, though we have chosen the other for illustration. For quality and excellence both may be classed with the diptych of the archangel.

We need not yet leave the sixth century, which furnishes us with such admirable examples. The episcopal chair of Maximian, Archbishop of Ravenna in 546 A.D., preserved in the sacristy of the cathedral, is entirely covered with ivory plaques carved in high relief with figures and scenes from the Old and New Testaments. The chair itself has a high curved back, and the ivory panels are carved upon both faces. A few are wanting, and have, in fact, been identified among some plaques in other collections. Otherwise it is in extremely perfect condition, and were it not for the slight discoloration resulting from the effect of time, it is little altered since the day it was put together.

Ivory plaques with subjects from the Scriptures are so often referred to in the course of our descriptions that we need not now particularise all those that occur on this chair. The most remarkable portion for our present purpose is the front, formed by two narrow upright pieces, and between them a panel on which are

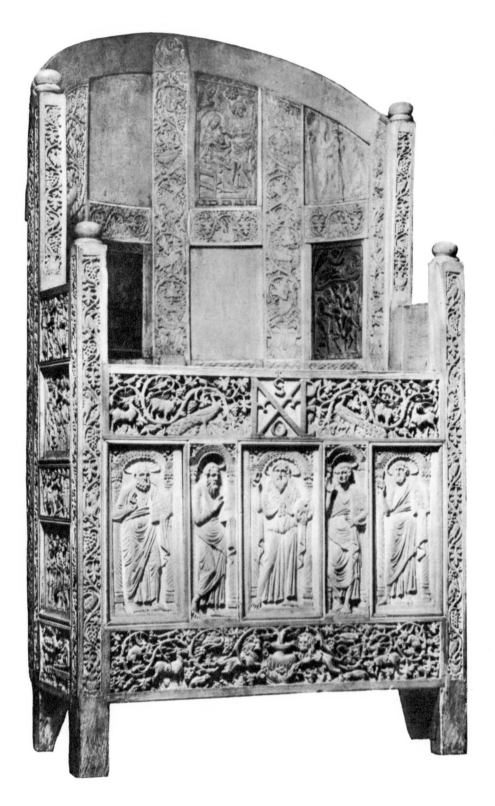

Plate 18. CHAIR OF MAXIMIAN AT RAVENNA

SIXTH CENTURY

five large plaques and two border pieces. The plaques represent standing figures of St. John the Baptist and the four evangelists, under decorated arcades separated by columns. Above and below, and ornamenting the narrow uprights, the plaques are carved with a decorative theme of great richness and delicacy—a branching and foliated scroll of vines and bunches of grapes, amongst the intertwinings and interlacements of which a variety of birds and animals, peacocks, doves, hares, lions, and stags disport themselves. On other ten plaques on the chair we have the history of Joseph and his brethren. The decorative work is of elegant taste and execution, rich and yet subdued, not crowded and without meaning, as we sometimes find in eastern work of a similar character. In short, it is entirely typical of the best style of Byzantine treatment. Finally, this fine throne is inscribed with the name of the prelate—" MAXIMIANVS EPISCOPVS " —for whom it was made.

Interesting as a relic, it is no less so, for the most part, as an instructive example of Byzantine methods of design and technique, especially in the fine work and style of the borders surrounding the panels, and in the true form and character of their interlacing and twining branches and foliage. We find also several examples of the mixture, or rather adaptation, of different styles; at one time almost entirely classical, at another—especially in the larger single figures—purely Greek; then again with reminiscences of the early Christian sarcophagi. One is inclined to ask in what way the ivory adornments of this chair were put together. Were they the work of one artist or of many; made entirely in Italy or imported; to be considered as a complete design or collected from various sources at different times, and fitted as they might happen to suit; all of them of contemporary work or added to at later dates? If we compare, for instance, the plaques representing the history of Joseph and his brethren with the figures of saints under

arcades, we seem scarcely warranted in the assumption
that they are by the same hand, or, again, that the borders
of the former are equal in character of design and work-
manship to the other elaborate borders.

The plaques with the large figures just referred to
recall the diptychs of the period, and it is quite possible
that they may originally have been portions of diptychs.
At the same time caution is necessary before arriving
at such conclusions, and also in the contrary case of
setting down leaves of diptychs as decorative plaques
of caskets or furniture. Passeri, the editor of Gorius,
in his *Monumenta Sacra Eburnea* (1759), has some
remarks to the purpose which it may be well to quote.
He says :—

"At Ravenna I saw in the episcopal archives room the ivory chair
of S. Maximian the bishop: of elaborate fifth-century workmanship,
the sides adorned with ivory panels about eighteen inches long, carved
for the most part in low relief by a skilled hand. If these should
become detached they might readily be taken by the ignorant for
diptychs. This, unquestionably, they are not, for they cannot be taken
for the consular diptychs which had their own ornamentation referring
to the consulate and its insignia, differing from the sculpture destined
for other purposes. Hence they are obviously mistaken who count
certain tablets as diptychs which have no ascription to any consuls, but
represent the muses, poets, bacchantes or gods. These seem to me to
have been book-covers, as the ornaments show. Furthermore there are
certain representations of emperors of a later age which show no traces
of hinges, so that they would appear to have been decorations of state
chairs rather than diptychs: especially as their exterior ornamentation
ends on the top in a point, which was entirely contrary to the fashion of
diptychs."

We must pass on now, three hundred years later, to
an example of Carlovingian or Italian work, a book
cover in the Kensington Museum in remarkably fine
condition. It is composed of five large vertical plaques
and of two horizontal ones of irregular shape in a
decorative frame work. The subject of the centre panel,
the only rectangular one, is the Virgin and Child ; on
the panels, on either side, there are, on left and right re-
spectively, two figures, probably Isaiah and Melchisedek,

the latter bearing a censer and incense-box. All are in rich architectural surroundings. The top panel has two charming figures of angels floating on clouds, and supporting between them a medallion with a bust of the Saviour. The wings and draperies are delightfully treated, the latter contracted and bound near the knees, and floating out again. They are in the manner of the early Christian monuments, such as the sarcophagi and the Rambona tablet of the crucifixion. Beneath are the Nativity, and the angels appearing to the shepherds. We have here, again, the stable and crib conventionally depicted as a kind of a classic temple, the ever-present oxen quite too large in proportion, so that the temple is hardly big enough to contain them, but this frequent manner is wholly decorative in intention. The museum at South Kensington, where this piece now is (acquired in 1866 at a cost of nearly £600, much less than its probable present value), has no finer example of the style and period, and we should have to search far to find its equal.

On a question of so much difficulty as the ascription and date of this splendid book cover, we may be quite content to accept the opinion of the learned author of the *Catalogue of Ancient and Mediæval Ivories* in the South Kensington Museum. He gives them as Carlovingian of the ninth century. At the same time it will be of interest, and serve as an excellent object lesson, to call attention to the very similar book cover in the Vatican, which is claimed as Italian work of two, or perhaps three, centuries earlier. The resemblance is certainly very striking, although the workmanship is coarser. The illustration which we give from a cast of the plaques from the Vatican book cover will suffice to show the points of difference.

The remarkable treatment of an arabesque of scrolled foliage, in which animals also appear, is well illustrated in portions of two plaques of a book cover, also of the

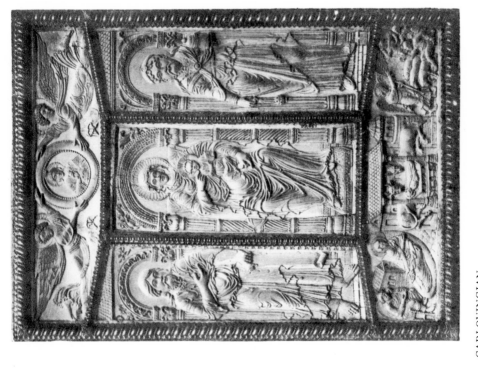

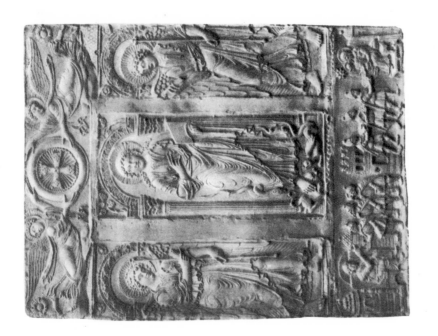

Plate 19. BOOK COVERS. CARLOVINGIAN
NINTH CENTURY

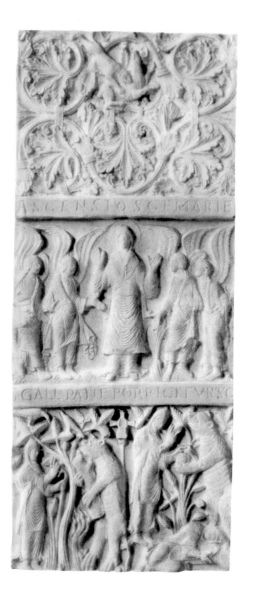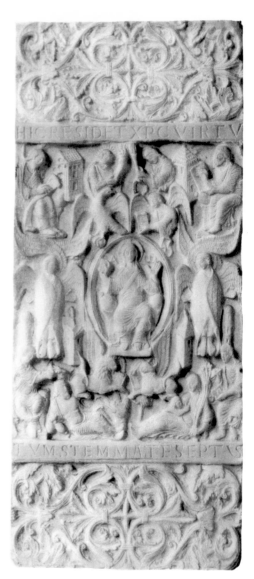

Plate 20. BOOK COVERS. ASCRIBED TO THE MONK TUTILO

NINTH CENTURY

ninth century, in the library of the monastery of St. Gall
in Switzerland. St. Gall is connected in legends with
bears, and these animals frequently appear. One of the
plaques represents the ascension of the Virgin. The
drapery is extraordinary, poor, and grotesque. The
work is ascribed to the monk Tutilo, on what authority
we know not, but worth mentioning, as the names of
artists are—for many centuries—entirely wanting. The
story of Tutilo, or Tuotilo, is, however, probably more
legendary than real. A history which is quite wonderful
in its minute details has been woven around him, and,
after all, there appears to be nothing in the least degree
certain, except that a monk of the name was guest-master
of the abbey of St. Gall in 912 A.D., to whom numbers
of other things, such as altar fronts in gold and bronze,
are attributed.

It may be that the gap in the series of illustrations
which we have selected carries us on three centuries
further, but it is an interesting and extremely popular
subject to which we now come, and one which is always
treated with perhaps more pathetic feeling than any
other. It could hardly be otherwise, for it represents
the death of the Blessed Virgin, that central figure
which is rarely absent during so many centuries of
Christian art, and approached in so many different
ways—now with great simplicity as a woman of the
people, then again glorified with the attributes of human
power, later still, as in the charming statuettes of the
middle ages, as the Mother of the divine Child, always
with tenderness and affection. The subject of her death
is almost invariably treated in the periods we are now
considering in the same manner, with the same attendant
figures and attributes. The one which we select is, there-
fore, representative. It is Byzantine of the eleventh or
twelfth century, in the Art Museum, Berlin. The Blessed
Virgin is stretched on her deathbed, the head raised and
surrounded by a jewelled nimbus. Around are some

[153]

fifteen figures of disciples and apostles, many in attitudes of grief. One of them, with a remarkable resemblance to the traditional type of St. Paul, stoops to arrange the drapery at her feet; another, at the head of the couch, swings a censer over the body. In the centre, apart from the others, appears our Lord, holding aloft in His hands a small infantile bust representing the soul of the Virgin, which two descending angels hovering above, with wings extending upwards, are prepared to receive in their hands, reverently covered with the sleeves of their garments. The composition is framed and surmounted by a pierced Byzantine canopy. Again we must call attention to the balance of such compositions; the contrasting vertical lines of the figures of the attendants, and the central one of the Saviour, with the curved horizontal disposition of the recumbent body, and the winged angels in the upper part. We have a plaque of similar character in the museum at South Kensington. The subject was for centuries extremely popular. Following the received tradition, which may be found at great length and poetically given in the *Golden Legend*, the Virgin, having arrived at the age of sixty years, received intimation from an angel of her approaching death. Miraculously brought from all parts, the apostles were present. The Saviour himself appeared, surrounded by patriarchs, martyrs and confessors, and the heavenly host. And so took place the *dormition*, as the more reverent term expresses it, of the Blessed Virgin. Of her tomb there is no trace or record, neither has any relic of the sacred body ever been venerated.

A round-headed Byzantine triptych of the eleventh century, in the Cabinet des Médailles at Paris, is considered by some to be the most beautiful specimen of Byzantine art in existence. As with other pieces, the range of date which may be given is extensive. It is most probably of the eleventh century, at the same time some are inclined to place it so late as the end of

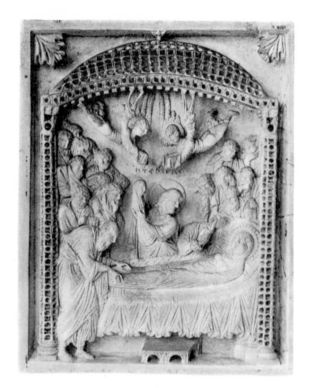

1

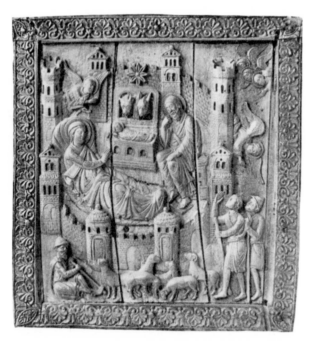

2

Plate 21. 1. PLAQUE. DORMITION OF THE B.V.M. BYZANTINE
ELEVENTH CENTURY

2. PLAQUE. THE NATIVITY. RHENISH.
ELEVENTH CENTURY

the thirteenth. In the centre compartment we have the crucifixion, with the Virgin and St. John on either side of the cross, these figures treated with the mannerism which gives them an abnormally elongated anatomy, and the straight, close folds in the drapery which generally accompany this type. Lower down are placed on either side Constantine and the Empress Helen, of microscopic proportions, no doubt from a feeling of reverence. The Christ is of the type which does not seek to horrify us by a realistic representation of suffering. The proportions of the figure, which is upright, with the arms fully extended, the feet apart, resting on a scabellum, are correct, and the body is draped in a short skirt. The sun and moon above are here shown in the usual conventional, instead of the allegorical, manner. On the folding doors of the triptych are busts of several saints in medallions, with the name on each. It is a remarkable piece, though we may not be able to share the enthusiasm which it has excited. Of similar style, but more charming, is the triptych, lately sold at the Gibson-Carmichael sale for £1,900, which had successively ornamented the Soltikoff, Seilliere, Spitzer, and Hartmann collections.

There is a typical example of the same method of treatment of the figure and draperies in an unquestionably fine ivory of the same period representing St. John. The tall and carefully carved figure is clothed in a long robe with close and straight folds. Above this he wears a cloak edged with fur, a fashion peculiar to representations of the Baptist.

We have now to consider an important and very curious work in the museum at Kensington, concerning which we may at once say that we are doubtful whether we ought to include it amongst Byzantine ivories, or to assign to it an origin of peculiar interest to us—viz. an Anglo-Saxon one—at the same time that the Byzantine influences may be fully admitted. We hesitate to

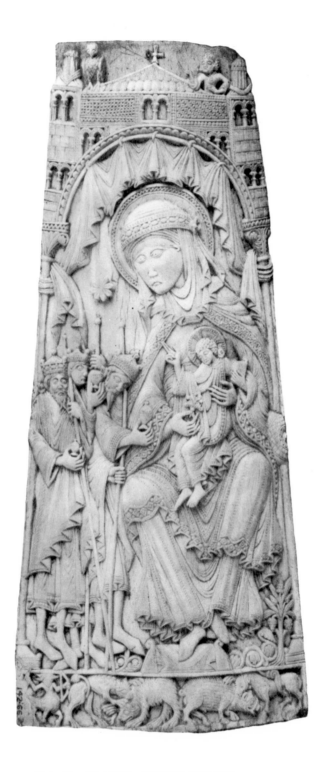

Plate 22. PLAQUE. NORTH EUROPE

ELEVENTH CENTURY

run counter to the judgment of such an acknowledged authority as the writer of the museum catalogue, who pronounces the piece in question to be Anglo-Saxon work of the eleventh century, but, while allowing it to be northern work—possibly North German—in the face of certain characteristics, and also because our plan will not permit of reserving distinct sections to every national work of the centuries down to gothic times, it will be most convenient to take this remarkable piece at this point.

The material is not true ivory, but bone of a very fine texture, possibly the bone of a whale. It is of considerable dimensions, measuring fourteen inches by six and a quarter. The manner of representation—the subject being the visit of the Magi—is extremely curious. The figure of the Virgin, who is seated with the Holy Child on her lap, is out of all proportion in its gigantic stature to those of the three kings close by her side. Very quaint is the manner in which the artist has not hesitated to allow the vertical lines of the architectural background to slope inwards in order to accommodate the restricted dimensions of the upper part of the plaque. The most interesting parts of the details are the costumes of the Virgin and Child. Their robes are of great richness, with pearled and diapered borders. The hair of the Virgin is arranged in narrow bands or rolls, a veil falls from the back of the head, and over this is a broad circlet or diadem, jewelled. She wears a richly decorated tunic and cloak, and pointed shoes. The Child raises the right hand in benediction, the two first fingers extended, but not touching the thumb. In a narrow border at the bottom of the plaque are a centaur, the human figure of which is of aboriginal type, and carries a bow and arrow, a lion attacking a bear, and a wild boar attacked by some nondescript creature. The whole design and arrangement are quaint, or even grotesque, but there can be no denying

the general decorative character and the evident devotional feeling. The figures may be disproportionate, their expressions wild, and the anatomy of an emaciated type, still there is evidence of the hand of an artist who knew what he was doing, and who delighted in the general effect, the richness of the draperies, and the elegant arrangement of their folds with which he presented us. This fine plaque was sold at the Soltikoff sale to Mr. Webb for £153, and passed with his collection in 1865 to South Kensington for £218. With regard to origin it is impossible to be certain. The treatment of the animals may be compared with those on the Carlovingian, or Rhenish, book cover, ascribed to Tutilo, to which reference has already been made. The plaque is certainly northern work. Why not, indeed, Irish?

Perhaps the most superb object which the South Kensington Museum was fortunate enough to acquire on the dispersal of the Soltikoff collection in the year 1861 was a Rhenish Byzantine reliquary in silver gilt and *cloisonné* enamel work of the twelfth century. This splendid shrine is, it must be said, but indirectly connected with our subject. It is so by reason only of the ivory figures and plaques which form part of the decoration. Of the reliquary itself, it will be sufficient to say that it is of copper gilt—a small church of the shape of a Greek cross with a bulbous dome divided into lobes, the transept brought forward from each of the four sides. It is richly enamelled. On the fronts of the transepts plaques of walrus ivory are let in, and the sides, and the drum on which the dome rests, contain twenty-eight arches, under which are figures of apostles, prophets, and saints. The sculptures on the plaques represent the visit of the Magi, the Virgin and the Holy Child, the Crucifixion, and the Resurrection. The figures are some of elephant, others of walrus ivory, and all bear scrolls with legends and texts, some of which are, however, difficult to decipher with certainty, owing

to the contractions. The sixteen figures of prophets and saints around the main body of the shrine are all standing, those of the twelve apostles which filled the niches under the dome are seated. Five or six of the figures are later restorations. It is supposed, according to Dr. Bock, to be the work of the monks of the monastery of St. Pantaleon—this at least so far as the metal and enamel are concerned, the ivory figures may have come from another source.

The history is curious, as may be gathered from an account furnished to the museum by Dr. Bock. There is evidence that until the French Revolution it was preserved at a monastery near Emmerich on the Rhine. At that time it was taken away and hidden for some time in a chimney in a house in the possession of the monastery in lower Elten. Later on it came into the possession of a priest at Dornich, was sold by him to a Jew for the sum of about four pounds, and from him purchased by Prince Salm-Salm for thirty pounds. It next passed into the hands of a collector at the price of £150, from whom it was acquired by Prince Soltikoff at a cost of £200. Finally, at the dispersal of the Soltikoff collection in 1861, the museum at Kensington paid for it what was then considered the very large sum of £2,142. If such a treasure could now again come into the market, it is impossible to imagine what it might fetch. It would not be unreasonable to estimate the value at double the amount given by the museum.

The last of the examples of Byzantine religious art to which we shall now refer are the two covers of the Psalter of the Princess Melisenda, daughter of Baldwin, King of Jerusalem, in the British Museum. The work is of the twelfth century. The dimensions of each leaf are nine by six inches. The subjects contained in six circular compartments on each cover are on the one side biblical, on the other, representations of six of the acts of mercy. The relief is shallow, and the drawing very

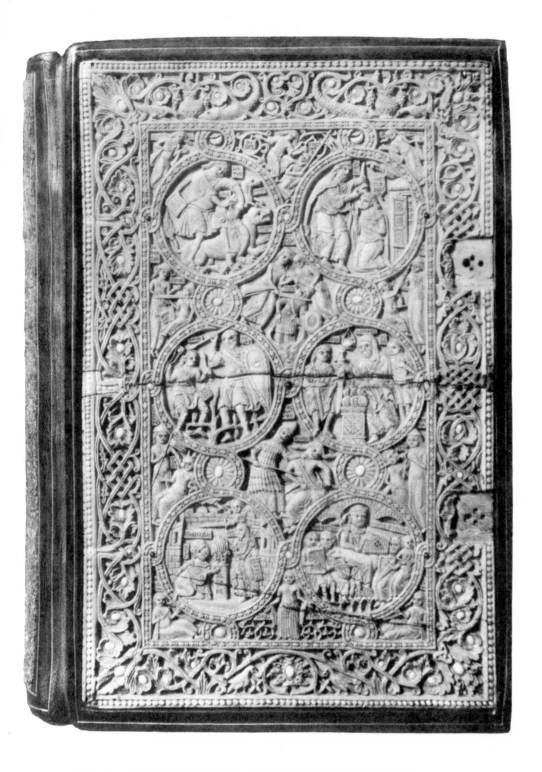

Plate 23. COVER OF PSALTER OF THE PRINCESS MELISENDA

TWELFTH CENTURY

rude. It is, however, the decoration of the plaques which is so remarkable and rich. The sets of compartments are bordered by a jewelled ribbon elegantly intertwined, the intervening spaces filled in with birds and animals personifying the Christian virtues. The border is an elegant arabesque of foliage and grapes in the best style of this characteristic Byzantine work. What we have to notice are the charming simplicity of the apparently interminable interlacements, clean cut and decided, and the curious combinations of birds and animals dear to oriental artists with which every available inch of space is filled. The book cover is now exhibited in the manuscript department of the British Museum. It has been set, within recent years, with turquoises, and the eyes of the figures filled with rubies. The authority for so doing is perhaps open to question, but it may be mentioned that ivories of this date—for example, the Carlovingian book covers in the museum at Kensington (Nos. 250, 251'67)—have been studded with gold pinheads. For the most part, only the perforations for them remain.

A similar style of ornament, but more complicated, and of a finer character even than these precious book covers, is shown in the portions of an arm of a chair formerly in the Meyrick collection and now in the museum at South Kensington. They are curved pieces made of two walrus tusks, measuring about two feet in length. But we have here apparently a combination of styles, with not a little suggestion of northern work. The relief is extraordinarily deep, so much so that it is almost detached in part—an arrangement of scrolls and foliage intertwined with human figures and fabulous animals; an eagle and a lion in medallions. The country of origin, and even the practical use of these magnificent fragments, are not easily to be determined. We may say that they are of about the twelfth century and in the finest style of Byzantine art.

Amongst carvings in ivory, to which a special interest is attached on account of external circumstances, some allusion must be made to the plaque or fragment said to be a portion of a casket which formerly contained the "Holy Coat" at Trèves. It is preserved in the treasury of the cathedral, and the subject carved upon it is supposed to represent the bringing of the relic to the city by St. Helena, and to be of seventh-century workmanship. The casket was lost at the Revolution, and this piece seems to have reappeared at Antwerp about 1830. It is sometimes quoted as evidence in support of the genuineness of the "Holy Coat" itself.

A curious piece of Byzantine work of the ninth century is in the Basilewski collection. It is an eland's antler with its branching points, carved with various religious subjects. The practical use, if it had any, is unknown.

The religious art of Russia falls naturally under consideration with that of the great empire of the east. But unfortunately the number of examples of ivory carving which we have in the museums and collections of Europe is extremely small, nor would it appear that in Russia itself are many more to be found. We must include also in this scarcity all work of this material belonging to the Greek church since its formation. What there is consists almost entirely of a few specimens of the peculiar liturgical accessory known as a *panagia*, some heads of pastoral staffs, and a small number of plaques.

The question of Russian art generally, and how far it may be considered a national and original style, is not one that we need go into here. In appreciating its manifestation, as exemplified in relation to works of a religious character, illustrated by the few examples we may be able to bring forward, we must bear in mind that from her connection with Constantinople at the time when she accepted Christianity from the Church

which had already been established there seven centuries previously, Russia could hardly have avoided borrowing largely, or, rather, frankly adopting the hieratism which she found ready to hand. Further than this, the change from paganism to Christianity was accomplished, as it were, at a blow. It was not a process of gradual growth, but immediate and striking. The eastern church was then at the zenith of its splendour. The envoys sent by Vladimir to Constantinople to report upon the religion which he had decided to adopt were no doubt dazzled by the magnificence of the ceremonial, and by the grandeur of the adornments of the churches. It was necessary for them to provide at once similar things for the introduction into their own country of corresponding rites. It was naturally to Byzantium that they would turn for their form and ornament. In the earliest times, no doubt, a profusion of objects for the services of religion would have been imported direct; but, as time went on, Russian artists would begin working for themselves, and while cheerfully following, almost with a servile imitation, Byzantine likings, which accorded so well with their own tastes and proclivities, they would also have freely added those touches of their own Sclavonic genius which give to Russian art a distinctive character of its own.

It may be remembered also that the art of Russia has always been strongly influenced by the oriental taste which arose from its geographical position, and that India and Persia have contributed largely to its development, and to the formation of its style and character. Byzantium herself had been to the same sources, but Russia, if inspired by her, searched also on her own account, with the result that we find in the ornament, in which her art delights, much evidence of adaptation taken direct, and not filtered through other sources. Once settled upon, the conservatism of the Russian type, in religious art, is remarkable. It

followed, in principle, the Byzantine school of Mount Athos, but while accepting the principles, it did not confine itself absolutely to the Greek school. There are many types and subjects which are proper to Russian religious art, but which are quite unknown to the Greeks. Such are certain images, and the stereotyped methods of representing them ; for instance, those of St. Nicholas the warrior, SS. Cyrillus and Methodius, St. Sergius, very many types of the Virgin, and others. Thus it is that although, of course, there is ever present in Russian religious art the family likeness in the forms and spirit, to which Russia has adhered so tenaciously from their introduction till the present day, though the same models have been copied with precision year after year, century after century, yet for all this there are sufficient differences which afford means by which we are seldom inclined to hesitate, but are able to say, in a moment, that is Russian. In this we are, of course, often helped by the Sclavonic inscriptions, the interlaced character of which is highly decorative and peculiar.

A characteristic of Russian iconography is the exaggerated austere aspect of the principal persons. The faces are lean, wild, and even savage ; their limbs emaciated, their garments few ; the same small, thin-cut eyes, long lank hair, and long and scanty beard ; the same sinewy limbs, the abnormally rounded skull, the recurring, upraised, bony hand, with fingers symbolically divided. The peculiarity of this last symbolical division, as the outward testimony of a great dogmatic distinction, is of the highest importance. Certain Greek saints are invariably distinguished by a small fold of particular form, or an opening in the robe above and below the knee. Although, therefore, Byzantine principles were freely adopted, and in the main strictly adhered to, we have many things to guide us in discriminating. In course of time modifications were introduced, but the

immobility of type has been so much preserved that it is sometimes extremely difficult to assign a date.

If we are unable to produce many examples of carvings in ivory, there are a few remarkable pieces as good of their kind as if we had picked them out of a large number of others, and they make the scarcity the more surprising, as they would appear to show a cultivation of the art of working in this material which would lead to great excellence. But even at the present day, the producers of the immense number of religious objects made in the monasteries—in the same way as, no doubt, such things were produced in the west in the middle ages—seem to prefer working in soft woods, often on a most minute scale. Carved pictures of this kind, frequently cut with an ordinary knife, abound, and though all made by hand, they scarcely vary in a single detail. For centuries the same rigid archaism has been preserved, the artist following in the most accurate manner the traditions that have been handed down to him.

The two pieces of a *panagia* in the Christian museum of the Vatican, probably of the seventeenth century, are typical examples. A *panagia* is a peculiar ornament or sacred vessel, in its usual form a kind of large circular locket, or saucer-shaped receptacle, made of two concave pieces, opening upon a hinge. It is used for conveying the consecrated bread to the sick, and for this purpose is suspended from the neck of the priest. One half of the example in the Vatican is completely filled with scenes from the New Testament most minutely carved, and yet with great skill of execution, so that even the expression on the faces is distinctly visible. They are contained in one large circle— in the centre of which are represented the three angels sitting at meat with Abraham, the usual manner of symbolising the Trinity—and in ten smaller circles surrounding it. Round the rim runs a Sclavonic inscription, but not treated in the usual decorative manner.

1

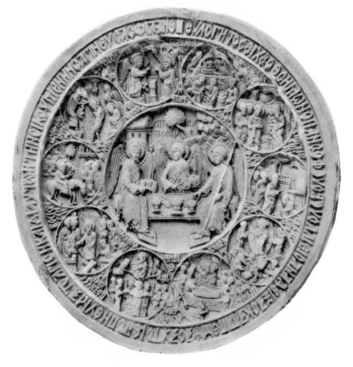

2

Plate 24. 1. TABLET. RUSSIAN 2. PANAGIA. RUSSIAN

SIXTEENTH CENTURY SIXTEENTH CENTURY

A plaque or tablet in the Soane Museum, Lincoln's Inn, is an extraordinary example of microscopic work. The subject is the glorification of the Virgin; she is seated on a throne, with the Holy Child on her lap. Around her are angels, and beneath a vast concourse of saints. In the background is a Russian church with five cupolas, flanked by very conventional trees. The little figures, scarcely more than an inch high, are sculptured with the greatest care, so that even the patterns and distinctions in the draperies are easily to be made out. The piece is, perhaps, of the sixteenth century. It is not easy to assign a date to such objects, or to distinguish, always, Russian from the work of other portions of the Greek Church. There are, however, certain indications that will help us; for instance, the symbolism of the Trinity, the forms and number of the cupolas, the attributes and nationality of saints, and Sclavonic instead of Greek inscriptions. There is one small plaque of interest at South Kensington, but in the British Museum nothing.

It will be convenient to refer here to the two thrones in the Kremlin at Moscow, although an entirely Russian origin cannot be claimed for either of them. The first is the ivory throne of Ivan III., and is said to have been brought from Constantinople in 1472 by the empress Sophia Paleologus, who, by her marriage with Ivan III., united the coats-of-arms of Byzantium and Russia. There is a certain resemblance between this throne and that known as the chair of St. Peter at Rome. The general form is the same, and so is the manner in which the ivory plaques and their borderings are placed. In a kind of way, also, many of the plaques recall those on the chair of St. Peter, and similar works of the class, such as the Veroli casket at Kensington. But here the identity ends. The figures are very poor, as if copied by an inexperienced artist from good models. Some of the plaques are additions of the sixteenth or seventeenth

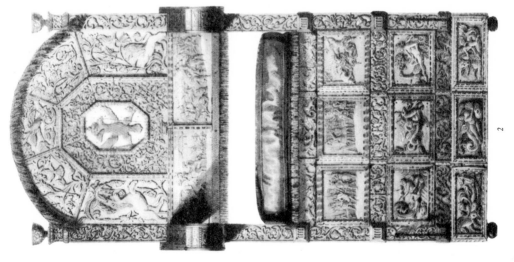

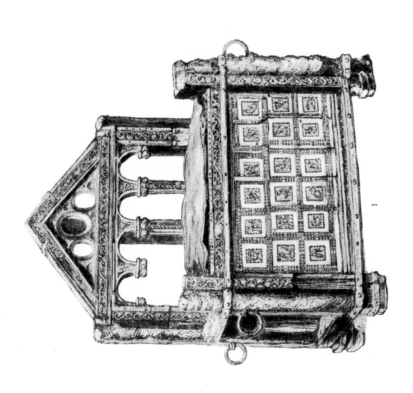

2. THRONE OF IVAN III

Plate 25. 1. CHAIR OF S. PETER, AT ROME

century, of quite a different character, and very bad work. On the whole, however, we may gather a good idea of the very fine effect which a throne of this description could be made to give. The second throne is a magnificent piece of work completely covered with gold ornament set with stones, of charming workmanship, having on the front, on the sides and back, and below the seat, plaques of ivory, the work evidently of Hindoo artists (the plaque on the front representing, amongst interlaced work, an elephant hunt). It was probably made in Persia for the Tsar Alexis about the year 1660.

The ivory chair of St. Peter, to which reference has been made in connection with the above, is preserved in a magnificent shrine in the Basilica. It is of a massive square shape, with a triangular pediment on the back, the whole surface covered with ivory plaques bordered with arabesque carvings of scroll patterns with foliage and animals. The plaques which correspond with Byzantine caskets of the eleventh century are carved with the labours of Hercules, and with representations of six of the constellations — Pisces, Hydra, Scorpio, Lepus, Eridanus, and Cetus. Plaques of a similar character, of the tenth or eleventh century, are in the museum of Arezzo, and at other places. The probability is that the chair was put together from a collection of such plaques, and tablets from caskets, and the fine foliated borders of the period added.

Important as are the ivories of the Byzantine epochs in the history of art down to at least the twelfth century, it would require more than a cursory glance, a rapid survey, to exhaust the lessons which may be derived from them. Regretfully we pass by instance after instance in other divisions of art when the connection, even though remote, tempts us to refer to them. But the history of Byzantine art in general is a vast subject, and of far-reaching extent, to which the ablest hands

have devoted themselves. In the references which have
been made it has been necessary, on the one hand, to
avoid too frequent and detailed descriptions, which
are, perhaps, more proper in a catalogue *raisonné;* on
the other hand, we cannot leave entirely on one side
the analogies and connections with such important
things as the monuments of the goldsmith's art, the
architecture, enamels, paintings, miniatures, frescoes,
and other things which are often so striking as to com-
pel attention to be drawn to them. In the selection of
examples more can hardly be done, within reasonable
limits, than to choose the most beautiful ; but besides
these there are others which are typical and possess
their peculiar interest and attraction, even if at times
the art may be of the rudest, the forms archaic, and the
feeling almost grotesque in its quaintness and con-
ventionality.

Those who are already familiar with the ivory
carving of pre-gothic times will remark that our refer-
ences to Byzantine art in the development known as
the Rhenish, Carlovingian, or Romanesque type, have
been few, and our treatment rather summary. But this
is not because it is unimportant. On the contrary, it
has special characteristics and a special relation to the
spread of the system in the west which call for notice
at greater length than can here be devoted to it. The
influence of Byzantium permeated throughout the
whole of Europe, and its art dominated the Christian
world. There resulted a general similarity, so much
so that almost any given example might have been
imagined and produced as well in one country as in
another. The Carlovingian and Rhenish developments
present, however, certain marked characteristics. We
find in them, for instance, a fondness for the fine bold
treatment of scroll and foliage work interspersed with
animals and birds of a spirited type, often within a
square border. We have the double aureola which

surrounds our Saviour, the lower part a circle forming a seat on which He sits, with various twisted and pearled decoration. He himself has a cruciferous nimbus, and is sometimes youthful, sometimes older with a short beard. The representations of the crucifixion are remarkable for the elaboration of the details, and for the surrounding figures. The instruments of the passion —the sponge, the lance, the nails—appear frequently, and the scene is accompanied by emblems of conventional or allegorical type, such as those of earth and water, the Jordan or the ocean, indicated by imaginative aquatic creatures and in several other ways; we have the sun and moon, the church and the synagogue. There is a peculiar method, which is frequent, of representing the baptism of Christ, in which our Lord stands up to the middle in water represented by wavy lines; inscriptions in Roman characters on various parts of the composition often occur; in some Rhenish ivories the backgrounds are in open-cut squares, the physiognomies grave and somewhat exaggerated in size, the hair in little clusters of knobs; there is a characteristic treatment of the wings of angels, and there is the very conventional method of representing such scenes as the Nativity, to which our attention has already been called. Then, again, we have the curious decoration of the draperies by means of punctures or pearlings in the lines of the folds, and there are details of great interest with regard to ritual, ceremonies, and vestments. Finally we have the Celtic ornament consisting of intricate interlacements in calligraphic style or mingled with monstrous animals having their tails prolonged and spirally twisted, which passed from Ireland to St. Gall, and is very apparent throughout France and Germany from the ninth to the twelfth century. A good example of this is the small Carlovingian tenth-century reliquary or casket, No. 253'67, in the Kensington Museum.

CHAPTER VII

ECCLESIASTICAL DIPTYCHS: PALIMPSESTS

WE owe the preservation of many plaques and diptychs, both consular and classical of all kinds, as well, perhaps, of other tablets of ivory, whether secular or religious, to a remarkable use to which they were put in the services of the Church. This use, which began in very early times, continued for several centuries. Even after the liturgical custom, which will presently be more fully alluded to, had fallen into disuse, these decorated pieces of ivory continued to be kept in the treasuries of the great cathedrals. Many of them are still so preserved, others have from various circumstances, unlikely perhaps to occur again, found their way into the museums and private collections of the world.

It has been shown that in their origin it was the fashion to present the consular diptychs, and the other diptychs in the form of writing tablets, to eminent persons in the state, to senators, governors of provinces, and to distinguished people. In course of time, and after the introduction of Christianity, bishops and the churches themselves naturally participated in these gifts, and it was not long before they were adapted to a liturgical requirement, for which, from their beauty and the appropriateness of their original use as records, they seemed to be eminently fitted. Transferred to pious uses, there does not appear to have been much hesita-

tion, as a rule, to using them in their pristine condition, however incongruous the pagan subjects or figures might appear. On the contrary, they were looked upon as legitimate spoil, as trophies illustrating the triumph of Christianity over paganism.

Amongst the crowd of converts in the early days of the Church, there would have been distinguished people who would have hastened to contribute these splendid objects to be applied to the service of God. A very common application would be for binding and adorning the gospels and other sacred books, or they would have been used for covering the sides of caskets and receptacles for relics. Then, again, the classical pyxes which have come down to us were convenient for keeping the unconsecrated wafers, and cylindrical boxes of this character are so used to the present day. *Situlæ* would naturally become holy-water buckets, and so on. But for this practice, and from such things thus acquiring a sacred character and not lightly to be parted with, it is likely that many more objects of comparatively small intrinsic value would have been lost or destroyed than has been the case: nor, indeed, should we perhaps still possess such a treasure as the magnificent antique sardonyx cameo in Vienna, the "Gemma Augustea." But the most important purpose to which these diptychs were applied was a liturgical one, that of furnishing a kind of memorandum of the living and of the dead, to be used at the most solemn portion of the canon of the mass, the ivory tablets themselves being placed upon the altar in somewhat the same way as what are known as altar cards, containing some parts of the service which it is not convenient to read direct from the missal, are now used. The diptychs kept even their ancient name. They were called holy diptychs, mystical diptychs, diptychs of the living and of the dead, and are commonly known by these terms in a liturgical sense. We thus see illustrated once more how the study of

ivory carvings leads us to consider almost every practice of daily social and religious life.

The use of the diptych in the service of the Church can be traced to the very earliest ages after the establishment of Christianity. When the consular and classical ones were transformed, the inscriptions within of the titles and prowess of the consuls, of the family records and marriage contracts, gave way to those of the commemoration of saints and martyrs, benefactors of the Church, or of the dead who were to be remembered at the sacrifice of the mass. Sometimes these new records were not inscribed as before on the wax, but written in ink, or even cut in and engraved on the ivory itself. It is certain that from the earliest times they contained lists of the dignitaries and benefactors of the Church, for whom the priest was never to omit to offer up prayers each time the holy sacrifice was offered.

From ancient liturgies we find that the deacon rehearsed aloud this catalogue. We learn from St. Dionysius, in his treatise on the ecclesiastical hierarchy —and whatever may be the disputed date of his writings, the general consensus of opinion hardly puts them later than the fourth century—that immediately after the kiss of peace is given, then is made the mystic recitation of the sacred tablets, and we know that in St. Chrysostom's time the custom was fully established. It would appear that at first the names were read out by the deacon from the ambo, or raised platform, in early Christian churches from which announcements were made; later the deacon or subdeacon reminded the priest of them at the altar in a low voice; and later still the diptychs themselves were placed on the altar. In the liturgy of St. Mark (without supposing that this is rightly named, we may be sure that, with other early liturgies, it contains considerably more ancient elements) the deacon reads the diptychs of the dead, and the priest then, bowing down, prays for the souls of these departed ones. Again, in

the liturgy of St. Chrysostom, in the fourth century, the deacon incenses the altar and the diptychs, and mentions those for whom it is intended to pray, both living and dead. So also in the Coptic liturgy and in the Alexandrian, called the liturgy of St. Basil, we find the use of the diptychs and, as in the others, the manner of using them and the prayers attached to them. The names of the martyrs whose relics were deposited in a church were inscribed on their own particular diptychs, and those who had acquired a reputation for sanctity were also honoured in the same way. It was equivalent to canonisation, and from this practice it is supposed, though the fact is disputed by some, we have the very term itself, for the names were read out at that most solemn part of the mass called the canon. In later times the names of the reigning emperor and empress, the pope, the bishop of the Church, and others were inscribed, and we have an example in the diptych of the consul Anastasius at Liège, whereon a list of eight of the bishops of Tongres, from 840 to 956, is written in ink. A similar instance occurs in the diptych of Bourges, in the Paris Library, and another in the cathedral at Novara, on the diptych of an unknown consul, on the inside of which is inscribed a list of the bishops of Novara, brought down to so late a date as 1170 A.D. Finally, other diptychs were inscribed with a register of the recently baptised at a time when that rite was more significant than now, and we may thus distinguish four classes, viz. the names of the newly baptised, those of sovereigns, bishops, and benefactors, those who died in the faith, and the authorised roll of saints and martyrs. If, as has been stated, the inscription of the names of holy personages was equivalent to canonisation, on the other hand, as regards the living, to be erased was a measure which meant a virtual denunciation as heretics to be no longer considered as belonging to the Church, in short, a sentence of excommunication.

Probably also the names of the sick and of those in trouble and to be prayed for were inscribed on the diptychs, and we are thus connected in an interesting manner with the announcements made at the present time usually before the sermon.

Yet another important value is attached to them. Besides the secular ivories adapted to the service of the Church, many others would have been made, and decorated with representations of religious subjects. In this way they would have aroused devotion and imparted instruction to the faithful. In the old Ambrosian rite of Milan the following instructions are given for their use: "The lesson ended, a scholar, vested in a surplice, takes the ivory tablets from the altar or the ambo, and ascends the pulpit." And again: "When the deacon chants the Alleluia, the key-bearer for the week hands the ivory tablets to him at the exit of the choir."

Not many of the later inscriptions on diptychs are now legible, being written in ink. The most interesting one we have is that of the Consul Clementinus (513 A.D.) in the Liverpool Museum. It is long, and in Greek, deeply cut within each leaf, and is usually taken to be of the eighth century. The purport of the inscription requires the people to be devout, and recites the names of those to be prayed for, amongst them those of the donors, "John, the least priest of the dwelling of the holy Agatha," and "Andreas Machera, servant of the Lord." Amongst other examples of secular plaques adapted to the service of the church are those adorning the silver pulpit of the cathedral of Aix-la-Chapelle. They are six in number, Roman, of the fourth or fifth century. The subjects are entirely mythological: hunting scenes in which an emperor figures, bacchanalian groups, nymphs and satyrs, and the like.

Another interesting detail connected with diptychs and ivories of the kind concerns those known as palimp-

sests, that is to say, where the original designs on an ivory plaque have been, at a subsequent period, partly or entirely transformed by removing them by means of planing or cutting away and substituting others. The term is a well-known one, applied also in such cases as manuscripts, monumental brasses, and the like. A notice of a few examples of a not uncommon practice will suffice. On the upper part of one leaf of a consular diptych in the Kensington Museum the raised parts have been entirely planed down. Enough, however, is left to distinguish the usual figure of a consul. The back is carved with a Russo-Byzantine figure of the Saviour of the thirteenth century. The lower part of the same diptych has been similarly treated, and is carved on the back with corresponding scenes of the Passion. It is now in the British Museum. For a consular diptych it was of unusually small dimensions. Again, on a single leaf of a bone diptych in the Liverpool Museum the original legend has been cut away, and an inscription substituted relating to a certain Bishop Baldricus. The name occurs not unfrequently amongst bishops of the tenth to twelfth centuries. The consular diptych has already been alluded to as ascribed to Paulus Probus. There might have been more certainty had the original inscription been allowed to remain.

An important example of a palimpsest, because of the controversy it has excited, is that of the two leaves of a consular diptych now forming the cover of a gradual of St. Gregory in the treasury of the cathedral of Monza. On each leaf the consul is represented in the usual manner, on the one seated, on the other standing. But over the two capitals of one leaf is inscribed "SCS GRECᵒR," on those of the other "DAVID REX." There are other alterations and differences, and the head of the consul on one leaf has been tonsured. The question has arisen whether these tablets are consular diptychs

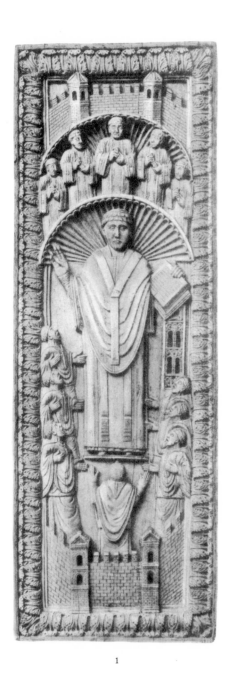

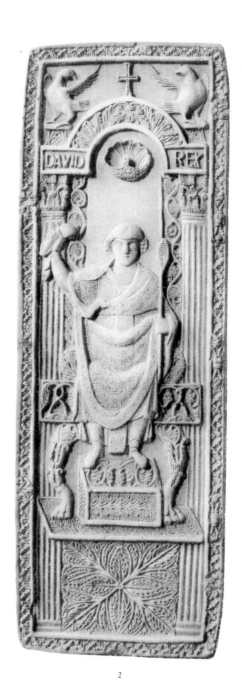

1

2

Plate 26. 1. COVER OF FRANKFURT LECTIONARY

2. PALIMPSEST CONSULAR DIPTYCH

palimpsestically treated, or whether they were originally made as they are now, and intended to represent an ecclesiastical personage. Now it is true that the ornamentation is not in the style of any known consular ivory, and in addition the floral designs are very poor indeed ; but though the costume of the clergy in early times was undoubtedly derived from the ordinary dress of the Roman empire, and no traces of distinct vestments are to be found earlier than—at the earliest—the sixth century, it is hardly likely that we are to see in these figures, as some do, the ancient *pœnula* transformed into the chasuble by a modification of the shape. The simplest explanation would seem to be that the artist of the seventh century happened to come across an unfinished consular diptych on which the figure of the consul only, or perhaps, also, the columns and arches, had been completed. He very easily effected the tonsure on one head (it may be remarked that the tonsure was first made obligatory at the Council of Toledo, 633 A.D., and was practically unknown earlier), added a cross to the top of the sceptre, and in view of its destined purpose carved the inscriptions before noted. The rest of the extremely bad decoration would have then been added. St. Gregory (544–604 A.D.) was a contemporary of Queen Theodolinda, by whom the treasure at Monza, of which these plaques form part, was founded.

It is somewhat remarkable that through the long series of ivories for religious purposes which have been referred to, and of those continuing onwards to later times, which we shall presently note in greater detail, we shall find, up to the sixteenth century, very few instances indeed of the representation of any saints other than those of biblical history. The subjects are confined almost entirely to Old Testament scenes and character, and to the life of our Lord and His mother, the apostles and disciples, and other personages directly connected with the Holy Scriptures. And this although

there is no such restraint, during the later period at least, in the statuary work of churches and shrines, or in illuminated manuscripts. In the canon of the mass certain saints—SS. Cosmas and Damian, St. Clement, St. Linas, and others—are mentioned, and one would almost expect to find diptychs representing them specially prepared, but even these saints are hardly to be met with. Again, there is a notable absence of the representation of ecclesiastical characters, such as popes, bishops, priests, monks, and nuns. Nor do we find them in objects for secular purposes, such as caskets and mirror cases, of which in the fourteenth century especially there are numerous examples, though one might imagine that they would readily suggest themselves, even if in a mirthful way, as, for instance, we see them on gargoyles, or in the misereres of choir stalls. We must regret the absence of such contemporary pictures, and the loss of the assistance we should gain from them in the illustration of ecclesiastical costume and sacred rites.

The examples of representations of saints which we do possess are so few that it may be of interest to enumerate them. St. Mennas, with his camels, appears on a pyx as early as the sixth to the eighth century (certainly the earliest known representation in ivory of events in the life of a saint), and again in the ninth. In the ninth we have St. Gall, and, on a Rhenish Byzantine diptych, St. Gregory with the dove. SS. Nazarius, Nicasius, Remigius, Gereon, and Victor are represented once each in the tenth century, and we have also SS. Stephen, Vitus, Modestus, and Cassian. We find SS. Cosmas and Damian, SS. John Chrysostom, Nicolaus, Pantaleēmon, Nerus, Achilleus Pancratius, Justina, Julia, Daria and Basil in the eleventh century, and St. Gregory more than once. In the twelfth, SS. Filibertus, Agnathus, Rusticus, Denis, Eleutherus, and the four doctors of the Church—

SS. Gregory, Ambrose, Augustine, and Jerome. We
have also on the great book cover of Italian work-
manship in the Cluny Museum SS. Vitalis, Valeria,
Lawrence, Pantaleēmon, Gregory, Benedict, Herma-
goras, and Nicolas. St. Francis of Assisi preaching to
the birds and fishes appears on an ivory plaque of the
thirteenth century in the Pesth National Museum. It
may be remarked that he died in 1226, and was canonised
by Pope Gregory IX. in 1230. We shall also notice,
later on, a casket of the thirteenth century with a paint-
ing of St. Felix. St. George with the dragon is found
fairly often in the fourteenth century. We have also SS.
Denis, Christopher, Margaret, Eustace, and Laurence,
and St. James of Compostella is represented more than
once. SS. Agnes, Catherine, Martin, Barbara, Margaret,
Sebastian, Antony, and Francis are found in the fifteenth
century, but in almost solitary instances only. Many
of the saints which have just been enumerated are not,
it will be observed, very familiar to us at the present
day, and it is curious that, with the possible exception
of the book cover in the Cluny Museum, the great
founder of the Benedictine order is conspicuous for
absence in our ivory carvings. Finally, we know no
instance in ivory of a representation of St. Veronica
and the *vera icon*. The list may not be an exhaustive
one, but, in any case, examples are uncommon and
seldom occur more than once or twice.

The subject of ivory carvings which illustrate the
ritual is of considerable interest, and the following are
among the few examples that we have. On the cover
of the *Sacramentaire de Metz* in the Paris Library are
nine ivory plaques of the ninth century, on six of which
are illustrations of episcopal ceremonials. They are the
ordination of a deacon by the bishop, the blessing of
the oils, in which the acolytes wear silken veils covering
their hands; the bishop anointing a child in swaddling
clothes which is held before him, an attendant with the

bishop's pastoral staff, and another carrying the chrism; the blessing of the font, an acolyte holding a long candle which the bishop will presently dip into the water; the consecration of a church, which is being sprinkled with holy water by the bishop, two priests carrying the relics on a kind of litter; and two deacons immersing a child in the font, the bishop standing near by beneath a canopy. On the back of the cover are nine more plaques representing other episcopal ceremonies. Two other plaques of the tenth century in the Louvre represent an archbishop celebrating mass, surrounded by many priests, thurifers, acolytes, and other attendants. On the cover of a lectionary of the eleventh century in the British Museum an archbishop is represented vested in chasuble and pall, holding a *tau* in one hand: two small figures kneel and kiss his feet. It is of walrus ivory. In the public library at Frankfurt is a highly interesting leaf of a diptych of the ninth century. A tonsured priest in a very full chasuble with a border resembling a pallium (perhaps the *rationale* or *superhumeral*) stands behind an altar facing the spectator. On the altar are a two-handled chalice, a paten on which are three altar breads of a peculiar pearl shape, an open and a closed book, and two candles. From the position of the hands, it is the moment just before the consecration of the wine. In the open book the words beginning the canon of the mass can be plainly read. There are attendants and many other details of great interest (figured in Passavant, *Archiv.*, i. pl. 1). A similar plaque, with a different subject, probably the other half of the diptych, was in the Spitzer collection. On a German diptych of the ninth century in the Berlin Library an archiepiscopal figure wearing a chasuble and pallium, the head tonsured, is represented. On a late Carlovingian diptych of the tenth century St. Nicasius is in episcopal vestments, attended by two priests wearing long maniples. On a small box, German, of the

[183]

tenth to twelfth century, in the Kensington Museum,
we have the legend of some saint, from the three scenes
in which we may gather details concerning the ceremonies
of the mass and monastic costumes. There are a few
other instances, such as a bishop in a low mitre in the
volute of a pastoral staff of the thirteenth century, and
some isolated figures, but not many. There are also
the bishops in the Lewis chessmen, which will be
noticed separately.

CHAPTER VIII

RELIGIOUS ART IN IVORY OF THE THIRTEENTH, FOURTEENTH, AND FIFTEENTH CENTURIES

IN the ivory carvings of the three centuries with which it is proposed principally to deal in this chapter we shall find a class of work which in feeling and in general character differs very considerably from that of the preceding periods since the introduction of Christianity. Constantinople had fallen, sacked and almost destroyed by the French and Venetians, and Byzantine artists no longer continued to influence, or were even employed in, the production of works of art for the western nations. The rise of the pointed, or Gothic, style in architecture marks the epoch of a great and lasting change. As in the art of the goldsmith and bronze-founder, so also in our ivory carvings will the influence of architectural lines and feeling be apparent. The forms, the groupings, the surroundings became brighter, more delicate, more cheerful—if the term may be applied—the composition more studied and scientific. The artist goes for models for his figures to the subjects which he has ready to hand in his immediate surroundings—we see the people which he saw, the character and joyousness of the period expressed in the faces and attitudes ; and the draperies are in the fashion of the time, instead of as formerly, when for centuries the stiff, emaciated limbs, the calm, unbending solemnity of feature, the stereotyped system of

narrow parallel folds had scarcely varied since Byzantine taste and feeling had almost dogmatically imposed them. Not that we shall lose sight altogether of traditionary styles and peculiarities. They will crop up now and again, for the spirit from which they were evolved would not easily die out, and there remained more than reverence—there was love for, and attachment to, the usefulness of such symbolic methods.

It is not easy to say when the style which, in our ivories, we call Gothic, actually had its commencement. The Romanesque was persisted in until well into the thirteenth century. Naturally, no transitions are sudden. Artists are sure to work for many years in an old system before it completely disappears and a new one takes its place. In the architectural tendencies which characterise the Gothic style the artist learnt to be more precise and more particular in the matter of perspective. We no longer find different stories placed one above the other in the same picture, or buildings put together like toy bricks and tumbling about in all directions. Every little scene or grouping is naturally arranged.

The three centuries which will now occupy our attention—the thirteenth, fourteenth, and fifteenth, and especially the fourteenth—will find us in full *moyen âge*, in a world in which religion was supreme and governed all; in an age of piety and of Christian chivalry; at a period of the world's art when there was practically but one form, and that the religious one, when the workmen were the artists of the cloister, and the monastery enclosure was the centre from which civilisation proceeded and was directed. The state of England, as well as the rest of Christendom in those times, was, so far as religious influence is concerned, not very different from that which has continued in Russia to the present day. A monastery was the centre and most important part of a great town. It was not an isolated building, surrounded, perhaps, by a park,

but often a vast walled-in enclosure within which were scattered churches, shrines, refectories, workshops, and detached blocks of buildings. The monastery, in many cases, possessed and governed the greater part of the neighbouring town, and was responsible for many of the industries which were carried on. Patiently and diligently the monk of those days sat at his accustomed daily employment in the preparation of manuscripts, and in their subsequent adornment with illuminations and miniatures; and from similar workshops, we imagine, must have issued the exquisite examples of ivory carvings in the form of diptychs, triptychs, and other objects of devotional use. From no other source could one expect to find bestowed upon them that loving care and devotion which the mind of an artist, whose every thought was concentrated on their conception and production, was able to give to them.

In general, and especially from the tenth to the twelfth century, the art of sculpture in the west had fallen very low. It is to the ivory carvings of these periods that we have to look for redeeming features of a deplorable condition of things resulting from a debased imitation of classic styles hardly tempered by an infusion of Byzantine regularity or mannerisms. In Italy, besides some noble work of the Pisan school, we find little else that can be referred to until we come to the great bronze gates of Ghiberti, which practically occupied in their making the whole of the fifteenth century. In the fifteenth century, too, we shall find the names of Donatello and his school, of Luca della Robbia and Verrocchio. We are preparing for the renaissance, for Michael Angelo, Cellini, and those whose names will loom large in the history of sculpture in the succeeding century, when the art of ivory carving in its turn will show evidence of the commencement of a period of decline and decay. It will be useful to connect these periods with the general history of the time; from the days of Magna

Charta, in the early part of the thirteenth century, through the reigns of Henry III. and of the first Edwards, through the wars with France, the battles of Poictiers and Agincourt, past the troublous times of the wars of the Roses, in the reigns of the sixth and seventh Henrys and of Richard III., and to the end of the fifteenth century and the accession of Henry VIII.

In the earlier days, sculpture, generally, had, as has been pointed out, come to a low and degraded condition; on the other hand, in painting there were Cimabue, Giotto, and Van Eyck, and, at the end of the period, Raphael, Dürer, and Perugino. Nor were these days without troublous times for the Church. The interdict under which England lay for six years under King John in the beginning of the thirteenth century, and with which France was afflicted in the fourteenth, must surely have had some effect on the production and use of works of art for ecclesiastical and devotional purposes. We shall find that ivory was very largely used for the decoration of ecclesiastical furniture, and for the making of all sorts of objects used in the liturgical services of the Church, and for private devotional purposes. There were diptychs and triptychs, retables or altar-pieces, pastoral staffs or crosiers, shrines, statuettes, caskets, book covers, liturgical combs, portable altars, holy-water buckets, and a number of lesser articles. All these are interesting, not only for their artistic value, but often, besides this, because of the uses to which they were put, and on account of the incidental associations attached to the subjects represented upon them. Not only, however, were diptychs and shrines, statuettes, and the like required for the public services of religion. The age was a devotional one, and the demand was very great for private devotional purposes. As a consequence, probably, of the repeated travels of men to the East during the crusades, such portable aids to devotion were made in large quantities. Religious objects of

one kind or another were always carried on the person, scarcely a room, certainly no sleeping apartment, was without its shrine or triptych, the shutters of which would be closed as an ordinary rule, and opened at the moment of prayers. They formed also elegant presents, and often, no doubt, answered to the little odds and ends which are to be found nowadays in ladies' drawing-rooms. We shall see presently in the cases of these diptychs and triptychs that they had their stories to tell, their instruction to give. They were meant to be examined, and if, as is probable, they were made to suit all tastes, and were adapted for people of small as well as large means, and therefore perhaps not always equally perfect in execution, still of those which have come down to us there is scarcely one which will not claim our admiration, while of many it may be said that sculpture has produced nothing better since the days of Constantine. At no time also would fine ivory have been anything but a somewhat costly luxury, and therefore it was hardly likely to have been used except for work of a high character and by the best artists.

Of the three centuries with which we shall be most particularly concerned it is remarkable that the fourteenth furnishes us with a very large majority of the finer works to be found in our museums and private collections, and of these nearly all are of French origin. At the same time we have in the thirteenth, and again in the fifteenth, specimens which cannot be surpassed, and it is reasonable to suppose that many more have been lost or have suffered destruction. We find in inventories and other documents of the fourteenth, fifteenth, and sixteenth centuries frequent references to religious objects in ivory preserved in churches, amongst the effects of princely and noble personages, or bequeathed by will. In the privy purse expenses of Elizabeth of York (1502) there is mention of a "chest of ivory with the Passion of our Lord thereon." Instances occur amongst the inventories of cathedrals

and churches also, as, for example, "a box of yvory with xi relics therein" in the church of St. Mary Outwich (1518), or a "lytill yvory cofyr with relekys" belonging to St. Mary Hill, London. And in the inventory of the treasure belonging to St. Paul's in 1295 "a broken ivory pyx: also, two boxes of ivory." And, again, at Durham in 1383, "an ivory casket containing a vestment of S. John the Baptist," "an ivory coffer containing a robe of S. Cuthbert," and "other ivory caskets with divers relics."

Perhaps the most interesting of many that might be referred to is the inventory of the extraordinarily rich treasure of the cathedral of Lincoln made in the fifteenth century, and again taken under Henry VIII., for his own unworthy purposes, in 1536. The earlier inventory is in Latin, but we shall quote from the later English one, making, when necessary, a reference to the first. Amongst the multitude of magnificent objects in gold and silver and jewels, adornments of altars and shrines, and sets of splendid vestments, we find :—

"In primis, one tabernacle of Ivery wt ij leves gymelles and loke of sylver contenynge the coronacion of owr lady. Item, a tabernacle of Every stondyng opon iiij feete wt ij leves wt one Image of owr lady yn the mydle and the salutacion of owr lady yn one leve and the Nativitie of owr lady yn the other.

"Item, a lytyll Tabernacle of Every lakyng a glasse.

"Item, a grett chyste of Every wt Images rownd aboute wt one handle of copor havyng a Jewell typped at every end wt sylver contenyng many Relykes. . . ." (Probably very large, as a long list of the contents was given in the previous inventory.)

"Item a chiste of sypers" (cypress) "bound wt copor ornate wt peces of Every contenynge dyverse Relykes.

"Item a lytyll chiste of Every bouñd wt sylver contenyng the Relikes of Seynt Remyg" (St. Remigius, bishop of Lincoln).

"Item, other iij chistes of Every bouñd wt copor.

"Item a chiste of Every full of Images havyng a loke & claspes of sylver of the gyft of dame Elizabeth Vahons.

"Item a nother rownd pyxe of Every bound wt copor contenyng the relikes of the sepulcr of owr lord and of the cheyn wt the wyche saynt Kateryn bound the devell.

"Item a pyxe of Every havyng a Rynge of sylver & no loke.

"Item one other pyxe lyke the sonne of Every bound wt sylver wt

one loke and one broken claspe of sylver contenyng parte of the hede of one of the xj ml virgins.

"Item a pyxe of Every bound above & be neygh wt sylver and gylte havyng a squared steple yn the topp wt a ryng & a rose and a scochon yn the bothom havyng wt yn. . . .

" Item iij lytyll crosses and one of Every ornate wt playtes of sylver."

The inventory of 1548 refers to nearly all the same objects. In the year 1553, when another was taken, three only of the pyxes appear, and two of the tabernacles; but they are all struck out and do not figure in subsequent lists. The term "tabernacle," no doubt, generally means a reliquary of some kind, though we may remember that the expression "tabernacle work" was used to denote small carving of the diptych or triptych kind. Such, probably, were the "tabernacles with leves" in the first entry above. But what could mean the tabernacle "lakyng a glass"?

Such lists are interesting, showing us, amongst other things, how ivory caskets were mounted in silver and silver gilt and copper, and we may form an idea that they were magnificent. Not one example of such mountings has come down to us. Probably numbers of the plaques that we now find in collections are simply detached portions of once splendid reliquaries.

Of the terrible destruction of religious property at the time of the Reformation in England, parish registers and churchwardens' accounts give us the history pretty plainly, especially in the twenty years from 1550 to 1570. One record of the county of Lincoln sums up the enumeration as "the rest of the trash and tromperie wch apertaynid to the popish service." While altar stones were broken and defaced, turned into cistern bottoms, set into fire hearths, or used for mending walls, or laid in the highways to "sarve as bridges for sheepe and cattall to go on," one wonders to what secular uses ivory coffers, caskets, and figures, holy-water buckets and the rest could have been put. They must have abounded, if not

of English, at any rate of foreign workmanship; but our greatest regret will be for the loss of examples of English work, which, though instances are now but few indeed, we can scarcely doubt must have been fairly numerous in cathedral and abbey treasuries. The amount of riches in the treasuries of the cathedrals may be estimated from the note appended to the inventory already referred to of the cathedral at Lincoln, taken in the time of Henry VIII. The memorandum is there made that by force of the commission appointed by the King, there was taken out of the said cathedral church 2,621 ounces of gold and 4,285 ounces of silver, besides a great number of pearls and precious stones, which were of great value, as diamonds, sapphires, rubies, turquoises, carbuncles, etc. Also that there were at that time two shrines, the one of pure gold, called St. Hugh's shrine, the other, called St. John of Dalderby, of pure silver.

All this, in the words of the King's Letters to the Royal Commission :—

"For as moch as we understand that there ys a certayn shryne and diverse fayned Reliquyes and Juels in the Cathedrall church of Lyncoln with whiche all the symple people be moch deceaved and broughte in to greate supersticion and Idolatrye . . . beinge mynded to bringe or lovinge subiectes to ye righte knowledge of ye truth . . . do aucthorise name and appointe you . . . to see the sayd reliquyes Juels and plate safely to be conveyde to owr towre of London in to owr Jewyll house there chargeing the mr of owr Jewyls wth the same."

The marvel is, that after the so frequent and terrible destructions of church property that have occurred from time to time throughout the world, so much remains to this day. The French Revolution at the end of the eighteenth century performed the same work for the churches in France that the Reformation accomplished in England. As one instance, a writer in the *Archæological Journal* of 1856 states that he had spoken with old men who remember having seen all the copes, chasubles, crosses, and pictures which were in the church and treasury of Beauvais collected in a great

heap before the door of the church, and set fire to as a
feu de joie in 1793. It would seem to be a law of
nature that such destructions should take place from
time to time. The pyramids and massive sepulchres
of Egypt have not secured their contents; nor even are
the museums of modern days more safe repositories,
for at the time of the Crimean War the museum at
Kertch was despoiled, and its magnificent collections of
treasures of the finest period of Greek art were wantonly
burnt and scattered to the winds by the allied troops.
We are fortunate, then, in having still preserved for us
a certain number of examples of the beautiful ivory
sculptures of the middle ages. Probably their com-
paratively small intrinsic value has saved them; at the
same time, the very same reason has, no doubt, caused
countless numbers to be thrown aside, and to have
perished as worthless.

Throughout the entire range which is covered by
sculpture in ivory, from the earliest times of which we
are able to produce specimens down to our own days,
the period which we are now considering stands out
alone in special interest, and in the peculiar character
and charm which attach to the methods of treatment,
and to the associations with the religious and domestic
life of the period. It is especially connected with the
rise and progress of the new system of architecture,
and in following its development it may be said that
we can follow at the same time, side by side, the history
of architecture from the thirteenth to the sixteenth
centuries. It is, in fact, monumental sculpture on a
small scale. Not, however, that the one is a copy of
the other, but an adaptation of the same sentiments
and principles; and we must not forget, in examining
the figure work, and especially those most exquisite
statuettes which are of all ivory carvings the most
beautiful and the most captivating, that they differ from
the monumental sculpture of the period, inasmuch as

they evidence a far more personal quality of the artist who so lovingly conceived and executed them. We seem to feel that here the artist and the workman are one, whereas in the larger sculptural work, with which the great religious edifices were adorned in such profusion, there is the element of the artisan working to order in the stone-carver's workshop, copying from models supplied to him, repeating over and over again, and unactuated by the same loving and individual care.

A taste for architectural ornament was a fashion which invaded everything. Sometimes it was applied in what, at first sight, might appear to be a very incongruous manner, though productive of a most charming and harmonious effect. Thus, for example, we find, in the museum at South Kensington, one of the most beautiful known examples of goldsmith's and enamel work—a covered drinking cup of the fifteenth century, probably of Flemish origin, set with mullioned and traceried windows, filled in with translucent enamel, and with an architectural finial forming the knop of the cover.

We shall over and over again be called upon to notice the tenderness of expression which in the same peculiar way exists in no other sculptured work of the period, the truly devotional feeling, the idealistic conception, the naïve and yet reverential grandeur of treatment, the admirable simplicity and naturalness in the arrangement of the draperies, and the wonderful way in which, in the compass of a few inches, whole histories and episodes of the scriptural narratives are brought before us in a vivid and telling manner. In other ways, also, this ivory sculpture has peculiar characteristics, sharing them, it is true, with carving in wood; for instance, in the admirable examples of the graceful open work which we shall find in some panels and portions of caskets, or in book covers, of the fourteenth century.

[194]

One important matter remains to be referred to. Although the names of many artists of these times, for instance, in sculpture in bronze, have come down to us, we search in vain for any record of those who imagined these lovely works in ivory, so full of sentiment and expression. They have fallen into an unjust oblivion, and history gives us no clue concerning them, or at least of the slightest, for up to the end of the sixteenth century, of all the workers in ivory, whether for secular or religious purposes, we are able to refer to two names only. One of these is Jean Lebraellier, of whom we find mention in an inventory of Charles V. of France (1337–80) as having made two large panels in ivory of the three Marys. There is also mention in the accounts of Amiot Amant, who was *valet de chambre* to Duke Philippe le Hardi, about 1394, of a sum of 500 livres paid to Héliot Berthelot for two large panels of ivory with figures, the one of the Passion of our Lord, the other the life of " Monsieur S. Jean Baptiste." And, we know not on what authority, a Virgin and Child, in ivory, in the sacristy of the cathedral at Pisa, is attributed to Giovanni Pisano, of the beginning of the fourteenth century. A pax in the British Museum bears in large capital letters the name "Jehan Nicolle," and it has been thought that this is the name of the artist who carved it ; but whatever may be the reason of its prominence, surely on such an object—if it is a pax—one would hardly expect to find it displayed in this way.

It is difficult to account for this absence of names, except partly on the supposition that a large proportion of the religious work was the production of monasteries, and that the individuality of the artist was absorbed or, perhaps even, as in the east, forbidden to be particularised. But this would hardly apply to secular work.

We may now proceed to consider some of the more important objects in detail. We find frequent mention of ivory caskets and coffers in inventories and other

documents of the middle ages. For bringing the chest
of ivory mentioned in the privy purse expenses of Eliza-
beth of York, the servant of the Lady Lovell is paid
3s. 4d.; the chest, therefore, must have been very valuable,
for that sum would represent more than £2 of our money,
for the carriage alone. Then there was in the church of
St. Mary Outwich, London, in 1518, "a box of eivery
garnyshede with sylver," according to the "enventorye
of all the hournaments" of that parish. The word pyx
was in early times applied to any sort of box, usually
round in shape, for containing ointments and spices.
We find it afterwards in the middle ages used for small
boxes of many kinds, for preserving unconsecrated wafers
and the like, and even for reliquaries; but it was more
properly, and is now, a vase in which the host is reserved
in the tabernacle. For this purpose, however, it can
only be of precious metal, generally in the form of a
chalice with a veil, or, for the larger hosts, a circular
box standing on a foot. In ivory, therefore, we need
not always understand pyxes, properly so called. It is
certain, however, that in the earlier ages ivory boxes
were constantly used for preserving and carrying the
sacrament, and amongst the property belonging to the
church of St. Faith under St. Paul's we find "an ivory
pyx in which the Eucharist is kept": at Canterbury,
"j pixis de ebore ad hostias." In the Greek Church,
as before mentioned, there are ivory pyxes called
panagias. And the synod of Exeter in 1287 orders
the sacrament to be carried to the sick in pyxes of
silver or ivory. In the Durham treasury in the
fourteenth century is mentioned, "Item, a tooth of S.
Gengulphus, good for the falling sickness, in a small
ivory pyx." In 1384 there were in the treasury of St.
George's, Windsor, "a noble ivory pyx garnished with
silver gilt," and another of the same description, and at
Lincoln, three round pyxes of ivory, bound with silver,
and four others of ivory; all of these we may take to

be for sacramental use. Reference must also be made to the cylindrical pyx, with conical cover, engraved with simple bands of lines and small circles, and with an Arab inscription, in the treasury of St. Gereon at Cologne; probably of the time of the crusades.

To come to caskets of a more ordinary kind and shape, a very remarkable one of the thirteenth century in the museum at Kensington is of wood overlaid with thin plaques of ivory. The dimensions are thirteen and a quarter inches in length by six and a half in height and six and three - quarters in width, rectangular, with a sloping lid. It is painted and gilt in the style of the miniatures of the period, and has probably enclosed a relic of St. Felix, for it bears the inscription, " S. FELIX: P̄I: ET: MAR.", and the archbishop is represented, enthroned and vested in red chasuble and mitre and the other episcopal vestments. His pastoral staff is surmounted by a cross. The other subject is the Virgin and Child, and the casket is also ornamented with twenty-two shields of arms, now almost entirely defaced. It is mounted with gilt metal mounts and lock.

A French casket of the fourteenth century, in the same museum, has the sides filled with scenes of the martyrdom of St. Margaret: on the lid are four saints, St. John Baptist, St. Agnes, St. Barnabas, and St. Catherine, standing under a canopy of four pointed arches with cusps and crocketed pediments.

We may take next two very fine examples of the rare pierced or open work which is characteristic of the fourteenth century. They are, as usual, French, and we find them both in the collection at South Kensington. The first consists of a plaque (probably one of several) in which are figures of our Lord, St. Peter, and St. Paul, standing under a rich canopy of three small arches, above which rise pediments with a rose and quatrefoil in each. The back of every niche is filled with tall, pointed, decorated windows, and above are three com-

partments in which are represented the Annunciation, the Adoration of the Kings, and the Presentation. The effect of the whole of this elaborate architectural decoration, which is carried out in the most careful way, so that every detail—even the groining and the patterns of the under parts of the canopies—can be clearly seen, the groups, the twelve smaller figures under canopies separating the principal divisions, the noble figures, and the fact that every portion is covered with minute and delicate work, presents an extraordinary richness and harmony. It is indeed one of the many beautiful examples of the connection with architecture, before referred to, which will meet us so constantly in the ivory sculpture of the period.

Not less admirable is the series of panels carved in open work with scenes from the Passion. Those which we now have in the museum are five in number, but it is probable that they form part of a set of twenty-four. We have again the richly decorated pointed architectural work, crocketed and finialed, with tiny figures of angels playing on instruments, or singing from scrolls, between each gable. But our attention will be directed more to the arrangement and execution of the various scenes, in which we have, even in these five panels only, as many as eight distinct episodes of the Passion, bringing in fifty or sixty figures. In most cases, with the exception of our Lord, the personages represented are in the costume of the period, the men in surcoats belted low down beneath the hips, with pointed hoods, the women in flowing gowns and with veils and wimples. Four plaques, which formed probably part of this set, brought no less than £1,240 at the dispersal of the Gibson-Carmichael collection in 1902.

A very interesting casket in the museum at Kensington is English work of the fifteenth century. It is filled with small panels, which are carved with no less than twenty subjects from the life of the Virgin and of

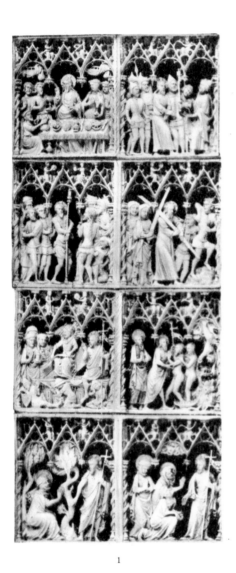

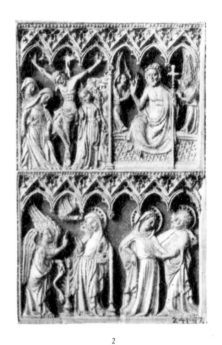

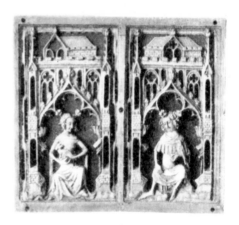

Plate 27. OPENWORKED PANELS. FRENCH (BURGUNDIAN)

1. THIRTEENTH CENTURY. 2, 3. FOURTEENTH CENTURY

her parents—St. Joachim and St. Anne. They are taken from apocryphal accounts, as it would appear, from the *Golden Legend*, so popular in the middle ages. There are in all twenty panels, and most of the subjects are beneath a canopy of a single flat ogee arch. We find also the linen pattern, a favourite one in English work of the time. Traces of the original colouring and gilding remain.

English ivories are, unfortunately, extremely rare, and their rarity is, no doubt, due for the most part to the causes to which we have already referred ; but we can hardly doubt that ivory was extensively worked in England in gothic times as it was elsewhere, and it may be said that the few examples which we have are as remarkable for excellence of treatment and purity of feeling as we should expect to find in the work of men contemporary with those who designed and built the magnificent cathedrals and churches of England, which yield to no other country in grandeur and beauty. And if we take minor works, who that knows the grand candlestick (of the twelfth century) in the museum at Kensington, called the Gloucester candlestick, can doubt that at that time there were English artists who could have held their own with any others for imagination and skill in execution, and that they would have abounded also in the succeeding centuries ?

It must be admitted that there is considerable difficulty in assigning the country of origin in the case of mediæval ivory carvings. The palm must unquestionably be given to France ; but still we must not be too hasty, and assume that every fine piece of work came from that country. Costume, unfortunately, helps us but little, as it was similar in most parts of Europe. But we can be guided by certain peculiarities in the arrangement of draperies in the larger pieces ; in perhaps a more solemn and realistic expression in English faces, in contradistinction to the gaiety and smiling charm of

the French treatment. Altogether, taking into account the influence which most certainly would have been exercised by Flemish, French, and Italian artists and their work, we may reasonably incline towards adding to the credit of English workmen more examples than the few that are usually somewhat grudgingly allowed to them. Indeed, amongst those which we think are characteristic and may be so claimed, we are strongly inclined to place many of the beautiful series of panels, with scenes from the Passion, which are so frequent. The expressions of the faces are often remarkable, certain details of costumes and the chain mail of the figures are characteristic, and there is also the treatment of the subject of the Harrowing of Hell.

It is natural that ivory plaques should continue to be used for book covers in the same way as so many of Byzantine workmanship. We should expect, indeed, that those wonderful and costly illuminated manuscripts should have no less noble and costly bindings allotted for their preservation. Doubtless, also, many detached plaques to be found in collections formed originally portions of book covers, and besides these, there would be some made in the first place for caskets or other purposes, and afterwards adapted for the bindings of books. An example is another specimen of the pierced work of the fourteenth century, than which nothing finer of the kind is anywhere in existence. It is the book cover of French origin, now in the British Museum. This extraordinary piece of ivory sculpture is of no greater dimensions than about six inches in length by four and a quarter in width, and yet in this restricted space we have no less than thirty small panels, each hardly an inch square, and containing each a scene from the life of the Virgin in the most exquisite and delicate open work. It is not, however, merely a *tour de force* with a crowd of figures, treated in the manner of perspective, such as is common later on in German work of the

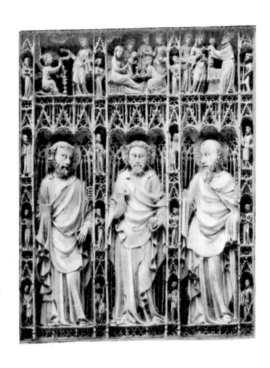

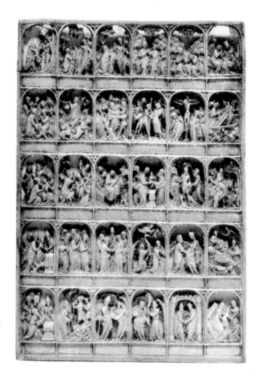

Plate 28. OPENWORKED PANEL, AND BOOKCOVER. FRENCH

FOURTEENTH CENTURY

seventeenth century, and in French of the eighteenth. There are in these little groups, every one of which has a complete story plainly told, a charm and simplicity, a directness of purpose, with no appeal to our admiration on account of difficulties on the score of minuteness, which put them entirely out of the category of those later works to which we have just referred. For all this, every figure, and in some panels there are as many as seven or eight, is easily recognisable, and the expressions are as carefully worked out as they might have been on a much larger scale. The divisions between the rows of compartments, there being five compartments in each row, are of the utmost simplicity, and completely unornamented.

Very important indeed amongst the ivory carvings of these ages are the diptychs, polyptychs, and small shrines which are perhaps more richly represented in the museum at South Kensington than in any other collection in the world. On this account it will be convenient to draw nearly all the examples which will be referred to from that source. In speaking of religious tablets of this kind, we mean by a diptych a pair of plaques hinged together, and so forming a kind of book of two thick leaves. A triptych has a centre tablet and two narrower ones hinged one on each side in such a manner that they fold and meet in the centre. Sometimes there are more leaves, or the arrangement is such as to form a kind of recess, within which a statuette or group may be placed and enclosed by the folding wings and centre doors. In this fashion they are usually called shrines. But in the ordinary diptychs we may also distinguish two varieties: one where the sculptured pictures within are disposed in rows, as we find them on plaques or book covers, the other where the figures are larger, and one subject only is represented on each leaf. Differing from classical diptychs, the outer sides of the leaves are usually quite plain.

Nothing is more typical of the fertile imagination, the harmonious composition, and the devotional feeling of the artists of these periods than these charming carvings. In all those which we shall select for special notice, and in many more to which it is impossible to refer, there is subject-matter for admiration. Indeed, it may be said that they are mines in which at every moment we make fresh discoveries. The architectural surroundings are delightfully appropriate, forming, as it were, miniature sanctuaries or oratories. The costumes and draperies of the period seem perfectly natural, and in no way shock our feelings. Somehow, the idea of anachronism does not occur to us. There is no crowding in the tableaux or overloading with ornament, and the main purpose, so admirably fulfilled, appears to be a decorative scheme, perfect in balance, unerring in simplicity, and yet never leaving out of sight the devotional use and the valuable instruction to be gained from the pictorial representation of the gospel narratives. Above all must the decorative scheme be borne in mind. By a kind of instinct the artist knew exactly the true arrangement of his lines, and how rightly to fill or leave unfilled a vacant space. This must not be forgotten when apparently there may be a mannerism sometimes in certain attitudes, in certain seeming disproportion of limbs, in what at first may appear unnatural. These things did not arise from ignorance or want of skill, but—to take one instance only, which will be again referred to later on, that of a peculiar bend or twist in the figure—they constituted a charm which was felt then, and is felt now. Such feelings may be acquired tastes. Possibly; and it is certain that acquired tastes are never quick in asserting themselves, but they are very lasting.

It will be worth while to compare the treatment of some of these scriptural tableaux with those of earlier times, which have been referred to in previous chapters. Allowing for the difference in costume and the different

type of features, we shall find the same system, the same feelings, the same suggestiveness, by means of which a slight detail, a well-understood symbol, a placing of a figure or group in a particular manner, is made to say a great deal. Again, we shall recognise particular personages by certain unvaried draperies, or by a physiognomy or even method of arranging the hair which will be found to be usual. And with regard to the feeling with which these holy subjects are treated, we are still in the age when tenderness prevails. Even in the most sacred scenes of all there is almost—if we may say so—a spirit of gaiety. We have not yet come to the times when horror and agony and the most terribly realistic suffering are invoked, to claim our pity and devotion. At least, it is not thought necessary so to represent them. On the other hand, nothing could be more touching, or could fulfil its purpose more properly, than such a representation, as we find so frequently—for instance, in the diptych (plate xxxii.) which we have illustrated—of the suffering heart of the Holy Mother at the moment of the crucifixion.

We shall find in collections many examples of diptychs with very numerous scenes treated in compartments. It is not unlikely that the system first arose before the artist sculptors had learnt how to pourtray many figures and actions in one scene. It was necessary to put one set of groups over another, and so they had to break the composition up and divide it, and the manner, perhaps, was afterwards persisted in as a matter of fashion. But the arrangements are rarely complicated. No doubt every artist often went to the same source, to some *Golden Legend* or apocryphal gospel, and thus there is a certain amount of repetition. But in that religious age, if the only books were religious ones, and such things as these the illustrated ones—without a text, for few could read if there were one—we may take it that such sacred narratives were subjects of everyday talk

and discussion. These beautiful pictures would be shown with pride, and pass from hand to hand; every allusion, every expression, would be easily caught up and commented upon. They formed, in fact, a kind of *memoria technica*, a convenient way of impressing on the mind the principal events of Holy Writ. Every incident is recalled and fixed on the memory; even the peculiarity of the treatment helps to do this. Take, for example, the beautiful fourteenth-century diptych of English workmanship which is here illustrated, where so much is compressed in the tiny compartments. In the upper division, on one leaf we have the visit of the Marys to the tomb. There is the garden represented by a tree. Near by the gardener (as Mary Magdalen imagined, for it is the *Noli me tangere* episode that we have here) leans upon His staff, Mary kneeling to Him, her upraised hands indicating the question that she is addressing to Him. The angel is seated on the sepulchre. He points with his hand to the interior of the tomb to show that it is empty. The grave-clothes are shown as they have been left; the three holy women stand behind the tomb with their vases of unguents and spices. Beneath the sepulchre lie the sleeping guards. What matter if they are attired in the hauberks and mail of the period? The whole story is brought distinctly before us in all its details, and every incident is treated in such a manner as to leave a definite image on the mind. And so with all the other episodes which are succinctly related, on so many of these little carvings, in a kind of pictorial shorthand. Compared with the fourteenth, those of the thirteenth century are few in number, but the three that we shall select for reference are of peculiar interest. Two of them are English, and of these one is the earliest specimen of English gothic work that we know. The third is French, a triptych which for beauty is not to be surpassed by any other example in existence. The leaf of a small

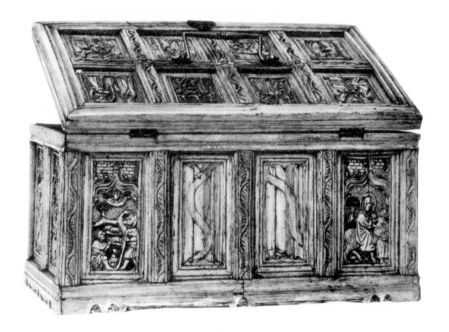

1

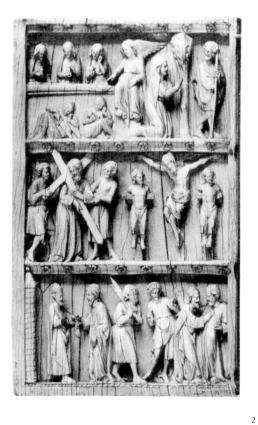 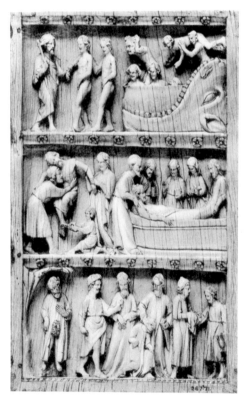

2

Plate 29. 1. CASKET. ENGLISH 2. DIPTYCH. ENGLISH

FIFTEENTH CENTURY FOURTEENTH CENTURY

English diptych was found about 1853 in the Minories, London. It is very deeply carved, the figures being almost detached. In the two compartments are represented the Crucifixion, and the Virgin seated and crowned with the Holy Child on her knee. It is mentioned in the proceedings of the Archæological Institute in 1855. In the museum at Kensington is a fine diptych of English work with scenes from the Passion (No. 367'71). There are three subjects on each leaf, again in very high relief, cut clear from the background. We find the soldiers at the sepulchre in chain mail with surcoats and hooded hauberks. Our Lord carries a crosier at the Resurrection. Another scene is the Descent into Hell, often called the Harrowing of Hell. This diptych was bought in 1871 for £200. The subjects, in six scenes, read from the left corner upwards from left to right, a very usual arrangement.

A fine diptych, late fourteenth, perhaps even fifteenth-century work, formerly in the Meyrick collection, is now in the Kensington Museum, lent by Mr. Salting. It is of most unusual and remarkable thickness of ivory and depth of carving, standing out nearly an inch from the background, and measures eight by four inches. On one leaf is the Virgin and Child, on the other our Lord holding a book. The draperies and workmanship are excellent. The cusped and crocketed arch above each figure must be noted. It is partly gilt, and traces of colour remain.

A plaque, or leaf of a diptych, as it is called, of the fourteenth century is also in the museum (No. 94'82), bought in 1882 for £110. The carving is again nearly an inch deep, and the treatment very unlike any other figures of the kind. The Virgin is seated, under a plain arch, holding the Child on one arm. The drapery, especially the veil, which on the further side of the face has a kind of realistic transparency, is unusual. So also is the attitude of the Child, fully clothed, and with

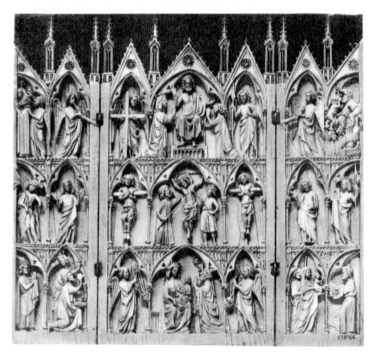

1

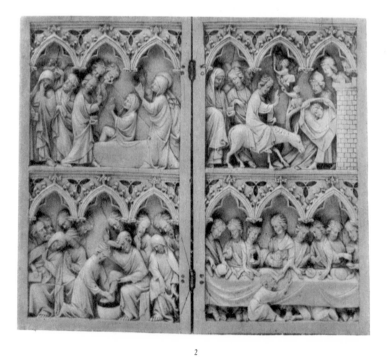

2

Plate 30. 1. TRIPTYCH. FRENCH 2. DIPTYCH. FRENCH

THIRTEENTH CENTURY FOURTEENTH CENTURY
 (Fitz-Henry Collection)

the limbs tucked under, as it were. Altogether some expression of doubt concerning the genuineness of this tablet might be permitted.

We may take next the wonderful triptych (No. 175'66), French work of the thirteenth century, in the Kensington Museum, which was acquired in 1866 for £210. The condition in which we find it is marvellous, when we consider the minute and delicate carving, and the number of projecting pieces. It seems in every way as perfect as the day it was made, and one must suppose has been most carefully preserved and hidden away. As an illustration is given, it is hardly necessary to do more than call attention to the architectural detail, the canopies of pointed arches, the arcading in the spandrels, the turrets, pinnacles, and rose windows. Remarkable also are the delicacy of the slender pillars, and the minute detail, even to the spears, which are quite uninjured. The subjects represented are the Visit of the Magi and the Presentation in the Temple; the Triumph of the New Law and figures of the Virgin and St. John; the Rewarding of the Blessed and the Punishment of the Wicked, with two figures of angels blowing trumpets. These are in the wings of the triptych. In the central portion, our Lady seated; the Crucifixion, the Last Judgment. Note the kneeling figure of the bishop and his floriated crosier, the charming figures of the angels throughout, and the beautiful one of the Virgin in the centre of the left-hand wing. We must remark also here a not uncommon emblem, that of the triumph of the new law over the old. The old law is always represented by a figure whose crown has half fallen off, her eyes partly bandaged, the head leaning to one side, and a pennoned spear broken in three pieces, but not yet quite detached, in one hand. The new dispensation is symbolised by a triumphant crowned figure, with a church in one hand and a perfect spear with pennon in the other.

A triptych which was carved for Grandisson, bishop

of Exeter, English fourteenth-century work, is in the British Museum. The centre is divided into two compartments; in the lower is the Crucifixion, in the upper the Coronation of the Virgin, and there are groups and figures of saints. In the panels over the canopies are roses and the arms of Grandisson, who was bishop from 1327 to 1369.

There is also in the British Museum one leaf of a beautiful diptych made for the same prelate. It is divided into two compartments. In the upper half is the Annunciation. The Virgin, sitting, bends her head aside as if listening to the dove which approaches closely to her ear, or to the angel who kneels at her feet. In the lower half St. John the Baptist is represented seated on a rock and pointing to an *Agnus Dei* which he holds in the left hand. There are slight traces of the arms of the bishop on a shield in one corner. A leaf of a diptych in the Louvre is evidently the companion to the one just described. The upper half represents the coronation of the Virgin in an identical manner to the central part of the Grandisson triptych. In the lower half St. John the Evangelist is seated on a large decorated bench, on one end of which is a movable desk, and the saint is writing with a style. An eagle, the emblem of the evangelist, is perched near him. The deeply carved arcading surmounted by quatrefoils is the same; there are the same roses in the angles, and the same shield of arms. The figures, also, are extremely characteristic, and entirely different from any which we find in French or German work of the same period. All these pieces should be compared with the diptych of English work of the fourteenth century, in the museum at Kensington (No. 6824'58).

Reference has already been made to examples sometimes hastily classed as French or Italian work, which seem to claim some right to their proper position as the productions of English artists. A case in point is the

[211]

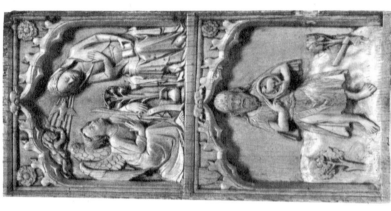

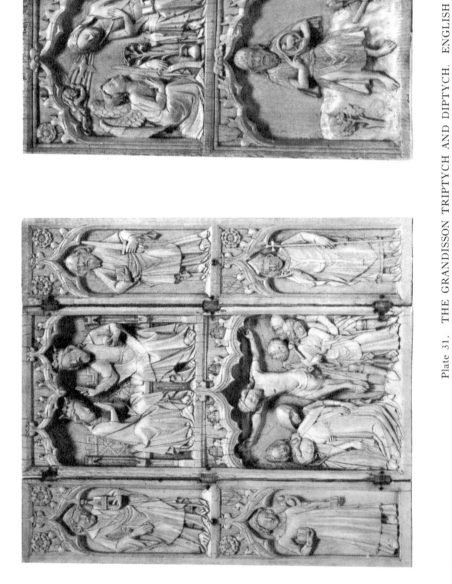

Plate 31. THE GRANDISSON TRIPTYCH AND DIPTYCH. ENGLISH

FOURTEENTH CENTURY

beautiful diptych in the possession of Count Escalopier, of which there is a cast in the museum at Kensington (No. 54'72). An instructive comparison may be made between this diptych and the English example (No. 367'71) which we have described and illustrated, remarking, in particular, the general character of the figures, especially of the scourgers, the treatment of the "harrowing of hell," and the borders of rosettes or roses between the subjects. Compare again the English example for the manner in which the hanging of Judas is represented, with the splendid triptych which we have illustrated (No. 211'65), and for the crucifixion of the two thieves, noting that, in the first, the feet are not tied; with the French diptych (No. 293'67) for the deposition and entombment, and all of these with the English diptych (No. 6824'58), the above numbers being those of the museum at Kensington. One more, a diptych in the Louvre (cast No. 54'73 at Kensington). The figures of the scourgers are certainly of an English type.

Another case in point is the extremely beautiful half of a diptych found in 1885 at Mansfield, Nottingham, and now in the British Museum. The subjects, in four compartments, are the Resurrection, the women at the sepulchre, St. Martin, and two apostles. These questions of origin are not easy to solve. However they may be, we have in the Grandisson examples three superb ivories, designed and executed with a boldness and charm which, in their way, it would be difficult to surpass. Graceful and charming above all is the kneeling figure of the angel in the diptych.

With more hesitation, perhaps, but holding a certain amount of probability, amounting to not far short of conviction, the opinion may be expressed that we may attribute to English workmanship the plaques, or semi-statuettes, carved in very deep relief, which were formerly in the Meyrick and are now in the Salting collection. We have already described them (page 208). A com-

parison with the English statuette of the Virgin and Child in the Kensington Museum (No. 7'72) and with the Grandisson diptych, will show in all three distinctive English characteristics. We find in the high forehead, the expression of the eyes, the arrangement of the hair, and general physiognomy of the Virgin, and in the treatment of the figure of the Child, a remarkable similarity. But probably the architectural style will be more decisive, although, it may be said, it was common to England and France in the late fourteenth and early fifteenth centuries.

To these instances of possible English origin must be added the admirable statuette in the British Museum, in which the Virgin offers her breast to the Holy Child, who stands unclothed on her lap; a plaque of the fourteenth century, with subjects in small circles, in the Salting collection; and a curious pax which is there labelled Italian. We have also a narrow tablet of the fourteenth century in the British Museum, representing the Crucifixion, with two rosettes in the upper corners; and an interesting plaque in the Mayer collection at Liverpool, on which Henry VI. of England is seated, in his royal robes, under a canopy and attended by nobles, in a manner which recalls the seals of the period. Finally, there are the seven plaques and diptychs in the Ashmolean Museum at Oxford.

We come next to a very fine French diptych, of early fourteenth - century work, at Kensington (No. 211'65), extremely rich in architectural decoration, and of unusual excellence of workmanship, but above all remarkable for the extraordinary number of detached scenes represented within such a limited compass. On each leaf are three compartments, surmounted each by an elaborate canopy, composed of three pointed arches springing from corbels, and beneath every arch, which is hardly more than an inch in width, is a separate subject of the Passion, so that there are in all no less

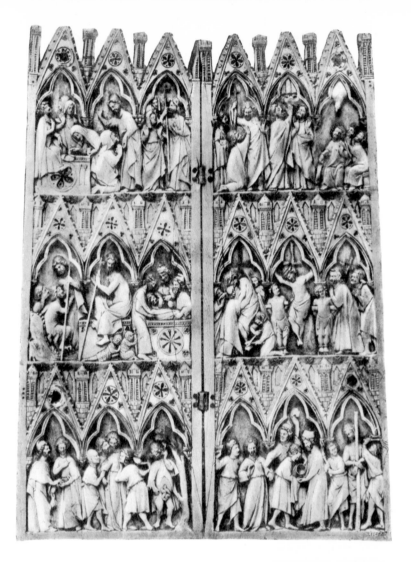

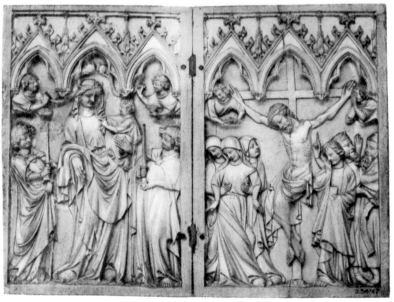

Plate 32 · DIPTYCHS. FRENCH

FOURTEENTH CENTURY

than eighteen distinct episodes depicted. Charming is the manner in which, with a few figures or indications, the whole of a story is, so to speak, sketched, and yet how completely and sufficiently! For instance, in the Resurrection, our Lord, holding the cross-headed staff, is seated on the tomb, and beneath are two sleeping mailed knights. In the Ascension two figures of apostles look upwards in astonishment; above is a cloud, two disappearing feet, and the lower part of a garment. The taking down from the cross is perfect, with its four figures one of which is extracting the nails with pincers. The betrayal by Judas is indicated by his attitude; in the division next following he is receiving the money, and in the next he is hanging from the tree, and his bowels gushing out in the manner in which this gruesome incident is so often represented. Throughout, the expressions on the faces of every figure are carefully studied and executed, and the draperies—all of which are flowing ones, and not costumes of the period—are admirable. The backgrounds of each division are coloured blue, the hair and beards of the figures and some details of the architecture gilded. This fine triptych was sold at the Soltikoff sale for £165, and eventually found its way to South Kensington, in 1866, for two hundred guineas.

A French diptych of the fourteenth century, at Kensington (No. 294'67), is, perhaps, as characteristic a specimen of fine work of the kind as could be selected. It is of the description in which one subject only is represented on each leaf. We have here, on one, the Virgin and Child attended by angels, on the other the Crucifixion, both beneath a canopy of three crocketed arches, with finials. Our illustration will show the admirable design and execution. The figure of the Virgin, recalling the style of the statuettes which will presently come under our notice; the half figures of angels, on one leaf swinging censers, on the other in

most charming attitudes of grief; the most touching representation of the Virgin fainting and falling into the arms of the two attendant women; the Saviour hanging on the cross as if at the moment just before death, the grief of the assistants shown merely by the conventional method of holding their hands—one angel descending from above with covered and averted face, the other wringing his hands with an expression of despair; the contrast with the joyousness of the scene on the other leaf of the diptych; all this, and more, perhaps, make our example one of the most typical which could be given of the devotional art of this period. To those who should fail to be touched by it, or unable to recognise the merits of the system, it would be useless further to appeal. The relief on this diptych is very deep, and the entire execution admirable. It is one, the theme of which is similarly treated in examples to be found in many collections, but rarely of so fine a character as that which has just been described.

The next example—again French of the fourteenth century, and at Kensington (No. 141'66)—is still more in the nature of a shrine. The centre is entirely filled by a figure of the Virgin with the Child in her arms, in bold and deep relief against the plain background; an angel has just placed the crown upon her head. The wings are occupied by six smaller subjects. The architecture is simple, but effective, and again we are charmed with the delightful angel figures, and note how wonderfully the drapery, especially of the one in the act of crowning, is expressed. Beautiful also is the tender expression of the mother gazing at the Child, who looks up with confidence. Note, again, the exquisite delicacy of the hands of both, the elegant arrangement of the veil. The piece is of unusually large dimensions, the centre portion measuring twelve inches by six. The price given was, for those days (1866), considered high, £448.

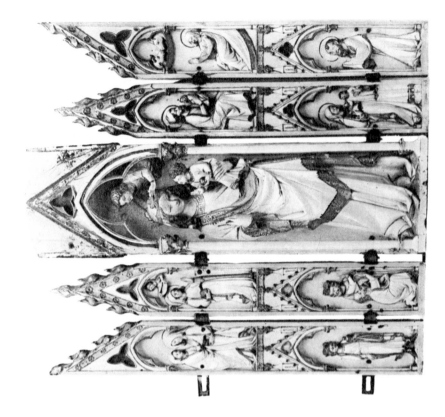

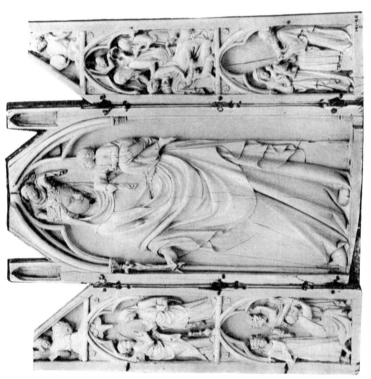

Plate 33. TRIPTYCHS. FRENCH
FOURTEENTH CENTURY

There are two more shrines in the museum (Nos. 370'71 and 4686'58) which must be noticed. In each the figure of the Virgin—almost a statuette—is beneath a canopy, the slender pillars of which stand out detached in front and support it. The shutters are each twofold, and close in the whole as in a small cabinet. The relief of all the principal figures is very deep, the draperies remarkably good, and the whole has been painted and gilded. Both are pieces of the fourteenth century, and although called French, there is really no reason why one at least (the second named) should not be claimed as English work. Fine as they are, there is quite as much evidence for this ascription as for the other. The state of preservation is remarkable; not one of the beautiful and delicately carved hands and other portions which project a good deal is broken off.

Another example of most marvellous preservation is that of a diptych in the museum lent by Mr. Fitz-Henry. Both as regards the condition of the ivory itself —pure white, with not a crack or flaw, except slightly in the thinner backgrounds—and the absolutely uninjured state of the carving, it is as if it had but just left the artist's hands. The piece is also not less beautiful and remarkable in other ways. It contains four subjects, viz. the entry into Jerusalem, the washing of the feet of the apostles, the raising of Lazarus, and the Last Supper. The relief is again somewhat deep, and the design and treatment excellent. It is interesting to compare this piece with another French diptych of the same century in the museum collection (No. 290'67). The latter has six subjects, three of which (the feet-washing, the entry, and the Last Supper) have many points of resemblance in design and execution with that of Mr. FitzHenry. The feet-washing in the FitzHenry diptych is, however, perhaps more striking, though in a certain way it appears to lack solemnity. But how admirably the treatment of the hair of the apostles who

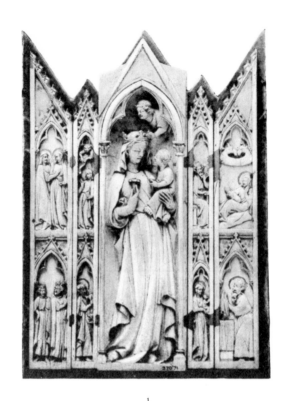

1

2

Plate 34. 1. TRIPTYCH. FRENCH 2. DIPTYCH. FRENCH

FOURTEENTH CENTURY FOURTEENTH CENTURY

(Collection of Rev. Ethelbert Horne)

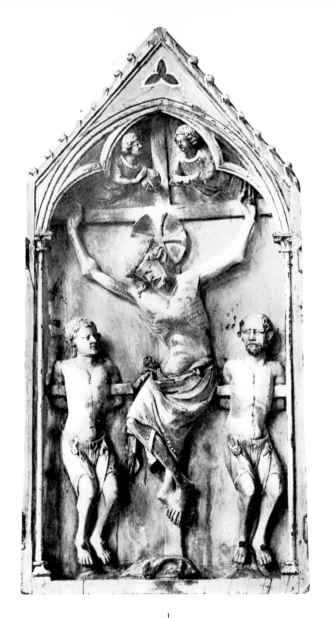

1

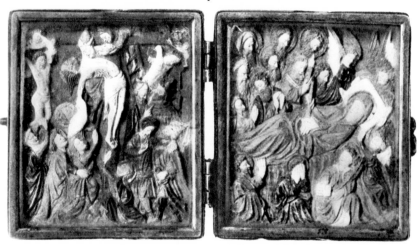

2

Plate 35.　1. LEAF OF DIPTYCH. FRENCH　　2. DIPTYCH (COLOURED). FLEMISH

FOURTEENTH CENTURY　　　　FIFTEENTH CENTURY *(size of original)*

are standing by contributes to the decorative arrangement of the composition! The raising of Lazarus is somewhat unusual, and is wanting in the South Kensington piece, as well as in another of the same style, period, and school (No. 291'67). We have in all three an identical figure casting off his clothes on the entry into Jerusalem; but in the Last Supper, in the Fitz-Henry example, the Magdalen lies at the Saviour's feet, and this is wanting in the others. Note also how in the raising of Lazarus, several of the figures hold their hands to their noses—"for by this time he stinketh."

The description of such diptychs and shrines as we have been noticing might be prolonged almost indefinitely. It must suffice to say that both in the British and Liverpool museums, especially in the latter, are many other admirable examples. In the Wallace collection also there is a very beautiful early fourteenth-century leaf of a French diptych, in almost full relief, representing the Crucifixion. The figures are very fine, especially the crucifix itself, above the arms of which we have the angels with the sun and moon, which are usual. On either side are the two thieves, and we see here the method of their death treated in the manner which was, at that time at least, traditional. Their feet are nailed, the arms bound behind the arms of the cross. Little or no distinction is made in the character or expression of the faces of the good or impenitent thief. There is also, in the same collection, another with scenes from the Passion, in no way inferior to any of those especially noticed. All the ivories in the Wallace collection are in exceptionally fine condition.

We have made no mention of German and Italian works of this kind, not because there are not many of them, but because we do not find many examples of particular excellence in our own collections, and it would be impossible to notice everything. An example must be given of the bone work common in Italy, during the

fourteenth and fifteenth centuries especially, to which attention will again be drawn when describing secular caskets in a succeeding chapter. A very large Italian triptych or retable in the museum at Kensington (No. 7606'61) illustrates very well these decorative altar-pieces. The pieces of bone, each about two inches wide, carved on their convex faces, are placed upright side by side as required. In this case the subjects, which are the Crucifixion, gospel narratives, and figures of saints, occupy two panels in the centre and two on each of the wings of the triptych. The whole is divided and framed with marquetry of wood inlaid with ivory in the style known as Certosina work, to which reference will again be made, and mounted on a base of the same character.

It will be noticed that, for diptychs and shrines of the kind we have been describing, we do not go beyond the fourteenth century. For whatever reason, nothing of value, at least nothing so admirable, of a later period appears to have come down to us. Or, not to be too sweeping, we may say it is not to be found in our public collections.

Perhaps after the praise which may appear to have been lavished upon these beautiful examples of fourteenth-century religious art, it may seem that we could go no further in our admiration. Yet there is another class of which we do not hesitate to say that it must be placed at the culminating point to which the imagination, the sincerity, and the technical skill of the artists of these times had attained. We refer to the charming series of statuettes of the Virgin and Child, of which the Kensington Museum has a rich collection, and to others which are the treasured possessions of such museums as those of the Louvre, of the Hôtel Cluny, and of famous public and private collections throughout the world. And, again, we need go no further for illustrations than to our own museum at Kensington, for the series there to be seen could scarcely be matched else-

[223]

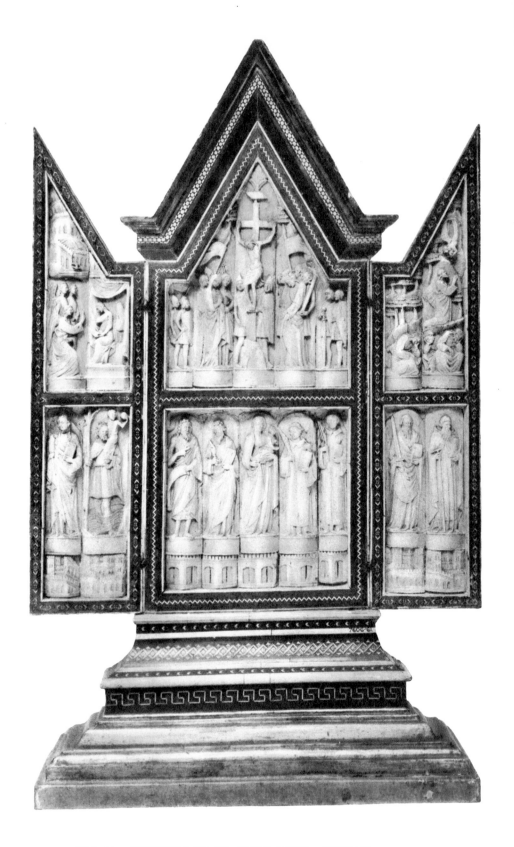

Plate 36. PREDELLA OF AN ALTAR-PIECE. ITALIAN
FOURTEENTH CENTURY

where, and is certainly sufficiently representative. Most beautiful and tender in treatment are these charming figures of the thirteenth and fourteenth centuries. They represent and bring home to us the truly devotional spirit in which the artist approached his work, the elevation in thought and style, the delicacy and refinement, the love and reverence which he lavished upon them. And with all this there is a simplicity, a pathos, a life and animation, which show them to be the work of men whose lives were devoted to religious ideas, who loved their art, and who worked solely for the love of it and in the cause of religion. Yet again must it be said that their reward is in these works alone. As perhaps they were content it should be, so, in no single instance, have we any trace of their names.

The earliest example which we have at South Kensington is a French statuette of the thirteenth century (No. 203'67), and indeed most of those in the museum are also French, though we shall make the same reservation with regard to the possible English origin of some of them that we have previously made. We must be guided in this matter mainly by the character of expression and by the disposition of the drapery. The Virgin is seated, clothed in a tunic girdled round the waist and falling in loose and elegant folds. On her head is a veil concealing most of the hair, and over it a narrow coronet. The Child is supported on one arm, and she gazes at Him affectionately, holding a foot in one of her hands and watching Him as He plays with a dove held downwards by both wings.

All our following examples, with one exception, will be of the fourteenth century. The first (No. 4685'58) is a seated figure of unusually large dimensions. The Virgin is vested in the same manner as the last described, and the Holy Child stands on her knee, turning towards her with affection and holding a small globe in one hand. He is dressed in a single long

garment, and one foot is shown bare. It is interesting to notice that the artist, wishing to take advantage of the best part of the top of a large tusk, found himself in a difficulty, and consequently the proportions of the head and upper part of the figure are too small and the length of the leg too great. This, however, detracts but little, if at all, from the grace of the whole.

As an example of the application to figures of very large pieces of ivory, it may be worth while to quote the dimensions of the largest statuette of this kind known, formerly in the possession of Mr. Alexander Barker. It is a standing figure, within an inch of two feet high, and six inches wide at the base, and the height of the figure of the Child, who is sitting on His mother's arm, is seven and a half inches. The whole figure slopes to the left, in accordance with the growth of the tusk, and opportunity may here be taken to remark upon the peculiar bend or twist which is found so commonly, not only in ivory figures, but in those of stone or wood in cathedrals and churches, and even on seals and in paintings and illuminations of the Virgin or of female saints. A marble Virgin and Child, of the fourteenth century, in the cathedral at Antwerp, is entirely in the style of the ivories. Undoubtedly the origin of this peculiarity arose from the difficulty which the worker in ivory lay under of dealing with the natural curve of the tusk. But there is, after all, a peculiar grace and charm in the treatment which was forced upon them, and so it came about that they were loath to abandon it even in cases when there was no absolute necessity. We shall find this attitude, therefore, in several figures of the Virgin and Child, in the shrines which have previously been noticed. It became, in fact, the fashion, and was extended to secular figures in sculpture and paintings also. It has an appearance of mannerism, no doubt, but it is unquestionably not displeasing. And is there not also something analogous to the attitude in

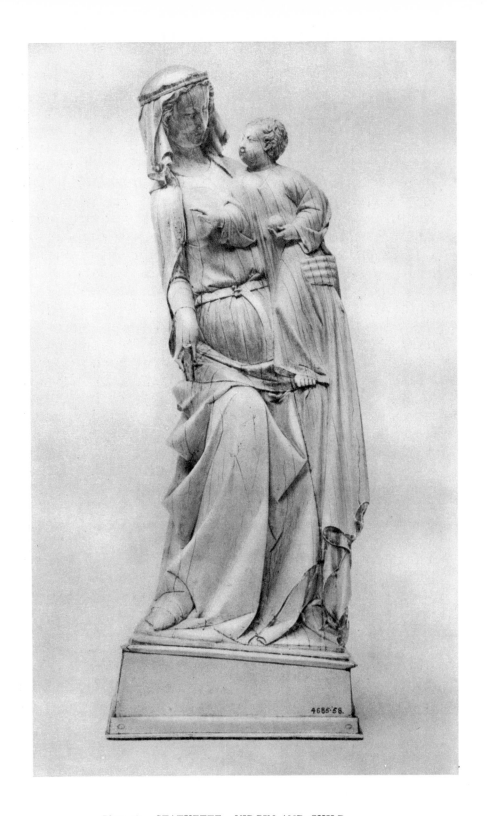

Plate 37. STATUETTE. VIRGIN AND CHILD

FOURTEENTH CENTURY

which a woman often stands when carrying a heavy child in her arms?

An English statuette of the fourteenth century, at Kensington (No. 7'72), in which the Virgin is standing, illustrates this peculiarity. She is vested in the usual manner, her long robe falling over and covering completely the feet. The Holy Child throws His right arm affectionately round the neck of His mother, a beautiful action of which we seldom find examples. There can be no mistaking the English character of this group, nor can there be any doubt about another, a sitting figure, in the museum, in which there is also a peculiarity, inasmuch as the Virgin sits holding the Child with the right hand instead of with the left in the almost invariable manner. And again, one of the most beautiful statuettes of this period which we possess may also be English work. It is in the British Museum, and is very large, being more than fourteen inches in height. The Virgin is seated, and wears a long tunic, falling in graceful folds over her feet. The veil which covers her head is larger than usual, and envelopes her down to the knees. The Child is naked, and, as He half stands on her lap, she supports Him with her right hand, and places her left under her breast to offer it to Him. In the British Museum there is a fragment of what was, no doubt, a charming figure of the Virgin, which is of a different style from any of the foregoing. The hands are clasped. It was found at Tower Hill in 1856. Many of these statuettes are partly coloured and gilded. Some have still the silver crowns belonging to them. In others the veil is partly cut away to receive the crown, which is missing.

There are four examples in ivory, supposing them all to be genuine—one in the Louvre, another at Lyon, the third at Rouen, the fourth known as the *Vierge de Boubon*—of a very peculiar kind of statuette or shrine, which is termed a "*Vierge ouvrante*." These

figures are so constructed that they open down the centre, forming two shutters or doors, which can be closed upon the central piece. Within, when opened, a variety of groups and figures are sculptured on the inner part of the tusk. These remarkable statuettes have been enormously written upon, especially by the learned Père Didron in the *Annales Archéologiques*, but there would appear to be some question of their authenticity. However this may be, it is certain that the fashion existed at an earlier date than the fourteenth century, for in the inventory of the church of Notre Dame at Paris in 1343 "an image of ivory cut down the middle and sculptured within with images, which used to be placed on the high altar," is mentioned as being at that time very old. The fashion (as it may be called) of *Vierges ouvrantes* was, no doubt, an extension of the diptychs and polyptychs with folding shutters, which came by degrees; in the first place, perhaps, through the carving of the outside of the shutters. There was no end to the ingenuity of the artists of those days. Sometimes, indeed, it was carried to extreme, and, in our eyes, irreverent lengths. An extraordinary image of the kind from the Bernardine Abbey of Maubuisson of the thirteenth century is in the church of St. Ouen, near Pontoise. Old French inventories mention numbers of figures of this class in various parts of the country. They were in all kinds of materials—in wood, in gold, silver, crystal, and so on; and there were other curiosities in the shape of opening flowers and fruits enclosing holy figures and groups. Besides the Louvre example, another, at Lyon, has been mentioned. Another is in the museum at Rouen, the resemblance of both to that in the Louvre, in the figures and groups, and in their arrangement—a few interesting differences apart—is remarkable. Whatever may be the verdict with regard to the genuineness of the Louvre figure, it cannot be denied that, if a forgery, it is

an extremely clever one. Both the composition and the execution of the groups in the interior are admirable. The authenticity has, however, been doubted, and by no less an authority than M. Emile Molinier, formerly keeper of the Louvre collection. Of it he says, in his *Histoire générale des Arts*, published in 1897 (before the discovery of the back or central part of the Boubon triptych), referring to these figures : " I refuse to admit for them the least degree of authenticity ; one alone, a fragment of a similar figure—the front portion of the *Vierge de Boubon*—which appears to be genuine, now exists, and it is to be supposed that it is this or another example unknown to-day which has served as a model to the forger, who about the year 1830 fabricated the two monsters of the Louvre and of Lyon." On the other hand, Viollet le Duc, speaking of the same figure in the Louvre, says of it that it is " extremely precious on account of the beauty of the workmanship" (*Dict. du mobilier*), and Labarte calls it a fine work, " un bel ouvrage" (*Hist. des arts indust.*). Didron, also, considered the sculpture to be infinitely superior to the *Vierge de Boubon*.

The subject of all these figures need not further be considered here at any length. With regard to the Louvre example, it will suffice to say that it has now been withdrawn from exhibition. Grave doubts have also been cast on those of Lyon and of Rouen. That of Boubon remains ; and apart from the undoubted merit of the sculpture itself, the story of this important piece is not a little interesting and remarkable. For many of the following details we are indebted to several communications made to the Archæological Society of Limoges at the time when it still remained in private hands in that district, and to the courtesy of M. Sailly, a former owner.

The *Vierge de Boubon* is so called because it belonged to the priory of Boubon in the Limousin

country, in the department of Haute-Vienne. The figure stands about eighteen inches in height, and opens down the centre in the manner which has just been described, forming in this way a kind of triptych. The Virgin, who is seated, holds on her lap a quatre-foiled panel carved with a seated figure of our Lord. When opened, there are within the statuette numerous groups and single subjects covering the whole of the interior, and these, indeed, correspond very closely with those of the three other examples which have been mentioned. It appears to have attracted little general attention until about the year 1873, at which time it belonged to the abbé Hugonneau-Beaufet, curé of Dournazac, a village in the vicinity of Boubon, to whom it had come through his great aunt, who had been a nun at the priory. It was not, however, the whole figure which was in his possession, but the front portion only, forming a diptych instead of a triptych. The back and the centre of the triptych when opened had been lost or had got into other hands, and in spite of researches continued for many years the abbé had never succeeded in tracing them. At the time of the French Revolution the convent at Boubon was suppressed. One of the sisterhood—Anne Hugonneau—retired to her brother's farm in the neighbouring hamlet of Saint-Mathieu. She took with her the folding-doors of the triptych, and from recent information we gather that the back and the base of the figure came at the same time into the possession of a M. Chaperon, the business agent of the community. On the death of her brother in 1800 Sister Anne continued to reside at Saint-Mathieu with her nephew, and, dying in 1826, bequeathed the figure to his son, afterwards curé of Dournazac. It appears to have been well known to the family for many years, but was treated with scant consideration, and in fact was little more than a plaything for the children—the *Baboïa*, or *poupeé*, as they called

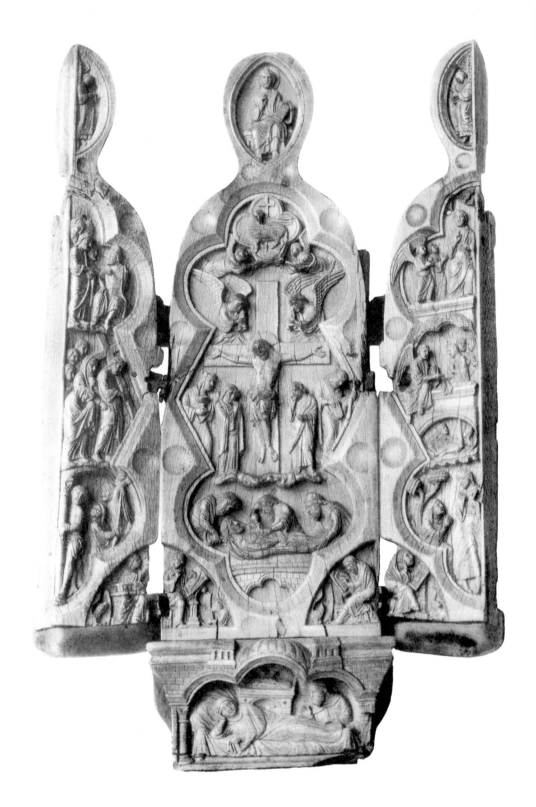

Plate 38. TRIPTYCH. "VIERGE OUVRANTE" OF BOUBON

THIRTEENTH CENTURY

it in their Limousin *patois*—who were accustomed to tie a string to it and to drag it about as they would a Dutch doll. The abbé Beaufet died in 1896, leaving the figure to his eight nephews and nieces; but it was still a fragment, consisting of the wings of the triptych only. Meanwhile it had attracted a certain amount of attention. The opinion of the learned Père Didron had been asked. He considered it to be inferior to the *Vierge ouvrante* of the Louvre—little suspecting the obloquy to be later on cast on this image—but of great beauty and interest. He valued it at twenty pounds—perhaps, with good luck, at twice or three times that sum—and recommended that it should be offered to the museum at Kensington. Whether this was done does not appear, but certainly our national collection is not placed in a position to compete against such prices as nowadays obtain. What, however, is still more interesting is that about the year 1898 the missing portions were discovered in the possession of a peasant at Saint-Mathieu, who gave them to the mayor of Abjat. The story is too long to relate in detail, but the honour of the research and discovery must be given to M. le Baron de Verneilh. At any rate, after the lapse of almost exactly a hundred years, the fragments of the *Vierge ouvrante* of Boubon were once more united. The then representative of the owners, M. Sailly, who was connected by marriage with the Beaufet family, exhibited the statuette at the Paris Exhibition of 1900. It was shortly afterwards sold to a Paris dealer for £1,360, and the complete figure was subsequently acquired by Sir Thomas Gibson Carmichael, at the sale of whose magnificent collection in 1902 it was bought by a London dealer for no less a sum than £3,800.

The importance of this figure in relation to the genuineness or otherwise of the similar ones in the Louvre and elsewhere is very great; but the few

[233]

remarks on this subject which may arise will be more fitly postponed to a succeeding chapter, when the question of forgeries in ivory generally will be considered. Not less important and interesting are those involved in a consideration of the style and execution of the beautiful statuette itself, and it is with reluctance that we yield to the limits of our space, which prevent our adding now more than some brief remarks and suggestions. We shall leave the subject with great regret, for there are few works of the period offering so many points for discussion and speculation.

It will be apparent, from an examination of the illustrations, that the whole composition and treatment express a different feeling and are of an earlier type than so many other charming examples of French work of the thirteenth century which have been described. There is, in the architectural details, in the arrangement and treatment and in the attitudes and expressions of the figures, a reminiscence of a severer style, which recalls Italian or Carlovingian developments. Note, especially, the use of the quatrefoil, in which our Lord is seated, and the mouldings which frame the subjects within the figure, and His attitude and draperies. The figure of our Lady herself resembles rather that on the Berlin book-cover (plate xiv.) than the smiling grace of the statuettes of the thirteenth and fourteenth centuries. Remark also the wide limbs and long upper arm of the cross, the uncontorted figure of the Saviour, and the feet nailed separately; the somewhat crude style and execution of the angel's wings and of the lamb within the small quatrefoil. And, indeed, there are other points requiring more than a hasty mention which might be open to misconstruction. They apply, it is true, to the centre of the triptych rather than to the subjects sculptured within the wings. For all this, although we might be inclined to place the date at an earlier period, we should hesitate to say that

the actual execution of the work may not be as late as the thirteenth century.

A very beautiful and affecting group at South Kensington is that on a plaque of the fourteenth century, in which the Virgin is fainting, as beneath the cross, and upheld by the holy women. All are in long draperies and veils of the period.

Another kind of group, of which we find some examples, is that of the favourite story of St. George and the Dragon. The ivory is usually in the form of a mound, or hillock, on the top of which is a castle. A little lower down the princess is on her knees praying, and at the base St. George is slaying the dragon. The whole, including the figures, is in full relief. A very fine specimen of late fifteenth-century work is in the Wallace Museum, and a smaller and less well-executed one among the Salting loans at South Kensington. No doubt the subject was often repeated.

Amongst the groups in ivory, perhaps there are few more interesting and beautiful than a very famous one of the thirteenth century in the Louvre, which was acquired at the sale of the Soltikoff collection. It is that of the Coronation of the Virgin, two figures seated. The costumes are of the time, and it is supposed, as some say, that the figures are portraits of Philip III., son of St. Louis, and Mary, daughter of Henry III. The whole composition is coloured, and it is curious to note the heraldic emblems on the embroideries of the garments. Very beautiful and remarkable is the anatomy of the hands of the figures, especially those of our Lord. The hands of the Virgin are a late restoration by M. Geoffroy Dechaulme. Beside this group are two most delightful figures of angels, which came to the Louvre in 1895.

It would seem to be more than likely that the two principal figures—our Lord in the act of crowning the Virgin — must have formed portions of a group to

which the two angels belonged, and possibly also one or more other figures. The principal figures were acquired from Chambéry by Prince Soltikoff, and from his collection came to the Louvre. In 1878 the town of Chambéry sent to the Paris Exhibition of that year the two angels. The resemblance in style and colouration was so striking that an arrangement for an exchange was speedily made, and these figures were added to the Louvre group. But previously another figure of a like character had been exhibited at the Paris Exhibition of 1867, and at that time catalogued as "S. Joseph, part of a group of the thirteenth century." This was acquired by Baron Gustave de Rothschild, and is now in his collection. Finally, in the inventory of Charles V., in 1380 A.D., is mentioned, "a coronation of our Lord at Nostre Dame, of ivory, and three little angels (*angelotz*) of the same sitting on a seat of cedar," and this is thought to be identical with the five figures referred to. It is true we have only two angels, and the seat of cedar does not correspond; but against this it may be said that mediæval inventories were often not very precise. In any case the group, such as we have it in the Louvre, is most charming. The principal figures are seated on a slightly decorated bench without a back, the Virgin, her hands reverently joined, inclined towards our Lord, who has just placed the crown on her head. She wears a long robe, over which is a flowing mantle, and beneath the crown a veil falls over her shoulders. Our Lord's crown is similar. The whole of the drapery of the costumes of both figures is painted and gilded and ornamented with a diaper pattern in gold of *fleurs-de-lys* and other heraldic decoration, from which it is conjectured that they are portraits of Philip the Hardy and his wife, Marie de Brabant. The faces and hair of both figures are also coloured. The group of two figures was acquired in 1861 for the then large price of £1,200. The

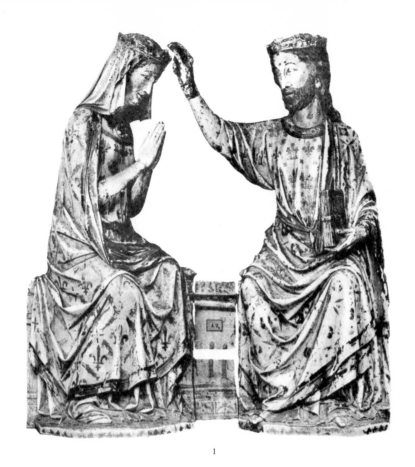

1

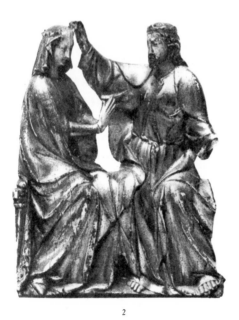

2

Plate 39. 1. PORTION OF GROUP. CORONATION OF THE VIRGIN. FRENCH
THIRTEENTH CENTURY. *(Louvre)*

2. GROUP. GILT AND COLOURED. FRENCH
FOURTEENTH CENTURY. *(Kensington Museum)*

Louvre possesses also several charming statuettes of the Virgin and Child of the kind already referred to. Amongst them there are two extremely beautiful ones, one of the thirteenth, another of the fourteenth century. The first bears numerous traces of coloured and gilt ornaments. The other is very large, coloured and gilt, and mounted on a base of silver gilt enamelled with the arms of France. On the breast of the Child is an agate cameo, the Virgin's crown is set with pearls and precious stones, and on her breast is an emerald. From old inventories it would appear certain that it belonged to St. Louis, and was formerly in the Sainte Chapelle.

By the side of the Louvre group we may very well place another small group of two figures in the museum at Kensington. It is again the Coronation. Our Lord is seated, and crowns the Virgin, who is seated near Him. The faces of the figures are coloured, the remainder is entirely gilt. It is French, of the fourteenth century. In both these groups the treatment differs from the usual feeling of the period. They are elegant and refined ; not wanting in idealism, and yet there is hardly present the same kind of reverential, devotional feeling. One does not seem to forget what has been suggested—and possibly the same train of thought engendered the suggestion—that there was perhaps in the case of the Louvre group a courtly purpose also to be fulfilled. It must be added also that not invariably in the groups in which the mother and Child appear do we find the same idealised simplicity. In a few, it is true, there is an air, on the other hand, too much of the fine lady, a simpering expression, or even an absolute boldness amounting almost to effrontery. With regard to the colouring of these groups and other ivory carvings, this is a practice in art as to which much may be said for and against. The difficulties are manifold, and there is always danger of vulgarity. In the diptychs and statuettes, however, which have been described, surely the artist has

worked with discretion, and it would be difficult to find fault; and after all, as a rule, it has been simply a question of accentuation, a touch here and there, a bordering of a garment, a gilding of the hair, an added brightness to the general effect. We shall have occasion, however, to consider this question later on, when we come to quite modern times. Meantime, mention may be made of a beautiful miniature diptych in the Wallace collection. It is Flemish, of the fifteenth century, each leaf measuring scarcely two inches square. It is entirely coloured, so that no trace of the ivory appears. On one leaf is the *dormition* of the Virgin, and it is interesting to compare the treatment of this subject with the conventional manner already described. On the other we have the crucifixion, and here we may remark a not uncommon detail. The souls of the thieves are represented by two tiny cherubs, one of which is received by an angel.

The descent from the cross, apart from its religious signification, is a subject which would naturally suggest itself to the mind of an artist as one demanding a high exercise of skill, not alone in the disposition of the figures, but also in the individual treatment of the action of the personages bearing the sacred burden. That is to say, that we are confronted with the problem of adequately representing with truth to anatomical detail the figures both of those engaged in lowering with reverence and tender care the weight of an inert human body, and of that body itself. It is a subject also which an artist would not shrink from expressing in a more dramatic manner than the great event of which it was the necessary sequel, and he is aided in such dramatic expression by the number of actors which he is able to introduce into the scene. For the Holy Scriptures themselves are his warrant for two at least who are mentioned by name— Joseph of Arimathæa, who is generally associated with the actual reception of the Lord's body, and Nicodemus,

who brought myrrh and aloes, and wound it in linen clothes with the spices. There are mentioned also the holy women; and St. John himself, who has given us the most complete record of the event, is rarely, if ever, absent from the representations which have come down to us. Other persons are also frequently introduced, and tradition in time assigned to them their several duties; for example, it is Nicodemus who removes the nails, and there are others whose identity is not perhaps always easy to verify, but who from their positions, or from being usually engaged in the same action, have, in the course of time, become definitely named.

It is not surprising, then, that the subject of the Deposition should frequently occur amongst our ivories. Examples are numerous in Byzantine and Western panels of the tenth, eleventh, and twelfth centuries, and are no less frequent in the diptychs, triptychs, and caskets of the gothic period. The earliest which we know is a Byzantine panel of the tenth century in the treasury of the cathedral at Hildesheim.

Our space will not permit our discussing in detail the earlier examples, but it would be impossible to pass by the beautiful and touching group of four figures in the museum of the Louvre. It is French work of the thirteenth century, and has formed part of some larger composition, in which the cross itself probably figured, and many other of the actors in the scene (*Frontispiece*).

Joseph of Arimathæa, bending forward under his burden, but the head raised and his gaze turned upwards with an expression of tender solicitude, bears hanging over his left shoulder, and advancing with steady steps, the body of our Lord, which has just been taken down from the cross. The head of the sacred figure hangs downward over the back of Joseph, who clasps the lower half of the body in front of him. One emaciated arm droops pendant, the other is seized by the second figure of the group, in whom we may recognise,

perhaps, one of the three Marys, who bends over the hand to imprint a kiss upon it. Of this figure alone, in the attitude, in the expression of the face, the long, clinging draperies of marvellous elegance in the disposition of the folds, in the tenderness with which she receives the hand, and the delicacy with which she raises a fold of her robe to cover it while she gazes on it with the utmost reverence and pity, all is incomparable, even in the figure work of this incomparable period of art.

Joseph himself wears a double garment, the under robe having a kind of tight-fitting sleeve to the wrists, above it a tunic with large, full sleeves, and an upper garment tied or knotted round the waist, in order to give more freedom in the execution of his task. The head of the Saviour Himself, bearded, and with long hair parted in the middle, the eyes closed in death, calm and serene as is the expression of those who have suffered even the most violent death, though the holy face bears the marks of the injuries which had been inflicted, is admirable in its realism, and yet the realism is of a kind which has no taint of horror in detail, and in its restraint is entirely reverential. Nor could anything be finer than the lower limbs, the feet drawn out and fixedly pendent from the treatment to which they had been subjected, crossed as they were crossed upon the cross, and showing the wounds of the nail which had transfixed them. The drapery is long and full, from the waist to the knees. Unfortunately, the left forearm has been broken off, and is wanting, and through this loss we miss a great deal, for it would be difficult to reconstruct the doubtless equally admirable manner in which the artist had completed the pose of the figure.

Reference has been made to an early example of the same subject. Another beautiful and remarkable Byzantine plaque of the tenth century was formerly in the Spitzer collection. The manner in which a similar style of treatment in the attitudes—it is not too much to say

even in the expression of the figures—has been carried on and preserved during so long a lapse of time, is very striking. Comparing the Spitzer plaque with the group just described, we find Joseph of Arimathæa in the same position, advancing, or one foot raised, and looking upwards, though in the first he holds the body of the Saviour lower down, and His head rests on his own. The holy woman receives and kisses the hand in the same way, covering her own with her robe. St. John stands by. The whole is beneath an open-worked canopy such as that with the Death of the Virgin (page 153). Nicodemus is in the act of extracting the nail from the feet. Probably it is his figure which is wanting in the thirteenth-century group.

The Louvre group may fittingly be placed in the same category as the group of the Coronation, already described, and as the work of southern France or northern Italy, to which the existence of a few, unfortunately but few, other examples of a similar character—for the most part elaborately painted and gilt—would lead us to suppose that much fine work of the kind now lost must have been executed in the thirteenth and fourteenth centuries. Attention may be directed to the very fine group of the Annunciation (two figures, the Virgin and the angel) in the museum at Langres, and the statuette of the Virgin at Villeneuve-lez-Avignon.

Of the fifteenth century a small round plaque of Flemish work, recently added to the collection at Kensington, must be noticed. The subject is the taking down from the cross, and it is an extraordinary piece of minute carving in relief and pierced work upon a coloured background. In the small space the figures are numerous, the expressions on the tiny faces well cared for and perfectly distinguishable, the composition excellent, and altogether it is a very interesting specimen of this period of transition.

We shall now go back some centuries to notice

an adjunct to the church services, of which some fine examples exist of the tenth to twelfth centuries. In many ways they are entitled to more attention than we are here able to give to them. They are the *situlæ*, or buckets for holy water, used in the ceremonial sprinkling of persons and things in the services of the church. The shape of a tusk would appear to naturally suggest itself as appropriate for such a vessel. One of the finest is that known as the situla of Charlemagne, of the tenth to twelfth century, in the cathedral of Aix-la-Chapelle. It is bound in gold, ornamented with precious stones, and carved with figures of an emperor, bishops, and archbishops, and other attendants. The ecclesiastical costumes are, of course, very interesting. Another is preserved in the treasury of the cathedral of Lyon, and another, of the tenth century, in the cathedral at Milan. The latter is inscribed, amongst other inscriptions, with the following: "Vates Ambrosi Gotfredus Dat tibi Scē Vas veniente sacra spargendū cesare Lȳphā." There was a Gotfredus archbishop of Milan in 973, and another of the same name in 1073, and the inscription, of course, puts beyond all question the use of the situla.

A curious liturgical accessory, of which the rare examples in ivory which exist are very beautiful, is the *flabellum*, or fan. Its primary use, originating in and necessitated by the requirements of the less temperate climates of eastern countries, was to keep away flies and insects from the ministers of the altar, and especially from the neighbourhood of the sacrament itself. In later times its use spread to the west, and symbolical meanings and a more sacred character became attached to it, as, in fact, was the case with other accessories for liturgical use, for which a perfect rage seemed to exist in discovering and adapting symbolism.

The use of the fan can be traced to a very early age. In the liturgy of St. James two deacons are directed to

hold fans of linen tissue or peacocks' feathers on each side of the altar to drive away insects. We find it also often mentioned in inventories. For instance, in one taken at St. Riquier, near Abbeville, "a silver flabellum for driving away flies from the Eucharist"; another, at Amiens, of silk and gold, given by a canon about A.D. 1250. In an inventory at Salisbury, A.D. 1314, are two flabella of silk and parchment; also at St. Faith's, in A.D. 1298, one of peacocks' feathers; at Rochester, in A.D. 1346, one of silk with an ivory handle; in the chapel of William Exeter, abbot of Bury St. Edmunds, A.D. 1429, "one muscifugium de pecok," and even as late as the year 1493 the churchwardens of Walberswick make a payment for "a bessume of pekoks fethers iv.d." Illuminations and miniatures show us these things in use, and they appear usually to be of the kind which expands into a circular shape, and can be shut up in a tube or case. Of course, the handles were often long, but we must be careful not to assume that all ivory handles of a similar character are flabellum handles. Holy-water sprinklers used at the asperges, no doubt, had often also handles of ivory, and there are other things for which they may have been used, for instance, for cantors' staves. There is a very beautiful example at Kensington—Carlovingian, probably south of France workmanship of the twelfth century—that is to say, that half of it is here, the other half, or at any rate a fragment very nearly resembling it, in the British Museum. The whole would have been about a foot long, very delicately carved in six compartments, divided by bands, ornamented with small round beads. The subjects, in high relief, are numerous fabulous animals, and birds and beasts, and some human figures, a centaur, monkeys, wild boars, dragons, and griffins. A monkey, especially, scratching his head with one paw and picking up nuts with the other, is very delightful. There are a few others of about the same date, mostly

ascribed to the south of France, carved in bands or compartments, sometimes with pastoral scenes, or even classical subjects, at others with beasts and birds and foliage, or, as in another example in the British Museum, with pictures describing the twelve months of the year. The last was a favourite subject with mediæval artists, who connected it with man's life and decline on earth. Or, again, as in the flabellum of the abbey of Tournus, there is a variety of decoration, full-length figures of saints—in this case the Virgin, St. Peter, St. Agnathus, and St. Filibertus—and an inscription, "JOHEL ME S̄CAE FECIT IN HONORE MARIÆ.' This flabellum is described at length in the travels of the two Benedictines, who mention that there is a similar one in the monastery of Prouille, in the diocese of Toulouse. A handle of a flabellum in the Salting collection, on loan at South Kensington, has four flat sides, on each of which are three niches surmounted by crocketed arches with, beneath, a figure of a saint. It is French work of the fourteenth century.

An important part of the furniture of the altar, which has now almost entirely dropped out of use in England, though the practice is still maintained in many parts of the Continent, is the pax. This is a plaque of metal, wood, or ivory, decorated with a sacred subject, used for transmitting the kiss of peace, instead of the ancient and now more usual practice of mutual salutation. It was kissed first by the celebrant, deacon, and sub-deacon, and other subordinate ministers, and then carried round by an acolyte to the laity. There are many very beautiful ones in silver and enamel, or in other precious material, in wood and glass, in existence, and the usual form is a plaque with a handle at the back, which formed a rest for it to stand in its place on the gospel side of the altar. We learn from Maskell's *Ancient Liturgies* that in the Sarum missal, " diaconus pacem recipiat," the deacon receives the pax. " The introduction of the pax

instead of the old practice of mutual salutation was not until about the thirteenth century. In a council held at York, in the year 1250, under Walter Gray, archbishop, the earliest mention occurs of the pax, or osculatorium, as used in England. It is named amongst the ornaments and furniture of the altar which were to be provided by the parishioners. In many of the printed editions of the Sarum missal it is represented as part of the furniture of the altar in the woodcut which commonly precedes the service for Advent Sunday" (*Ancient Liturgies*, page 116). The practice appears first to have fallen into disuse in England owing to quarrels relating to precedency in the order of its transmission to the people. Chaucer, in the Parson's tale, tells us of the "proud man who awaited to sit or to kisse paxe or be encenced before his neighbour." Those familiar with Shakespeare will not have forgotten that "Bardolph hath stolen a pax, and hang'd must a be." Sometimes the splendid coverings of books were used as paxes, as at Durham, where there was "a marvelous Faire Book which had the epistles and gospels in it. The which book had on the outside of the coveringe the picture of our Saviour Christe all of silver, which booke did serve for the paxe in the masse." It is said that a Carlovingian ivory plaque of the ninth century, fixed on the cover of the gospels in the cathedral of Tongres, is used as a pax, and kissed by the canons, after the gospels, with the words, "Ecce lex sacra"; but this would hardly be the proper time for the use of the pax, and is rather an extension of the kissing of the book by the officiating priest. And even under the new church régime the pax was not abolished, but adapted, for in one of the injunctions issued by the king's visitors to the clergy within the deanery of Doncaster, in the first year of Edward VI., "the clerk was ordered at the proper time to bring down the pax, and standing without the church door to say these words aloud to the people,

'This is a token of joyful peace which is betwixt God and men's conscience.'" The inventory of the parish church of Send, in Surrey, taken in the sixth year of Edward VI. (A.D. 1552), records "a paxe of ivory." The church at Send is very small, but the parish appears to have possessed at that time a large quantity of rich vestments and altar plate. In England the custom still obtains, at least in some monastic churches, for the writer remembers the use of a beautiful enamelled one, in late years, in the abbey church of Downside, near Bath, and its being placed upon the altar according to ancient usage. Ivory paxes are not very common, but there are several in the Kensington Museum, of the shape which was most usual, that is to say, with the natural curvature of the tusk. They are of the fourteenth and fifteenth centuries. The subjects with which they are decorated vary. St. George and the Dragon would appear to have been a favourite one, though the Crucifixion is, of course, the most appropriate. The pax of the eighth century at Cividale in Friuli, with the subject of the crucifixion, is referred to later on. If it is a pax, it must be the earliest in existence.

Some reference may now be made to rosary beads, for which ivory would naturally suggest itself as a material, and also to the curious devotional objects in the shape of deaths' heads, known as *memento mori;* but as examples are more numerous in the sixteenth and seventeenth centuries, we may postpone the general consideration till later on. A curious boss, or terminating bead of a rosary, German of the fifteenth century, in the museum at Kensington, may be noticed here. It is large—two inches in diameter—and consists of four half figures placed back to back. One is a man in the costume of the time with a cup in his hand, and beneath is inscribed, "Amor mundi." In the next he is dying, the mouth open, gasping for breath, and under him "Vado mori." In the third he is in a shroud, with horrifying details,

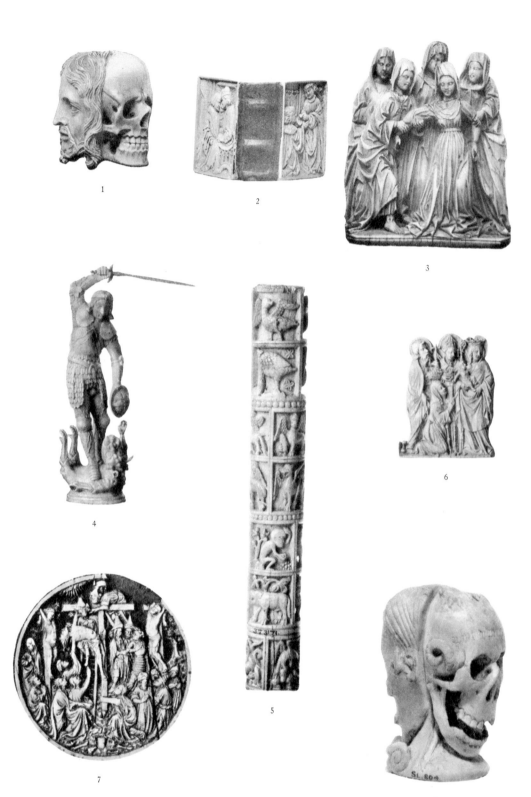

Plate 40. MISCELLANEOUS SMALL IVORIES

FOURTEENTH TO SIXTEENTH CENTURIES

1, 8. MEMENTO MORI. 3. GROUP, FLEMISH. 5. FLABELLUM HANDLE. FLEMISH MINIATURE WORK

and " Sequere me." And the fourth is a skeleton with an hour-glass, worms crawling in and out of the sockets of the eyes, and the inscription beneath, " Ego sum."

Ivory horns appear frequently amongst precious objects given to churches. They are mentioned in several inventories and, in illuminated manuscripts, they are represented as suspended in the church. Perhaps in country districts they served to call to prayers. They were also used as receptacles for relics. About 1060 A.D. Bishop Leofric presented four ivory horns to Exeter Cathedral.

There are two or three interesting specimens of small writing tablets decorated with religious subjects in the Kensington Museum, all French, of the fourteenth century. The first has, between the decorated outer covers, six separate leaves which have been slightly hollowed for wax, but afterwards painted very delicately in colours and gold in the style of contemporary MSS. The covers are carved with subjects under canopies of plain pointed arches, and have also been coloured and gilded. On one cover are St. Laurence in his dalmatic holding a gridiron, and a bishop fully vested ; on the other, the coronation of the Virgin. The second set of tablets still contains the green wax, prepared for writing, on the six leaves of which it is composed, and the covers are carved with three subjects under gothic canopies.

A brief reference, at least, should be made to the *cofanetto*, or casket, in the Prato at Florence, in which the holy *cingolo*, the girdle of the Virgin, has been preserved for centuries. The groups of winged cherubs, in ivory, which surround it, dancing and bearing what seem to be portions of the girdle, are said to have been restored in Donatello's time. However this may be, they are very poor in style and execution.

We cannot leave this part of our subject without referring once more to the probability that in our search

for the artists who designed and executed many of the beautiful works which have been described, we should find them amongst those who had devoted their lives to the service of the religion which is thus nobly illustrated. The conjecture can hardly be far wrong which ascribes them to the inhabitants of the monasteries and convents throughout western Europe. Probably in many instances they were the work of nuns. An illumination in a French MS. of the fifteenth century shows us a lady engaged in painting a statuette, her palette and brushes lying beside her, and other objects near by, ready to be proceeded with. There is no doubt that nuns were especially skilled in the transcription and illumination of MSS. M. de Montalembert tells us in his *Monks of the West*, quoting from numerous writers of the times alluded to, that "it can never be known how many services to learning and history were rendered by their delicate hands. They brought to their work a dexterity, an excellence, and an assiduity which the monks themselves could not attain, and we owe to them some of the most beautiful specimens of the marvellous calligraphy of the period." Can it be reasonably supposed that they should not also have applied themselves to such appropriate and elegant work as small sculpture?

The chronicles of monasteries such as those of St. Gall, of Cluny, or of Monte Cassino (of the latter especially), abound in references to the work of their monks, in chasing and setting, besides calligraphy, and we know that they were not only the architects, but the actual builders and carvers of the splendid cathedrals which adorned every land. At Monte Cassino, as we learn from its chronicles (*Leo Ostiensis, Chron. Cassinens*, book iii.), great works were carried out in painting, embroidery, carvings in wood and ivory, and gold and silversmiths' work, and we are told that they were executed there also by Byzantine and Moorish artists. Nor can we imagine that the monks of our great English abbeys

of Netley, of Croyland, of Evesham, or of Fountains, were not employed in a similar manner, and we must believe that from their hands proceeded the work of the splendid shrines. The monk Tutilo, already alluded to, seems to have been a universal genius—architect, painter, organ-builder and organist, and, withal, a theologian, "*valde eloquens*," a great preacher. Once more, amongst Englishmen, the abbot of Evesham, Mannius (eleventh century), is mentioned as skilled in the arts, particularly in goldsmith's work, and Matthew Paris, in his *Life of St. Alban*, tells us of Anketil "monachus et aurifaber incomparabilis," who made the splendid shrine at St. Albans for the relics of its saint and patron. References might be multiplied almost indefinitely. Enough has been said to justify the inference that although in the later middle ages secular guilds existed whose statutes show that ivory carving was amongst them an honoured craft, still it is perhaps to unknown monks and nuns that we owe the best and greater part of the religious carvings which have come down to us.

Finally, the rule of St. Benedict expressly enjoins the education in and practice of arts of all kinds in his monasteries. In accordance therewith they became furnished, not only with schools and libraries, but with studios where painting and sculpture, goldsmith's work and bookbinding were carried out. Very important indeed, and indicative of the reason why there is almost utter default of the names of artists, is the fifty-seventh chapter of the Rule, which may be quoted at length. It says :—

"If there be artists in the monastery, let them exercise their crafts with all humility and reverence, provided the abbot shall have ordered them. But if any of them be proud of the skill he hath in his craft, because he thereby seemeth to gain something for the monastery, let him be removed from it and not exercise it again, unless, after humbling himself, the abbot shall permit him."

CHAPTER IX

PASTORAL STAVES AND LITURGICAL COMBS

THERE are two important liturgical accessories in which ivory carving at its best times has played an interesting and prominent part. They are first the pastoral staff, or crosier,* of the bishop, and next the liturgical comb, used principally in the episcopal ceremonies, but also by minor ecclesiastics.

In all ages it has been customary for rulers of nations and for certain high dignitaries to carry a staff, or wand, or in the case of potentates a sceptre, as an emblem of their authority and power. The staff of the earliest ecclesiastical dignitaries, which by a process of evolution developed into the bishop's crook with its appropriate symbolical meaning is, amongst ivory carvings, one of the most beautiful of all the liturgical accessories with which we are concerned.

The most ancient form of bishop's staff which we find in early representations is that with a short handle and a plain boss or oval knob at the top, or bent aside

* The term crosier is used for the crook-shaped staff, although the objection is often made that it is incorrect. It is here, however, deliberately maintained, amongst other reasons, because it is more familiar and more expressive. The term would appear to go back to the eleventh century. In a charter of 1086 A.D. there is mention "de baculis abbatis qui *crocia* dicitur." And it is called the bishop's *cross* in the dialogue between *Dives* and *Pauper*, to which allusion will presently be made. In French the term is *bâton pastoral*, but more colloquially *crosse*, and in some parts of France the shepherd's crook is also a *crosse*. An archbishop's cross is borne before him, but he carries his crosier. (See also " *Origines et raisons de la liturgie Catholique*," by the Abbé Pascal.)

like a walking-stick. In fact, it is more than likely that the bishop's staff was at first nothing more than the ordinary staff or stick of domestic use. We have next the form to which the name of *tau* has been given, from the Greek letter τ, that is to say, a transverse bar on the top, the ends of which became curved in some cases, or at least the ornamentation upon them assumed such curves. There is no great variation in the shape of taus, of which we have several beautiful examples in ivory, and in metal and other material they are not uncommon (especially in the east), and equally beautiful.

The crook, or crosier, presents several varieties, sometimes in the earlier times having an affinity with the tau, or with the lituus of the Roman augurs, sometimes simply bent aside at the top, or extended horizontally from the staff itself, sometimes with a double crook one at each side. With these must be included the more sceptre-like rod or staff which we see frequently represented on our ivories, either in the hand of our Lord, or carried by an archbishop, down to at least the fifteenth century. In course of time the pastoral staff of a bishop assumed the more regular form of a shepherd's crook, and it is not difficult to understand how the elegant shape of the volute would have been eagerly seized upon by the artistic designers of these staffs, and treated with such variety and with so many shades of difference that the consequent variation of the curves alone is by no means the least interesting part of the study which may be devoted to these objects.

Nowadays, at least, the pastoral staves are no longer the insignia of or carried by the pope himself. In early times he bore merely a straight staff or sceptre, known as a *ferula*, but at no time a crosier. Even if a simple priest should be elected pope, he would not at his consecration receive the crosier. Tradition says that St. Peter sent a staff to St. Eucharius, the first bishop of Treves, and that it was preserved for some time in that

church; and St. Thomas Aquinas replies to a question on the subject, that the pope carries a staff only in the diocese of Treves, and not in any other; but whether this rule holds good with regard to the exception at the present time it would not be easy to say. An ancient representation of St. Gregory the Great (sixth century) shows the pope with a small staff in his hand, and we find the ferula of the pope referred to in the *Ordo* of Cardinal Censio, in the Ceremonial of Gregory X., both of the thirteenth century, and in that of Cardinal Cajetan, of the fourteenth century. Other instances might be multiplied, but it need only be said that at the election of Sixtus V., in A.D. 1585, the custom fell into disuse. Another kind of staff is sometimes seen in representations of St. Gregory the Great—a kind of cross with triple head or three transverse bars. But there would appear to be no authority for this. It has not improbably grown out of a simple cross and the bar or rest for the feet, to which, with an idea of further dignity, someone added a third bar. Possibly the third bar is an extension of the *titulus*.

With regard to the bishop's staff, we have early reference in the will of St. Reni, who bequeathed to his nephew his decorated staff of silver. Isidorus Hispalensis (St. Isidor of Seville, sixth century), in his *De officiis*, speaking of the consecration of bishops, says that the staff (baculus) is given as *indicio subditam sibi plebem vel regat vel corrigat vel infirmitates infirmorum sustineat*, referring to the subjection to it of the people whom it is to rule or correct, or to sustain the infirmities of the weak, by its indication of the right path; and there are numerous early writers who mention the delivery as part of the office of consecration. The staff, or crosier, belongs also to abbots and abbesses and cathedral priors, and is so mentioned in documents as early as the sixth century. On the tomb of Abbot Isarn (1048), in the museum at Marseille, the abbot

carries a *tau*, inscribed "VIRGA." In the penitential of Theodore, archbishop of Canterbury, in the seventh century, at the blessing of an abbot, the delivery of the staff is mentioned, but there is no liturgical formula. In other early Ceremonials, as in a Sacramentarium of the ninth century, we find, however, the injunction, "*In the name of our Lord Jesus Christ, receive the pastoral staff to guard the flock and to restore them to the supreme Pastor,*" and the same ceremonies and a similar formula in the case of an abbess. At that time, it may be noted that an abbess received her staff from the community; but later, as we see in the Pontifical of Sens, of the fourteenth century, from the bishop. The old Sarum pontificals also prescribe similar rites.

In many representations we find a kind of veil, or piece of stuff, which hangs from the knop of the crosier, and it has been thought by some writers that abbatial staffs are in this way distinguished from episcopal ones. But this can hardly be universal, at least, for on the tombs of Bishops Branscomb at Westminster, Oldham at Exeter, John de Sheppy of Rochester, and on other English tombs, we have the *velum* rolled round spirally. The point is interesting, but beyond our present scope; neither can we do more than mention that the usually received opinion that a bishop carries his staff in his left hand, an abbot in his right, and that the one has the crook turned outwards, the other inwards, is incorrect. On many tombs, also, of bishop and abbot, the staff is held indifferently either way.

The symbolisms attached to the crosier are various and interesting; some, as we shall see, are to be found inscribed on the staves themselves. On the ivory pastoral staff of Otho, bishop of Hildesheim (A.D. 1260), we have inscribed, together with the bishop's name, "Attrahe per primum, medio rege, punge per imum." That is, "Carry it by the upper part, govern by the middle, correct by the lower part (or point)." Or, shortly, "Persuade, rule,

punish." One or two references may be permitted here. Hugo de St. Victor thus explains the symbolism: *"Quae significatione non carent, recurvitas, virga, cuspis: significatio hoc carmine continetur :—*

> *" Collige sustenta stimula*
> *Vaga, morbida, lenta,*
> *Hoc est pastoris, hoc virga figurat honoris."*

Which is to say that the important points are the rod, the curve, and the cusping, signifying in verse :—

> Gather the strayed, help the diseased, stir up the indolent,
> This is the shepherd's duty, this the staff of honour figures.

And there is a quaint dialogue of the fifteenth century between Dives and Pauper.

> *"Pauper.* The byshops crosse is called a shepherds staffe to styre the byshop to lownesse, and to thynke on the cure and on the besynesse and the charge that he taketh upon him when he is made bysshop. He bereth no sceptre of worldely dygnyte to styre him to pryde, ne bereth ne swerde that is token of cruelte, but he bereth a shepherdes staff, not to slee ne to smyte, but for to saue his sheep that ben his suggetts spyrytually, whiche staff aboue is croked in maner of an hoke to drawe agen that wolde not come, or ellys go awaye."

Crosiers have been, and are, made of all kinds of materials—of wood, of horn, of iron, of crystal; and of course there are magnificent specimens in silver and silver gilt, jewelled and adorned in various ways. The metal ones were usually of extraordinary richness and elaborate design, and most frequently of an architectural type, which our ivory artists, with rare intuition, beautifully as we have shown they were able to apply it, carefully avoided. In the instances we have in ivory of its use, it was not altogether successful. In the list of crosiers belonging to Canterbury Cathedral in 1315 are one of cedar, with nine golden angels, others of silver, wood with head of black horn, ivory, and silver gilt. In the inventory of Lincoln, already mentioned, is "a staff of horn and wood for ye head of copper," but, singularly, amongst so vast an accumulation of treasures, not one

crook of ivory. An amusing jest of Guy Coquille is often referred to :—

> "Au temps passé du siècle d'or
> Crosse de bois, évêque d'or
> Maintenant, changeant les lois
> Crosse d'or, évêque de bois."

or, as we might say :—

> " The staff of a bishop in days that are old
> Was of wood, if the bishop himself were of gold ;
> But a bishop of wood prefers gorgeous array,
> So his staff is of gold in the new-fashioned way."

However magnificent many of the old crosiers in precious metal may be, it can hardly be gainsaid that there is something extremely charming in the lightness and simplicity of the examples in ivory which more particularly interest us, and we cannot but regret that the fashion of using this material appears to have entirely died out. In the metal and enamelled crosiers there is a sense of overloading, of over-richness. The details are not easily to be made out, if indeed more is intended than to give a general idea of gorgeousness and magnificence. In ivory we are able—in addition to the delicacy and purity of the material—to follow easily the scientific treatment of the curves, and to note the almost imperceptible differences in the manner in which the volute springs from the head of the staff and develops itself. We are able also to distinguish more readily the symbolical figures which are frequent in the earlier examples, and the charming groups which, so cleverly placed back to back in the centre of the volute, characterise nearly all the crosier heads of the thirteenth and fourteenth centuries. It is unfortunate that as a rule only the heads remain; few of the staves have come down to us, and they are the more to be regretted as we lose thereby the lesson of harmonious adaptation which we should undoubtedly gain from them.

Throughout the series of taus and crosiers which we shall notice, the prevailing symbol or emblem is that of the serpent. It is prominent, of course, in the examples, and we do not know that we should go very far wrong in surmising that it survives even in the form of the shepherd's crook, which was afterwards universal, and which may be only an instance of evolution. That the symbol of the serpent was adopted in Christian art from the first ages of Christianity is certain, and many are the significations applied to it. There is, of course, the reference to Moses' rod, and again we shall find very often in the crosiers the association of the serpent with the dove. We shall see him also entangled or combating or on the point of devouring the cross, the dove, or the Lamb, and in these things will be symbolised the combat of our Lord with sin, or the triumph of the Church over Satan.

It will be more convenient in noticing the series of pastoral staffs in ivory—and we propose to include all which have come down to us that we are able to identify —to take first the taus. These will practically cover a range of but two centuries, the eleventh and twelfth, and although during this period the crook shape was also equally as much in use, probably more common, still the tau, apparently, entirely died out about the end of the time.

The most usual method of treatment of the volutes of the tau was as an imitation of a serpent, sometimes simple and apparent, at others suggested only and covered with decoration ; and as many of these taus are of northern workmanship, so we find naturally that they are of walrus ivory and the characteristic decoration of floral arabesques, interlacing bands, and grotesque figures of men and animals is frequent. A very fine example from the abbey of Fécamp, of perhaps the tenth century, is in the Rouen Museum. The most remarkable, however, of this kind is the one at Kensing-

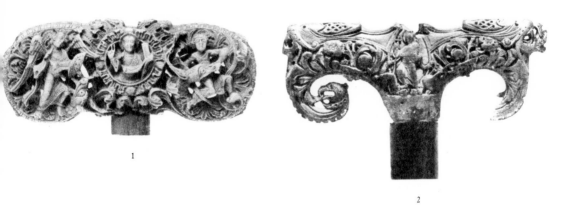

1

2

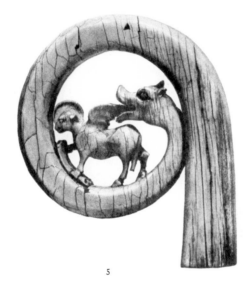

5

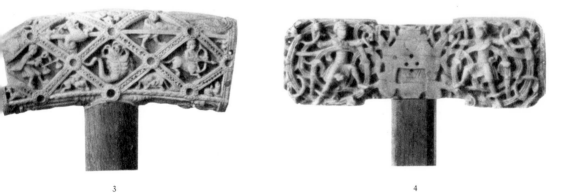

3

4

Plate 41. FOUR HEADS OF ELEVENTH CENTURY TAUS AND A CROSIER HEAD

1 AND 4. NORTHERN EUROPE. 2. THE ALCESTER TAU. 3. THE SOLTIKOFF TAU

ton of the eleventh century, which was formerly in the Soltikoff collection. It has lost the two ends, which were probably heads of animals, and perhaps of crystal. The decoration is most elaborate, and includes very interesting figures of priests vested for mass. In addition to the rich decoration, every little bead along the edges of the interlacements was set with a precious stone, as well also as the eyes of the animals.

There was another very fine tau of the thirteenth century in the Soltikoff collection, or perhaps, rather, a most elaborate head of a staff, for the summit is a figure of a lion. Beneath, around the staff, are, in compartments, representations of the consecration of a bishop. A head of a tau, French, of the twelfth century at Kensington is made out of a flat piece of ivory, carved in high relief, and represents men clothed in tunics and apparently tied by the convolutions of the interlacing arabesque work in which they are struggling.

Still more curious, and of a different type, is the tau which tradition attributes to St. Herebert, archbishop of Cologne, in the eleventh century. The ends are lions' heads with interlaced work round their necks. On one side is a figure of our Lord in an oval aureola, supported by two angels stretched out horizontally. On the other side is the crucifixion, with busts of the Virgin and St. John. It is now in the church of Deutz, near Cologne.

An interesting head of a tau of the usual character of northern work was discovered so lately as the year 1903, in the grounds of the vicarage at Alcester, near Warwick. It is of about the end of the tenth or beginning of the twelfth century, and no doubt came from the abbey which formerly existed in the neighbourhood. The floral ornament terminates in serpents' heads, and there is a representation of the crucifixion on one side. It is said that on its discovery it was sent to the British Museum for examination. The authorities there

desired the finders to name a price at which they would part with it. Wishing to put on what they considered a prohibitive one, they named a hundred pounds, which was promptly given. The style and the character of the decoration recall, in a way, the tau in the museum at Kensington (No. 371'71), but the latter is finer. There is also a similar tau in the Basilewski collection. Wherever made, the art is Byzantine. The Meyrick chair-arm and many oliphants and draughtsmen have a like style of ornament and origin.

For the remainder of the taus we may refer to the tabulated list in the Appendix, and proceed next to the more usual shape of the shepherd's crook. The figure of the serpent, with its usually opened mouth, forming the volute of the crook, occurs over and over again, until we come to the thirteenth century, when it is generally displaced by the elegant method of the charmingly decorated curve enclosing two subjects back to back. We pass through numerous variations of the symbolism of the serpent, the dove, the cross, and the Lamb, already mentioned. Of the two first we are at once, and obviously, reminded of St. Matthew x. 16: "Behold, I send you forth as sheep in the midst of wolves: be ye therefore wise as serpents, and harmless as doves." But we find also many instances of a cross, usually a Maltese one, or a *croix pattée*, stuck in the mouth of the serpent, or, to use the heraldic term, by which the serpent's or dragon's mouth is empaled. In other cases the projecting tongue of the serpent is forked, or elaborated into a floriated form. It is permissible, therefore, to conjecture that the cross in the mouth may come simply from additions such as these to the tongue to which a symbolical meaning would readily suggest itself, and convert into a practice that which was at first accidental. We may refer, for instance, to the floriation in an early example, such as the crook of Bishop Ivos, of Chartres, A.D. 1091.

Another emblem in the volutes of early crooks is the combat between the dragon and the lamb, as, for example, in the crosier of the thirteenth century preserved in the convent of the Sœurs de Ste. Marie, at Namur, or in a similar one in the Ashmolean Museum. Or, again, as in the one called St. Gregory's, in his church at Rome, though doubtless not older than the twelfth century, in which a ram holding a cross is attacked by the dragon or serpent terminating the volute. The ram, as leader of the flock, with a cross, is frequently represented, or the Lamb, with or without a cross or banneret, and in one instance, at least, with the breast pierced, from which blood flows into a chalice. After a time the serpent is absent, or we find it (an interesting imagery) with foliage in the mouth, as if feeding. Then the lamb disappears, and sometimes the crook is absolutely plain, and dependent on the elegance of the curve. The serpent termination would seem, in fact, at one time to have been almost obligatory. Later it is mingled with ornament and leaf work. Finally it disappears, and the foliage ornamentation dominates, until we settle down, as it were, to the elegant and simple type of floral ornament with a double subject, and the angel supporting the volute, which are characteristic of the refined period of the fourteenth century.

To follow in a regular manner the evolution of the ornament and symbolism to which we have alluded would be far beyond our limits. We shall therefore select a few prominent examples, and leave the remainder to the tabulated list.

A curious circumstance which these crosiers share with the liturgical combs is the large number which are attributed to canonised saints. It is, of course, evident in most cases that the date of workmanship is very considerably later than the date at which the saint lived; but, as in the case of the staff of St. Gregory the Great, it is probable that on the opening of tombs, or on the

translation of relics, a new staff was substituted for the one previously enclosed.

An early example of a style which is not common is the Siculo-Arab crosier of the thirteenth century at Kensington. It is of bone, and in this case, besides the head, we have also the whole of the staff. The volute springs from a geometrically sided knop on which angels and emblems of the evangelists are alternately carved in relief. The serpent's head which terminates the volute is in the act of devouring a dove, and in the centre a lamb turns up his head towards the dove, as if to assure it of protection. The outer edge of the volute is crocketed with a series of projecting winged ornaments. The staff is composed of cylindrical sections, and the whole is diapered in colours and gold. A somewhat similar staff is in the Salting loan collection. The top of the staff is a serpent's head, and from its opened mouth springs the volute, which is surmounted by busts of our Lord and two apostles. Beneath is a four-sided crocketed knop on which are painted the four evangelists with dragons and foliated work. It is perhaps more interesting than beautiful.

Amongst all the ivory crosiers which we possess, probably there is none more beautiful than the famous one formerly in the Soltikoff collection. It is French work of the thirteenth century, and in splendid preservation. Above all should be remarked the elegant proportions and sweep of the volute, somewhat small and contracted, and diminishing in width in a most charming manner from the point where it springs from the stem to where the curve begins. Nothing could be more elegant than the effect which is thus produced and opposed to the lumpiness which prevailed in later times. In the centre is the clever arrangement of two subjects placed back to back, but in such a way that the open work of one scarcely interferes at all with the other, giving us on one side of the crook the crucifixion, on

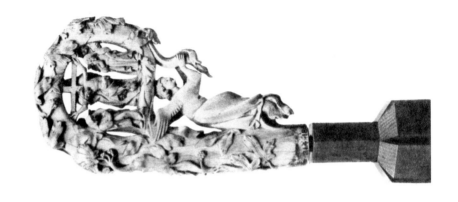

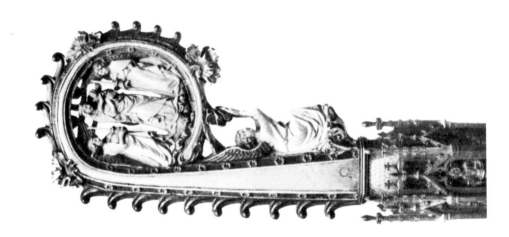

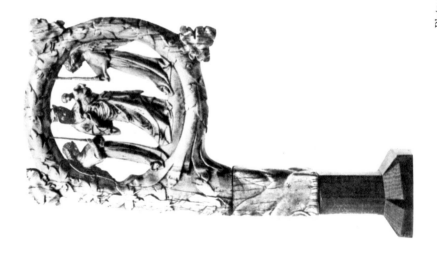

Plate 42. CROSIER HEADS. FRENCH

THIRTEENTH AND FOURTEENTH CENTURIES

the other the Virgin crowned and standing on a dragon, which she treads beneath her feet. An angel, in a tunic girded round the waist, supports with uplifted arms the volute, kneeling on one knee on a bracket which springs from the staff. Around the curve runs a deep moulding, within which are roses at intervals, and three floriated ornaments break the outside line of the crocketed curve. There are sufficient traces remaining of the rich colouring and gilding which formerly decorated this very precious work. It was sold at the sale of the Soltikoff collection for £180, and acquired by the museum in 1862 for £265.

We have several other beautiful instances in the museum and in other collections of the same style of treatment of a crosier in ivory of the thirteenth and fourteenth centuries—that is to say, of the volute carved usually with leaf work, upheld by a kneeling angel, and having a double group in the centre. Sometimes there are three or more bold foliations, or crockets, on the outer edge of the curve which break the line, and perhaps give a square-headed effect, to some extent hiding the crook shape, and now and again there is no supporting angel.

In the *Revue Archéologique*, vol. xiii., an ivory crosier is mentioned and figured and described by M. Guénébault as being in 1856 in the collection of M. Jacquinot Godard: Romanesque work of the eleventh or twelfth century. The flat sides are covered with foliated interlacements of birds and fabulous animals of extreme elegance of design, the volute terminating in a dragon which bites part of the staff. Within the volute a bishop in chasuble and mitre and with his staff is in the act of blessing or confirming a figure kneeling before him, and around the base from which the curve springs are three figures—a bishop, a deacon, and a sub-deacon. The head of the staff is of an architectural character, with the inscription, "Sit nomen

Domini benedictum." M. Guénébault remarks that in the figures referred to, the absolute form of ecclesiastical costume of the eleventh or twelfth century is clearly indicated. It would be interesting to know where this apparently beautiful work is now to be found. The illustration given is unfortunately a woodcut, and such reproductions are often very misleading.

A very beautiful crosier of this class is in the possession of the Howard family of Corby. It bears on one side a representation of the Virgin and Child seated and attended by angels; below are diminutive figures of the three kings. On the other side our Lord is seated in judgment between two angels bearing instruments of His passion; at His feet human figures issue from their tombs. On the knop are the twelve apostles arranged under six canopies with two niches in each. It is of the fourteenth century, and may reasonably be considered as a fine specimen of English work.

The crosier of Bishop Otho of Hildesheim, son of Duke Otho of Brunswick Luneburg, in the cathedral of Hildesheim, is of the serpent and Lamb type, and bears the inscription previously noticed, "+OTTO EPISC I HILDENS. Collige sustenta, stimula vaga morbida lenta Attrahe per primum, medio rege, punge per imum Pasce gregem norma, doce, serva corrige forma"; and on that of St. Annon, at Cologne—a beautiful example of Rhenish work of the eleventh century, a quite plain but very elegant curve—we have, "Sterne resistentes, stantes rege, tolle jacentes."

A very beautiful staff, French work of the eleventh century, in the British Museum, is said to be that of St. Bernard. The volute ends in a serpent's head about to devour a cockatrice, which fills the centre, and beneath it is supported by an eagle. It has at one time been covered with gems, but the setting and gilding only remain. In the same museum are also an extremely interesting crosier head of English work with a grotesque

group of a man struggling with the serpent which forms the staff and volute, his feet already within the jaws; the head of the staff of Alexander, abbot of Peterborough, A.D. 1226, which was found in his coffin; and another English one of the fourteenth century.

The crosier of St. Gautier, abbot of St. Martin, at Pontoise, A.D. 1066, has thirty scriptural subjects sculptured round the staff. Another very curious example is that called the crosier of St. Trophimus, at Arles, of the twelfth century. It is square in section, terminated by a dragon's head, which touches the staff where it is upheld by a figure of a boy. In the volute the translation of the saint's body is represented in an archaic manner. An elaborate example is the crosier formerly in the Soltikoff and now in the Salting collection in the museum at Kensington. The volute is upheld by the kneeling figures of an angel and a tonsured bishop. Within the curve are figures of the Virgin, an angel, and a bishop. It appears to be late fourteenth-century work, if not indeed at least as late as the middle of the fifteenth. The aspect is rather square-shaped than that of a crook, and it seems overloaded with figures and ornament. The portion of the staff below the crook is decorated with leaf-work rosettes and plain shields. Both this and the other crosier in the collection are accompanied by their beautiful cases of *cuir-bouilli* work of the period.

One more example, or rather, a portion of a crosier, remains to be described. Of any work in ivory of mediæval times which has come down to us it is perhaps the most beautiful, and it is included here because, though a fragment, it can scarcely be doubted that it must at one time have formed one of the double groups within the volute of a crosier which have already been mentioned more than once. On one side is represented the agony in the garden; on the other is a group of the kind which we know by the expressive term, a *Pietà*,

that is, a representation of the Virgin holding in her lap the body of her divine Son at the moment immediately after the descent from the cross. There is no more touching episode in the world's history, and it may safely be asserted that in no other material, and by no other artist, be he known by a great name, or unknown and undistinguished as is the designer and sculptor of this exquisite group, has the subject been more admirably and pathetically treated than in this small ivory. The position in which the mother supports the head, while the lifeless body is half falling in helplessness, the simplicity and naturalness of the veil and draperies, the bereaved gaze of the Virgin, above all, the reality of death in the face and limbs of the divine Person, are almost beyond expression. For a description to be sufficiently true it would indeed be necessary to dwell upon every and the smallest detail; the position of the hands, the anatomy in the figure of the dead Christ—there is nothing that could be omitted. The whole piece is hardly three inches high, and has been coloured. Indeed, one wishes it had not (plate lii.).

It will be seen that the variety amongst these beautiful specimens of bishops' crooks is very great. More could be specified and further variations, but it would become tedious. The best examples stop early in the fifteenth century, and we have little interest in following them through the time of the renaissance and succeeding periods, for in ivory there is nothing worth notice. As in other church work of the rococo times, we find but overloaded and unmeaning ornament, grotesqueness and vulgarity often at its worst. The blessed Virgin is enthroned and crowned with monstrous crowns, we have cherubs instead of angels, coarse acanthus and bulbous ornaments in profusion, unreal clouds, and flames for glories. Meretricious extravagance takes the place of refined devotional feeling; there are hardness of line and precision of chasing, instead of the freedom of better

times. There is an ivory crosier of the eighteenth century in the Kensington Museum which is better left un-described. Of the period of the high French mitre and of the elegant abbé we must be prepared to expect something equally fantastic.

A few words must be added regarding another kind of staff used in the church service, although we are un-aware of examples in ivory. This was the staff of the ruler of the choir, or cantor's staff. It would appear that it was usually surmounted by a short crosspiece, on the top of which images were sometimes set. Bishop Leofric left three cantors' staves to his cathedral of Exeter. In the treasury of Salisbury, in 1222, there were eight, and at Canterbury, in 1315, among the cantors' staves, four were of horn with ivory heads, and five of silver, also with ivory heads. (Dart, *App.*)

The comb was a very important accessory in the ceremonial of the Church, and its use may be traced to very ancient times. It was often elaborately decorated, and as most of the finest specimens that have come down to us are of ivory, they form a very interesting portion of our subject. Ivory appears to have been the natural material for such things, and we shall in a succeeding chapter refer to many beautiful examples for ordinary domestic use. In both cases they were often very large, and evidently considered fit subjects for decoration. The form is nearly always the double one, that is, with two rows of teeth, of the style which we now call the small-tooth comb. Although in early and mediæval times the tonsure of the clergy was much the same as it is now-adays, it would appear that in the case of some orders of monks a circle of thick hair was left which often re-quired the use of the comb. Thus in time it became a recognised liturgical accessory, especially of a bishop when ceremonially vesting before celebrating High Mass; and in the ceremonial, as we find in the Roman pontificals, there were also provided special *peignoirs*, or wrappers

(*tobalia, touaille, towel*), to be used during the combing.
In the missal of Lunden, A.D. 1514, we have the prayer,
common to both priests and bishops, prescribed to be
used. The expressions are naïve and unnecessary to
quote, praying that as the head is cleansed, so also may
be the heart. In the case of a bishop the ceremonial
lays down that, being seated in the faldstool, after having
had his ordinary shoes changed for the sandals, the deacon
envelopes him in the *peignoir*, and combs the hair re-
spectfully and lightly. In the pontifical of Clement VIII.
and of Urban VIII. (1623), amongst the objects necessary
to be provided at the consecration of bishops are "a ring
with a stone to be blessed, a comb *of ivory*, and two
candles for the offering." The combs are often so large
that the ceremony no doubt, like many others, was
perfunctory and partly symbolical. It is not uninteresting
to remark, as touching possibly the habits of divers
periods with regard to the wearing of the hair or beard,
that most of the examples of combs which remain to us
are of the tenth to twelfth centuries. Most likely at
first it was a sacristy article for the use of all ecclesiastics.

The custom appears to have fallen into disuse early
in the sixteenth century, except possibly for consecra-
tions, where the hair is disarranged owing to the
enveloping of the head with linen after anointing. In
this conjunction we have an interesting instance in the
Order of the Coronation service of King James I., in
which we find: "The prayers being ended, First a
shallow 'quoif' is put on the King's head, because of
the anointing: if his Majesty's hair be not smooth after
it, there is King Edward's ivory comb for that end."
This may have been the "one old comb of horn, worth
nothing," in the list of the regalia destroyed on the 9th
August, 1649. (Davenport, *The English Regalia*.)

Liturgical combs are very often mentioned in wills
and inventories. In the inventory of St. Paul's in the
year 1222 there were three large, three small, one

"pecten pulchrum," the gift of John de Chishulle, and three others, all of ivory, and as many in the treasury of the cathedral of Canterbury in 1315, besides "j pecten eburneus cum lamine argento et deaurato cum gemmis ex utraque parte." An ivory comb was found amongst the relics of the supposed tomb of St. Cuthbert at Durham, and in Raine's account of the tomb he prints an inventory, dated 1383, of the relics at Durham, amongst which were the combs of Malachias the archbishop, of St. Boysil the priest, and of St. Dunstan. A rubric in the pontifical of Archbishop Bainbridge of York shows that the ceremonial use of the comb continued in England until the Reformation. It is curious to observe, amongst the ivory combs now in existence, how very many, as in the case of pastoral staves, are attributed to saintly personages. No doubt a reason for this comes from the old chronicles. At the times of translations, for example, a comb would be noted in the inventories, made good or replaced, and by degrees would become attributed to the saint in whose reliquary it was kept.

The number of liturgical combs that are known is not very large, and they are all interesting. It is not always easy to be certain of the dates, and probably many would have been copied from other existing ones over and over again. The comb called the comb of St. Loup is in the treasury of St. Etienne at Sens. St. Lupus died A.D. 623, and it would be difficult to be more precise as to the date of this beautiful example than to place it somewhere between this time and five or six centuries later. It is of the usual double shape, the teeth smaller on one side than on the other, and in the centre is a semicircular plaque ornamented with foliage and lions, and set with precious stones. The design of the foliage is almost identical with that on the comb of the eleventh century in the museum at Cologne. The inscription, "PECTEN. S. LVPI," is of the fourteenth century.

[271]

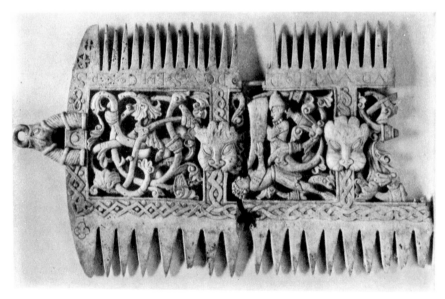

2

Plate 43. LITURGICAL COMBS

1. ENGLISH. TWELFTH CENTURY. 2. COMB OF ST. HEREBERT. NINTH CENTURY

1

The comb of St. Herebert, Carlovingian work of the ninth century, is an extremely fine example, unusual in shape and of remarkably good design and execution. It has one row of teeth only, the large handle being cut out to suit the fingers holding it, and in such a way as to give it a very elegant form, the curves of the notches having been made the most of in the admirable arrangement of acanthus foliage, and of an angel on each side, with wings stretched upwards, descending, as it were, to the group of the crucifixion above the curved top of the range of teeth. The back is also decorated with acanthus foliage, disposed with the utmost symmetry. A comb, known as the comb of St. Berthuin, in the diocesan museum at Liège, came from the treasury of the abbey of Malonne, an abbey founded by St. Berthuin, who was of English origin, at the end of the sixth century. It bears a peculiar figure, from which it is not unreasonable to suppose that it is of eastern, possibly Persian, workmanship.

The comb of St. Gauzelin is in the treasury of the cathedral of Nancy. St. Gauzelin was bishop of Toul from A.D. 922 to A.D. 962, and this comb is a graceful design, which we can without any difficulty accept as an example of tenth-century workmanship. It has two rows of teeth, the centre portion, which is nearly square, open-worked with a very beautiful design under arcades; an arabesque of vine leaves and of bunches of grapes, which appears to spring from a chalice. Among the vine branches are three doves. The ornamentation is boldly designed and admirably executed, and it has a remarkable resemblance to that on a sarcophagus at Ravenna, from which it would almost appear to have been directly copied. There are the same interlacements of foliage and bunches of grapes springing from the chalice, the same three doves pecking at the fruit, and, as a matter of fact, these symmetrical arrangements and symbolical groupings of vines issuing from chalices,

with doves or lambs, with crosses and monograms, are frequent in the sculptured monuments of Ravenna. They are seen also in early mosaics, for example those of the sixth century in the church of St. Apollinare Nuovo, at Ravenna, and in the catacombs at Rome. And again, in the black font at Winchester we have the birds and cup from which a vine issues. Sometimes the doves are drinking from the vase, or their heads are inclined backwards to each other, beak to beak; but the vase, or chalice, and the vine branches are the most frequent. That Christian symbolism is intended is of course evident; at the same time the device has, in all probability, a pagan origin, to be traced back, perhaps, to remote oriental times.

Two interesting liturgical combs from the old church of the Capuchins at Stavelot are now in the museum at Brussels. The first is very large, with two rows of long teeth, the centre ornamented with an arabesque of foliage and birds. The second has in the middle a large foliated rosette and the inscription, "Quicunque ex me suum planaverit quoque caput, ipse vivat feliciter semper annis," a pious wish for happy years to those who use it. Both were found in a wooden box amongst other débris of the principal altar in the church at Stavelot, and had probably been enclosed in a reliquary.

The comb of St. Hubert, patron of hunters, who was bishop of Tongres in 727, is preserved in the abbey of St. Hubert, in the Ardennes. It is of the usual shape, the field ornamented with elegant floral arabesques. There are several others, which we must be content to notice shortly in our tabulated list, and for the present describe only two of English origin. The first, probably thirteenth-century work, has long been preserved at Hardwicke Court, Gloucestershire. It is carved in high relief with New Testament scenes—the Nativity, the angels appearing to the shepherds, the Flight into Egypt, the Massacre of the Innocents, the Last Supper,

the Betrayal, the Crucifixion, and the Entombment. The armed figures in the Entombment have pointed helmets with nasals and long kite-shaped shields.

The second English comb is a very remarkable and beautiful specimen of perhaps the twelfth century, in the British Museum. There are two rows of coarse teeth, and between them in three compartments (though unfortunately one end of the comb is broken and missing) are interlacing leaf-work scrolls, and amongst them a man in a belted tunic blowing a huge trumpet. The flat bands have a very curious plaited ornament in relief, and a kind of small handle with a ring for suspension is still more interesting. The latter portion recalls in a curious way the peculiar method of inlay in precious stones, and of depressions in the metal resembling those prepared for inlay, which characterise some early northern work, for example, the gold ornaments known as the treasure of Novo-Tcherkask, which were found in 1864, but of what date or origin it is difficult to say. The incised inscription on the comb is, as far as it is to be read, " VD. VVLT. D.....DEVS. LHꙠ ꓿ PS."

With regard to the shape of liturgical combs, there would appear to be a certain amount of progressive regularity. At the same time it must be remembered that though probably of larger size, they would have followed to some extent the usual form of ordinary domestic combs of the various countries of origin. The semicircular field of the central portion, either plain or open-worked, or, as in the case of the comb of St. Loup, ornamented with precious stones, and having two rows of teeth, was perhaps the result of a gradual evolution, which became fixed, as a type, about the eleventh century. We find, then, the characteristic ornamentation of foliated arabesque, amongst which are grotesque or symbolical animals or birds. The largest combs would have two rows of teeth, on the one side large, on the other small; the smaller combs but one row. Both kinds are ex-

emplified in the Stavelot combs. An earlier form was a rectangular centre with shorter and thicker teeth, which becomes square with extremely long teeth, as in the comb of St. Gauzelin, in the early part of the tenth century. Earlier still is the extremely elegant notched shape with a single row of fine and closely ranged teeth, which we find in the two combs in the Cologne Museum and in the comb of Henry II. at Quedlinburg, which much resembles them. These three are probably of eastern origin, or at least to be attributed to eastern influence.

Besides the combs for liturgical uses, ivory mirror cases, decorated with religious subjects, are sometimes found; and although they are not referred to in rituals as forming part of the furniture of the sanctuary, still they would have been probably used in the sacristy. In the same way very large shoe-horns of ivory, similarly decorated, would perhaps have been required, for a bishop is ceremonially vested with sandals, and shoes are taken off by priests in a part of the services of Holy Week.

An unique example—in ivory, at least—of a curious instrument for ecclesiastical purposes is in the Basilewski collection. It is a *crepitaculum*, or rattle, used during the offices of the church on days in Holy Week when bells are silenced. The broad blades, which are of a long rectangular shape, are carved with scenes from the Passion, and the handle with figures of SS. Peter and Paul. Passeri describes and figures it in his *Thesaurus*, but imagines it to be of wood. The date and origin are uncertain. It may be Italian of about the twelfth century.

A LIST AND SHORT DESCRIPTION OF SOME KNOWN EXAMPLES OF IVORY TAUS AND CROSIERS

TAUS

SIXTH CENTURY?

Cathedral at Bruges. Staff of St. Maclou. Fragments mounted in copper gilt.

NINTH CENTURY?

Parish church, Deutz. Tau of St. Herebert? Our Lord in oval aureola, on each side wingless angels stretched horizontally; crucifixion, descent into hell, etc. Lions' head ends. Probably not earlier than the eleventh century.

ELEVENTH AND TWELFTH CENTURIES

Paris. Cluny Museum. French. Unusually simple shape; found at St. Germain des Près in tomb of Abbot Morard (A.D. 990–1014).

St. Petersburg. Basilewski collection. An animal biting Maltese cross, at each end.

Paris. Texier collection. A large reversed triangular head, the outer angles ending in lions' heads.

London. British Museum. English. Floral ornament, etc. Found at Alcester. Described in text.

London. Kensington Museum. N. Europe. Formerly in Soltikoff. Described in text.

London. Kensington Museum. Volutes of serpents seizing men, subdued by Archangel Michael; our Lord in glory in centre of one side; in the other the Virgin and Child; a very fine example.

Rouen. Museum. Arabesque foliage and figures; interesting symbolism; a lion, dragons, birds, etc., in the whorls.

Maestricht. Cathedral of St. Servais. Tau of St. Servais. Arabesque foliage and branching acanthus leaves. (St. Servatius, or Servais, was of the fourth century.)

Salzburg. Monastery of St. Peter. Tau of St. Rupert. Octagonal stem with inscriptions; serpents' head volutes.

Regensburg. Ramwolds Gruft. Staff of St. Wolfgang; foliage; head of unicorn.

Chartres. Museum. French. Lion's head in centre; foliated branches.

Brussels. De Crassier collection (?). Medallion with Virgin and Child in centre of one side; on the other St. Michael subduing dragon; men struggling with dragons on volutes (perhaps identical with that at Kensington described above).

London. Kensington Museum. N. Europe. In form of snakes; an archbishop on one side, on the other a saint, under round Norman arches; doubtful authenticity.

London. Kensington Museum. French. Flat-sided; two men struggling amidst the floral arabesques on one side; winged griffins on the other; the ends lost.

St. Petersburg. Basilewski collection. N. Europe. Medallion in centre of each side with busts of our Lord and of Virgin and Child; foliage; dragon's head ends.

CROSIERS

NINTH (ELEVENTH?) CENTURY

Rome. Vatican Museum. Octagonal whorl; animal's head end.

Fulda. Cathedral. Staff of St. Boniface. Dragon's head end; unicorn and cross in volute.

TENTH CENTURY?

Rome. Church of St. Gregory. Staff of St. Gregory. Combat between serpent and cross; ram with cross (St. Gregory was of sixth century), given by Pope Gregory XVI. to the monastery of St. Gregorio, in Monte Celio, where it is exposed as a relic. Tenth century, or later. Some incised ornament is probably considerably later. The Maltese cross is on a staff, or *ferula*, and is not held by, but stands behind, the ram.

Newcastle-on-Tyne. Museum of Philosophical Society? Formerly in Allan Museum of this town. Resembles that of St. Gregory, but the lamb has the head turned to a large *croix patée*, which the serpent is apparently attacking; said to have come from Easby Abbey; illustrated in catalogue of Allan Museum (1827).

London. British Museum. Irish. Interlaced animals; dragon head end of volute; found in ruins of cathedral of Aghadoe. Tenth to twelfth century. Formerly in Meyrick.

Como. Church of St. Carpoforo. Staff of St. Felix. Combat of serpent and cross.

ELEVENTH, TWELFTH, AND THIRTEENTH CENTURIES

Cologne. Cathedral. Staff of St. Annon. Plain volute; serpent's head end.

Reims. Cathedral. Fragments of stem; scriptural subjects in fifteen compartments.

Lyon. Cathedral. Ram or unicorn head, with Maltese cross.

Florence. Bargello (Carrand). Figures of bishop and priests at base, evangelists above knop, arabesques with men, birds, and beasts on volute; dragon's head end with Maltese cross.

Pontoise. Staff of St. Gautier, abbot in 1066. Thirty-six scriptural subjects.

Admont. Monastery. Dragon's head end; winged horse in centre with Maltese cross in mouth.

Narbonne. Museum. Dragon end; Annunciation in volute.

Bamberg. Cathedral. Staff of St. Otto. Serpent whorl; Annunciation within.

Altenburg (Aust.). Monastery. Volute terminates in head of a beast; eagle and another bird in centre; a Maltese cross on open wing of eagle.

Regensburg. Church of St. Emmeram. Staff of St. Wolfgang. Figure of the bishop.

Regensburg. Niedermünster. Interlaced ribbon work. Dragon's head end.

Arles. Cathedral. Staff of St. Trophimus. Translation of the saint in the volute.

Trent. Church of St. Apollinaris. Spiral whorl, knobs on edge, snake's head end.

Göttweitz. Monastery. Two birds within volute, necks intertwined; serpent's head end.

Rome. Vatican Museum. Whorl ends in unicorn's head, branch in mouth.

Salzburg. Frauenstift. Volute springs from dragon's mouth; *agnus dei* in centre; foliage crockets; dragon's head end. Inscriptions: Ave Maria, etc.; Salve Regina, etc.

Maestricht. Cathedral. Staff of St. Servais. Quite plain, flat-sided volute; serpent's head end.

Niedermünster. Serpent with cross. Floriated.

Siegburg. Staff of Bishop Anno II. Plain volute ending in serpent's head with bird in mouth.

London. British Museum. Staff of abbot of Peterborough. Scroll ornament; floriated end.

Copenhagen. Royal Museum. Plain whorl continued twice round; dragons' heads in centre.

Copenhagen. Royal Museum. Figure of bishop. Foliage, whorl, and grapes.

Vannes. Cathedral. Staff of St. Paternus. Serpent's head. Ram in centre.

Metz. Cathedral. Double subject; supporting angel.

Namur. Convent of N.D. Volute ending in dragon's head; lamb in centre.

Oxford. Bodleian. Volute ending in serpent's head; lamb in centre; combat with dragon.

Ravenna. Museum. Volute ending in serpent's head; lamb in centre.

Fabriano. Possente collection (formerly). Two examples: serpent's head and lamb.

Perugia. Museum of the Academy. Volute ending in serpents' heads; lamb in centre.

Swetl. Monastery. Leaf ornament round volute; Virgin and Child, to whom the donor is kneeling. The whole staff.

London. Kensington Museum. Siculo-Arab work. Described in text.

Paris. Cluny Museum. Virgin and Child within foliated volute.

London. Kensington Museum. The Soltikoff crosier head. Described in text.

Raigern. Monastery. Double subject; inscription.

London. Salting collection. Siculo-Arab. Described in text.

Hildesheim. Cathedral. Staff of St. Otho. Serpent's head end; lamb with banner in centre; silver ornament is later; inscriptions. Otto or Otho was bishop about 1260.

Hildesheim. Cathedral. Double subject; angel carries an apple in his hand.

Florence. Bargello (Carrand). Two examples; foliated arabesques; bird and lamb in centre of volute of one; youth amongst branches in the other. The staff of St. Ives.

Hildesheim. Cathedral. Staff of St. Gothard. Plain volute, double whorl ending in unicorn's head, Maltese cross in mouth.

Metz. Cathedral. Staff of first bishop of Metz; volute carried twice round, decorated with small leaves and buds.

London. British Museum. French. Staff of St. Bernard; cockatrice biting serpent's tongue; formerly thickly set with gems, of which the settings only remain.

London. British Museum. English. Ox of St. Luke in volute ending in serpent's head.

London. Kensington Museum. German. Elaborately carved with many figures; a remarkable example. Twelfth? century.

Oxford. Ashmolean Museum. English. Dragon and lamb.

St. Petersburg. Basilewski collection. Three examples; ram in centre; dragon's head ends.

FOURTEENTH CENTURY

Paris. Louvre. Known as staff of St. Robert. Double subject; foliated crockets. St. Robert founded abbey of Molesmes in eleventh century.

London. Kensington Museum. Double subject; three examples.

London. Kensington Museum. Virgin and Child and angels; foliated crockets.

Metz. Cathedral. Double subject. The whole staff.

Vienna. Neuburg monastery. Annunciation above the volute; gilt and painted.

Berlin. Kunst Kammer. Double subject.

London. Formerly in Beresford Hope collection. Top of staff carved with Annunciation, dove descending; coronation beneath crocketed arch; angel holding candlestick; foliaged volute with statuettes within of our Lord and B.V.M., on whose head angel places crown.

London. Salting collection. Italian. Two plaques with subjects coloured and gilt set in silver volute.

London. Pierpont Morgan collection. Double subject and kneeling angel. Formerly in Mannheim collection.

Yorkshire. Corby castle. Described in text.

London. British Museum. English. Carved on one side with Crucifixion.

Munich. Museum. Coronation of B.V.M.

Pavia. Museum. Pelican in her piety.

Paris. Dutuit collection of V. de P. Double subject.

Paris. Jacquinot Godard collection. Described in text.

Paris. Spitzer collection (dispersed). Double subject.

Venice. St. Mark's. Head of a crystal and silver-gilt staff.

Volterra. Museum. In this collection, which was sold in 1880, there was a very fine example, with the staff, of the thirteenth or fourteenth century, which came from the abbey of St. Justus alle Balze. On the octagonal knop are full-length figures of SS. Peter, Paul, and the evangelists. The volute issues from a dragon's mouth, forming a perfect circle, having nine foliated crockets with a bust in each of a prophet. Within the volute, the baptism of our Lord. Another, Italian, fourteenth century, had belonged to Benci Aldobrandini, bishop of Gubbio in 1331, and was in its original case of *cuir-bouilli* engraved with three coats of the arms of Aldobrandini amongst an ornament of animals and interlacing foliage. The staff itself is composed of four cylindrical carved pieces, and on the square knop the four evangelists. Within the volute, the visit of the Magi. We have no information regarding the present ownership, except of the last, which, with its case, is now in the Salting collection.

FIFTEENTH CENTURY

London. British Museum. German. Lamb in centre of volute.

London. Salting collection. Kneeling bishop. Described in text.

Brussels. Nédonchel collection. Italian. Crocketed volute, ending in serpent; within, the Annunciation.

A LIST AND SHORT DESCRIPTION OF KNOWN EXAMPLES OF IVORY LITURGICAL COMBS

SEVENTH TO NINTH CENTURY

Brussels. Museum. The Stavelot combs of SS. Remacle and Lambert. Described in text.

Ardennes. Abbey of St. Hubert. Comb of St. Hubert. Described in text.

Durham. Cathedral. Comb of St. Cuthbert. Double row, plain band between.

Liège. Diocesan Museum. Comb of St. Berthuin. Persian work. Seventh or eighth century.

Cologne. Museum. Comb of St. Herebert. Ninth century? Described in text. Tenth to eleventh century?

Paris. Spitzer collection (dispersed). Carlovingian. Semicircular centre; double row of teeth—one large and coarse, the other long, jewelled; signs of the Zodiac, Sagittarius, and Capricornus. Ninth to tenth century.

IVORIES

London. Salting collection. One side an archer, the other set with coloured glass. Resembles the preceding. Formerly in Heckscher collection?

TENTH TO THIRTEENTH CENTURY

Nuremberg Nat. Museum. One side two doves drinking from vase; on the other griffins *affrontés*.

Nancy. Cathedral. Comb of St. Gauzelin, bishop of Toul. Described in text. Tenth century.

Cologne. Museum. One row of teeth; two horses *adossés;* notched for the fingers. Eleventh century.

Siegburg. Museum. Comb of Bishop Anno II. Eleventh century.

Bamberg. Cathedral. Combs of the Empress Cunegonda (2) Dogs, birds drinking. Eleventh century.

Osnabruck. Cathedral. Comb of Charlemagne. Christ delivering the gospels. Eleventh century.

Elbingen. Parish church. Comb of St. Hildegarde. Roman period. Race of quadrigæ. (St. Hildegarde died 1179; here placed on account of ascription.)

Auch. Caneto collection. Two rows of teeth; medallions, foliations, animals. Eleventh century.

Paris. Louvre. German. Samson and the lion.

Quedlinburg. Cathedral. Comb of St. Henry. Similar to Cologne combs. Eleventh century.

Augsburg. Church of St. Ulrich. Comb of St. Ulrich. St. George and dragon. Tenth to eleventh century.

Augsburg. Church of St. Ulrich. Comb of St. Conrad. Quite plain.

London. British Museum. English. Described in text. Twelfth century.

Nivelles. Church. Comb of St. Gertrude. Open-worked.

Sens. Cathedral. Comb of St. Loup. Described in text. Tenth to eleventh century.

Gloucestershire. Hardwicke Court. Subjects from Scriptures. Twelfth century.

Reims. Cathedral. Comb of St. Bernard. Figures of apostles— SS. Barbe, Fiacre, Catherine, etc. Thirteenth century.

Berlin. Kunst Kammer. Annunciation and visit of Magi.

St. Brieuc. Cathedral. Comb of St. William. Thirteenth century.

The nucleus of the treasure of Monza (Milan), where the iron crown of Lombardy is deposited, was formed by Queen Theodolinda. Her comb of ivory, in a setting of silver-gilt filigree adorned with jewels, is also there, and may be included amongst liturgical combs. A comb of precisely similar form, but without the setting, is figured in Akermann's *Remains of Saxon Pagandom.* It was found in 1771 in a tomb on Barham Downs, near Canterbury.

CHAPTER X

SECULAR ART IN IVORY IN THE THIRTEENTH, FOURTEENTH, AND FIFTEENTH CENTURIES

U NTIL, perhaps, late in the thirteenth century, art and the subjects on which it was exercised were still almost entirely in the hands of the Church. Illustrations of purely secular scenes were, at least, very infrequent. For centuries Byzantine influences had prevailed throughout the western world, and from the precincts of monasteries alone came forth the dominating spirit which gave the tone to almost every impulse of the skill of the painter and sculptor. The final defeat of the iconoclasts would have led us to expect a still further tightening of the bands which restricted imagery of all kinds to religious requirements, and bound the artists by the unyielding rules of Byzantine hieratism. But with the ninth and tenth centuries came a taste and love for classic models and ideas. Schools were formed which, notwithstanding the fact that art for the service of religion still reigned almost alone, began, nevertheless, to introduce a form of treatment based on an imitation of classical styles, and even disguised the holy personages under the names and with the attributes of the deities and emblems of heathen mythology. We have in miniatures of the time, for example, the youthful David in classical costume playing on his harp, while near him is seated

the goddess of Melody; or the prophet Isaiah is accompanied by mythological figures representing Night and the Dawn. Such representations—and they are many —are in evident imitation of the antique, from still existing frescoes and wall-paintings, no doubt. As a matter of fact, it is not a little difficult sometimes to recognise in them the biblical episodes to which they refer, and the symbolism is equally cryptic.

At the same periods we find amongst our ivories in the numerous Byzantine caskets of the ninth to the twelfth centuries the decoration almost entirely confined to such subjects as Europa and the bull, Orpheus with his lyre, Achilles, or Hercules, amorini, centaurs, and the like. These, however, have no connection with religious symbolism. The literature of pagan times and mythological stories had evidently, in one way or another, acquired a high popularity, no less in the west than in the east. Later on, when Byzantine influence has ceased to exercise its sway on western art, when its traditions are abandoned, and when, in the thirteenth and fourteenth centuries especially, a freer spirit prevails, we shall still meet the stories of Pyramus and Thisbe, of Alexander, of Romulus and Remus, and many others flourishing side by side with the mediæval romances which then become so popular. Especially is this the case with the caskets, mirror cases, combs, and other articles of domestic use and adornment. The use of ivory for such things was universal, and while we are more rich in fine examples of religious art in ivory of the thirteenth, and especially of the fourteenth centuries, than of any other period, we are none the less so in those which were not confined to church and other devotional purposes. The constitutions of the various guilds and corporations of the period make frequent mention of ivory workers. For instance, in the *Livre des Métiers* of the city of Paris, in 1258, there were three corporations to which the right was given to work in ivory.

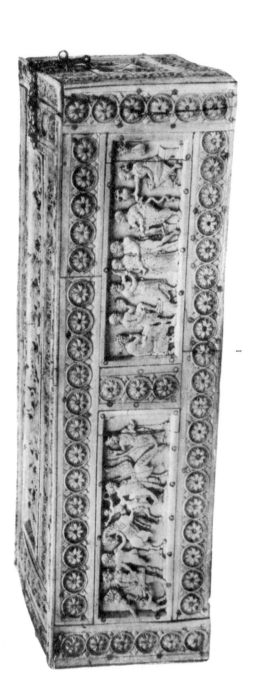

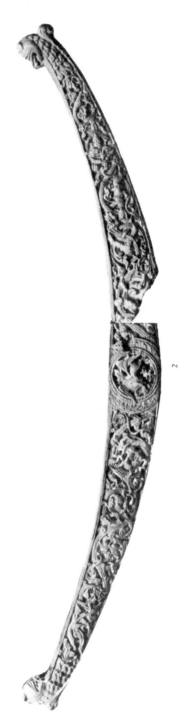

Plate 44. 1. CASKET. BYZANTINE. 2. FRAGMENT. (CHAIR ARM?) BYZANTINE

ELEVENTH CENTURY TWELFTH CENTURY

Beginning with caskets, we must, in a few instances, go back to the time to which we have referred when there was a revival amongst the Byzantine artists, or, more correctly, an imitation of classical work and design. There are few, if any, finer examples of this kind than the casket in the South Kensington Museum (No. 216'65), formerly in the treasury of the cathedral of Veroli. It is a rectangular wooden casket overlaid with ivory plaques, about sixteen inches long by six inches wide, and was acquired in 1865 for £420. We have in the ornamentation the stories of Europa, of Orpheus, and of Pegasus, with figures of centaurs, lions, Bacchus in a car drawn by leopards, sea monsters, and groups and figures of many kinds. The borders are narrow, with a small pierced ornament on their edges, and between them rosettes and profile heads in low relief, with scrolls and foliated terminations. There are other examples of this fashion of copying antique styles ascribed to Italy in the eleventh and twelfth centuries, none perhaps as fine as this splendid casket, in which the workmanship is so good and the imitation so close that it might well be referred to a much earlier date than the eleventh century, at which it is placed by the best authorities. The carving is wonderfully sharp and fine, and the piece is in a remarkably good state of preservation. Features to be noticed are the method of rendering the hair by a mass of small knobs, as we have seen, for example, in the beautiful figure of the angel in the diptych of the fourth century. And again, the treatment, quite oriental, by which the whole decoration is sunk, as it were, so that a level surface is presented throughout. We are indeed inclined to ascribe caskets of this kind to Constantinople workmanship rather than to Italy. Not only so, but to a much earlier date than the eleventh century.

There is a similar casket in the museum at Brussels, not, however, equal to the Veroli casket in design or

workmanship. It is not without interest to remark that the subjects on the top are of a *loose* character. Examples of such a kind are rare in ivory sculpture of the period, if, indeed, any others are known to exist. Many other caskets of the same class, always with the rosette or eight-pointed leaved-star borders, are to be found in Italian collections and museums at Ravenna, Pisa, Bologna, Capo d'Istria, and throughout Italy; and among religious caskets that of the twelfth century in the Bargello, Florence, with the figures, interesting from their costume, of SS. Sergius and Bacchus, has the same border of rosettes. An eleventh-century German casket of bone, mounted with copper gilt, in the Kensington Museum (No. 2440'56) shows us the interlaced scroll style of decoration which, later on, became general throughout western Europe.

Before leaving the earlier period, some space must be devoted to two extremely important caskets, both of which are probably the workmanship of our own Northumbrian artists. The first is that known as the Franks casket, now in the British Museum; the other is in the museum at Brunswick. It may be as well to begin with what information we have of the history of the British Museum casket; unfortunately this is but scanty. It was found some years ago by the late Sir Augustus Franks, the distinguished archæologist, whose generous gifts to the nation have been so many and so valuable, at a dealer's in Paris. It appears that it had been some time in the possession of a well-to-do family in the department of the Haute-Loire, and was used as a work-box by the ladies of the household. It was not much valued by them, and portions had been thrown away and lost. The importance and interest were, however, at once recognised by (the then) Mr. Franks, who acquired it at a high price and most liberally presented it to the museum.

This casket—unfortunately somewhat damaged and

imperfect, for the fourth side is almost entirely wanting
—is of bone, probably the shoulder-blade of a whale.
It is carved over the whole surface in sharp and clear
relief, with curious mythical and scriptural subjects,
somewhat difficult to recognise in some cases, so crude
and childlike is the drawing. The arrangement, how-
ever, and the runic lettering are distinctly decorative.
The scenes are in panels, each of which bears a runic
inscription, except the top panel, on which is one
word only, "Ægili," and on the back, in one corner,
"DOM GISL." One panel represents the story of Romulus
and Remus, and the runic inscription, so far as it can
be deciphered, would appear to run as follows : "Were
exposed — close together—Romwalus—Reumwalus—
twins—then a she wolf—Romecaster"; or, to give even
the quaint wording as a specimen of the language
familiar to our Northumbrian ancestors, "Odlaeum—
neg — Romwalus — Reumwalus—twaegen gibrodae —
feddae—hiae—wulif—Romaecaestri." The myth was
well known in classical and mediæval times. We have
already referred to the Rambona diptych, in which it ap-
pears beneath the Crucifixion, the name *Remus*, spelt, in
much the same way, *Remulus*. On the front panel is
the storming of Jerusalem, the warriors wearing scale
armour with conical helmets and nasals. The inhabit-
ants are leaving the city, and an inscription in Anglo-
Saxon characters tells us that "HIC FUGIANT JERUSALEM."
On the back we have the delivery of the head of St. John
the Baptist and the visit of the Magi, as we learn from
the inscriptions.

The principal inscription records in verse the capture
of the whale, and has been interpreted :—

> " The whale's bones from the fishes' floods
> I lifted on Fergen Hill ;
> He was dashed to death in his gambols,
> As aground he swam in the shallows."

The name Fergen has been identified with what is now

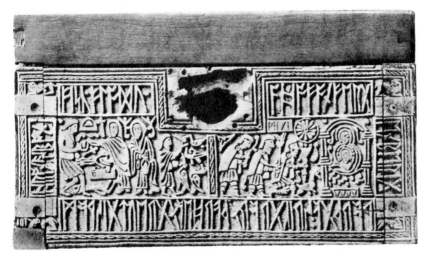

1

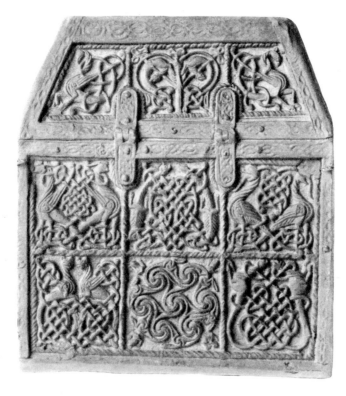

2

Plate 45. 1. FRONT OF RUNIC CASKET. 2. SIDE OF RUNIC CASKET
British Museum *Brunswick Museum*

Ferry Hill, in the county of Durham, so that we may take it that it was a prehistoric whale.

Many conjectures have been hazarded, and many fantastic stories woven around this casket, especially by the Rev. D. H. Haigh, who first commented upon it when it was discovered. He connects the words Dom Gisl with a king of Spain named Agila, who was slain at Cordoba in the year 554. He was the grandfather of the wife of the famous Chilperic, and it would seem that Chilperic sent an envoy into Spain whose name was Domegiselus; in other words, Gisl, who made and signed his name on the casket. There is, of course, nothing to prevent anyone else from constructing a similar hypothesis. The casket remains full of interest, and although in the opinion of some it is to be referred to Scandinavian workmanship, there would appear to be more reason for the idea that it was made by a Northumbrian artist for English people. A casket of similar style, no doubt also of like origin, is in the Bargello at Florence (photograph in Art Library, Kensington, No. 1354–1900). With regard to the date, the learned author of the catalogue of ancient and mediæval ivories in the museum at Kensington states definitely that it is of the eighth century; but a careful comparison with the style and ornament of the caskets next to be described, the animals with interlacing bodies, the armour worn by the soldiers, and the decoration of runic, Scotch, and Irish monuments in stone, may at least leave it open to doubt whether it should not rather be referred, with these other caskets, to the eleventh or twelfth century.

No less interesting, from the same point of view— for a Northumbrian origin is also claimed for it—and more beautiful, is the runic casket in the Royal Museum at Brunswick. It is of quadrangular form, with a roof-shaped top, made of thin plates of walrus ivory set in slips of bronze. The ornamentation which fills the panels is of beautiful design and execution; for the

most part interlaced work springing from the prolonged tails of gryphons and lizards—each reptile occupying a separate compartment—together with the spiral ornament in the calligraphic style peculiar to Anglo-Saxon and early northern work. The borders are also very beautiful and unusual, but the variety is so great that it would be necessary to illustrate the whole in order to give a clear idea.

On the otherwise plain plaque on the bottom is the runic inscription, twice repeated, which has been read as follows: "Wrote this (carved) Nethii, for the most noble Ælic in Montpellier of Gaul," and from this the following story has been evolved by Professor Stephens. Towards the end of the sixth century there was at Limoges a famous sculptor or art workman named Eligius. He was the hero of many popular tales, and, giving up his art to become a priest, was eventually consecrated bishop of Tournay, and died in the middle of the seventh century. In France he is known as St. Eloi, patron saint of goldsmiths. Then, it would seem that he had an English foreman in his employ who had been sold as a slave into Gaul. This Englishman was converted, became a wondrous artist, a monk, and eventually a saint—St. Tillo, or, in France, St. Théau. All this we may find in Dr. Maitland's charming book, *The Dark Ages*.

It is always extremely difficult to assign a date to a work and ornamentation of this kind, or to lay down with any certainty the country of origin. We have here an extremely beautiful casket of exquisite design and workmanship, and there would seem to be no reason why it should not be ascribed to Northumbrian art of the ninth to the eleventh centuries. It is northern work, and the style of ornament was by no means confined to any particular locality. The spiral interlacements are frequent in Irish MSS., and it will be interesting also to compare the decoration with that on the famous

chessmen of walrus ivory found in the island of Lewis, in Scotland, which will presently be described and illustrated.

The runic inscription—" Urit Nethii Sigyor Aeli in Mungpaelyo Gaelica"—has been variously read and interpreted. The application of the word Mungpaelyo to Montpelier, in France, is more than doubtful, and the connection with Eligius scarcely more than guesswork. However this may be, our principal interest is in the beautiful decoration, the system of calligraphic ornament, mixed with fabulous animals, which is so characteristic of Anglo-Saxon manuscripts, and of certain sculptured monuments of the ninth to the twelfth century.

Two more interesting caskets with a similar character of ornament remain to be noticed. The first, known as the casket of Cunegunda, of the tenth or eleventh century, is in the Bavarian National Museum at Munich. The plaques of morse ivory of which it is composed are decorated in low relief with grotesque animals of a runic character, and are set in a framing of oak, bound together with metal bands. The second casket, that of St. Cordula, in the cathedral of Cammin, in Pomerania, is of bone, bound in a similar way to the first. We have here again the long-tailed grotesque animals that we find on the Brunswick casket with the characteristic interlacements of Scandinavian and other northern art. Casts of both are in the Kensington Museum (Nos. 442'73 and 59'72).

We come now to an entirely different class of decoration, very prevalent, especially throughout the fourteenth century, in most western countries, on such objects as small boxes and caskets for toilet use, mirror cases, writing tablets, combs, and the like. An era of romance had set in, and the pious legends and illustrations of scriptural narratives, which before had formed the exclusive source of inspiration for the sculptor in ivory, the painter and the miniaturist of illuminated manu-

scripts, had to give way before the charm of the wonderful allegories and romantic stories which supplied the artist with endless themes.

These famous romances were drawn from several sources. The history of King Arthur and the Knights of the Round Table was particularly in vogue. Then there were the classical romances, amongst which were two very favourite and amusing stories, in which such ancient heroes as Alexander and Virgil played curious parts, and people delighted in being shown how they were made fools of by women. And there were the histories of Valentine and Orson, of Lancelot du Lac and the quest of the Sangreal, of the loves of Tristan and Yseult, of Queen Guinever, of Ysaie le triste the knight of the woeful countenance, the stories of Merlin, of Perceval, of Meliachus, of Perceforest, the Fountain of Youth, of the Chastelaine de Vergi (there is a fine casket with this story in the Louvre and another in the Pierpont Morgan collection), and many other popular romances and allegories both in prose and verse. And, indeed, are not these names almost as familiar and as popular amongst us, under other forms perhaps, in our modern times? A favourite story was one from which the subject on a large number of the mirror cases was taken. The *Romance of the Rose* was a long allegorical poem which Chaucer made familiar in England by his translation. From it was derived the very popular theme which we shall find illustrated, in one way or another, over and over again—the assault on the Castle of Love. This famous poem, which was intended to be looked upon with the mind framed to extract from it the mystical morality which its lines enclosed, was indeed full of scholastic subtleties. If the people, then, saw in it only a plain everyday romantic story, it is no more than has happened to it since, and to other allegorical or satirical compositions. It was written about the year 1300 by Guillaume de Lorris and

Jean de Meung, and was frequently moralised. One extract from the Early English translation by Robert Grosseteste, bishop of Lincoln, relating to the episode most frequently illustrated in the ivories, will suffice :—

> "This is the castel of love and lisse,
> Of solace, of socour, of joye and blisse,
> Of hope, of hele, of sikernesse,
> And ful of alle swetnesse."

In this romance, according to some of the moralists, we are to see the rose to be the personification of the Virgin Mary; the towers and defences of the castle are the four cardinal virtues, with chastity, buxomness, and meekness.

But besides the subjects supplied by these famous romances, we shall find also some very delightful and interesting illustrations of the domestic life of the time. Most valuable and curious are the details which we may gather from them of the occupations, the sports and pastimes, the costumes and general habits of the people, great and small, the nobles, the knights, the courtiers, and the ladies and gentlemen of these most interesting periods. They occur so often, that except in one or two instances, it will be scarcely necessary in noticing a few of these pictures to refer particularly to any special subject. A short *résumé* of some of those which occur most frequently on the caskets, combs, or mirror cases may, however, be useful.

Tournament scenes are common, either in a general *mêlée* of knights in full armour, or before the Castle of Love, where the knights are encouraged by ladies on the battlements, who shower down roses on their favourites; or the knights are themselves fighting each other with branches of roses. Then we have such scenes as a hawking party; a lady and gentleman playing chess; a pair of lovers riding in a wood (the lady rides astride); a priest hearing a confession; two lovers embracing, a cowled monk approaching from some trees near by and

holding up his hand in warning; Cupid crowned and shooting his arrows at a couple making love; a lover and a lady out walking with a lap-dog; a lady and gentleman tenderly kissing each other as they ride through a wood; a gentleman in a *côte-hardie* and long pointed shoes, presenting with one hand a heart to a lady, while with the other he half draws a dagger from its sheath; a lady and gentleman both sitting on the ground in a wood, as if resting after hawking, he with a hawk on his wrist, she teaching a little dog to sit up; and so on, the list could be enlarged to an almost unlimited extent. One may look at these things as the Punches or Charivaris of the epoch, but they require no letterpress to tell their stories. There can be no mistaking the amiable flirtation in which the lady and gentleman are engaged, even if he were not, as in some cases, chucking her under the chin. And, after all, it is always more artistic to tell a story without the necessity of labelling, and even to leave something for the imagination.

Very interesting are the realistic representations of the costumes of the times which we obtain—the long loose gowns of the ladies covering their feet, and with narrow sleeves hanging from the elbows; the tight tunics of the gentlemen buttoned down the front with innumerable little buttons, the hoods and tippets, and the liripipe hanging down their backs from the former, the scalloped sleeves, the long peaked shoes, and the exaggeration of all this in the *outré* dress of the time of Richard II.

A beautiful casket in the Kensington Museum (No. 146'66), acquired in 1866 for £296, has no less than thirteen panels with bronze mountings which resume in an excellent way a number both of classical, allegorical, and romantic subjects. We have on it a tournament, the assault on the Castle of Love, Cupid shooting his arrows, the fable of the unicorn, and the romance of

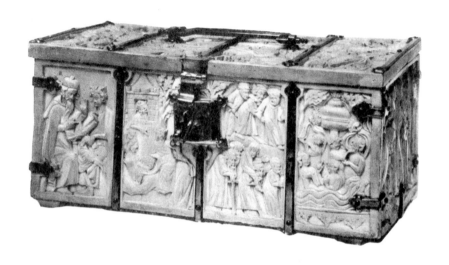

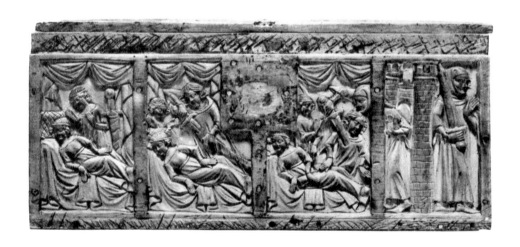

Plate 46. CASKETS WITH ROMANCE SUBJECTS. FRENCH

FOURTEENTH CENTURY

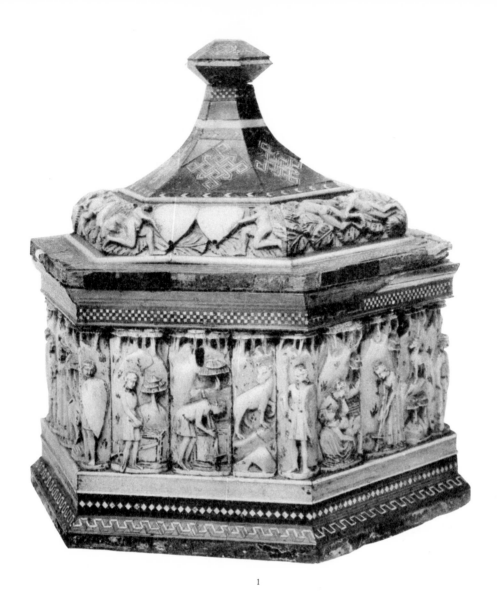

1

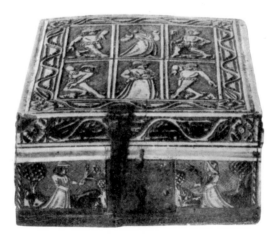

2

Plate 47. 1. MARRIAGE COFFER. ITALIAN. 2. CASKET. FRENCH
 FIFTEENTH CENTURY FIFTEENTH CENTURY

Lancelot. Then there is the story of Tristan, where Tristan disguised as a beggar carries Yseult across the water on his back; and the Fountain of Youth, with men and women bathing together under a fountain, while three old people are approaching with halting steps. There is the story of Aristotle instructing the king, and again the amusing and very favourite episode of the princess riding on the back of this philosopher, whom she has subdued by her charms. He has a bridle in his mouth, crawls on his hands and knees, and is being whipped by the lady. The king is looking out of a window in a tower and pointing to the figures beneath.

A curious example of the use to which such caskets as those we have been describing has been put is the one with love scenes in four compartments, which contains the foot of St. Ursula in the cathedral at Cologne, where are preserved also the bones of her eleven thousand virgins.

Italian caskets of bone of the fifteenth century, which were generally marriage caskets, are plentiful in most museums and great collections. They are usually of hexagonal form, the covers brought up from the sides in a dome shape to a point, and inlaid with marquetry of stained woods. Bone was very frequently used in Italy instead of ivory, and as a rule most bone carvings of these periods are Italian. Ivory was scarce and costly, but it must not be concluded that the workmanship of these coffers was any the less fine on account of the inferior material. On the contrary, many of them, as well as the numerous predellas and triptychs of a similar kind, show that the best artists must have been employed upon them. Most of the subjects are executed by means of several pieces of bone arranged as has already been described, and to take one collection only —that at Kensington—there is considerable variety in form and decoration. The subjects are generally from the romances; for example, on that acquired by the

museum from the Soulages collection, we have the history of Pyramus and Thisbe, the lion, the fountain, and the whispering through the wall, with which Shakespeare has made us familiar.

A very good example of English caskets carved with domestic scenes is No. 264'67 at Kensington. We have here the pointed arches and crocketed pediments of the period ; a hawking party, in which the gentlemen are in the close-fitting buttoned tunics, with hoods and liri-pipes, their belts very low down across the hips ; the ladies with long narrow sleeves hanging from the elbows, of the time of Edward III. On other panels people are amusing themselves in a garden, playing on musical instruments, at chess, and so on—a garden party of the period.

What are known as mirror cases have also come down to us in considerable quantities, to be found in most collections. The shape is nearly always the same —round, from about four to six inches in diameter, and in pairs so as to shut up like modern pocket mirrors. But in order to make them easier to hold, and perhaps to be stood upright, they are often given a more square form by the addition of four crockets, either of leaves or of lions or monstrous animals. Ancient mirrors were generally metallic, but the use of glass with lead at the back had probably come in about the time most of our ivory ones were made. These hand or pocket mirrors are certainly not large, but there are no examples of ivory framings to any larger kind ; and we find them of pre-cisely this shape and size, sometimes attached to the girdle by chains of silver and gold, being used by ladies at their toilet in manuscripts of the fourteenth century. In the manuscript romance of Lancelot du Lac, in the British Museum, a lady lying on a couch holds the mirror in her hand whilst an attendant dresses her hair with a comb. In another she is using both mirror and comb. They are also often mentioned in inventories of

the fourteenth century. Eustache Deschamps, *huissier d'armes* to Charles V., speaks poetically in a pleasant reference to the exigencies and necessities of high-born ladies of his time, and of the expensive objects in ivory required for their toilet :—

> " Pique, tressoir semblablement
> Et miroir pour moy ordonner
> D'yvoire me devez donner
> Et l'estuy qui soit noble et gent
> Pendu à chéannes d'argent."

We seldom find both pieces of a mirror case. As it was usual to decorate only one side, the other was, perhaps, not thought worth keeping ; but, of course, it may be that some of the decorated ones which we have are pairs. The most common subject on a mirror case is the assault of the Castle of Love. It was treated in various ways, but a description of one of the finest mirror cases known (No. 16'55 at Kensington) will suffice. It is French, of the fourteenth century, and measures five inches in diameter. We have the front of the castle with the portcullised gateway. Several knights in full armour have arrived on caparisoned horses, and have commenced the attack, but the ladies on the lower battlemented parapet offer no resistance. On the contrary, they are welcoming the intruders, some of whom are gaining an entry by means of a rope ladder, others by standing on the pommels of their saddles and being helped up by their companions. Those who have reached the battlements are embracing the ladies of their choice with great vigour. In a balcony above, with a trefoiled balustrade, Love as a seraph with four wings strikes with his arrows two ladies, whilst two others are pensively meditating—on the watch, no doubt, for their own knights. The attitudes and expressions throughout are charming, and the composition extremely well arranged and spirited. The date may be fairly identified by the shoulder-pieces on the armour of the knights.

These curious additions bore, emblazoned upon them, the arms of their owners. The fashion was not of long duration, and disappeared entirely early in the reign of Edward III. This very fine example was exhibited at the Society of Antiquaries in 1808 by Mr. Richard Haynes, to whom it then belonged. In the short account accompanying the exhibition it is called a curious bas-relief in ivory, and there is no reference to mirror cases.

A common subject on mirror cases and caskets is the adventures of Huon de Bordeaux, where the hero plays a game of backgammon, the stakes between the players being the lady's virtue against the head of the other. Or, again, that of the Chastelaine de Vergi, which appears on the mirror case here illustrated.

A very unusual example is figured in the *Revue Archéologique* for 1857, and described by M. Guéné-bault. A knight has been arrested, and is being conducted to the fortress or prison which appears in the background with its gates and towers The shape of the case is rather oval than round, and the corners are four grotesque faces. It would appear probable that it depicts an incident in the life of St. Louis. It is French of the thirteenth or fourteenth century, but we have no information whence it came in 1857, and where it now may be. One of the latest to be added to the British Museum is half of one valve, exhibited at the Society of Antiquaries in 1902 (*Proc.*, vol. xix.). The details of the suits of mail worn by the knights who completely fill the lower part are very interesting. The style of the upper portion recalls the casket with the story of Aristotle, but on the whole it has an English character.

The fashion of these mirror cases and the favourite subject of the Castle of Love continued throughout the fifteenth century, but the style of armour and the costumes naturally changed somewhat. There is a very beautiful example in the Wallace Museum, which was formerly in the Fountaine collection. One valve shows

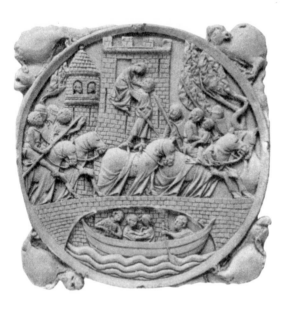
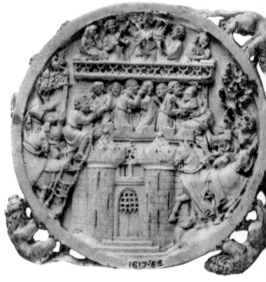
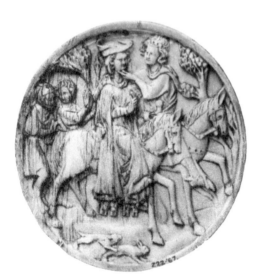
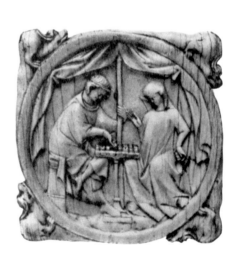

Plate 48. MIRROR CASES. FRENCH

FOURTEENTH CENTURY

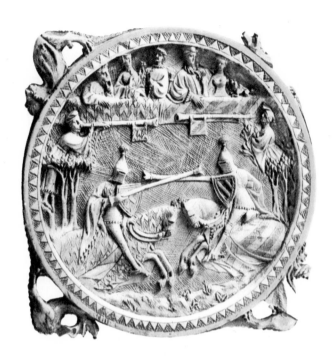

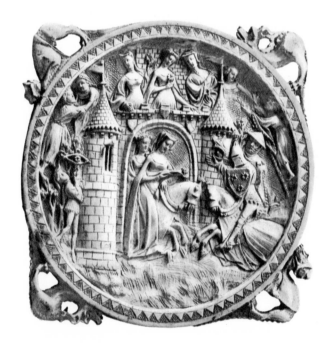

Plate 49. MIRROR CASE. (BOTH VALVES.) FRENCH
FIFTEENTH CENTURY. (*Wallace Collection*)

the assault on the castle, or rather the capitulation of the ladies, one of whom rides forth from under the portcullis, bearing roses in her arms. The subject of the other is a tournament of knights in the presence of a bevy of noble ladies. The execution is sharper than in earlier examples, very delicately, yet vigorously carved, the faces of the figures especially careful in the minute details. The backgrounds are guilloched, as became the fashion in work of this period. An interesting detail is that one of the attacking knights is firing a cross-bow loaded with flowers at the ladies on the battle-ments above. New styles came in with the sixteenth century, and we have a shield-shaped mirror, with a handle, in the Louvre. The back is carved with ladies and gentlemen in the costume of Louis XII., one of the latter presenting his heart to his mistress in quite the old style. The mirror itself is of polished steel.

Ivory has naturally been a favourite material for toilet combs of all descriptions from very early times. There are ivory combs in the Nineveh collection of the Louvre. Several of them are ornamented with lions and winged human-headed lions. An early one found at Pompeii is in the British Museum, and is made to shut up like a modern pocket-comb. Another from Pompeii in the Boocke collection is of the double-tooth kind, very large, and carved with the three Graces, Venus and Cupids, and there are two fine Roman combs of the first to the fourth century in the museum at Liverpool. Three, which were found in 1771 in the tomb of a woman at Kingston, near Canterbury, are also in the Mayer collection of the same museum. They are identical in shape with that of Queen Theodolinda at Monza. In the excavation of a Pict's house at Kettleburn, Caithness, a curious bone comb in the shape of the hand and part of the arm was found.

There are some beautiful examples of combs of the fourteenth and fifteenth centuries in the Kensington

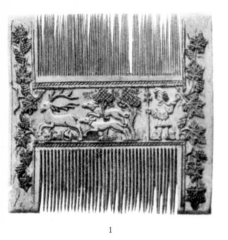

1

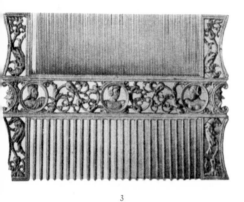

2

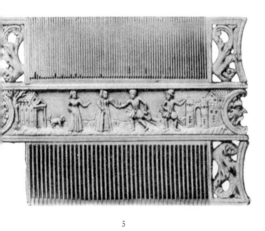

3

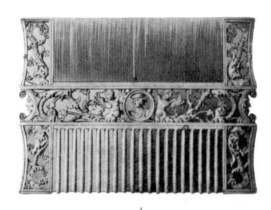

4

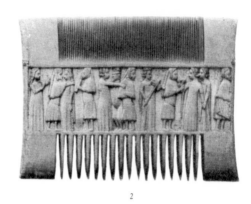

5

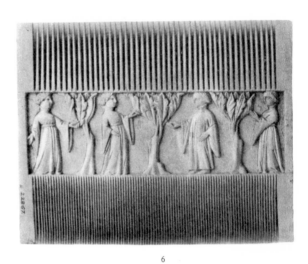

6

Plate 50. TOILET COMBS

1, 6. ITALIAN. FIFTEENTH CENTURY.　2. ITALIAN. FOURTEENTH CENTURY.

3, 4. ITALIAN. SIXTEENTH CENTURY

5. ENGLISH. SIXTEENTH CENTURY (BORDERS COPIED)

Museum, for the most part in a surprisingly good state of preservation, the ivory pure white, and the carving perfectly clean and sharp.

The favourite subjects for combs at this period appear to have been either the story of David and Bathsheba, or else the romance of the Fountain of Youth, both of them very appropriate. There are others; for example, at Kensington, a beautiful Italian comb of the fourteenth century, with groups of figures, some playing the fiddle, tambourine, or hand-organ, others talking and embracing, and one curious group where a crowned figure, quite naked, is blindfolded. It has been coloured, as is the case with several others. In an English comb of the sixteenth century the costumes are of Elizabeth's time. On one side there is a large battlemented house with groups of figures; on the other the same house with a flag flying, a church, and a lady and gentleman walking hand-in-hand, evidently the return from a wedding.

All the ivory combs of these periods are of the double-tooth kind. They are again most interesting examples, together with the caskets, mirror cases, and writing-tablets, of the habits of our mediæval ancestors, of their quaint conceits, and of the pains that were taken to decorate even apparently trivial objects.

A kind of long ivory *stylus*, or what might be mistaken for one, is sometimes found, with a figure on the top, or men and women embracing; but these are not writing implements. They are a description of comb used for parting the hair.

Writing tablets to be covered with wax, on which the writing was made by means of a pointed style, have been already referred to at some length in the account of classical and consular diptychs. The habit of using such tablets was persisted in to a considerable extent throughout the middle ages, and indeed until quite recent times. Many beautiful memorandum tablets of

ivory of mediæval times are to be found in museums and private collections, and even at the present time such little books, with thin leaves of ivory for writing on in pencil, and with decorated outer covers, have not died out. The term "tables," by which writing-tablets were known in England, was also applied to other things. Draught-boards were called tables, and the paintings on boards, or even alabaster carvings in churches, were known by the same name. It was used also for diptychs; for example, in the will of John Baret, of Bury, in 1463, " My tablees of every, with the combe." It is curious that what would seem to be a clumsy and troublesome fashion should have persisted so long. But people had more leisure in earlier days, and took matters more quietly. Almost in our own times cricket was scored on sticks, and it is perhaps not more than a hundred years or so since the national accounts were kept in much the same way by what were known as tallies.

References to "tables" are common in early writings. Chaucer in the Sompnour's tale tells us of the friar's companion that he had

and

> " A pair of tables all of ivory
> And a pointel ypolished fetishly,"

> " He planed away the names everich on
> That he before had written in his tables."

He was a preaching friar, and the reward of those who gave him, as the poem tells us, a piece of brawn or a "blanquette," was to be inscribed on his tables. Again, a reference in Shakespeare's *Henry IV.* is interesting, where we find so poetically described the forgetting of injuries and grievances while erasing them from the waxen tablet :—

> " And therefore will he wipe his tables clean
> And keep no tell-tale to his memory."

St. Augustine, in a letter on one occasion, excuses himself for writing on parchment, for, as he says :—

"This letter signifies not so much scarcity of paper as abundance of parchment. My ivory tablets I sent with letters to your uncle. You will, however, more readily excuse this parchment, because the matter treated of could not be put off, and I thought it very wrong not to write to you. If you have any of my tablets, please send them, in case of similar emergencies."

And in the *Boke of Curtasye* :—

"At counting stuarde schalle ben,
Tylle alle be brevet of wax so greene,
Wrytten in bokes without let,
That before in tabuls have been set."

The wax was often coloured green to save the eyes, and a set of tablets with the green wax still remaining on them has already been mentioned. Schoolboys used them instead of slates, as at present, and they were frequently given as presents, as nowadays we give note-books, pens, inkstands, and similar things. They were, of course, often made of other materials than ivory.

Various kinds of wood were used—box, beech, sycamore, maple, lime, pine, or cedar, stained and ornamented with ivory, horn and precious metals. Sometimes wooden tables had ivory covers, and they were often enclosed in cases and suspended from the girdle. The *stylus*, which was often of silver, had one end flattened out for the purpose of erasures by smoothing the wax again. Many examples have been found, some of very early times, in various parts of the world, but of English ones perhaps not more than two are known. A set containing as many as eight inner leaves was found lately in some excavations at Cambridge, and in 1902 a small pair of such tables with three styles were found at Blythborough, in Suffolk, near where formerly stood a priory of Black Canons, a cell to the abbey of St. Osyth, Essex, in the reign of Henry I. They are of

bone, of small dimensions, measuring not more than two and a half by three and three-quarter inches. They are carved with an ornamentation of the interlaced character common in northern work of the ninth to the twelfth centuries, and are now in the British Museum. In the library of St. Germain des Près at Paris is a set of eight wooden tablets with the writing on the wax still legible. They contain an account of the itinerary of Philippe le Bel from January to July, 1307. Other equally interesting examples are preserved in museums abroad. Specimens of single tablets as large as an ordinary school slate also exist. It is said that the custom has not even yet entirely died out, and that waxed tablets are still used for keeping accounts in the fish market at Rouen.

The examples of ivory tablets for ordinary use which we have are for the most part carved on the outside with domestic scenes or stories from the romances of chivalry. Nothing could be more interesting than, with such illustrations in our hands as we find on these caskets, combs, and tablets, to follow the curious and romantic stories which abounded in French, Italian, and English. Of the romances, perhaps the most popular was the Quest of the Sangreal made by the knights Lancelot, Galahad, Boort, and Perceval, a story which was, in fact, the foundation of that of the Round Table. Of spiritual romances and allegories, of mystical stories of monks and nuns, and of the visions which they had, there was also no end; and an intimate knowledge of the symbolism which was still so frequently used is necessary for the elucidation of some obscure subjects.

Before leaving the subject of materials for writing, mention may be made of examples of ivory rests for the hand of the scribe or illuminator. They are long skewer-shaped implements with flat sides, surmounted by a figure, which is usually a lion; sometimes a group of lions, or other figures. There are four examples—two

French of the fourteenth century, and two Italian of the fifteenth—in the Kensington Museum.

Horns of ivory were of frequent use in very early and in mediæval times. The shape of the elephant's tusk would naturally suggest itself for such a purpose, and, as a matter of fact, it is from this circumstance that the well-known term, oliphant, for a horn, is derived. Examples of great beauty from the ninth or tenth to the seventeenth centuries may be referred to.

Horns were of two kinds or uses. One, the hunting-horn, used in the chase or for war, was worn by the knight or carried after him by his esquire. Or, again, a horn was used by the warders of the old feudal castles to give the alarm on the approach of an enemy, or even of a visitor of distinction. They were also commonly used as drinking-horns, in many cases, of course, lined with silver or metal for this purpose, and mounted on feet, and with bands of metal and other ornament. Horns are very often referred to in old wills and inventories. In a list of the royal treasures seized by King Edward in the castle of Edinburgh, after he had reduced John Balliol, king of Scotland, to submission, there are mentioned "three ivory horns adorned (*harnesiata*) with silver and with silk." In the inventory of the wardrobe of Charles V., made in 1379, a horn of ivory mounted in gold, and hanging to a belt or band of silken tissue sewn with fleurs-de-lis and dolphins in gold, is mentioned. In the will of Sir John de Foxle, in 1378, he leaves to the king his great bugle-horn, ornamented with gold. And again, Thomas, earl of Ormonde, in his will dated A.D. 1515, leaves "to my dar Dame Margaret Bolin . . . item when my lorde my father whose soul God assoile left and delivered unto me a lytle whyte horne of ivory garnished at both ends with gold, and corse thereunto of whyte sylke . . . which was myn auncestours at fiyrste time they were called to honour." We have before alluded to the prac-

tice of presenting horns to churches, and we find that there were in the treasury of St. Paul's at the end of the thirteenth century "a great ivory horn engraved with beasts and birds : item, another small plain horn of ivory," and at Canterbury, for a reliquary : "*In majori cornu eburneo pendente sub trabe ultra magnum altare*" (Dart, *App.*). Horns are fairly common on the Continent as reliquaries ; for instance, at Cologne, in the church of St. Severin, at Aix-la-Chapelle, and at Hildesheim.

A peculiar use to which horns were put, and one which is illustrated in a very interesting manner by the considerable number of examples which still exist, was that by which they were made to serve as charters or instruments of the conveyance of land. They are known as "tenure horns." The custom is particularly specified by Ingulphus, abbot of Croyland, as the manner whereby in the Conqueror's time "many estates were transferred by word of mouth, without any writing or character, only by the Lord's sword, a horn or cup." Several very interesting examples of tenure horns were exhibited in the loan exhibition of objects of art at South Kensington in 1862, amongst them the Ulphus, the Carlisle, the Bruce, and the Pusey horns. The horn of Ulphus, the son of Thorald, who ruled in the west of Deira, in the ancient kingdom of Northumbria, about the year 1036, is mentioned in an early chronicle, which tells us that "with that horn he was used to drink filled it with wine and before the altar of God kneeling devoutly, drank the wine and by that ceremony enfeoffed this church with all his lands and revenues." The horn is still preserved in the minster of York. It is referred to in a sixteenth-century inventory of the cathedral church of St. Peter : "*Item, unum magnum cornu de ebore ornatum cum argento deaurato ex dono Ulphi filii Thoraldi cum zona annexa ex dono Joannis Newton.*" Another interesting example is in Carlisle Cathedral—

the horn given by Henry I. to the priory of Carlisle when he enfeoffed it with certain lands to be held " per quodam cornu eburneum "—by a certain ivory horn. An inventory made in 1530 mentions "the greate horn venōry havynge certain bandes of sylver and golde," and the verses following graved upon: " Henricus Primus noster Fundator Hoc dedit in teste carte pro jure foreste." The Bruce horn is in the possession of the Ailesbury family. The whole tusk is plain and very magnificently mounted with silver bands, chased in compartments with stags and dogs, one animal in each compartment. The belt is richly adorned. The family of Pusey also hold the village of Pusey, in Berkshire, by a horn, which was first given to William Picote by King Canute.

The *Archæological Journal*, vol. xi. p. 188, describes a remarkable ivory drinking-horn, exhibited by Mr. Blackburn in 1854, which had been long in his family and regarded as a tenure horn. It is mounted in silver on an eagle's gamb, with two little wyverns for the smaller end, and with tip, bands, and mouthpiece, also in silver. The tusk is carved with elephants and other animals, and is probably oriental.

For ivory horns no doubt comparatively small tusks would have been chosen, and some method of hollowing the tusk must have been known so as to take out the greater part in a solid core, as is now often done in the manufacture of billiard balls. They would not have been likely to waste such valuable material by scooping it out.

A magnificent horn of large size, measuring more than two feet in length and five and a quarter inches in diameter, is in the Kensington Museum. It is northern work of the Byzantine school of the eleventh century, carved with interlacing circles enclosing figures of animals and birds in high relief, and around each end is a broad border of similar ornamentation.

Many other examples of fine horns up to the six-

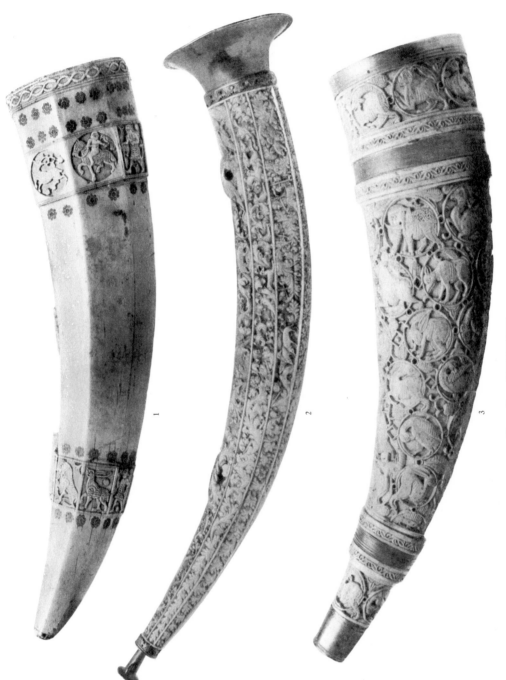

Plate 51. OLIPHANTS

1. GERMAN. TWELFTH CENTURY. 2. GERMAN. FIFTEENTH CENTURY. 3. NORTH EUROPE. ELEVENTH CENTURY

teenth century exist in most of the collections on the Continent, but there are perhaps few finer to be found than the very beautiful German hunting-horn of the fifteenth century acquired by the Kensington Museum at the Soltikoff sale for £265. It is completely covered with excellently well-executed hunting scenes in low relief, in longitudinal rows separated from each other by similar rows filled with foliage. Amongst the subjects we have St. Christopher carrying our Lord across the river. He is preceded by a hermit, who is lighting the way with a lantern. Then there is a fight of seven men with a dragon; they have spears, and the dragon issues from a cave vomiting forth flames. Other ornaments are fabulous beasts and a curious scene in which a man is being led through rocks and trees by two ladies; men and women are looking out through openings, and two pairs kissing one another. The tone of the horn is said to be extremely good.

Examples of ivory horns of early date are of comparatively frequent occurrence, but their origin and date are not always easy to determine. That the former, generally speaking, is oriental is more than probable, and when they come to us through Byzantium one can hardly hesitate. At the same time we are confronted with many examples from the northern countries of Europe, which in style come evidently from the east, though whether direct from Constantinople or influenced only from thence it would be difficult to say. The Royal Society of Antiquaries of Scotland possesses a fine horn of northern work, carved with scroll work and deer. The tenure horn belonging to the Marquess of Northampton is of ivory, which has become very dark, almost like wood. The decoration consists of sphinxes, griffins, floral scrolls, and figures copied from oriental and classical sources. And, as another example, there is the Crathes tenure horn, in the possession for centuries of Sir James Home Burnett, of Crathes Castle, Kincardineshire. It

is of ivory, mounted with silver gilt, with a baldric of green silk. The Rothschild renaissance horn will be referred to later on.

Ivory seals were probably not unusual, not only for the handle, but for the seal itself. The double ivory seal of the thane Godwin and of Godwytha is in the British Museum. It consists of a circular disc with an oval projection on one side. On one face is the half-length figure of a man in profile, and the legend, " + SIGILLVM. B. GODWINI. MINSTRI." The projecting portion is carved in high relief with two seated figures, one holding a sceptre; their feet are on another figure lying prostrate beneath them. Anglo-Saxon seals of any kind are very rare indeed.

A fine example of a handle of a seal of the thirteenth century in the British Museum came from the Gherardesca collection. On one side is a bishop wearing a low mitre, in the act of blessing; on the other the archangel Michael seated and holding a sword and scales. The chubby faces are very interesting and natural. It is a beautiful example of figure work in ivory of such an early period.

On the seal of walrus ivory of the abbey of St. Alban, also in the British Museum, the saint is represented holding a cross and palm branch. There are, besides, the ivory seals of Southwick Priory, of Oseney Abbey, and of Elsing Spittle Priory, all of the thirteenth century, and others in collections abroad.

A few examples remain of a curious kind of ring which was prevalent about the fourteenth and fifteenth centuries. These were "rosary" rings. We find them alluded to sometimes in wills and inventories as "ringes with knoppes and bullionys." A remarkable one, in the possession of the Waterton family, is of ivory, with ten knobs or bosses for the *Aves*, and one, larger, for the *Pater noster*. It was found, about 1850, in Merston churchyard, Holdernesse.

IVORIES

A remarkable piece of Anglo-Saxon jewellery, a *fibula* composed of a circular plaque of silver, to which is applied two filigree plaques of gold, was found, in the early part of last century, near Bosworth, in Lincoln-shire. It is set with four studs, or buttons, of ivory, in the centre of each of which is a garnet.

CHAPTER XI

CRUCIFIXES: THE ICONOGRAPHY OF THE CROSS IN EARLY AND MEDIÆVAL IVORIES; RELIGIOUS ART IN THE FIFTEENTH AND SIXTEENTH CENTURIES

WE have postponed the consideration of one of the most important applications of ivory sculpture to religious purposes, viz. the crucifix, or, more strictly, the figures for crucifixes, because we have scarcely any examples in ivory of an earlier date than the seventeenth century. The Crucifixion is, of course, often represented on diptychs, book-covers, and other devotional objects of the kind, and many beautiful examples have already been noticed; but we have very few figures for the definite purpose of what is usually understood by the term. That is to say, that by crucifix is meant the figure of our Lord to be attached to a cross as an isolated object of devotion, unaccompanied by representations of other actors in that sacred event.

Following the same plan that has hitherto been pursued, it is not proposed to concern ourselves with the history of crucifixes in wood, in goldsmiths' work, or in other materials. To note even the analogies or differences in treatment would lead us too far.

The extreme rarity of examples of crucifixes of any kind of an earlier date than the fourteenth century is well known. In such a comprehensive collection as that of the Kensington Museum there are not, perhaps, more than a dozen, all told, from the earliest times until about

the latter period. From that time onwards, no doubt, they abounded in churches, on altars, on rood-screens, and adapted for other uses. But it is remarkable that in the case of examples in ivory the rarity is for some time still more marked. It would hardly be an exaggeration to say that for the thirteenth, fourteenth, fifteenth, and the antecedent centuries, the number known to exist may almost be counted on the fingers of one hand. At least we are able to point to no more than those which will be presently noticed in detail. It is difficult to be absolutely precise, because others may still possibly be in use in churches in remote districts, or to be found in private collections; but as to museums and public treasuries, both at home and abroad, and to the best-known cathedrals and churches, the examples to which reference will be made will probably exhaust the list.

For those who are captivated by the devotional art of the three centuries of gothic times when it was at its highest period of beauty and development, the apparent omission to make use of ivory in the case of the crucifix is a fact which must fill them with regret and with speculation as to the reasons or causes. Excellent as may be some examples of post-renaissance times which we shall meet with presently, curious and beautiful from a certain point of view, and calling for our admiration on account of the artistic qualities and truth to anatomical detail which it would be impossible to deny to some of them, they differ greatly from the conventional, yet sufficiently near approach to naturalistic treatment, which forms the glory of the devotional work of the artists in ivory of the gothic period. They are realistic, and in some cases—such as the Spanish, and of these, the painted ones especially—painfully, horribly so.

It will have been seen that amongst the groups representing scenes in the Passion, in the diptychs and triptychs which have been described, we find many and

many representations of the Crucifixion, in which the figure of our Lord is sometimes of not inconsiderable size; for example, in the beautiful diptych of the fourteenth century (plate xxxii.). It is here on quite a sufficiently large scale to give the admirable expression of the features together with those of the figures in the surrounding groups. We may deduce from these instances some idea of the manner in which the mediæval artists would have treated a larger figure such as would have been required for a crucifix as usually understood. It can scarcely be imagined that it did not occur to them to use the large tusks for such a purpose as they did in the case of the statuettes of the Virgin, of which such beautiful examples have come down to us. May it have been that as the outstretched arms of a crucified figure precluded the possibility of working the whole in one piece, the necessity of making the arms separately, as was later on the universal custom, was repugnant to their ideas of artistic propriety? Whatever the reason, the rarity of existing examples, and the comparatively few instances of the mention of ivory crucifixes in church and other inventories, lead to the conclusion that they were unusual in mediæval times. Still, we find in the records of guilds and corporations that amongst the three corporations of ivory workers, which existed in Paris as early as the thirteenth century, the first was called that of the "Ymagiers tailleurs de Paris et de ceux qui taillent *crucefis*." It was by such corporations that the diptychs and triptychs were carved, and the most stringent regulations as to capacity in the art were required of those who were admitted to them.

We cannot say, then, that crucifixes in ivory were not made, merely that we can now point to very few examples. For in inventories and visitation lists of times as early as the twelfth century one comes across such entries as "a cross of bone," or, as in that of Canterbury, "an ivory crucifix containing relics." But

[319]

to refer again to the already quoted inventory of Lincoln Cathedral, it is singular that amongst such a vast accumulation of riches there is but one mention of an ivory crucifix or the figure for one. We find in the inventory made in the fifteenth century, "j crux eburnea floriata, cum ymagine Crucifixi cujus pes frangitur," but it does not appear in the inventory of 1538, unless the entry, "iij lyttyl crosses and one of every ornate wᵗ playtes of sylver," refers to it.

Nor have we any record of the kind of cross or crucifix used in the beautiful and touching ceremony of "creeping to the cross," for which one with an ivory figure would seem to be appropriate. In a manuscript of about the year 1500, printed in the Northumberland Housebook (see Maskell's *Monumenta*, Oxford ed. vol. iii. 391) we find a long rubric concerning the "Order of the Kinge and hys creepinge to the crosse."

"*Firste the Kinge to come to the chappell or closset withe the lords and noblemen waytinge upon him, without any sword borne before him as that daye: and ther to tarrie in his travers until the byshoppe and the deane have brought in the crucifixe out of the vestrie and layd it upon the cushion before the highe alter. And then the usher to lay a carpet for the Kinge to creepe to the crosse upon. And that done ther shal be a forme sett upon the carpett before the crucifix and a cushion laid upon it for the Kinge to kneale upon . . . and this done the queene shall come downe out of her closett or traverse unto the chapell with la. and gentlewomen waytinge upon her, and creepe to the crosse: and then goe agayne to her closett or traverse, and then the la. to creepe to the crosse likewise: and the lords and noblemen likewise.*"

It will not be without value, perhaps, to review shortly the evolution of the representation of the Crucifixion as we find it illustrated in ivory sculpture, and to follow it on until it arrives at the type which may be said to have been most common in the seventeenth century, and is now the fixed and accepted one. The study is the more interesting, because the earliest representation that we know is one in ivory, and in our own times this is the most commonly chosen material for the figures of crucifixes which are everywhere to be found.

Natural, indeed, was the shrinking which we find in early Christian art from representing a subject of such tremendous significance, combined with a record of such cruel sufferings. It is not surprising that the lapse of centuries was required before the prejudice and timidity should disappear; before the reverential awe which hung about all reference to the event should give place to any kind of representation in which a human figure should be used, and allow those who attempted it to venture even upon a conventional form of the death of divine humanity—a distorted one, perhaps, to our eyes, but suggestive enough to those who needed no more than a suggestion. In early Christian times sufferings of such a kind in their awful reality came too near home to those who themselves knew well in the persons of those dearest to them what martyrdom meant. And again, it would have been to represent an occurrence which was a subject for derision to non-believers. Therefore it was that in the first ages, if not entirely avoided, care was taken to dissimulate it under the least apparent forms. This supreme event—the greatest in history—was as a matter of imagery approached only through the medium of forms and symbols, types and allegories known and understood by the initiated. We find, for example, the symbolism of the death of Abel, or the sacrifice of Isaac. And when, as time went on, the abstract symbolism gave place to an actual representation, it was still only an attempt to translate into action, by means of a kind of conventional formula, an event, and the sentiments connected with it, which were impossible to be expressed with propriety.

In our ancient ivories we have, almost invariably, the allegorical figures of the sun and moon veiling their faces in grief. There are the figures of the Mother and the beloved disciple. Or, again, the cup of sacrifice placed beneath the rest for the feet, or such an emblem as the pelican in her piety feeding her young. Through-

out we must notice the reverential feeling which prevents the doing more than make, as it were, a bare record of the great Fact. Never are we called upon to dwell upon the sufferings and horrors which accompanied it. Nor, indeed, could it be possible to contemplate calmly the representations which later times have put before us, were it not that the custom of ages has turned even the realism itself into a convention. It would not be difficult, perhaps, to imagine the feelings with which the first attempt at a naturalistic pourtrayal would have been received. But, as will be shown, the transitions have been gradual, until at last even the repulsive realities, more daring in the Spanish school than in any other, appear to be defensible and almost cease to shock.

To the religious mind of the early centuries the Crucified One was God in the figure of man—usually of a youthful, beardless type—and not even a suggestion of the possibility of suffering is indicated. The artist appealed to faith alone, and in his art preserved the mystery. For a less believing age it was necessary, perhaps, to excite emotions of pity, and finally we are presented with the image of a purely human being undergoing the most painful death which it is possible to conceive. We are spared scarcely a realistic detail which can add horror to a situation which it would be impossible calmly to gaze upon, unless the mind has been unconsciously brought to idealise a type which at the same time professes to be a truthful presentment of an actual and terrible fact. Such representations are, it may be said, in one sense truthful, in another they are untrue. For it is difficult to conceive that the reverential feeling of devotion and of faith in the divine mystery of the Passion and death of our Lord can be measured by the degree of excellence in art—great, no doubt, as this excellence may be, as in the case of the Spanish crucifix to be presently described—which we cannot help associating with them. It is this point of

view which is of so great interest in comparing the early representations of the Crucifixion and the feelings which actuated their makers with those of later times. On the one hand there is the spirit of awe and reverence which dared not go beyond recording the fact in what was scarcely more than a symbolical manner; on the other (after about the sixteenth century at least) we have the artist expending all his talent on the representation as an anatomical exercise of a human body nailed to a cross, going so far, as we shall have occasion to refer to in one instance, as to use a corpse for his model. Legitimate enough, no doubt, in the preparation of a work of art—for Rembrandt has made powerful use of such a model—but hardly fitting in the case of the holiest of themes.

The earliest representation of the Crucifixion which has come down to us is perhaps the one which we have in the Passion plaques in the British Museum (plate xii.), if we except what may be a still earlier example in the case of the doors of the church of St. Sabina at Rome. In these doors, which are attributed to the sixth, or even the fifth, century, we have a number of subjects carved in wood. Amongst them is a group of three figures, which are taken to represent the Crucifixion. The central one of these, very slightly draped, extends both arms from the elbow only, in a manner more suggestive of the *orantes*, as if praying, than of a crucified figure. Two others, smaller, indeed almost infantile in proportions, stand, one on either side. There is no cross, and they appear to be placed against a wall—the walls of Jerusalem, as it is thought. To the above may be added the reliquary of Queen Theodolinda, of the sixth century, on which the two thieves appear to be indicated in the attitude of crucifixion; and the Syriac evangeliarium at Florence (A.D. 586?), in which is a representation of the two thieves, and the soldiers playing *mora* or casting dice. The latter rarity is also found

on the ivory pax, or plaque, of the eighth century at Cividale in Friuli.

In early art our Lord on the cross is nearly always youthful, erect, and in life; beardless and without crown or nimbus. The feet are separate, sometimes pointed to the front, and without signs of nails. The drapery in the British Museum plaque is scanty; but, on the other hand, it is usual to find the figure more or less clothed, either in a long-sleeved garment which extends to the feet, or in a skirt reaching to the knees, or even lower. The arms are at right angles to the body, the hands extended quite straight. It was a period of tradition, and the traditionary methods are strictly preserved. The wound in the side does not appear till much later, and is not even then always constant. As before remarked, many were the figures and symbolical allusions. Of the two thieves a very early, if not the earliest, instance amongst our ivories appears on a palimpsest plaque in the Kensington Museum—Carlovingian work of the ninth or tenth century. The arms of the thieves are turned back over the arms of the cross, and their feet bound with ropes. Often the hand of the Father issues from a cloud above the head of the Saviour in the act of blessing. The spirit of those times would never have brooked the representation of the Almighty as a venerable old man, as we find later on. As time went on the symbolisms were still further extended. The enemy of mankind, the serpent, earth and water, the church and the synagogue, a skull, the dead, or Adam alone, rising from their graves, ministering angels, the pelican, Romulus and Remus (as in the Rambona diptych), or the emblems of the Passion in the form of the sponge, the nails, the pincers, the lance, and dice, and so on, are found as adjuncts. The form of the cross itself, at first perfectly plain with rectangular beams, usually of narrow dimensions, becomes fantastic. This is indeed carried so far that

at length, as in a painting of the sixteenth century and in woodcuts of the period, we have human arms issuing from the four arms of the cross, one of which opens with a key the gate of paradise, another crowns an allegorical female figure riding upon a lion, a third stabs in the head another allegorical female figure, and the fourth locks up the gates of hell.

To resume, and referring solely to ivories, the Saviour in the British Museum plaque is youthful, without crown or nimbus or scabellum, the feet without nails, the arms at right angles. In the ninth century the scabellum, or rest for the feet, appears, the head is inclined, there is sometimes a royal crown, the body is completely clothed (as in the Kensington Museum palimpsest) or wears a skirt. In the tenth or eleventh centuries the skirt is usual, but sometimes there is the full clothing. In one instance our Lord is old and the beard long. The feet are crossed and nailed with one nail. There are the titulus and the scabellum. In the thirteenth and fourteenth centuries the body becomes more emaciated, with signs of suffering in the face, and a tendency to realism, still, however, brought before us in the most reverential way, with a reticence which is not the less touching and suggestive. The body is much contorted, the arms sometimes disproportionately elongated and not so straight, the cross long and slender. The crown of thorns appears, but oftener, as will be noticed in the beautiful diptych (plate xxxii.), this is no more than a fillet. Finally, we pass to the striking change in the expression of artistic feeling which was manifest at the epoch known under the name of the renaissance, and there will be little of religious art in ivory to call for notice until we come to the crucifixes of the seventeenth century. These, for the most part, are of a type which attracts attention on somewhat different grounds from those upon which we have hitherto dwelt.

We may now briefly refer to the few examples of very

[325]

early crosses and crucifixes in ivory which we are fortunate enough to possess, and next devote some space to the work of the ivory carvers of the seventeenth and eighteenth centuries, of which indeed there is no lack, though it is of very unequal merit, and for the most part in its latest phases must be admitted to be deplorable.

A crucifix with an ivory figure, from the Soltikoff collection, is in the Kensington Museum. The cross is of cedar, overlaid with plates of gold filigree work, and with four medallions of *cloisonné* enamel with the emblems of the evangelists. The figure is of walrus ivory, the arms being of separate pieces from the body. There is a fillet instead of a crown of thorns. The gold cross is Byzantine work of the tenth century, and with this we need not concern ourselves; but it may be asked whether the figure may not be later, and, again, was it made for the cross, or, perhaps, part of a plaque or book cover?

The cross, known as that of the Princess Gunhilda, niece of King Canute, in the museum at Copenhagen, is not, perhaps, in its present condition strictly a crucifix, for the figure is lost; but it has incontestably possessed one, as the place for the head shows a cruciferous nimbus, and there are representations of drops of blood below where the feet and hands were nailed. It is an interesting specimen of Scandinavian Byzantine work. Both sides are beautifully carved in low relief, with medallions at the ends of the arms, having representations, amongst others, of our Lord in glory, royal and priestly personages, Dives and Lazarus, and the allegory of the church and the synagogue, and there are many decorative inscriptions in Roman capitals.

A splendid crucifix of primitive type, work of the eleventh century, formerly in the cathedral of St. Isidore, at Leon, is now in the Archæological Museum at Madrid. It is composed on both sides of ivory tablets elaborately sculptured, the figure of Christ draped with a long skirt, and attached with four nails. The open eyes are set with

coloured glass beads. It was exhibited as Spanish work at the loan exhibition at Kensington in 1881, but it may be questioned whether the origin is not oriental. The figure is of the archaic Byzantine type. At the foot is the inscription, in relief, " FERDINANDVS. REX. SANCIA. REGINA.", the gift of King Ferdinand to his queen Sancia. The date is therefore between A.D. 1037 and 1065. The elaborate decoration on the back recalls—indeed, it is identical in character with—the chair arms from the Meyrick collection, which have been noticed. There is always a difficulty in distinguishing a certain class of Arabian art from Byzantine. The decorative ideas adopted by both came from Persia. We see this, for instance, in the case of oliphants. But the relations of Spain with Constantinople and its emperors in the days of the caliphs of Cordoba must not be forgotten, and the consequent influx of Byzantine artists into Spain. We find the same system of interlaced scroll foliage work in the two arms of an ivory cross of the twelfth century in the collection of M. Doistan, exhibited in Paris in 1878, and since presented to the Louvre; in this case a kind of border or frieze of grotesque animals running along the edges. These crucifixes may well be, then, Byzantine, or the work of Moorish artists for the Christians of Spain; for ornament they are thoroughly oriental. The decorative elements introduced by the Moors into Spain are, above all, conspicuous, and it is interesting to compare such work with that of the Arab caskets of the cathedrals of Pampeluna and of Palencia. We need not pursue further this interesting subject except to notice that M. de Linas, in his learned article in the *Revue de l'art chrétien* (vol. iii.) asserts his conclusion that the Leon crucifix is purely Spanish.

A large crucifix in the cathedral at Bamberg, said to be of the eleventh century, is described by Kugler (*Kleine Schriften*, vol. i.), and another, in the cathedral at Bor-

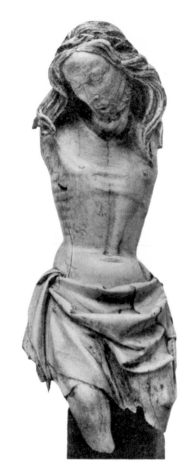

1

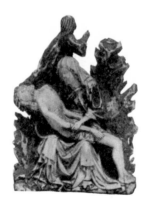

2

Plate 52. 1. FRAGMENT OF A CRUCIFIX. ITALIAN

THIRTEENTH CENTURY

2. PIETA

AT ONE TIME CENTRE OF THE VOLUTE OF A CROSIER. FOURTEENTH CENTURY

(British Museum)

deaux, assigned to the twelfth century, is briefly alluded to by Viollet le Duc in his *Dictionnaire de l'architecture* (article "Crucifix").

So far, therefore, as our knowledge goes, these five examples exhaust the list of early ivory crucifixes, and we pass at a bound to the fourteenth century. Here we shall find the sole example which we are able to produce of that glorious period of devotional art—the only link of its kind between the much earlier types which we have been considering and the crowd of crucifixes which the seventeenth and eighteenth centuries will present to us. It is a long interval—a great gap indeed—more than five hundred years which remains to be filled between the middle of the eleventh and the beginning of the seventeenth centuries.

But if we have but this one example, now in the museum at Kensington, it is—though hardly more than a fragment—a very fine and instructive one. It is the prototype of those later models which characterise the form given to the crucifix even down to our own time, though far finer in conception and devotional treatment than anything that succeeding centuries can show. There is, indeed, in the head of our Lord, falling over after death on the right shoulder, an indication of the agony which has been gone through, but it is not of an exaggerated type, neither has the artist shirked this expression of suffering, or contented himself with the placid sentimentalism which characterises so many of the crucified figures of post-renaissance times. It is an ideal of the highest kind, conceived with a perfect reticence of feeling, even though—by hardly more than indications —it suggests to us the anatomy of the emaciated body and of the legs drawn up in agony. There has been a crown of thorns, beneath which the hair falls over in long, dank ringlets, but there are no realistic drops of blood or painful wounds. There is sufficient of the real combined with a subtle spirit of convention. Fragment

though it may be, it is noble and poetical, and our regrets are increased that we may only conjecture in what way the sculptor completed the treatment of his subject in the positions of the arms and legs, which have always presented difficulties in works of this kind. So far as we can judge, the arms were extended, if not almost at right angles, at any rate without being much drawn upwards, as became what is called the Jansenist practice later on.

A lesser fragment, found not long ago in making some excavations in London, is in the Guildhall Museum. Scarcely more than the torso remains. The head and arms are missing, and the legs have been broken off below the knees. Still, we may gather that the complete figure must have been very beautiful, and was probably English work. The skirt is long, and gracefully draped with a decorative border. It is, perhaps, as early as the twelfth century.

In a succeeding chapter there will be occasion to consider the new spirit which was introduced into art of all kinds at the period of the renaissance, and its effect on ivory sculpture in the seventeenth century will have to receive attention. From that time onwards, so far as religious art is concerned, the crucifix is the only object, with very few exceptions, which calls for serious notice. For the present we may take these crucifixes here, as a class apart, without reference to the general condition of ivory carving in the century alluded to, from which all our examples will be drawn.

In the seventeenth century ivory crucifixes—that is to say, figures in ivory to be attached to a cross—abounded. Probably every sculptor would, at one time or another, have tried his hand at one, for such things are always attractive objects in this material. Without attempting to compile a list of known examples, it will be interesting to note the most important ones, and the artists to whom they are attributed, for it is only in rare

cases that we have any certainty of this attribution. We shall find them distributed amongst the ivory sculptors, for the most part, of France, Germany, and the Netherlands; in the first-named country, especially of the schools of Dieppe and St. Claude in the Jura, which were the two most important centres of ivory carving in France.

It will be hardly worth while to do more than mention, in passing, that a figure of Christ for a crucifix attributed to Jean Goujon formed the subject of a lawsuit in Paris in 1856, and that another at Munich is said to be by Michael Angelo, and another attributed to Cellini. With regard to Cellini, nothing is more likely than that he worked in ivory, and would probably have executed a crucifix; but there is, unfortunately, not the least scrap of evidence to this effect. There is a crucifix by him, in the Escurial, of life-size, in one piece of white marble. It is entirely nude, the feet crossed and nailed with one nail, the arms almost straight. He tells us, in his memoirs, that he vowed to make an image of Christ as He appeared to him in a vision when he was a prisoner in the castle of St. Angelo, and it is claimed that this is the one which he made. Another crucifix in the royal chapel at Munich is said to be by Algardi. Probably, with that attributed to Michael Angelo, it is German or Flemish of the seventeenth century.

The name of François Duquesnoy will figure prominently when we come to consider generally the ivory carvers of the seventeenth century. Several crucifixes from his hand, or supposed so to be, were exhibited at the Brussels Exhibition of 1880—one, at least (from the collection of the Comte de Grunne), with his signature. Of the work of his brother Jerome, a crucifix made for Antoine Trieste, bishop of Ghent, is illustrated in Mae's and Weale's *Album des objets d'art exposés à Malines en 1864*, and the authors tell us that it is irreproachable in anatomy, with the expression of suffering well rendered; but the Catholic traditions were neglected

not only as to the vertical position of the arms, but also with regard to the scantiness of the drapery.

Another famous crucifix, or one of two—for the one is a replica of the other—attributed to no less an artist than François Girardon, is in the archiepiscopal palace at Troyes. The replica, or original, as the case may be, is in the cathedral of Sens. They are not of great merit, or likely to be the work of Girardon.

Joseph Villerme, of St. Claude (+ 1720), was a French ivory sculptor, who devoted himself entirely to crucifixes, and many of those to be found in French churches in Franche Comté are doubtless from his hand. In order better to understand the anatomy of a figure attached to a cross, he is said to have frequently used dead bodies as models, and on one occasion to have nearly lost his life from a malignant fever caught during the process of making a plaster cast.

An interesting French crucifix of the seventeenth century is that by Jean Baptiste Guillermin (1623–79), of the Dieppe school, signed by him and dated 1659. It was made for the chapel of a confraternity of penitents at Avignon, and is now preserved in the Calvet Museum of that town. There is an interesting history attached to it. The story goes that the " Confrérie des Pénitents de la Miséricorde" were charged with the care of prisons, and accompanied condemned criminals to the scaffold. Once a year they were allowed the privilege of obtaining the pardon of a condemned person, and on one occasion the criminal happened to be a nephew of Jean Guillermin, who offered his crucifix in return for his nephew's release. There is, however, a long and interesting record in the archives of the confraternity, giving in detail the negotiations which took place between them and the sculptor concerning this crucifix. The *procès-verbal* speaks of the excellent foreign sculptor then staying in or passing through the town, and the proposal is made to entrust him with the execution of an ivory

crucifix finer and larger than any they possessed at the time. Guillermin promises that if a piece of ivory can be obtained of sufficient size and quality, he will remain and exercise all his talent in making the crucifix. One of the council goes to Marseille to procure a piece, but finding none there, after some trouble manages to procure one at Montpelier weighing seventy-three pounds, which is purchased at thirty-eight sols the pound. It is then agreed that the sculptor shall receive for his work forty crowns, and one pistole (twenty francs) in addition if satisfaction is given. The work is begun, but not being satisfied with the two first arms of the figure which he made, Guillermin makes two more, and the confraternity congratulate themselves on having two pairs, which they decide to keep carefully. The work occupies the months of July and August, and is ready for delivery a few days before the feast of St. John Baptist. The confraternity are delighted, and the *procès-verbal* says that an honest man who saw the crucifix offered a hundred louis d'or if they would part with it. Then follows an account of the joy of the people, and of the processions and special services which were organised to accompany the reception of the crucifix at the cathedral. It would appear that Guillermin received 280 francs for his work, and that the cost of the ivory was 138 francs; so that, allowing for the difference in value of money at the time, the confraternity made a very good bargain. The account is interesting, as it shows the value of artistic work of the kind in those days, the time taken to complete the work, the size and weight of the tusk used, and also that none was procurable at so important a port as Marseille, though a more inland town was able to furnish it.

Other French crucifixes are those of Michel and François Anguier (1614–86), the latter of whom executed the crucifix for the high altar of the Sorbonne, and of Simon and Hubert Jaillot (1657–81), who were

makers of crucifixes only. A good example by the former is in the hospital of St. Germain-des-Près at Paris. Michel Anguier was a sculptor of considerable merit. There is a pair of very fine bronze fire-dogs, with figures of Jupiter and Juno, by him in the Wallace Museum.

Amongst others who carved crucifixes were Le Geret (1628–88), and at the end of the eighteenth century the Rossets, father and son, of St. Claude; and so we come to the ivory crucifixes which up to the present day are turned out in vast quantities at such ivory-working centres as Dieppe and Geislingen. They are, of course, simply workshop work made after the same model over and over again, after the fashion started some time in the eighteenth century, which has gone on getting worse and worse to our own times.

Of German crucifixes the list would probably be a very long one if we should seek to include all who addressed themselves to this work among the ivory sculptors of Bavaria, Saxony, Suabia, and other places. Prominent amongst them stands the work of Andreas Faistenberger (1646–1735), to whom we shall again have occasion to refer. It is seldom, indeed, that we are enabled to identify the work of ivory sculptors by their signatures, but happily the very fine crucifix belonging to the archbishop of Tours, shown at the Lille Exhibition of 1874, bears the initials of Faistenberger. It is made of an extremely fine piece of ivory, of a very large and distinct grain. The figure measures nearly thirty inches in length. The arms, following to some extent the ancient tradition, are not so far removed from the horizontal position as we unfortunately find too often in figures of this period and later; the feet are apart and nailed with two nails, and the drapery—so far as it may be considered appropriate—is excellent. The head is crowned with thorns, and the expression of the face, the uplifted eyebrows, the wide-opened eyes,

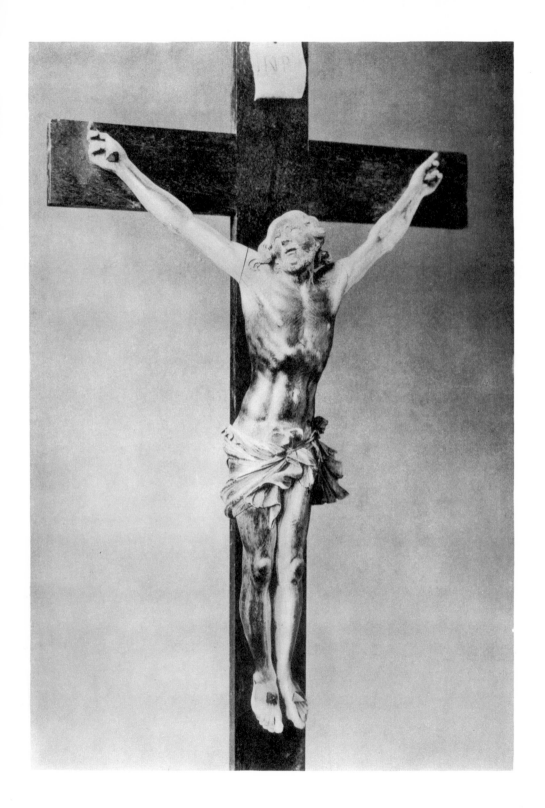

Plate 53. CRUCIFIX

FROM THE ABBEY CHURCH OF DOWNSIDE. SEVENTEENTH CENTURY

from which tears flow and rest on the cheeks, the partly opened mouth, and the flowing locks are admirable. The eyes are coloured blue, the wound in the side and the drops of blood are also coloured. A little above the drapery on the left side are the initials "A F" and the date "1681." Another crucifix, possibly also by Faistenberger, was shown at the same exhibition by M. Alfred Mamé, of Tours; but though the anatomy is good, it is not equal in expression. The face is insipid, and, as it were, too correct and careful.

Of all the crucifixes of this period we know none so fine as the beautiful one in the Benedictine abbey church at Downside, near Bath, which, in default of any absolute indication, and comparing it with the first of those described, there would appear some reason to attribute to the same excellent sculptor. It is again of large dimensions and of a very fine quality of ivory. Time, which deals in a somewhat unaccountable manner with ivory in respect to colouration, has stained the greater part of the figure a fine chestnut or mahogany colour, which, far from being a deterioration to be regretted, adds greatly to its beauty. The suffering expression of the face, in its simple and touching pathos, the eyes opened as in life, the anatomy of the torso, the strained muscles and the prominently marked veins, are of rare beauty and scientific truth. The arms, the knees, show a surprising vigour and yet restrained delicacy of modelling. The *titulus* is separate, and beneath is a detached skull, the crossed bones missing. There is no crown of thorns, but this omission was not unusual at the time. The figure measures nineteen inches in length and fourteen and a half inches in breadth between the finger-tips, the circumference of the torso, or chest measurement, being nearly thirteen inches.

The history of this crucifix is unknown, except that it is traditionally supposed to have been taken from a Spanish pirate ship, and as an example of Spanish art

it was exhibited at the loan exhibition at South Kensington in 1881. It was the gift, about the year 1814, to the newly erected church of the Benedictines at Downside, of Mrs. Sartorius, mother of Admiral Sartorius, who had captured it from a Spanish galleon.

Another remarkably fine crucifix of a similar type, but somewhat larger, is at Oscott College, near Birmingham. The head wears a crown of thorns, and the anatomy of the body is extremely fine. It belonged to Napoleon I., who gave it to Cardinal Fesch, and he in turn gave it to Cardinal Fieschi, through whom it came to Oscott. The figure measures thirty inches in height.

A crucifix undoubtedly Spanish in feeling, probably late seventeenth-century work, and admirable indeed from a purely artistic point of view, if not for the sentiment which, in the opinion of many, ought to govern the illustration of such an exalted theme, is the one which has been now for many years in the church of St. James, in Spanish Place, London. We have here pushed almost to the ultimate limits possible a realistic presentment of a human being who has already suffered the most cruel treatment by scourging, hanging suspended by nails on a cross, in the last agony of death, or at the moment after death. By colour and jewelling we are shown the shocking state of the whole body from the effect of blows, the lacerated back, the knees broken and streaming with blood, which is indicated throughout the wounds on the body by tiny rubies. The feet are crossed and nailed with one nail, the crown of thorns is of metal. It is unnecessary further to dwell on this painful realism. After all, the face is calm and beautiful, but it is a method of expressing such a sacred subject to which the term morbid is alone applicable.

We are not inclined to attribute to Spanish art—as regards workmanship at least—many of the crucifixes of the type with which we have been dealing. Ivory was not very much used in Spain at the periods in

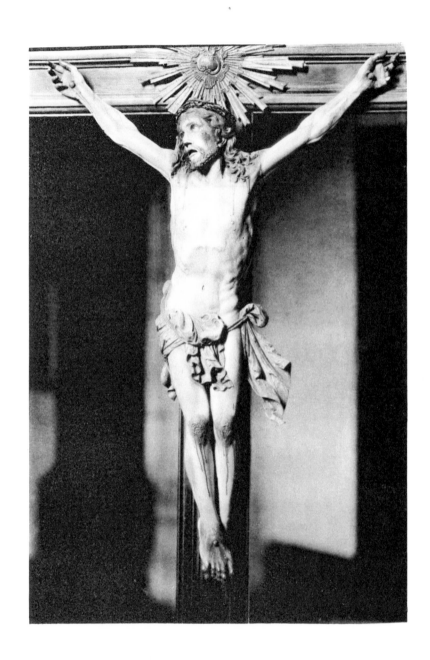

Plate 54. CRUCIFIX. COLOURED AND JEWELLED

SEVENTEENTH CENTURY

question. Besides, one may easily imagine a Spanish ecclesiastic in Rome or elsewhere giving instructions for the making of a crucifix according to his ideas, ordering that it should be coloured, the wounds emphasised, and the blood indicated by rubies. Strip the Spanish Place crucifix of these additions or peculiarities, and there would be nothing particularly Spanish about it except the treatment of the hair and beard.

Another crucifix of very large size and of good type is in the British Museum. It is said to be Italian of the sixteenth century. But, as in other cases, it is difficult to be precise ; and even if some may be by German or Flemish sculptors, it must be remembered how many of these studied and worked for a long time in Rome, and were permeated by Italian influence and feeling. Indeed, they must have known the great crucifix of Donatello. Generally speaking, it is seldom that we find any striking originality.

A brief reference must suffice for some other examples by German artists. A crucifix by Georg Petel (+ 1634), a Bavarian sculptor of some repute, settled at Augsburg, is in the Imperial Museum, Vienna. It is not without merit, but is in no way equal to the work of Faistenberger. The same remark will apply to the crucifixes of Melchior Barthel (1625–72), of Balthasar Permoser (1650–1732), and of Bernhard Bendel (1668–1736). Examples by these are, respectively, in the museums at Florence and Brunswick, and in the Frauenkirche at Munich. They all worked in Italy, and to this circumstance must be attributed the similarity of style and feeling. One cannot help finding in them, as in so many others of a similar type, a suggestion rather of a living, unclothed body, in full health and strength, merely suspended or hanging by the hands, than any idealised conception of a cruel martyrdom. And this without reference to what has already been said with regard to devotional treatment.

Considerable space has been given to crucifixes and their makers for reasons relating to the important position which they hold in the evolution of the history of art, and because also, in a matter which concerns a devotional object of such frequent and universal use, which is more often, perhaps, now made in ivory than in any other material, it is surely desirable that the influence of the best traditions should make themselves felt. And the suggestion may at least be hazarded that the truest and best form of expression might be found midway between that of extreme archaicism and the soulless, undraped figure which has no more devotional inspiration than the most undiluted work of pagan art.

Before leaving the times when religion exercised a purer influence on art than it did after the renaissance, we must cast a glance at the few pieces of importance of a religious character with which the sixteenth century supplies us, and at other minor religious objects in ivory not hitherto touched upon. Though small in number, those which will be selected will suffice to show that if a period of decadence set in later, at least the fall was not an absolutely sudden one, and that this century still possessed some artist sculptors in ivory of not inconsiderable talent.

The Flagellation is a subject that we should expect to find not unfrequently treated, amongst incidents of the Passion, on diptychs and triptychs, and other religious objects in the middle ages; but it would seem, as in the case of the Crucifixion, to have been avoided in earlier times. We do not meet with many instances in ivory previous to the thirteenth century. One is a small plaque, German, of the tenth to twelfth century, in the Sneyd collection. Our Lord is fastened to a branching tree, and stands on tiptoe, while two jailers inflict the blows. Coming to the sixteenth century, we have a very fine plaque, also German, from the Maskell collection, now in the British Museum. The relief is

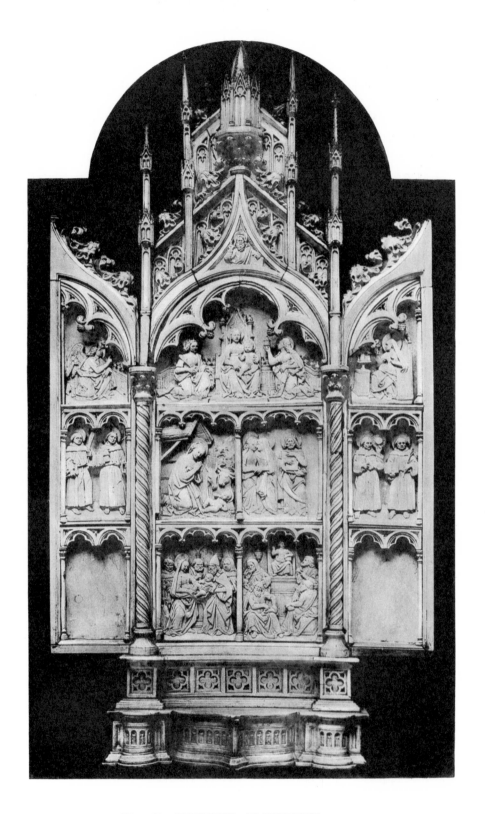

Plate 55. TRIPTYCH. FLORENTINE

SIXTEENTH CENTURY

low, and the figures are characteristic of the type and costume of the period. The design and action are very good and boldly expressed. Our Lord is bound to a pillar, one jailer seizes Him by the hair, another holds a lanthorn, and in the upper angles are two cherubs.

A magnificent triptych in the museum of the Louvre shows in a marked manner, in the character of the figures, in the architecture, and in the general style, the period of transition from the fashion of the three previous centuries to that which came in with the renaissance. The groups are more dramatic and less conventional, and the same spirit of more realistically dramatic action goes on increasing, and is exemplified in the fine group of the deposition from the cross in the Florence National Museum, which has, with little authority and less probability, been attributed to Michael Angelo. The Louvre triptych shows a master hand, not copying from contemporary sculpture, but of original conception and of excellent execution. It is Florentine work of the beginning of the sixteenth century, possibly later; and Molinier, in his *Histoire Générale*, reminds us that it is in the style of the sculptures in marble of a celebrated Florentine master of the second half of the fifteenth century— Benedetto da Majano—and that it is well known that this master executed for Mathias Corvinus, king of Hungary, some works which recall by their technique the methods of ivory sculptors of the time. The tradition also exists that this triptych was made for the king of Hungary.

Following on, we have a charming Madonna and Child, labelled Hispano-Flemish work, also in the Louvre Museum; very different, indeed, in its realism, type, and costume of the period—the waved hair, the long curls, a jewel on a band encircling the forehead— from the statuettes of the thirteenth century, but still of a delightful and attractive character. Note also the preservation of the idea of the holy Child playing with

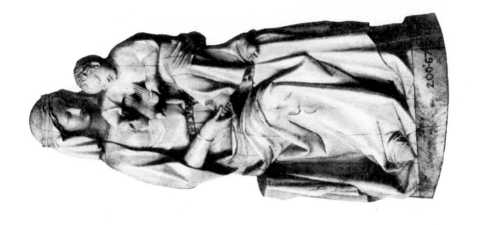

STATUETTE. VIRGIN AND CHILD. FRENCH

FOURTEENTH CENTURY

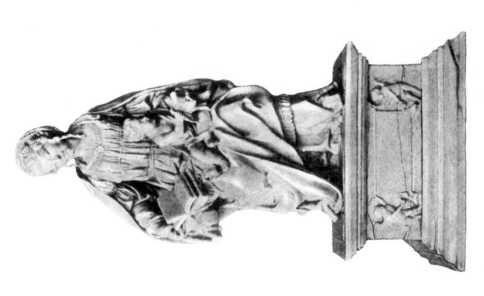

STATUETTE. VIRGIN AND CHILD. FLEMISH

SIXTEENTH CENTURY

Plate 56.

a bird, which was so frequent an accompaniment of the earlier kind.

We find other instances of the commencement of the transition in styles, for example, in the little French triptych at Kensington, in the centre panel of which two angels uphold a monstrance, having an opening in it for a small reliquary, the grounds of the leaves diapered with fleurs-de-lys and delicately hatched lines. A similar triptych is in the Louvre. And again, a plaque in the Louvre with Louis XI. at his prayers, his hat on the ground, though we do not detect the little leaden images, in the manner with which we are familiar. There are also the hatched ground and the fleurs-de-lys. Nor must an admirable plaque, representing the martyrdom of St. Sebastian, of Italian late fifteenth-century work, in the Kensington Museum, be forgotten. It is in low relief on a background of dark wood, the saint unclothed and bound to a tree, his hair falling in rows of curls down his back.

Of religious sculpture in ivory, other than crucifixes, of later date than the sixteenth century, but two examples call for any particular notice. One is the plaque in the British Museum representing our Lord upheld by angels after the descent from the cross. It is in very deep— more than two inches deep—relief. Cicognara, in his *Storia della Scultura*, speaks of it with great admiration, and supposes it to have been executed by the pupils of Valerio Vicentino and Giovanni Bernardi ; and Digby Wyatt goes further, for he says, " In this sublime and beautiful work of art I recognise the ultimate perfection of cabinet carving in ivory, having never seen a specimen equal to it." These are strong expressions, and may have been intended to apply only to sculpture of the period in which it was executed. On the other hand, Labarte says that the modelling is hardly correct, the figures commonplace, the limbs too thin (*Hist. des arts indust.*). A curious criticism, especially with regard to

[344]

the modelling of the limbs. However this may be, there are some grounds for supposing it to be the work of Andreas Faistenberger, whose crucifixes have already been described. There is an almost identical piece attributed to him in the museum at Munich. The head of the dead Christ bears not a little resemblance to that of Faistenberger's crucifix, and the modelling is of the same firm and decided style. It remains, however, to be noted that the group is, with slight modifications, a reproduction of a fine marble bas-relief by Girolamo Campana (1552–1623), in the church of St. Giuliano at Venice, and this of course somewhat discounts its value as an original work. Undoubtedly Faistenberger, with many other of his contemporary ivory sculptors in Germany, drew his inspiration and models from his long stay and artistic education in Italy. Without any evidence that Girolamo Campana himself worked in ivory, we cannot, of course, venture to suggest that either of these pieces are by him, nor if he did does it seem likely that he would repeat his bas-relief in this way. As a fine ivory reproduction it may perhaps remain, for what this may be worth, to the credit of Faistenberger.

The British Museum has an example of the work of Christoph Angermair, a plaque with the Temptation of our Lord deeply cut, with a landscape background in perspective. It is signed, and dated 1616. It is not remarkable except as an instance of extreme patience and minute elaboration of blades of grass, leaves of trees, and so on. We shall have better work of his to consider in the succeeding chapter.

A curious *memento mori* of the fifteenth century has already been mentioned. Many little works of the kind may be said to have been fashionable, either for rosary beads or as single objects. In the British Museum is a very gruesome but elegant specimen of sculptured ivory and goldsmith's work. It is by Christof Harrich,

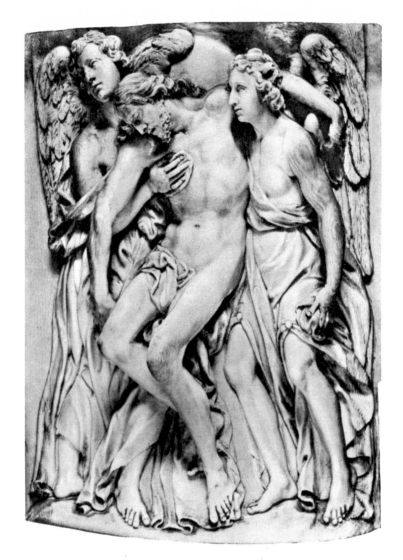

1

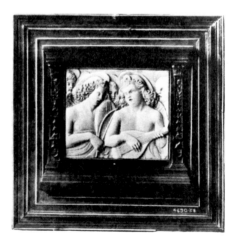

2

Plate 57. 1. PLAQUE. BY FAYD'HERBE? 2. PLAQUE. ITALIAN

SEVENTEENTH CENTURY SIXTEENTH CENTURY

a German decorative artist of the latter part of the six-
teenth century—a skull and a human head in life placed
back to back—of ivory mounted in gold and enamel.
Another, in ivory, represents in one half the vertical
section of a fashionable lady's head, attired in ruff and
wearing jewels; the other half is a grinning death's
head. A third example is a very large death's head,
with worms and other horrible creeping things crawling
in and out; a kind of thing one would expect in a
Japanese netsuké. And, indeed, all these little objects
have a curious resemblance to netsukés. A devotional
head of the kind is in the Mayer Museum at Liverpool.
It is French work of the fifteenth century, and represents
on one side the face of our Lord crowned with thorns,
from which drops of blood stream down. On the other
side is a man's head, half skull, half covered with flesh
as in life. Again, for rosary beads we have the heads
of a monk and of an aged man wearing a ducal coronet,
or a negro's head, with curly hair, wearing a cap with a
jewelled band. And, again, a set of eight heads repre-
senting an emperor, a bishop, a noble lady, a knight, an
old lawyer or judge with spectacles on nose, and so on.
The fashion in nearly all such examples is two heads
adossées—as, in the Louvre, a Flemish rosary bead with
a head of Christ crowned with thorns, and on the back
a Magdalen in the headdress of the period. Finally,
for one more example, also in the Louvre, a whole rosary
of sixteenth-century Flemish work composed of six
large and fifty-two smaller beads, each bead consisting
of four heads back to back; heads of Christ, and of
male and female saints with headdresses or coiffures
of the period, and all of very careful workmanship. Of
a somewhat different kind are some larger figures some-
times met with. One is in the Ashmolean Museum,
eight inches high—a woman slightly draped, and, at
the back, a skeleton in a shroud.

CHAPTER XII

POST-RENAISSANCE SCULPTURE IN IVORY

IT is a new art, a new fashion that meets us at the beginning of the sixteenth century, if we remember that up to about that time ivory carving was almost entirely restricted to work for the service of the Church or of a devotional character, with the exception of a certain number of motives taken from classical models or from mediæval romances for the decoration of caskets, mirror cases, and the like. The direct influence of the Church had waned. Therefore it is that we must not look with the same eyes as we did when we had before us the work of the thirteenth or fourteenth centuries, or compare from the same point of view the "Descent from the Cross" in the Florence Museum with the fragmentary piece of the same subject (*Frontispiece*) in the Louvre. The untranslatable devotional feeling is absent. Instead of the artists being men to whom their work was a vocation, an act of religion in itself, they were mercenary craftsmen who appealed to the senses, who strove to produce an effect by dramatic means, whose aim was solely æsthetic, and who were influenced, moreover, by the necessity of pleasing their patrons. In the first case the beauty, the art, was innate in the unconscious worker. His first idea was to teach, and his gifts ensured that his teaching should be delivered in a beautiful manner. In the middle ages, unknown though their names may be, it is evident that the ivory carvers

were a class apart. Later on, and up to our own time, when we find an uncommonly fine piece, it is by a great sculptor, distinguished also in other ways, who has elected to work now and again for distraction, as it were, in this material.

Now, on the other hand, we shall see the ivory carvers following the taste of the time. The nude, formerly entirely absent, is eagerly seized upon, and naturally so, for there could be no more charming material with special qualities of its own wherewith to express it. We do not wholly lose religious subjects, but in times when the rococo style runs riot we must expect to find the usual meretricious accompaniments of figures of sprawling angels and cherubs, and allegorical anachronisms combined with tasteless adornments and framings of curly scrollwork and overloaded foliage. We leave behind us the ages of faith. The spirit of inquiry takes its place. Realism and a following of nature are substituted for conventional forms. Everything has to be expressed. People are no longer satisfied with the simple sign-language of mediæval times, by which a gesture, a fold in a robe, or one or two figures, told so much in a kind of pictorial shorthand.

We have seen the art of ivory carving at the period of its highest development in the middle ages, when, if it may have been equalled in other branches of art, at least it was surpassed by none. We have now to trace the history of its decline, for it must be admitted that the period of neglect and decadence, which to a great extent set in about the beginning of the sixteenth, became accentuated in the seventeenth, and culminated in the eighteenth centuries. Yet as it shared this decadence with most of the other plastic arts of the periods, which have been nicknamed *baroque* or *rococo*, so also we shall find exceptions which will justify the attention which may be given to them.

To account for the position, it will not be without

interest to refer briefly to the condition of art generally from the time of the renaissance, confining ourselves as much as possible to the direct influences which affected ivory carving itself.

Everyone is acquainted with the change of system in the practice of all the arts which, brought about by various causes, took place about the end of the fifteenth century, and the name of Renaissance, by which it is universally known. It was foremost above all in Italy, and the return of the popes to Rome after their long exile, the taste for antiquities and collecting them, the unearthing of the old pagan monuments of the imperial city, the revival of classical literature, the lead which the Church itself took in the protection and encouragement of artists, the general prosperity and the excessive riches of the Italian princes consequent on the release from the charges of war which had previously weighed heavily—all this contributed to form an epoch of exuberant enthusiasm for the arts, and especially for those which encouraged a taste for splendour and a lavish use of the precious metals, enamels, and the other productions of the goldsmith and silversmith. It is hardly within our province to do more than recall some features and great names of this important epoch. But as all the arts hang together, it will be useful—nay, it is necessary—to bear in mind the progress of the revival from the time of him who has been called the father of renaissance sculpture—of Nicola of Pisa—in the middle of the thirteenth century. Following him come the great names of Ghiberti, maker of the famous gates, of Donatello, of Verrocchio, and the change from the methods which had previously prevailed to a more dramatic and pictorial treatment, and to the more common use of perspective, and we must take into account the schools which developed under these influences. It will be necessary to remember the influence of such names as Della Robbia, of the great goldsmiths, of Francia and

of Cellini, of Briot, Visscher, and the Jamnitzers, of the bronzists, of Michael Angelo, of Giovanni di Bologna, of Dürer, and Beham, and Krafft. The difficulty is to make a representative choice before we arrive at the period of general decline and the degeneration of taste which affected an unhealthy copying of the antique, an appeal to more commonplace intelligence, a love of display and extravagance which without restraint becomes vulgarity, and an inability to distinguish the lesser value of technical *tours de force* compared with the simplicity which marks the productions of genius.

It has been shown that, compared with the wealth of ivory carving which the thirteenth and fourteenth centuries afforded us, the fifteenth, and especially the sixteenth, are singularly poor in really fine work. The reasons for this dearth were probably various, and have already been partly alluded to. Another reason may possibly have been that the supply of the raw material may have failed about these periods. Yet another cause may be found in the popularity and perfection which the art of wood carving attained, especially in Germany and Flanders, in the late fifteenth and the sixteenth centuries. The material abounded, and the roll of great names comprises those of the most celebrated artists of these times. There is, of course, an affinity in technique between the arts of sculpture in wood and ivory; and if we cannot point, perhaps, with any certainty to carvings in ivory which have come down to us from the hands of the greatest of the wood-carvers, still it can hardly be doubted that many of them must also from time to time have chosen that medium. Whether this may have been so or not, nothing can be more certain than that we cannot, of the later times to which we are coming, now show anything in any way approaching such things as, for example, the Adam and Eve, in pear wood, by Dürer, in the Saxe-Coburg collection, or his busts in the Kensington Museum; nothing with such character as the wonderful

[351]

group of the Entombment, and, again, the three nude coloured figures, back to back, by Tielmann Riemenschneider; nothing so charming as that Nuremberg figure of the Virgin, in which she stands with clasped hands and uplifted eyes, in the wimple and veil of the period. Nor can we point to anything which recalls the work of Veit Stoss and Adam Krafft, and their followers, or of the Jörg Syrlins and the Suabian school, of the masters of the Upper Rhine, of Michael Wohlgemüth, of the Augsburg and Nuremberg schools, of Michael Pacherl, Stöberl, and the wood-carvers of the Tyrol, of Bohemia and Hungary.

Instead, in the mass of ivory carving which, in Germany especially, was turned out in the seventeenth century, we shall have to wade through the interminable series of gods and goddesses, pseudo-classical copies from the antique, bacchanals and satyrs, and the prevalence of the school of Rubens—work poor in character and destitute of originality. Everywhere the nude statuette abounds, but it is nudity of a commonplace and insipid type. We shall have enough of it and to spare. Happily we have not to judge all ivory carving of the period by this standard, or it would hardly have been necessary to write this chapter; and we shall be able to sift out from the mass sufficient to convince us that in ivory carving there were still masters in those days, and that the healthy traditions of art had not been altogether abandoned. We shall come across such things as the sixteenth-century Italian dagger or knife formerly in the Spitzer collection, which in the Louvre is known as the knife of Diane de Poitiers, the sceptre of Louis XIII., the Goujon (so called), and other Italian powder-horns, the Rothschild hunting-horn, the German Psyche in the Louvre, the young girl and Death in the Munich Museum. Here at least is originality, here is talent of the first order. Besides, even the lesser names cannot be wholly overlooked, and history must not give way

entirely to criticism. Nor must we forget, in coming to the seventeenth century, that whatever reproaches may be levelled against a large proportion of the ivory carving of that time, it is equally applicable to the condition of all the sculptural arts from the time when the baroque or rococo style prevailed till it happily went out of fashion.

The most striking impression which one gets from the great mass of ivory sculpture in the seventeenth century, apart from the selection of subject, which was due, and not unnaturally, to the prevailing taste of the time for classical adaptations, and for nudities of all kinds, is the want of originality in ideas. Nor can it be denied that, speaking generally, the artists were of inferior rank. Ivory carving was not a profession by itself. In many instances it can hardly be said to have been the work of individual artists, but rather to have been abandoned to the artisans of trade workshops, much in the same way, in fact, as we find too commonly the case in the silversmith's and other decorative work of the present day. But even when we come to examine the better class of work, which will not unreasonably claim our attention, we shall find frequently among the artists a want of spontaneous feeling. They were contented to borrow their subjects from classical and other sources, and even then often not at first hand, but from existing works in painting or engraving, in the same way, it may be said, that some Limoges enamellers did. Their inspirations came, not from models or designs made especially for their own craft, but from any works of the great masters which fell into their hands. They transformed compositions of paintings and engravings into bas-reliefs, and altered, reduced, and adapted from existing monumental sculpture, from marble, stone, bronze, and gold and silver smiths' work; from wood and honestone. They appear to have cared little for, or were ignorant of, the special requirements and characteristics of their art, and of the material in which they

were to work. They attempted too much, and in the wrong direction. The greatest artists alone are capable of combining the pictorial and sculptural arts. What, indeed, can be said when we find, for example, a reduction in ivory bas-relief of the "Last Judgment," by Michael Angelo, as in a plaque by the brothers Steinhard at Vienna? Again, if they were compelled to copy so much, it is to be regretted that they did not feel themselves drawn for that purpose to the great masters who had not long preceded them. They were infected by the detestable taste of the time, and some allowance must be made also for the exigencies of their patrons. It would appear that, for them, the style of the Florentine and Lombard schools of the fifteenth century, of Agostino di Duccio, of Donatello, of Rossellino, or of Mantegazza, had no charm. There is no note of these in any of the work which we can bring forward. Instead, they chose Bernini.

However varied the quality may have been, the art of ivory carving became extremely popular throughout the whole of the seventeenth and succeeding centuries, especially in Flanders and Germany, and the amount of ivory consumed must have been enormous. It is hardly too much to say that it became an absolute passion, and entered into the decoration of every description of object to which art could be applied. It would be almost impossible to enumerate all the various applications which were found for it. Statuettes and groups, plaques in low and high relief as purely cabinet objects or for the decoration of furniture, ivory engraved, chased and inlaid, tankards, cups, hunting-horns, and other objects for the chase, ewers and plateaux, busts, portrait medallions, crucifixes, caskets, toilet objects, chess and draughts men and boards, counter boxes, arms and sporting weapons, intricate turnery, and a host of minor objects of use and adornment, all made a demand for the employment of the favourite material. In addition

there were multitudes of great cabinets, inlaid and adorned with figures. Nor should we omit the elegant tobacco-graters which will presently be noticed, which have such a singular charm in the quaint costume groups. Even the little nudities and Watteau figures which characterise them come as a welcome relief from the classical compositions, the eternal Minervas in helmets and waving plumes, and the chubby little satyrs and bacchanals with their goats and vine branches.

Ivory carving was not only generally popular, but it was especially patronised by many of the great princes and electors of the independent German states, who encouraged the artists, maintained them in their service, and themselves practised the art. Amongst those who delighted in so doing were Augustus the Pious, Elector of Saxony, who founded the Dresden Green Vaults, Maximilian, Elector of Bavaria, the princely family of Fuggers, Ferdinand and Maximilian II. of Bavaria, and the Elector George William of Brandenburg. Peter the Great also dabbled not a little in ivory carving. Of his work there are in the Green Vaults two snuff-boxes and a ship in full sail, and at the Hermitage Museum, St. Petersburg, are quantities of nick-nacks and turnery work.

Taking into consideration the general state of sculpture of the time, it is to be expected that amongst such masses of ivory carving as abound in the museums throughout Germany, much would be of unequal or inferior merit. In some of the allegorical groups made to flatter the vanity of great princes the rococo style outdoes itself in vulgarity and bad taste. In such an example, for instance, as an allegorical group in the Vienna Museum by Christoph Maucher, one feels that the degradation of art could scarcely descend lower than in this curious mixture of bewigged princes, holy figures, stars and masks, conglomerates of cherubs, trumpet-blowing angels, scrolls, and garlands. It would

be unfair, however, to saddle ivory carving generally, on account of such things, with a reproach with which other arts of the period are equally tainted.

In the ivory work of the best times of the two centuries with which we shall be principally concerned, there were, of course, several schools. But it is not always easy to distinguish them, because it is certain that there was a great influx of German and Flemish artists both into Italy and into France. Many Flemish and German artists lived long in Italy, and became so permeated with Italian feeling that we should rather, perhaps, call their work Italian, in the same way as that of the Herkomers, Tademas, Solons, and others domiciled amongst ourselves has become recognised in English art. Van Opstal also is an example of a great Flemish worker who became settled in France.

Amongst the crowd of objects executed in ivory, to which allusion has already been made, tankards and tall-standing cups hold a prominent position. The form of the tusk suggests itself naturally for such uses, and in the groups and stories that run around the drum, as on a frieze, we shall find some of the most charming of any ivory carvings of these days. That the best work of the best artists should be bestowed upon them was but natural, for, in addition, the most distinguished goldsmiths, especially of Augsburg and Nuremberg, completed them by their mountings. Some of the finest figured in the famous sale at Stowe in 1848, and will be found illustrated and described in publications of the time.

Portrait medallions also are numerous, and if not of great importance, are to some extent interesting, though they cannot pretend to the merit of the more costly works in bronze, or to rival the productions either of the great bronzists or of the wood-carvers. Nor, again, do they often bear comparison with the best of Wedgwood's portrait medallions. They were equivalent, in a

way, to the photographic portraits which we now have, and for such memorials advantage was taken of every kind of material. We find them also in wax, in wood, which was sometimes carved, sometimes pressed with dies, and in tortoise-shell. The finest work is generally where the relief is low.

Turning in ivory has always had an attraction for those who delight in mechanical skill and *tours de force*, and some references will be made in their place to the most distinguished turners and their work. There is no lack of examples for those it may interest, for it became the rage. Princes and grand-dukes encouraged it, and collectors vied with each other for the number and variety of curiosities of this kind, some of which have also a certain amount of artistic value.

The chief centres of ivory carving in Germany seem to have been Augsburg, Munich, and Nuremberg, the last, perhaps, more distinguished for turnery and trick pieces. Geislingen, Ulm, Stuttgardt, and Gmünd were celebrated as early as the sixteenth century, and are so still as industrial factories. From them came probably a large number of the fine inlaid arms and powder-flasks, which will call for special attention.

The ivory workers of Dieppe are known to all tourists, and the town has been famous and important in this industry since it was first established there in the fourteenth century. The history is not a little interesting. In 1364 the enterprise of some of its merchants fitted out two vessels of about a hundred tons each, and started them for the great African hunting-grounds. Sailing past the Canaries and Verde Islands, they arrived at the mouth of a little river near Rio Sestos, where they founded an *entrepôt*, which they called "Little Dieppe." Evidently there was not in those days a rage for colonisation and annexation, or the territories might be even now part of France. In any case, they loaded up their ships with quantities of ivory, amongst other productions

of the coast, and returned to France. But though the facts of these voyages and of the extensive working of ivory in Normandy are beyond question, there is little, if any, record of early examples from here. Still, it may be the origin of much of the best French work of the fourteenth century. The trading companies were joined in their speculations by the merchants of Rouen, and the statutes of the painters' and sculptors' guilds of that city prove that the art was practised there also, and not merely as turners or for industrial purposes only. The bombardment of Dieppe by the English in 1694 put a stop for a time to the industry, and later on it seems to have disappeared almost entirely. After Waterloo the crowds of English tourists who visited France contributed to its revival, and it is still an important trade, and to some extent an art. Besides Dieppe, a considerable centre in France for ivory carving was St. Claude, in the Jura.

It is to be regretted that our museums in London, from which most of the examples throughout this work have intentionally been drawn, are singularly deficient in specimens of the best work in ivory of post-renaissance times. Not only so, but if we are lacking in originals, we are lacking even in the fictile copies, which are such an invaluable aid to study. The otherwise admirable collection of casts in the museum at Kensington stops short at about the sixteenth century. As a matter of fact, nothing seems to have been added to it even of the fine work of the fifteenth and previous centuries since about the year 1872. No doubt the collections at Windsor, and the great private collections throughout England, would afford numerous examples; but they are not easily accessible, except when lent for exhibitions.

Some remarkable pieces in the possession of Lord Londesborough, which figured in the famous loan exhibition of 1862, must be noticed. Amongst them is the ivory sceptre, or *main de justice*, of Louis XIII., a

work of extreme elegance. It is surmounted by a hand pointing upwards, with two fingers extended; round the wrist is a ruffle. The inscription in relief is "LVDOVIC. REX. FRANCORV." Besides this are a German sixteenth-century dagger, a fine Nuremberg ivory cup upheld by a figure of a mermaid, and mounted in silver gilt, and many interesting caskets, mirror cases, and other mediæval objects, and the tenure and Scandinavian horns already noticed. A grace cup in the possession of the Howards of Corby has a perfectly plain bowl of ivory, and is, perhaps, more remarkable for the setting of goldsmith's work. Still, it is worth referring to. It was presented to the valiant admiral, Sir Edward Howard, by Katherine of Aragon. It has always been known as the grace cup of Thomas à Becket. Possibly there may be some reason for this, as regards the bowl. On the fine silver-gilt mounting is "God. Ferrare," perhaps the name of the goldsmith. There is a good engraving of the cup in Grose and Astle's *Antiquarian Repertory*, 1808.

It is to the museums of the Continent, especially to those of Berlin, Dresden, and Munich, that we must go in order to form a just estimate of the value of ivory sculpture of late periods. In addition to those just mentioned, all German museums, Nuremberg, Cassel, Gotha, Brunswick, Karlsruhe, Vienna, and others, abound in examples of varying degrees of merit.

Before proceeding to notice in detail some specimens of the best work of post-renaissance times, and more especially of the seventeenth and eighteenth centuries, it may be as well to make some reference to a few pieces which, with or without much reason, as the case may be, have been attributed to great masters of the three preceding eras.

In the sacristy of the Duomo at Pisa is an ivory statuette of the Virgin and Child, which Ciampi, in his notice of this sacristy (Florence, 1810), engraves, and states that it is attributed to Giovanni Pisano (the son

of Nicola). It is, of course, thirteenth-century work, with the twist or bend in the figure of the period somewhat exaggerated, and doubtless there may be a certain amount of probability in the attribution.

Of Albert Dürer, a bas-relief in the Munich Museum bears his monogram, and two others in the Cluny Museum the monogram of Hans Sebald Beham. But it is well known that the practice of copying existing works, together with the signatures, was not uncommon, and was equally indulged in by sculptors in wood and honestone.

To Giovanni di Bologna are given a figure of Hercules at one time in the collection of Count de Nieuwekerke, and a crucifix in that of M. Richelot. Photographs of both are in the Art Library at Kensington. Judging from these, the first appears to be a work of fine character, and if not by the hand of Giovanni, may very well be after a bronze by him or his pupil, Francavilla, who is credited with an ivory statuette of Virtue chastising Vice, which is in the Cluny Museum. The figure is perhaps the Hercules now in the Wallace Museum.

There is a powder-flask in the Louvre, said to be by Jean Goujon. The carved work on the horn has a youthful figure, which has certainly the charm of manner of the great French sculptor, and therefore, even as an example from an unknown hand, is of considerable importance and interest to us.

Finally, to Michael Angelo many things are attributed, amongst them a crucifix in the Munich Museum and a figure of Silenus at Vienna, both probably Flemish work; and Cellini is naturally credited with anything fine in the way of dagger handles and the like, also with a Flagellation and a St. Sebastian in the Palazzo del Podestà at Florence. The question whether Rubens himself carved in ivory is scarcely worth consideration. That he delighted in it, and superintended the work of

his favourite pupil, Fayd'herbe, is certain, and the influence of his school is very evident in ivory sculpture. Too much so, many will think.

We have, therefore, no positive evidence in the case of the great sculptors who have been mentioned that they ever applied themselves to ivory carving. It is highly probable, indeed, that they should have done so now and again; but Cellini makes no mention of it in his memoirs, and, somehow, it would hardly appear suited to the manner and methods of Michael Angelo. It is more likely that his pupils worked from his numerous models. Sometimes apparently convincing details of origin are given, as in the case of a Virgin and Child in the collection of M. Goethals Danneels, which was exhibited at the Brussels retrospective exhibition in 1880, and attributed to Michael Angelo. It is said to have been brought from Italy by Cardinal de Jourdes, and given, about 1616, to the convent of the Chartreuse at Bordeaux founded by him. A glance at the style, which is doubtless extremely pretty, is sufficient to dispel any illusions. However the case may be, in these instances of uncertain attribution we have often objects of considerable interest which we may be quite content to take on their merits. A name is easily given, and once given it remains. There is little to be gained, as a rule, by seeking to father works of art by means of comparisons of style and attempts to see what are often far-fetched similarities. Of course, it must always be interesting when genuine signatures are discovered, and it may be that such results may follow even from the brief descriptions and references given in this book.

From the beginning of the seventeenth century we know the names of a considerable number of ivory sculptors; but as they seldom appear to have signed their works, it is not always easy to ascribe these to a particular artist, or from the fact of so many of the

latter having been settled in Italy, France, or England, even to be certain of the country of origin. On this account we often find ivories in collections and at exhibitions which are called Italian, but are more probably by Flemish or German artists. Nagler's well-known *Künstler Lexikon* and *Die Monogrammisten* are, of course, useful guides to signatures and monograms and to the lives of artists.

There is little in Italian ivory sculpture which calls for attention. Crucifixes have already been alluded to, and no doubt many of the large number in existence dating from this period had their origin in Italy; but for the most part there is little to be said about them. Algardi in his quite youthful student days undoubtedly worked in ivory, and possibly the Munich crucifix before mentioned may be of his early work: but it is not a matter of much importance. He will always be known by his bronzes. Of the Venetian, Antonio Leoni, who appears to have worked mostly at Düsseldorf, the Munich Museum possesses a plaque in relief with the "Conversion of Saul"—quantities of figures in the strife of battle, the Saviour appearing from a heaven of hard, unnatural clouds, with angels of the Cupid kind. We have also in the same museum some figures of saints—the undraped St. Jerome, so much affected by many ivory carvers, and an undraped St. John and several plaques with nymph and satyr, or classical subjects. They are signed "Antonius Leoni Venetus F."

When we come to the country of the great painters of the sixteenth and seventeenth centuries—of Rubens, of Teniers, of Vandyck and Hobbema and Rembrandt—and when we remember the influence that Rubens undoubtedly exercised in his studios on ivory sculpture, and the delight he appears to have taken in it, we shall not be surprised that it furnishes us with three, at least, whose work is entitled to be placed in the first rank of carving in ivory of the period we are now considering.

They are François Duquesnoy (better known as "Il Fiammingo," from his Flemish origin), Lucas Fayd'herbe, and Gerhard van Opstal. They are all contemporaries, and all—whichever among them was the first to set the fashion—mostly to be distinguished in their ivory work by the groups or friezes of playing children, little satyrs with goats, and nymphs and bacchanalian subjects, which became later such favourite and, it may be said, tiresome themes with the ivory carvers of Germany. But in these groups of nudities, especially of the children, although it is common to set down anything good of the kind as the work of Fiammingo, it may be pointed out that the styles are pretty distinct if, in the unfortunate absence of signatures, we are right in our attribution of such and such example to one or other of these three artists. That is, one seems justified in saying this is by Fayd'-herbe, that by Van Opstal, as the case may be, instead of an indiscriminate attribution to Duquesnoy. Instances will occur as we proceed.

François Duquesnoy was born in Brussels in 1594, and brought up as a marble sculptor. He seems to have been sent while quite young to study in Italy, and while there to have applied himself to ivory carving. He worked also in bronze, and on his return to his native country he executed a considerable quantity of important pieces of sculpture of various kinds, having already made, amongst other things in Rome, some large statues in marble, as, for example, the St. Andrew in St. Peter's. With these we need not concern ourselves further than as a guide for comparison in style with the number of figurines in ivory which in many collections are put down as his work. One interesting specimen of his modelling in bronze is the famous *manneken* at Brussels, to which every tourist's attention is directed. But Duquesnoy is best known by his plaques of youthful satyrs, and other playing children, of which we possess the most characteristic in the charming set of

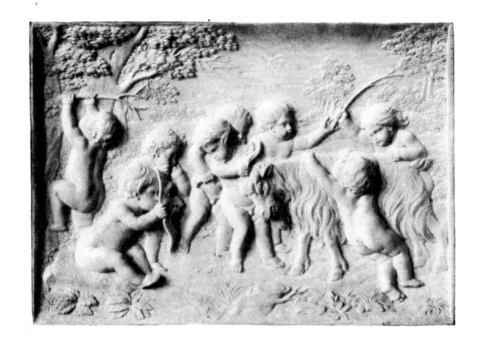

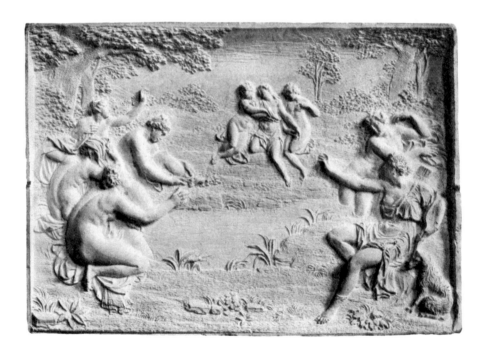

Plate 58. PLAQUES ATTRIBUTED TO DUQUESNOY (FIAMMINGO)

SEVENTEENTH CENTURY

six which are now in the Kensington Museum. It is true that no absolute authority exists, even for these, as being without question from his hand, but they are universally accepted as such, and the name of the "Fiammingo boys" has been given to them for some time. They may be taken as typical of his style, and it is easy to see how the influence of Titian, which is strongest in Duquesnoy's work, distinguishes them from that of Rubens, under which that of Fayd'herbe was executed. It has been somewhat the fashion of late years to depreciate Duquesnoy, and to relegate him to inferior rank amongst sculptors; but though opinions may reasonably differ, and may place him below Fayd'-herbe from certain points of view, it is quite impossible not to admit the merit of these most charming and delicately executed plaques, and with them may be placed another delightful plaque with Diana and her nymphs bathing in the midst of a wooded landscape. A cast is in the museum at Kensington, but there is no information concerning the possessor of the original.

All the above are executed in low relief, by which manner they are distinguished from a great deal of work of the kind by numbers of other ivory sculptors who followed, and the gain in delicacy and masterly treatment is apparent compared with the lumpy and confused style which we find in so many small plaques with similar subjects in German work. Of the figure work in ivory attributed to Fiammingo, there is an extremely fine little Cupid bending his bow in the Green Vaults at Dresden, and other figures, for the most part nude, are to be found in many collections. When draped, the drapery is very good and careful, and from the best classical models. A brother of François, Jerome Duquesnoy, was also an ivory sculptor. A crucifix by him is illustrated in Maes and Weales' *Objets d'art à Malines*. He came to a bad end, and was executed at Ghent in the seventeenth century.

There were two other sculptors of the name Fiammingo, of whom, however, little is known. It appears from Bertolotti's work on Flemish sculptors in Italy that there was a Giacomo Fiammingo living in Rome about 1595 who worked in ivory, and some figures of the Five Senses, dated 1565, are attributed to Giovanni Fiammingo. A large plaque in the Wallace Museum, carved in almost full relief with the story of David and Bathsheba, which is here illustrated, has written on it in ink beneath the base, " Giovanni Fiammingo a Vasazio." It is late seventeenth-century work.

The second of the trio of Flemish sculptors which has been named is interesting from many points of view. Lucas Fayd'herbe was born at Malines in 1617, the son of a sculptor. At the age of nineteen he entered the school of Rubens at Antwerp, and soon became the favourite pupil of his master in drawing and painting. He then applied himself to sculpture, and besides his work in marble, stone, and alabaster, he appears to have taken up the practice of ivory carving under the direct incentive of Rubens, and to have executed when a pupil of the painter, and from his compositions, a considerable number of ivories. He saw how the diaphanous texture of ivory, its soft satiny surface and peculiar sheen, easily amenable also to the chisel, was adapted to the exuberant forms, the nudities, and the rich detail which characterise the style of his master. Rubens himself, in the certificate, still preserved, which he gave him on leaving, speaks in the highest terms of his work in ivory, and especially of "a statuette of N(otre) D(ame) which he has made in my studio, alone and no one aiding him, for the church of the Béguinage at Malines, 'morceau d'une beauté ravissante.'" In the catalogue of the sale at Antwerp after the death of the painter in 1641—but we must remember that Fayd'herbe was then only twenty-four years old—we find mentioned the following works in ivory executed after his designs : a crucifix, a

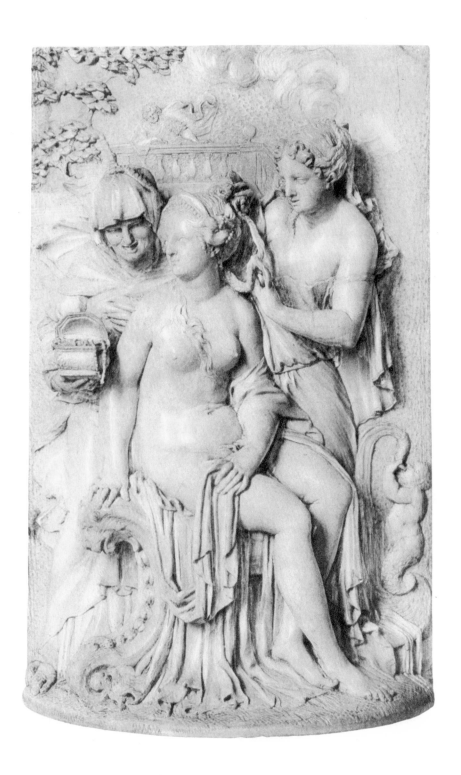

Plate 59. PLAQUE. GERMAN

SEVENTEENTH CENTURY

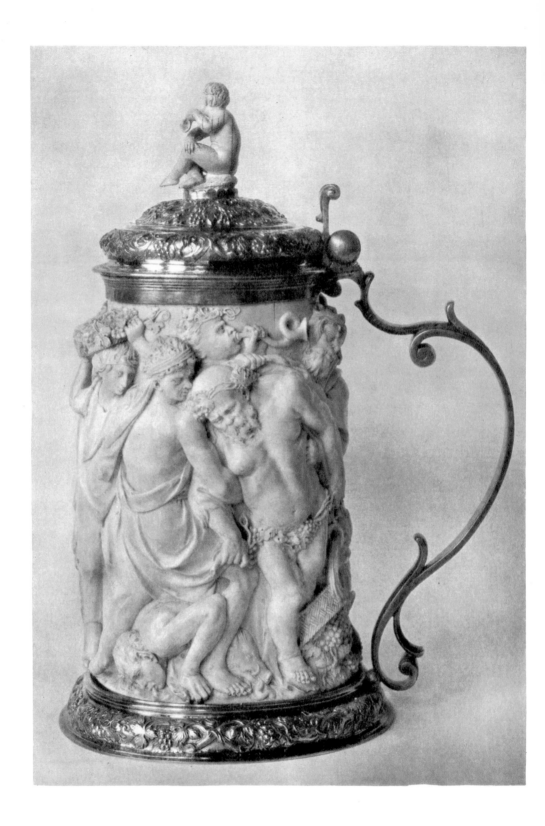

Plate 60. TANKARD. FLEMISH

SEVENTEENTH CENTURY

Venus disrobing, a Mercury, a dance of children, a Psyche asleep—the bed being made of tortoise-shell—and others—the greater number the work of Fayd'herbe. Amongst them also is "a salt-cellar with sea-nymphs and Tritons and with Cupids bearing garlands." Where this may now be it is impossible to say, but amongst the photographs in the Art Library at Kensington is one of two ivory salts, concerning which we have no information. They were probably in the Field collection. Each is composed of three little naked boys or Cupids (one blindfolded), back to back, upholding the pool for the salt. There are garlands, a goat near one group and a mask by the other. They are in the style of Fayd'herbe.

Signatures of Fayd'herbe's work in ivory are wanting, but at the Prado Museum, Madrid, is a group of Pan piping to dancing amorini which is almost identical with a large relief in terra-cotta in the Palais du Cinquantenaire at Brussels, known to be by Fayd'herbe, and bearing his initials, " L.F."

But the most remarkable of the important pieces which we are inclined to ascribe to Fayd'herbe are the tankards and standing cups mounted in silver gilt, and carved, as a rule, with dances or processions of satyrs. Of the large number of these—many very fine—which are distributed amongst the great museums and collections, it will be sufficient to refer to three examples. Than the first, a tankard in the Jones bequest in the South Kensington Museum, perhaps no finer example amongst tankards is anywhere to be found. It is not large, of elegant proportions, and mounted in the best style of the Augsburg silversmiths' work. The bold design, in which the school of Rubens is apparent, is admirable in the sobriety of taste so often wanting in other productions of the class. Had the material been wax, instead of the more unyielding ivory, the execution could not have been more free, or carried out with a

firmer hand. On the drum is a mad dance around of nymphs, and satyrs, and little bacchanalians. Silenus lurches along—very drunk indeed—spilling the contents of his wine jar, a pig, typical of his condition, lying beside him ; and the faces of the nymphs are charming. On the lid sits a piping Cupid. The quality of the ivory itself is of the choicest, the handle slender and graceful, and the *repoussé* silver work simple in design and of the highest class. This tankard is alone sufficient to redeem the reputation of the post-renaissance ivory sculptors. Undoubtedly by a Flemish artist, if we see in it the influence of Rubens, there is at the same time, in the faces of the nymphs especially, and in the boys, Italian feeling of the best type. More need scarcely be said.

The second example is a tall standing cup and cover in the Vienna Museum. The design is very similar to the preceding, the same Silenus attended by female satyrs, a standing figure of a boy holding up a bunch of grapes on the lid; but the figures are in more detached relief, and altogether it is, though fine, inferior to the first. The goldsmith's work is of the same character, but, of course, there is no handle.

The third tankard is in the Kunstkammer at Karlsruhe, and we have again a satyr dance with the same character of figures and a boy with grapes on the top; but the mounting is heavy, and not to be compared with that of the Jones tankard. It is to be noted, however, that the goldsmith's work of the Vienna cup and the Karlsruhe tankard bears, together with the Augsburg pine-apple, the mark "AW" (A.W.), possibly Andreas Wickert. There were several goldsmiths of this name in Augsburg from 1654–1728. The maker's mark on the Jones tankard is "W.S."

Whether or not these three fine pieces are the work of Fayd'herbe it is impossible to say with certainty, or under what circumstances they came to and were mounted

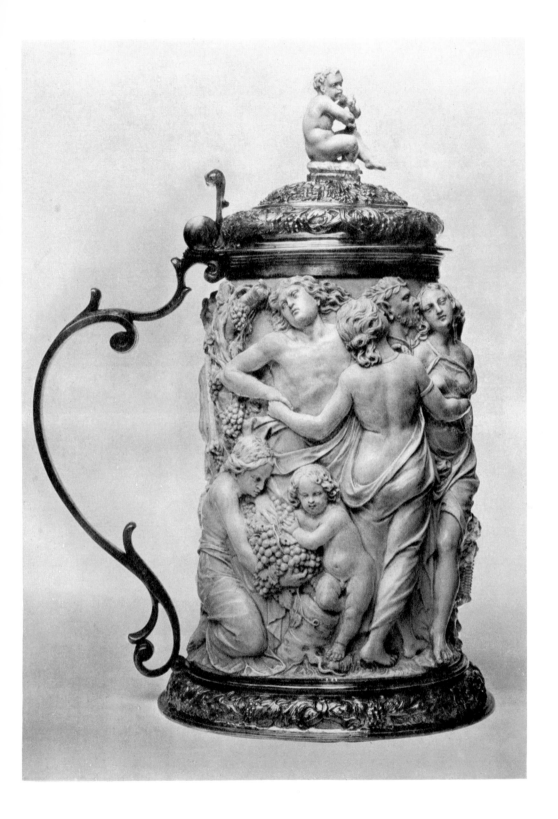

Plate 61. TANKARD. FLEMISH

SEVENTEENTH CENTURY

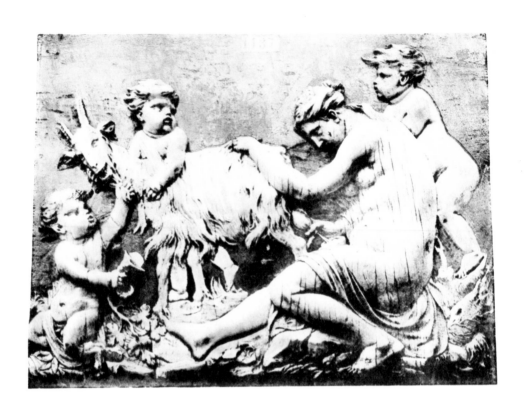

Plate 62. PLAQUES. BY GERHARD VAN OPSTAL
SEVENTEENTH CENTURY

in Augsburg. But there can be little doubt that they are by the same hand; and we have no German work, of the kind, of sufficient merit to induce us to give them to Germany. The Jones tankard is described in the museum as by Fiammingo, but comparisons with his known work may at least leave this ascription open to question.

Fayd'herbe is known by many examples of sculpture for churches throughout Belgium, amongst them the high altar and choir stalls of the church of St. Rambault at Malines, in which city he died in 1697. There is a boxwood group, by him, of the death of St. John the Baptist, in the Kensington Museum.

From his long connection with Paris, where he appears to have been permanently settled, and from the character of his work, Gerhard van Opstal should perhaps be classed with French rather than with Flemish sculptors. Born at Antwerp in 1595, his early influences were undoubtedly connected with the Rubens school. His best productions are plaques, often with floral borders, and with bas-reliefs of naked figures of the bacchanalian type, amorini and Venuses, young satyrs and goats. He worked also as a sculptor in marble and bronze. He came to Paris at the invitation of Cardinal Richelieu, and was attached to the court of Louis XIII. Very charming are his bacchanalian groups in somewhat low relief, and his children, really childish, and of the type and surroundings which Boucher, a hundred years later, loved to paint. In these the flowing hair of the little figures, streaming in the wind, is amongst ivory carvers very characteristic of his style. We have no information whether Van Opstal worked for gold and silver smiths, but one is sometimes reminded of his modelling in the figure work of the elegant table plate of his time. He died in Paris in 1668.

Some mention must be made of a fourth Flemish

ivory sculptor, of a very different calibre to the other three. Francis van Bossuit was born at Amsterdam in 1635. His work, which has been much praised, is almost wholly after the antique. We know it principally, perhaps, from the numerous illustrations by Barent Graat to a book published either by him or by Mathys Pool in 1727. In the title, which is partly in English, Bossuit is described as "well known and famous for making the most curious and artificial ivory work arising from the contemplation of old antick figures . . . by his ingenious and free manner of managing the hard ivory could work on it as if it was wax." There appears to be very little character or originality about his productions. The museum at Brunswick possesses specimens.

Ivory carving fell off in the Netherlands, almost entirely, about the middle of the eighteenth century, to be again revived in our own time, by none more enthusiastically or with greater talent than by the artist sculptors of that part of the former united kingdom which is now Belgium. This revival will, of course, call for notice in a subsequent chapter.

At the head of the list of German ivory sculptors of the seventeenth century must certainly be placed the name of Christoph Angermair. He appears to have spent the greater part of his working life in Munich in the service of the art-loving sovereign, Maximilian I. of Bavaria. His great work is one of the treasures of the Bavarian Museum—a magnificent coin cabinet, made for Elizabeth of Lorraine, wife of Maximilian. He made also three other fine ivory coin cabinets, now in the same museum ; but two of them are rather combinations of ivory and goldsmith's work than pure specimens of the adaptation of ivory to cabinets. The third, all of ivory, was made for the Queen of Bohemia, Elizabeth Stuart of England. In all, the richness of detail may be thought by some to be excessive.

The first of these cabinets stands some eighteen

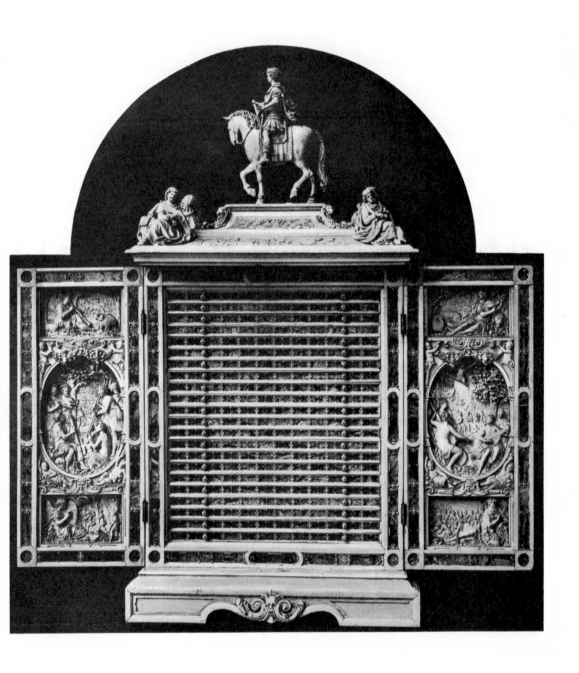

Plate 63. COIN CABINET. BY CHRISTOPH ANGERMAIR
SEVENTEENTH CENTURY

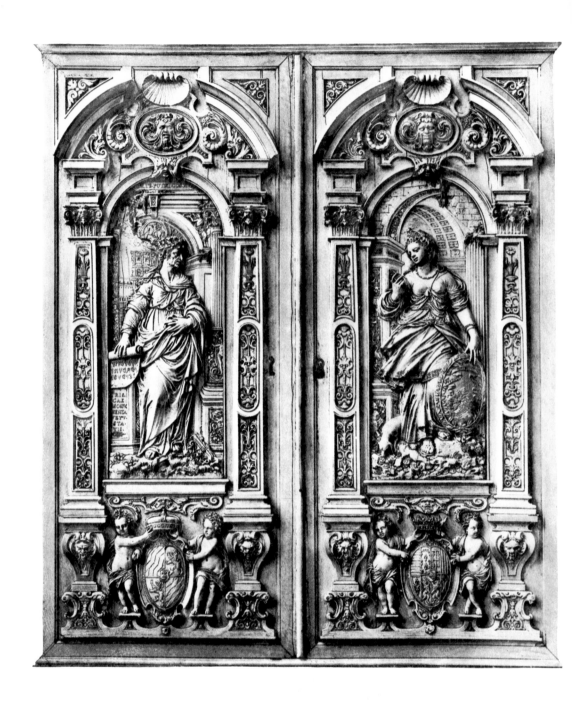

Plate 64. DOORS OF COIN CABINET. BY CHRISTOPH ANGERMAIR

inches high by thirty-two inches wide. It is closed by folding-doors, and all the visible portions may be said to be completely covered by rich sculpture on thick plaques of fine ivory, the whole surmounted by an equestrian statuette of the elector in Roman armour, and by a sitting figure at each angle of the coved top. Within are twenty-two sliding drawers to contain the coins, the fronts of each drawer having ivory knobs and a simple decoration of rosettes. On each of the outer sides of the doors is an architectural composition in late renaissance style, representing antique science and numismatology. The back of the cabinet is sculptured with equal richness. The inner sides of the doors are carved with classical subjects in oval and rectangular compartments, of a finer style than we usually find on German work of this kind and period. Whatever may be thought of the artistic value of this particular kind of decoration, it was undoubtedly in accordance with the taste of the day. Without implying that this fine piece of work will bear comparison with that of the best period of the renaissance, it will be admitted to be a striking example of the application of ivory carving to the utmost richness of design in which this richness has not been vulgarly overdone. The groups and scenes, though they cover every available inch of space, yet call for separate attention, and are not merely decorative without other meaning or intention, as in the case of work of a similar character. Such, for example, as the great rosewater dishes. It remains to be added that, according to some authors, given by Dr. P. J. Rée in his life of the painter, the designs for the panels were probably made for Angermair by Peter de Witte (Peter Candid), court painter of that time to the princes of Bavaria.

The Bavarian Museum has also of Angermair's work a plaque with a Holy Family in the style of the Italian renaissance, signed by him "Cristof Angermair B.H. von Minchen 1632," and another, an unsigned

group of the Virgin and saints, also under the influence of Italian ideas, but by no means so much to be commended. It is doubtful whether Angermair was ever in Italy. Mention has already been made of his "Temptation of Christ," in the British Museum.

George Petel, another Bavarian sculptor, studied in Rome, and worked afterwards both in wood and ivory at Augsburg. He was influenced also by the school of Rubens, with whom he was intimate. In his work we find the usual run of satyr and bacchanalian compositions, and plaques with saints, amongst them St. Jerome, who, on account, perhaps, of the opportunity of representing him in an almost nude condition, was in such peculiar favour with ivory sculptors at that time. Many large tankards are from his hand, not unfrequently with plaques let into the cover and base, a fashion which rarely, if ever, adds to the beauty of the mounting, or that we find on really good specimens of Augsburg silversmith's work. Petel died in 1634.

Leonhard Kern, who was born at Forchtenberg in 1588, and died in 1663, was by no means the least important of the Suabian school of the German ivory sculptors. His work is distinctly original, with more character than we find in that of the majority of his contemporaries. Like so many others he was a marble sculptor, and worked also in wood. The Berlin Museum has an interesting group, by Kern, of Adam and Eve, which is treated by him in an original manner. Both figures are nude, Adam seated, Eve apparently coaxing him to take the apple. Adam himself is of a very modern type, with hair in close, curling locks and an up-to-date moustache and imperial. The group bears his monogram, and so also does a St. Jerome in the Vienna Museum. The saint is of the usual semi-nude type, a curiously designed lion crouching behind him.

Bernhard Strauss appears to have been an Augsburg goldsmith of the latter part of the seventeenth century,

who, besides being responsible for ivory carving, worked also in wood. We have his signature, "Bernard Strauss Awrifaber fecit," on an ivory standing cup in the Vienna Museum. The museum at Kensington possesses a tankard by him, formerly in the collection of Mr. Philip Henry Howard, of Corby. The drum is a very large and fine piece of ivory, carved in high relief with gods and goddesses, poor in design and execution. Nor can the metal mounting be said to be of very good style; it is heavy and coarse, with curly ornaments. The best part of the work is the group on the cover of a combat between Hercules and a female centaur, which is really good. The drum of a tall standing salt with a similar subject of Minerva and the Muses in the Chérémeteff collection, St. Petersburg, is probably by the same maker. The mount of silver gilt, consisting of a base and pool for salt with a cover, is extremely good Russian work, dated 1800. The base is gadrooned, with upright handles springing from masks.

The work of Ignaz Elhafen — or Œlhafen — a Nuremberg artist of the middle of the seventeenth century, although for the most part in the wearisome style of plaques with complicated groups of nymphs and satyrs, yet has more character and originality than is usual, and a personality by which his style is not difficult to recognise. There is a good deal of spirit and humour in his compositions; the modelling is good, the foliage and landscape and the handling generally not altogether unlike the plaque of Diana and her attendants, in fact, of the Fiammingo school. He made also large figures and groups—for instance, a Bacchus and a Venus in the Munich Museum—Madonnas, and other things of the kind; and a good example, known as the "Augsburg clock," is in the Kunstkammer at Karlsruhe. It is in the fashion of a tall standing cup, the drum carved with the usual satyr subjects, a flat metal top surmounted by a Cupid, and the works within the cylinder. The

[379]

ivory is signed, "Ignatius Elhafen 1697." Many tankards also are, no doubt, due to Elhafen.

The work of Balthasar Permoser (1650–1732), a Dresden sculptor, enjoys a considerable reputation in German collections. The taste of the time for rococo figures and groups, pairs of "Spring" and "Summer," and the like, is characteristic, and there appears to be nothing to call for particular attention.

J. Michael Maucher (1646) was a prolific worker of the Suabian school, especially for the huge rosewater dishes and ewers used more for decorative than for practical purposes. Made up in separate pieces, they are overloaded with figures and groups which no one ever dreams of examining for their subjects, with the fixed idea, apparently, of leaving no space unoccupied. A cast of a dish of the kind is in the Kensington Museum. A ewer by Maucher, in the Hohenlohe collection at Wurtemberg, recalls nothing so much as the sugar ornament surmounting a wedding cake. The outline is buried in a mass of horses and men, Cupids and foliage of a distracting kind.

Mathias Rauchmiller was a Viennese ivory sculptor of the latter half of the seventeenth century, of whose work there are two excellent groups in the museum at Munich, and casts from them at South Kensington (Nos. '73.440.477). These are the Centaur carrying off Proserpine and a group from the Rape of the Sabines. The curve of the tusk and a large proportion of the material have been utilised in a very clever way. In addition to this, the anatomy and modelling of the figures in both groups are extremely good. As much cannot be said for a poor reduction in the Vienna Museum, or rather an adaptation from Bernini's Apollo and Daphne in the Villa Borghese, the original itself of a style which was unfortunately too popular and too much copied by the sculptors of the time.

A mixture of ivory and wood—the ivory for the

faces and exposed flesh, the wood for the dress—was a favourite practice with German ivory sculptors, and not without effective and sometimes extremely good results. Figures of this kind were, for the most part, of peasants or beggars, or, as in the museum at Kensington, a very clever one of an emaciated man, probably an illustration of the " Dance of Death." He dances along, with his wasted limbs, beating a drum, the nearly skeleton face grinning, and one empty eye-socket. One of the best-known workers in this combination style was Simon Troger, a Munich sculptor of the early eighteenth century. His work is really remarkable and original, and deserves notice. Another was Wilhelm Krüger, of Dantzig. Combinations with gold and silver smiths' work by jewellers and others were also made, notably by the last-named and by his fellow-townsman, Johann Köhler. It is a fashion which is asserting itself strongly at the present time, as we shall see in a subsequent chapter.

Some account must be given of the turned work in ivory, which was such a popular distraction in the seventeenth and eighteenth centuries. Doubtless a considerable amount of technical skill is shown in work of this kind, if the art displayed in connection with it is not of a particularly striking character. The most celebrated amongst the workers in this line, in which Nuremberg was especially distinguished, was perhaps the Zick family, the father Lorenz and his sons, David, Peter, and Stephen, about the second half of the seventeenth century. Amongst many others were Martin Teuber, who wrote an elaborate treatise on the subject, Marcus Heiden, and Fil. Senger (1681). Two tall cups by the last-named are in the museum at Kensington. Ivory turners will understand and be interested in the technical description of these. One of them was " executed on a rose-engine lathe, with pumping and rose motions to give pentagonal and swash forms, and with slide-rest

and template for the profile." The other was turned, "in eccentric turned mouldings, on the ellipse chuck, which was itself mounted on a rose-engine lathe, with both rose and pumping motions to form the bulbs." How much of the actual figures, such as those which form the stems and other intricate ornament, is due to the operations of the lathe, must be left to experts to determine.

Besides turned work, there was a rage for trick carving, of the kind in which the Chinese excel; balls within balls, movable objects and the like, as well as marvellous exercises of patient skill in the shape of minute carving; for example, several hundreds of tiny objects enclosed in a cherry stone, and similar things, with which most people are familiar in ordinary museums. In connection with minute carving, it may not be without interest to recall the microscopic work of the little religious triptychs, rosary beads, and things of the kind in box wood and pear wood, with which for excellence we have nothing in ivory to compare. Very wonderful are some examples of these in the Rothschild bequest in the British Museum and others in the Wallace collection.

It is unnecessary to follow further in detail the lesser lights among the German ivory carvers. It will be sufficient to name them, with brief references in the classified list subjoined to this chapter. Of the more northern countries little need be said. In Norway and Sweden and Denmark ivory sculpture was hardly less popular and prolific, but with few exceptions the art is deplorable. The best-known artists worked for the courts, and, to flatter their patrons, produced an exaggerated mixture of pseudo-classic allegorical groups: princes in Roman armour and full-bottomed wigs, attended by Minervas and chubby angels blowing trumpets, and so on, which seemed to please the ultra-rococo tastes of these potentates. One of the greatest

Plate 65. EXAMPLES OF LATHE WORK. GERMAN

EIGHTEENTH CENTURY

sinners in this respect was the Norwegian, Magnus Berg, who at the end of the seventeenth century worked principally for the court of Frederick IV. of Denmark.

In France, the Dieppe and Franche-Comté schools and the crucifix makers have already been referred to, and the religious work of the sixteenth century has also received attention. Of secular work, the charming hunting-horn in the collection of Baron de Rothschild is classed as French. Whether by a French or Italian artist, it must, in its simple elegance, take rank amongst works of art of the best period of the Italian renaissance. Curved into a semicircle, it is ornamented with a delicate arabesque of slender wreaths, cherubs' heads, and flowers, of fine taste and execution. It was formerly in the Fountaine collection, and was purchased at the sale by Baron de Rothschild for £4,452, the highest price attained by any object at that sale. We have nothing of importance in secular work of this period or of the two following centuries at Kensington, nor is more to be found in the Louvre, except that which has already been mentioned.

A certain number of late eighteenth-century ivory carvings are not unfrequently to be met with in England, very often of that kind of microscopic work upon which a good deal of artistic talent of a kind is wasted. They are probably due to French refugees who came over to England, and were employed in various factories. Nothing is known about the artists, except of one, Jean Voyez, and even concerning him there is not much reliable information. The Holbourne Museum at Bath possesses a plaque with a figure of Prometheus bound to the rock, and the same design is exactly repeated on a basalt vase in the style of Wedgwood, by Palmer, of Hanley, also in the same collection. It appears from Miss Meteyard's life of Wedgwood that Voyez worked for him early in 1768, but in the following year he seems to have been imprisoned for rioting, and on his release transferred his services to Palmer. In

the Holbourne Museum there are also some dozen or more open-worked medallions or small plaques, hardly more than two inches in diameter, in which the ivory is carved with an extraordinary degree of minuteness, so much so that it is necessary to use a magnifying glass to examine the details. There are landscapes with vessels in the distance, in which the tiny sails are of extreme tenuity, the rigging of hair-like fineness, and the little figures on the shore, though scarcely perceptible, yet finished in every detail. The leaves of trees and blades of grass are marvels of ingenuity and patient application. These microscopic works are also attributed to Voyez ; but the evidence appears to be scanty, and if we may judge from his Prometheus and the designs which he executed for the potters, are hardly in his style. There is, of course, a certain merit in such things ; but they cannot be compared with the book cover in the British Museum (see page 201), or with the fine specimens of minute box-wood carving of the sixteenth century.

Dieppe was celebrated for *tours de force* of this kind, and for wonderful and intricate lacework. The method employed was to glue thin sheets of ivory upon wood, and with fine gravers and infinite patience, backing up the substance in various ways as the work proceeded, these tiny figures and foliage, the leaves of which a breath would almost suffice to break, these garlands and festoons and open-worked temples were achieved.

Of the eighteenth century also, a necklace of ivory beads in the Wallace Museum is elegant and interesting. It was given by Marie Antoinette to the Princesse de Lamballe. Each bead is wrought with a fleur-de-lys in very minute gold *piqué* work.

There remain only to be noted the medallions by David le Marchand and Jean Cavalier, of which there are several examples in the British Museum. Medallion portraits were a speciality of Le Marchand, and his handling of them is, in general, broad and artistic. One

[385]

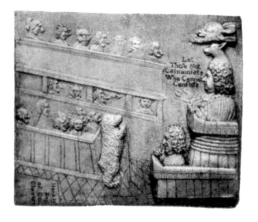

Plate 66. PORTRAIT MEDALLIONS AND PLAQUES

SEVENTEENTH AND EIGHTEENTH CENTURIES

by him, of George I. of England, in armour and flowing wig, which seems to be a good portrait, is in the museum at Brunswick. The George Richmond of his time, he appears to have settled in England, and to have executed medallion portraits of most people then prominent. Walpole mentions him with great praise in his memoirs. Another portrait of George I. is in the British Museum, signed "Le Marchand, carved from life." A large medallion in very prominent relief of Samuel Pepys is signed "DLMF."; another is of Sir Christopher Wren; and there are others in full-bottomed wigs, unnamed. A bust of Rigaud was exhibited by Mr. Alfred Morrison at the Burlington Fine Arts Club Exhibition of Bronzes and Ivories. Le Marchand died in 1726.

Jean Cavalier (1680–1707) was scarcely of the force of Le Marchand, but he executed a number of fine medallions of princes and great people. He also was domiciled in England. Among the portraits by him in the British Museum are those of Sophia Carolina, electress of Brandenburg, of the duke of Brunswick, and of the markgraf of Brandenburg. He signs in full name or initials.

Of English sculpture in ivory of this time we have little to which we can refer. No doubt quantities of ivory were used for all kinds of nick-nacks, fittings of work-boxes, counter and patch-boxes, and the like, and one comes across at times figures in costumes of the period which have a certain amount of interest. But there is little that can be identified. A satirical plaque in low relief in the British Museum on "Orator" Henley is amusing. It is the interior of a dissenting chapel. The orator is in the pulpit in gown and bands, with a fox's head over his own. Below him is his audience, in three rows, with monstrous animal heads and a dancing bear, and on a gravestone is inscribed, "Here ly . . . body of Col. Charl." Another inscription is, "Let those not calumniate who cannot confute." Henley was an

eccentric preacher who indulged in all sorts of extrava-
gances, set up what he called an "oratory," and used
therein a good deal of vulgar abuse. He died in 1756.

Very charming are many of the curious implements
known as *rappoirs*, or tobacco-graters for snuff, which
were in constant use in the seventeenth and early
eighteenth centuries. Snuff was then not often sold
ready made, so that snuff-takers had to prepare it them-
selves. People went about also from house to house
with graters, the tobacco being tightly fastened up with
string, as sailors keep it now. Hence the sign on
tobacconists' shops which still obtains. In *Gil Blas*
we find Mathias da Silva "lying back in an armchair,
over the arm of which one leg was negligently thrown,
he carefully balanced himself as he grated his snuff."
These graters are usually of a kind of flattened cone
shape, sometimes nearly a foot in length and broad in
proportion, terminated at one end by a sort of small
spoon, or shell, for the snuff, and at the other by a little
box, with a sliding lid, for the reserve, and to catch
it as it was rasped by the rasp on the back ; hence
the term *rappee*. They were made of all kinds of
materials, in ivory, wood, enamel, pottery and porcelain,
and metal, and it became the practice to decorate them
in various ways—with monograms, coats of arms,
mythological stories, Watteau pictures, religious subjects
(for ecclesiastics), and, in short, as with snuff-boxes,
there was no end to conceits and extravagances. The
best we have in ivory are probably Flemish or French.
Many are charming with their reminiscences of Beau-
marchais-like or Italian comedy scenes, and it may be
added that the low relief on the greater number is more
in accordance with fine taste than the type which we
find so frequently in other ivory sculpture of the time,
to which attention has been directed. Good examples
are in the Wallace collection ; amongst them a very large
one, with the fall of Phäeton, another of very white and

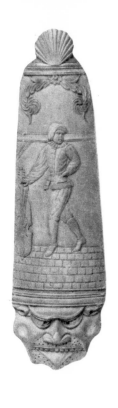
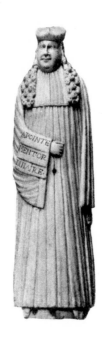
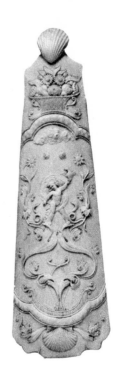
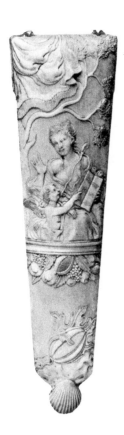
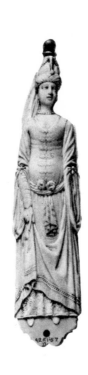
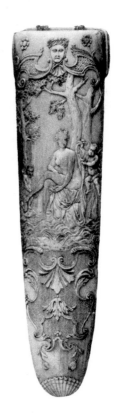

Plate 67. TOBACCO GRATERS

SEVENTEENTH AND EIGHTEENTH CENTURIES

grainless ivory with the story of Actæon and Diana ;
both Flemish of the seventeenth century. There is also
a very elegant one in the Louvre—Flemish, of the end
of the seventh century, surmounted by figures of a faun
and a nymph embracing. Tobacco-graters were some-
times called "grivois," not, however, in allusion to the
subjects with which some of them were decorated, but
from the *grivois*, or soldiers of bad character who first
used them.

A bare mention must suffice for such other things
as decorated knife and fork handles, which were natur-
ally not an unusual application of ivory. A very curious
set in the Kensington Museum is elaborately carved
with figures of kings and queens of England in their
royal robes, the latest ones—Edward VI., Elizabeth, and
James I.—in costumes of the period. They are dated
1607. Knives and forks of this kind were often kept in
sets in cases of ornamented *cuir-bouilli*, themselves
beautiful and interesting. Ivory was also used for all
kinds of domestic purposes, much as it is now, but with
greater love of decoration. Thus we find interesting
examples of official staves, combs, mirrors, billiard-cues
(a short one, Italian sixteenth century at Kensington of
a good style of engraving), ladies' stay-busks, spindles,
shuttles, and other work-box implements; yard-measure
cases, rules and measures, clogs and pattens, the
magnetic folding and other dials called *viatoria*, or
journey rings, hour-glasses, and so on. An extra-
ordinary amount of decoration, often of very high
merit in design and workmanship, was lavished on
many of these where we should be least inclined to
expect it; better work, indeed, than on more pretentious
things. Fans also must not be forgotten, the sticks and
guards pierced and chased in the Chinese fashion, of
lace-like fineness. A number of these are, no doubt, of
the eighteenth century, from Dieppe ; possibly, even
with European designs, not unfrequently exported from

China. The subjects are often in the style that we find on the snuff-graters, and of very careful work. Ivory fans might, indeed, form matter for special consideration which would possess not a little interest.

Ivory carvings are to be found in every part of the world, and museums teem with curiosities. In the British Museum is a large model with many detached figures in mammoth ivory of a Yakuts' encampment. There is also a hat made of strips of plaited ivory, folded up like a modern Panama, which is said to have belonged to Queen Elizabeth. This is not at all unlikely, as it may have been brought back from the English expeditions to the Benin country in West Africa of that time. At South Kensington we have curious patient work from Archangel in the shape of extremely fine chains with minute links. Throughout the Malay peninsula the handles of daggers and krisses are elaborately carved and ornamented with figures of deities and all manner of strange shapes and decorations, and in the islands of the South Pacific, whales' and cachalots' teeth and boars' tusks are carved and used for ornaments and even for money.

A LIST OF SOME SCULPTORS IN IVORY WHOSE WORK IS KNOWN, OR TO WHOM WORKS ARE ASSIGNED, FROM THE THIRTEENTH TO THE NINETEENTH CENTURY

THIRTEENTH CENTURY

Giovanni Pisano. A Madonna attributed to him.

FOURTEENTH CENTURY

Jean Lebraellier. Mentioned in an inventory of Charles V. of France.
? Jehan Nicolle. A pax in British Museum with this name inscribed.

FIFTEENTH AND SIXTEENTH CENTURIES

Giovanni di Bologna. A Hercules.
Bianchi, F. F. (+1507). Figure of Virgin signed by him (exhibited Burlington Fine Arts Club Exhibition by Mr. Philip Hardwick).

[391]

Albrecht Dürer. A plaque with his monogram (probably copied) at Munich.

Lorenzo da Pavia (end of sixteenth century) worked for Isabella d'Este, especially for inlay of musical instruments.

Hans Beham. A plaque in Cluny Museum with "H.S.B. 1545," probably copied. A naked figure of a woman in Nuremberg National Museum.

Michael Angelo. A Taking Down from Cross and several other things attributed to him. See also under his name in "List of Works on Ivory Sculpture" at end of this book.

Jean Goujon. A crucifix and a powder-flask in the Louvre have been attributed to him.

Giovanni Copé (called Fiammingo). "The Five Senses," signed "Giovanni Fiammingo." A plaque in Wallace Museum (described in text).

Peter Flottner (+1546). See *Graesse*, "Monogrammisten."

Edouard Lobenigk. Nuremberg, 1588. See *Graesse*.

Hans Lenker. Nuremberg, 1573. See *Graesse*.

Hans Lautensack (1516). See *Graesse*.

Paul Melchior. Cologne, 1521. See *Graesse*.

Agostino Caracci (1557–1605). A satyr and nymph in Correr Museum, Venice.

Georg Weckhart (1587). See *Graesse*.

Jacob Hesin (1586). Lute. Music Exhibition, London, 1885.

Giovanni Krebar. Padua, 1629. Ivory lute.

Joachim Tielke. 1701. A very fine Viola da gamba in the Brussels Conservatoire.

Antonio Spano. An Adoration of the Magi, formerly in collection of Prince Lucien Bonaparte. Signed "Ant. Spano Tropiensis Neap. incisor. 1555."

SEVENTEENTH CENTURY
ITALIAN SCULPTORS

Alessandro Algardi (1620–54). Crucifix at Munich attributed to him.

Francesco Francelli (end of seventeenth century) worked for some time in England; probably many of our portrait medallions are by him.

Antonio Leoni. Some pieces in Bav. Nat. Mus. signed "Antonius Leoni Venetus F."

Filippo Planzone (+1636). *Tours de force*. Horse in a cage in Florence Nat. Mus.

Pietro Andrea Torre (+1668). Genoa. Crucifixes.

Giovanni Pozzo (1700). Portrait medallions.

Donatello Fiorentino. Jacquemart mentions "une gracieuse figure de femme nue."

FLEMISH SCULPTORS

Mathieu van Beveren (1670). Antwerp. Crucifixes.

Francis van Bossuit (1635–92).

J. or H. Cosyns (+1700). Worked in London. Bacchanalian children.

François Duquesnoy (Il Fiammingo). 1594–1644.

POST-RENAISSANCE SCULPTURE

Jerome Duquesnoy. Crucifixes.

Lucas Fayd'herbe (1617–97). Pupil of Rubens.

J. Mansel. Bacchanalian plaques. Munich Museum.

Gerhard van Opstal (1595–1668). Settled in Paris.

Arthur Quellinus (1609–68). Sculptor of groups at Rathaus, Amsterdam. Pupil of Duquesnoy. Graesse monogram, "A.Q.F."

P. Scheemackers. Bacchanalian children. Bav. Nat. Mus. Poor work.

Rombout Verhulst (1624–96). Groups and medallions.

Albert Vinckenbrinck (1604–64). Probably worked with Verhulst.

J. B. Xavery. A faun exhibited at Amsterdam Exhibition, 1883.

"Jacobus Agnesius Caluensis sculp 1638." There is a good group of the martyrdom of St. Bartholemew, with this signature, in the Albi Museum. Nationality uncertain. Attributed to Jacques L'Agneau, of Douai.

GERMAN SCULPTORS

Christoph Angermair (1616). Coin cabinet. Munich. Graesse gives " 🔲 " as his monogram. Plaque dated 1616 in B.M.

G. Angerman (1672). Skeletons.

Melchior Bartel (1625–72). Dresden. Lived and worked in Italy. Crucifix in Florence Nat. Mus.

Bernhard Bendel (1668–1736). Augsburg. Crucifix. Classical reliefs.

Christian Braun. Ulm. " Ecce Homo" in Louvre.

Jacob Dobbermann (1682–1745). Cassel. Classical reliefs. Portrait medallions. Worked a good deal in amber.

J. Hennen. Berlin. Medallion portraits.

Georg Burrer (1616). Stuttgardt. Turnery cups.

Michael Daebler (1635–1702).

Ignaz Elhafen (1650–1700). Bacchus and Venus in Bav. Nat. Mus. Plaques.

Andreas Faistenberger (1646–74). Tyrol. Crucifix.

Raymond Faltz. Medallions. Berlin Kunstkammer.

Hammeran. Portrait medallion of Leopold I., Emperor of Germany, thus signed, in B.M. signed " Hammeran fecit 1679."

Christoph Harrich (1630). Skeletons and skulls.

Joachim Hennen (1663). Medallion portraits.

Benedict Herz (1635). Nuremberg. Crucifixes.

Marcus Heiden (1644). Coburg. Turnery cups.

David Heschler (1635). Ulm. Wood and ivory.

Wilhelm Krüger. Wood and ivory beggar figures.

Leonhard Kern (1588–1663).

J. Michael Maucher (1646–1700). Gmünd. Large ewers and rose-water dishes.

Max Emanuel, Elector of Bavaria (1651). Chandelier and two candelabra. Casts in S.K.M.

Balthasar Permoser (1650–1732). Salzburg. Crucifix. A rococo crucifixion group in ivory, wood, and metal in Town Hall, Leipzig. Worked in wax, wood, and metal.

Jean Conrad Tornier (1630). Inlaying. Wallace collection.

Georg Petel (1634). Augsburg. Was some time in Italy and Flanders. Crucifix in Vienna Mus.

Leopold Pronner. Nuremberg. Microscopic *tours de force*.

Mathias Rauchmiller (1693).

Schuler, a fine "Adam and Eve" by, in Manchester Exhibition, 1857.

Philip Senger (1681). Turner to Cosmo III., Grand Duke of Tuscany.

Andreas Schlüter. Berlin. Figures.

Steinhards, Franz and Dominicus. Plaques for cabinets.

Steudner, Esaias and Marc (1691–1760). Medallions.

Balthasar Stockamer (1700). Nuremberg.

J. Martin Teuber. Turnery.

Bernhard Strauss. Augsburg (late seventeenth century). Tankards.

Zick family (1594–1696). Nuremberg. Turnery and trick pieces.

Melchior Paulus. A group of a monk and two soldiers, signed *M. P. fecit*, in B.M. And see *Graesse*.

P-I or |-|. Probably Peter Hencke. Ultra baroque style. Crucifixes etc.

I-E. Several in Brunswick Museum. Medallions. Plaques. Name unknown.

Theophilus W. Freese. Bremen.

FRENCH SCULPTORS

Michel and François Anguier (1614–86). Dieppe. Crucifixes. A group of Holy Family by Michel.

François Girardon. A crucifix is attributed to him.

Jean Baptiste Guillermin (1623–79). Crucifix at Avignon. Two vases signed by him in Vienna Mus.

Nicollas Chevallier (sixteenth century). On a staghorn powderflask in Louvre.

Simon and Hubert Jaillot (1657–81). St. Claude, Jura. Crucifixes only. One in hospital of St. Germain-des-près, by Simon.

Jean Cavalier (1680–1707). Portrait medallions.

David le Marchand (+1726). Medallions. Signs in full or DLMF.

S. Gouin. Two medallion portraits in B.M. Is not known to Nagler.

Jean Mauger (1634–1715). Portrait medallion in B.M.

P. Lacroix. A good bust, in periwig, in Fau collection.

Jean Millet (1664).

G. VDR. Medallion portrait so signed in B.M.

Adrien Philippe (1608). Wristguard. Wallace collection.

EIGHTEENTH AND NINETEENTH CENTURIES

E. Bouchardon (1698–1762). A crucifix in church of St. Sulpice, Paris.

Guiseppe Bonzanigo (1740–1820). Bust of Marie Louise in Louvre.

Joseph Villerme (1720). St. Claude, Jura. Crucifixes.

Simon Troger (+1769). Bavaria. Wood and ivory figures.

POST-RENAISSANCE SCULPTURE

François and Joseph Rosset (1706–86). St. Claude, Jura. Busts and statuettes of saints; also of Rousseau, Voltaire (the latter mentions François); a St. Theresa in Louvre by Rosset, *père*.

G. Gerber. Portrait medallions.

Johann Christoph Köller. Combination of wood and ivory.

Magnus Berg (1666–1739). Norwegian.

Belleteste. Copies of the Four Seasons at Versailles.

Crucvolle family. Crucifixes.

Cointre. Beggar figures.

Georg Franz Ebenhech. Plaques and medallions.

Jean Voyez (1768). Designed for Wedgwood.

Pieter Geûns (+1776). Maesyck, Belgium. A medallion with Judith and Holofernes. Brussels Exhibition, 1880.

Walther Pompe (+1777). Netherlands. Crucifixes and bas reliefs.

J. Christoph Ludwig von Lücke (1750). Veiled busts, Brunswick Mus. Crucifix, Dresden Green Vaults. Sleeping shepherdess, Munich. Distinguished as a porcelain modeller. Much work of all kinds in ivory and other materials in various German museums and collections. Worked in England.

Baron Triqueti. A large figure of Bacchus in the British Museum.

Scailliet, Henneguy, Delacour, Degoney, Vaillant, Aloise, Cresson, Dechaulme, Ferrary, Hengrave, Vever, Soitoux.

Note.—Of the nineteenth century others are mentioned in the text.

CHAPTER XIII

CHESSMEN AND DRAUGHTSMEN

IT can hardly be questioned that ivory has been for a very long time, and is still, the favourite material for a handsome set of chessmen. We find them, not infrequently, it is true, in box wood, and at times almost every kind of material, in every description of form and decoration, has been pressed into the service; but for centuries past, dating back, in all probability, to the time when the origin of the game becomes lost in obscurity, we have numerous evidences, both in the pieces themselves and in records and writings of all kinds, of the greater popularity and universal use of ivory or bone.

It has, perhaps, not often occurred to most people, who are accustomed to chessmen as we now have them, to give a thought to the question of their origin, and to the history of the changes through which they have passed in the evolution from primitive and succeeding types to their present extremely conventional forms. The first time one comes across the strange-looking, ancient chessmen, to be met with in many museums, not only is it puzzling to know what pieces they may represent, but one hears with surprise that they are chessmen at all. So little, in fact, do many of the more highly decorated figures and groups resemble what we are accustomed to in the modern simple style, that they have not seldom been mistaken for portions

of dagger or sword hilts. The present forms are, of course, an evolution from primitive types which in the course of the ages during which the game has been known have undergone, as it were, a see-saw from simple to elaborate and back again, from the earliest kind, no doubt perfectly plain, to representations of men and animals, and more or less complicated groups; then again confined to simple figures, and, finally, reduced as we see them now. For instance, of the knight on horseback nothing remains but the head of his horse—a kind of *hippocampus;* of the bishop his mitre; the king's and queen's royal robes, and the armour of the warders represented by a succession of horizontal rolls, or a rounded top for the pawns. How far this may be due to China, whence come so many of our modern ivory sets, may possibly be another question.

The origin of the game itself, its phases in various countries, and the pieces employed, necessitate at least some brief references. The eastern origin is not disputed; but although we cannot determine exactly when it was introduced into Europe, it came probably through Byzantium, whither it may have gone from farther east, and originally from Egypt. For ourselves it is to the northern countries, to Scandinavia especially, that we must turn in order to follow out the origin of the various pieces which, at any rate at a certain period, seem to have been furnished to a considerable portion of western Europe. Some think the game was brought to England by King Canute—but this by the way.

It would not be difficult to multiply references and allusions from old chronicles. A few will suffice. The author of Caxton's famous book, *The Playe of the Chesse,* supposed to be a certain French Dominican, Jacobus de Casulis, about 1290 A.D., discusses the question of the origin of the game. He says, "This playe fonde a phylosopher of thoryent whych was named in caldee Exerces," and that "somme men wene that this playe

was founden in the tyme of the battayles and siege of Troye. But that is not so." And Chaucer, who has something to say about most things which occupied or amused people of his time, tells us in his " Dreame," or " Book of the Duchess," that—

> " Full craftier to play she was
> Than Athalus that made the game
> First to the chesse, so was his name."

And again—

> " They dancen and they play at ches and tables."

And in the Merchant's tale we are told that—

> " When they had ydyned, the cloth was up ytake
> A ches there was ybrought forth ;
> The ches was all of ivory, the meyne fresh and new
> Ipulshid and ypikid, of white, azure and blew."

That chess and backgammon were favourite games with the Anglo-Saxons we find in the metrical romance of Ypomydon, in the description of the festivities attending his marriage with the princess of Calabria, that—

> " When they had dyned as I you saye
> Lordes and ladyes yede to playe
> Some to tables and some to chesse
> With other games more or lesse."

Not always, though, in the best of tempers. In the romance of Ogier le Danois we have a long account of a game between Charlot and Baudouin which ends in high words, and in the former seizing the chessboard and dashing out the brains of the latter ; and a similar fatal quarrel occurs in the story of Guy of Warwick, where he slays the prince of Persia with a chessboard. In a Harleian MS. there is an amusing account taken from a fourteenth-century French book—*The Knight of La Tour Landry*, or, as Caxton's translation gives it, " The Booke whiche the Knight of the Tour made

to the Enseygnement and Teching of his doughters"—
about a "gentille knights daughter that wratthed atte
the tables with a gentill man that was riotous and
comberous and hadd an evelle hede, and the debate
was on a point that he plaide, that she saide that it was
wronge: and so the wordes and the debate rose so that
she saide that he was a lewde fole, and thane lost the
game in chiding." We shall see presently that in the
middle ages the queen in chess was called *ferce*, or
vierge; and in a treatise on the game, the *Moralitas
de Scaccario* of Pope Innocent, we are told that "the
queen moves obliquely and takes on any side: the
reason being that women being very avaricious they
take nothing, unless it be given to them with a good
grace, but what they can get by rapine and injustice."

To turn to references of ivory chessmen and boards
in wills and inventories. Sir William Compton be-
queathed to Henry VIII. "a little chest of ivory, with
a chessboard under the same, and a pair of tables on it."
The wardrobe accounts of Edward I. mention "*una
familia de ebore pro ludendo ad scaccarium,*" and in
the inventory of the effects of Roger de Mortimer,
in the time of Edward II., which is given at length in
the *Archæological Journal*, vol. xv., we have, besides a
comb, a mirror, a small image of the Blessed Virgin,
and a "scurgiam" (a whip, or, less likely, an aspergillum
or holy-water sprinkler), all in ivory, "j famil' de ebore
pro scaccario," that is, a set of ivory chessmen, and also
a board of some eastern wood for the game of tables, or
draughts.

The game of chess was certainly of ancient standing
in Iceland and throughout the north of Europe. In
Denmark the old names of the pieces persisted to a
comparatively recent date, as we learn from an account
of the travels of Olassen in 1752–7: thus, the men are
menn and *skakmen*, the queen *fru*, the bishop *biskup*,
the king *konungr*, the knight *riddar*, checkmate *skaka-*

mata. We learn also from old chronicles that in the reign of King Alfred, about 890 A.D., a Norwegian named Ohtere was hunting the walrus for its ivory in the north seas. He visited England, and gave an account of his expedition to the king. It is related further, in a curious old *saga* of the tenth century, that the prefect of Greenland sent to Harold Hardrada, amongst other precious gifts, a set of chessmen finely carved. And throughout the chronicles we find that the ancient Norwegians and other northern nations and tribes were highly skilled in carving figures and ornaments in bone and ivory.

Bone or ivory of some kind was certainly extensively used by the Anglo-Saxons for ornaments and the decoration of dwellings. An old chronicle speaks of the house which Locrine built for his mistress Estrild— "the walls of stone, the doors of whalles-bone." For whalles-bone, or ypen-ban (*elfenbein*), was the name for ivory, probably morse or walrus. We have it compared with a lady's teeth: "Hire teht aren white ase bon of whal." The tusk of the walrus, or seahorse, of the northern seas is distinguished by its fine grain and by the true ivory skin being not so deep as in the elephant's tusk, sooner worn through and succeeded by a more bony substance. Good specimens are from one to three feet in length and six to nine inches in circumference.

It is time to turn to the examples which our museums afford of various kinds of chessmen. The most interesting of all, from many points of view, is the set, or parts of sets, in the British Museum, known as the Lewis chessmen. These pieces may be taken as characteristic of the style adopted throughout northern Europe for some centuries. They have the additional interest of affording us correct information upon the costume and armour of the period, together with valuable material for comparison in respect to the decorative ornament which has already been noticed on other examples of

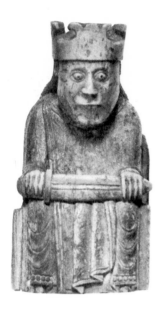
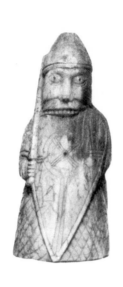
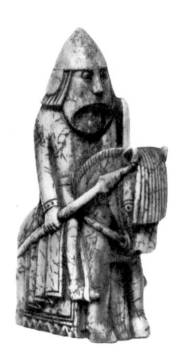
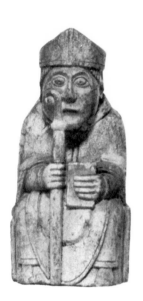
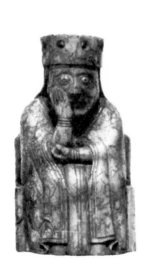
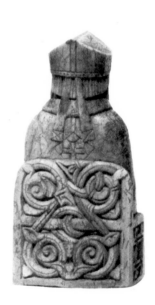

Plate 68 . SOME OF THE "LEWIS" CHESSMEN

TWELFTH CENTURY

ivory sculpture. The island of Lewis, where they were found, is one of the group of the outer Hebrides in the North Atlantic Ocean. The story of their discovery is that in the spring of 1831 a labourer digging a sand-bank in the parish of Uig laid bare a large oven-like kind of building. A little later on, breaking into it and further exploring, he found these figures ranged upon the floor, and horrified and frightened at what he thought were elves or some other uncanny creatures, he threw down his tools and fled. He afterwards returned and collected some ninety-two pieces, which were nearly all acquired for the British Museum. About eleven, how-ever, were bought later on by the Society of Antiquaries of Scotland and are now in its museum. They do not appear to form complete sets, but to be portions of several and of different sizes, of excellent workmanship, the smaller pieces having the more elaborate decoration. It has been conjectured that they possibly belonged to a convent of which some ruins exist near the spot where they were found. A very long and interesting account, with illustrations of all the pieces, together with a learned dissertation on the game of chess, is given by Sir Frederick Madden in volume xxiv. of *Archaeologia*, to which the reader must be referred for the fullest particulars. A few may be here described, and in so doing it will be as well to refer briefly to the various other forms of each piece in the game of which examples in ivory are known.

Of the varieties of chess pieces, the kings are those, perhaps, which differ most. In the Lewis set they are represented as elderly men, sometimes with, sometimes without, a large spade-shaped beard and moustaches, the hair divided in plaits or ringlets falling over the shoulders. They wear low trefoil crowns, and sit on high-backed, square chairs, the backs of which are carved with beautiful patterns of scrolls and interlacements. Their robes are a kind of dalmatic, and each holds on his lap a sword in its scabbard. In the Drey collection,

at Munich, the king is on horseback, accompanied by seven crossbowmen and other figures. An Anglo-Saxon king-piece, found at Beckley, in Oxfordshire, is circular, with a rounded top, and an angular piece jutting out on one side—a projection characteristic of many king-pieces. It is simply ornamented with incised circles and lines. The king in the set in the Paris National Library, traditionally known as the chessmen of Charlemagne, is one of a number of very large pieces, evidently of eastern origin. He is represented riding on an elephant surrounded by numerous attendants and other figures. In another set at Paris, in the Cabinet de Médailles, the king-piece is of bone; he stands erect, holding his sceptre, beneath a flat battlemented pediment, with curtains on each side held back by attendants.

These are some varieties, but there are many more in museums and collections—notable ones in the museums at Berlin, Paris, Copenhagen, and Dublin. It would be impossible, without unduly exceeding our limits, to describe the almost endless variations, and useless without a large number of illustrations. The same remarks must apply to the other pieces of the game. Almost every known piece is especially interesting from one point of view or another, and from the figures and groups relating to religious subjects, arms and armour, costume, and other details and incidents.

The queen, called in mediæval times *fierge, firge,* and, by corruption, *vierge* (Madden derives the term from the Persian *pherz,* a councillor), is scarcely less remarkable for variety of type. Sometimes it is a general commanding an army. But the form of which we have the most examples resembles generally that of the Lewis chessmen. Here the queen is seated in a like chair to the king's; she wears a veil falling over her shoulders, and over this a low crown; in one piece she rests her head on her right hand, and in the left holds a horn which may be meant for a drinking-horn,

[403]

but is more probably a money-box such as was then used. We have examples of such money-boxes in bone and ivory.

The knight is sometimes a large figure on horseback, surrounded by others, smaller, to show their inferior rank. The piece is found in the shape of other complicated groups, and carved with subjects of infinite variety. In the Lewis set some of the knights are represented by a standing figure in armour, wearing a conical helmet with a nasal, and a surcoat reaching to the heels. He grasps a tall, kite-shaped shield, nearly as high as himself. Other knights are on sturdy little caparisoned horses with curiously embroidered saddle-cloths.

The bishop seems to have replaced the fool or jester of earlier times, and, again, the elephant, from the early Persian word *pil* or *phil*, whence *al phil* and other derived terms to be met with in chronicles. Of the Lewis bishops, some are seated, some stand; some are vested in chasuble, dalmatic, and tunicle, with the ends of their stoles showing. Others wear a cope over the dalmatic. They wear also mitres of the low gothic form, so different from the hideous and ridiculous tall Roman or French kind which was evolved later on. The *infulæ* are shown, and every detail of the episcopal vestments is remarkably exact.

The rook or castle appears to have come from the Persian *rokh*, a free-lance or adventurer, but how transformed into a crenellated tower one can only conjecture. No doubt the warder is a more appropriate term, his moves a kind of sentry-go, keeping watch and ward in a steady sort of fashion, and later on represented by the battlements themselves. The Lewis warders are the same kind of figures as the unmounted knights, but in this case they hide almost entirely behind their shields, holding the top edges in their mouths, a row of huge teeth appearing, as if biting it.

Finally, the pawns are of various shapes and sizes— usually a kind of cone with chamfered sides. Many of the pawns in the Lewis set are ornamented on the broader face with beautiful designs of conventional floriations of a distinctly different character to the interlaced work on the figure-pieces.

A few curious pieces, amongst many others, may be briefly mentioned. The first was found in 1839 in the ruins of Kirkstall Abbey. It is of walrus ivory, covered with an elaborate decoration of fabulous birds and beasts and human figures of the kind already often referred to in twelfth-century work. From the projecting piece or peak it may be taken to be a king. The Society of Antiquaries of Scotland has a knight and a warder, crouching figures in armour amidst deeply cut interlacements, later than the Lewis examples, probably of the thirteenth century. The Ashmolean Museum has also a thirteenth-century piece for a knight, representing two knights on horseback and in armour, of the time of Henry III. or late King John, as they wear the curious cylindrical flat-topped helmet. And it is impossible to avoid mention, at least, of what is probably the most ancient—and it is also complete—set of chessmen in existence. These were found about fifty years ago among the ruins of Brahminadab, in Scinde, a city which was destroyed by an earthquake in the eighth century. The pieces are turned and quite plain, without any ornament. With them were also fragments of a chessboard in ivory and ebony, but all in an extremely fragile condition. They are now in the India Museum.

Although the chessmen of the Lewis type may have been, and probably were, made in other countries, the fashion does not appear to have come very far south, and it is to Denmark and Scandinavia generally that we must look for their origin. Other examples—for instance, in the museums of Naples and Berlin—are known, besides those of the great find at Uig, unless,

indeed, the former were abstracted and sold separately. A bishop, formerly in the Maskell collection, is now in the British Museum. In endeavouring to assign an exact origin and date to these pieces, we are guided principally by the material, the style of ornament, the costume, the physiognomies, such details as the fashion of the hair, and especially by the armour. This, with the pointed helmet and kite-shaped shield, is distinctly Norman. At the same time a like fashion may have prevailed in Denmark and Scandinavia. The physiognomies of the figures are decidedly marked, and even the diminutive ponies on which the knights are mounted may be not without value in the argument. Very interesting are the figures of the bishops and the accuracy of detail in their vestments, their crosiers with a plain, simple volute and a certain amount of variety in the form of their more or less pointed mitres. We may even base upon the exactitude of these details some surmise that the figures are the work of monks, or at least come from a religious house, perhaps in the neighbourhood of the place of their discovery. It must be remembered also that the mitre as an ecclesiastical headdress is not of great antiquity. Menard, the learned Benedictine editor of the Sacramentary of St. Gregory, says that they were not in general use for the first thousand years of our era. No ritual mentions them before the year 1000 A.D., although the most elaborate ceremonial is laid down in the order for the consecration of bishops. We may conclude that these interesting figures are the work either of the northern hordes who overran Scotland and the greater part of Europe in the twelfth century, of the inhabitants of a monastery or settlement in the vicinity of Uig, or that they may have formed part of the stock of an Icelandic merchant who carried them as traffic to the Hebrides or Ireland; or, again, that they may be from a wreck of some merchant ship. But it is certain that walrus ivory was worked in

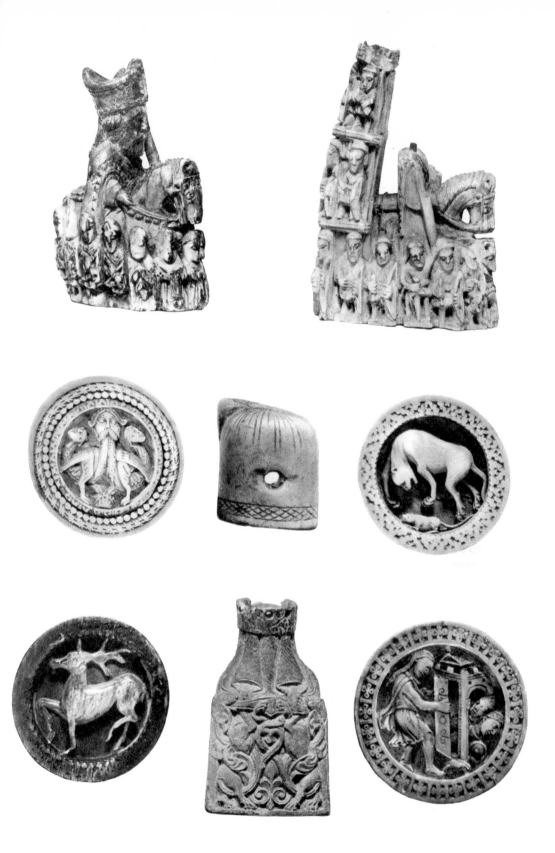

Plate 69. CHESS AND DRAUGHTS MEN

ELEVENTH AND TWELFTH CENTURIES

various parts throughout the isles, especially for daggers and sword-hilts, and the like. We may remember, however, that the Lewis group of islands was chiefly peopled by Scandinavians. They had princes of their own until the island of Lewis was ravaged by King Magnus Barefoot, who added it to his own dominions.

As ivories, it is for the character of the decoration that we chiefly value them. It is useful to compare the beautiful ornament of the interlaced work on the backs of the chairs, the foliated arabesques and the animals with foliated tails, with that on the Brunswick and other caskets of northern origin which have already been described.

Early draughtsmen in ivory and bone of the eleventh and twelfth centuries are not uncommon. They are generally thick slabs or sections of walrus tusks, of northern or Byzantine origin, the subjects carved in almost full relief beneath the level top of the piece, so as not to interfere with their being placed one on another for the purposes of the game. One of this kind was found recently in a quarry at Glastonbury; another at Salisbury. Anglo-Saxon draughtsmen are often simply ornamented with lines in concentric circles and half circles, the latter forming festoons round the edge. The same system of incised lines and circles is found on two Anglo-Saxon chessmen found near Warrington in 1852. They are plain pieces, one a cylinder, the other a kind of section of a cone, and are of jet for the black men, the corresponding white ones having doubtless been of walrus ivory. Scriptural subjects are common on Byzantine examples, of which there are several in the British Museum. Besides these and others, there is in the same museum a very interesting set of ivory, of large size, each piece carved with an animal—a stag, an elephant, a horse, a sow with young, a camel, a goat, and so on. In the Kensington Museum the subject on one piece is a man and woman playing the game; four other people

stand behind looking on. And another curious piece—
or rather fragment of a piece—has in the centre, in high
relief, a kind of wingless dragon biting the end of a rod
or spear. The Ashmolean has two pieces, on both of
which are representations of St. Martin dividing his
cloak to clothe a beggar. All the above are of the
eleventh to the thirteenth century. As might be ex-
pected, the subjects are very varied, and most museums
possess examples of the work of different countries; but
in ivory they are usually confined to the centuries just
mentioned.

In connection with these draughtsmen, it is worth
while to call attention to the decoration of some of the
pillars of the old Norman church of Shobdon, in Here-
fordshire. These are ornamented with medallions which
resemble precisely many of the Byzantine draughtsmen.
The similarity between the style of decoration on the
back of the crucifix of Leon and that of the arms of
a chair from the Meyrick collection, now in the Ken-
sington Museum, has previously been noticed. With
these it is instructive to compare both the draughtsmen
and the pillars. The vandalism of some restorers of
1752 pulled down the ancient church, but the pillars
were rescued and erected in Lord Bateman's park close
by. An account and illustration of them will be found
in the first volume of the *Journal of the Archæological
Institute*.

CHAPTER XIV

IVORY SCULPTURE IN SPAIN, PORTUGAL, AND WEST AFRICA

THERE appears to have been a less general use of ivory for sculpture in Spain and Portugal than in most other countries. Nevertheless, if we take into consideration, with regard to Spain, what is known as Hispano-Moresque art, resulting from the invasions of the Peninsula by the Arabs in the eighth century, and their influence which endured until they were finally expelled at the end of the fifteenth, and, with regard to Portugal, her colonies, her settlements in India and China, and her connection with a certain part of West Africa, we shall find some interesting subjects to occupy our attention.

So far as the arts are concerned, the situation created in Spain by the contact of the two races was, of course, somewhat complex. The question, however, affects ivory sculpture less, perhaps, than some other descriptions of art, and it will be hardly necessary, therefore, to do more than call attention to it in the briefest manner. Moreover, the examples which will be selected will be for the most part almost purely oriental as regards their decoration. The result of the fusion of the two influences was naturally to create a hybrid type, sometimes purely national on the one side or the other, sometimes with mixed characteristics. Again, in the times when Byzantine art reigned supreme in the west, it is to be expected

that we should find, in the Christian art of Spain, the Byzantine influence exercised through the medium of western models ; while, on the other hand, the Moors would draw their inspirations and preferences direct from their oriental sources. They would further be governed by the Mahomedan objection to using in ornament any kind of representation of the human form or animal life: an objection which, however, in their new surroundings was not always rigidly observed, nor was any great reluctance shown to working for Christian masters. Spanish artists, on their side, could scarcely avoid being influenced by and adapting Moorish styles and methods.

We arrive, then, at a peculiar style of mixed art, in which oriental feeling predominates, which we call Hispano-Moresque. Of the later periods—after about the thirteenth century—it is not at all easy to account for the various transitions through which the Arab influences on the style of decoration passed ; nor can we, in many cases, fix the dates with any degree of certainty. The oriental manner varies but little, and it would have been copied over and over again, even long after the expulsion of the Moors.

In considering the examples of ivory carving in Spain which we possess, of any kind—and they are not many—there is little reason to do otherwise than confine the remarks which may be made to a certain class of object of Moorish or Hispano-Moresque origin, of which some fine examples are to be found in the Kensington Museum. These are the boxes and caskets of peculiar form, which were evidently made for the use of the palaces of the conquering race. There is little or nothing to correspond with the devotional work in other countries of the thirteenth and fourteenth centuries. Of the best time of the Italian renaissance, the effects of which were felt in Spain, as they were everywhere else, we are absolutely destitute of anything in ivory sculpture which could

[411]

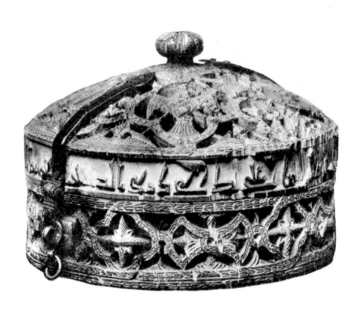

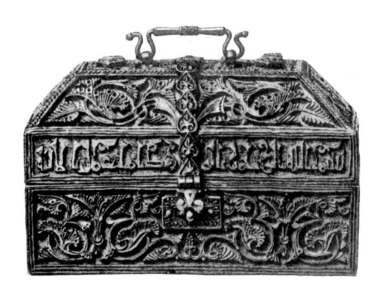

Plate 70. CASKETS. MOORISH

TENTH AND ELEVENTH CENTURIES

be brought forward. In later times the case is still worse. What is left of purely Spanish character is unfortunately of a type—especially in religious objects—which, if not always of the most debased description which we associate with this form of art in Spain, has certainly very little to recommend it. It cannot always even be properly called Spanish, for it was frequently the work of the natives of the colonies in the Chinese seas and elsewhere. Italian influence and models prevailed in the statuettes and religious plaques of which we have examples, and were adapted to the requirements which Spanish de- votional art seems to demand: the colouring, the gro- tesque exaggerated crowns, and all the rest of it. It is unfortunate that it should be so, for we cannot forget the splendid examples of sculpture in wood—the retables and the choir-stalls—which Spain can show of its finest epoch.

The most characteristic of the caskets to which allusion has been made are the circular boxes with flattened, dome-shaped covers, and a knob on the top. It would be difficult to exceed the firmness and precision of the carving of these admirable works. The surface is almost entirely open-worked in the thick substance of the ivory with a pattern of narrow interlacing bands, which form quatrefoils and devices, within which are conventional antelopes, deer, eagles, and other animals and birds—even angels with spreading wings—together with a rich foliation of palm leaves. Around the deep margins of the lids are inscriptions in relief in an ancient Cufic character, which are, of themselves, extremely decorative. Of these we have for example: "It is more beautiful than a casket adorned with diamonds, it serves to contain precious spices, musk, camphor, and ambergris." Or, "A favour of God to the servant of God, Al Hakem al Mostanser Billah, Commander of the faithful" (a caliph of Cordoba in A.D. 961). And, again, on an elaborately carved Saracenic casket in the

treasury of the cathedral of Sens: "Hail to him whose equal I never met, upon whom I rely more than on any other, that generous man from whom whenever I came with a request I never returned but with what contented me and with a joyful face." Other caskets are of various shapes, but the ornamentation is similar. A Spanish box of the fourteenth century carries on the Saracenic character, and has also an Arab inscription.

If we may judge from the rich decoration and fine execution of these caskets, bearing in mind also the magnificence and luxury which surrounded the caliphs, it would appear highly probable that ivory carving was extensively practised. We owe, no doubt, the preservation of the examples which have come down to us to their having been adapted to ecclesiastical uses, such, for instance, as receptacles for unconsecrated wafers. That the designs and inscriptions were inappropriate would have mattered little, even if the meaning of the latter were at all understood; on the contrary, the new service to which they were dedicated would have signalised the triumph of Christianity.

A very curious cylindrical casket in the Kensington Museum, acquired in 1880, was made, as appears from the inscription, for a captain of the guard of Abderahman III., caliph of Cordoba in A.D. 971. It may have been executed at Cordoba, but the style is Persian, and there are many human and other figures; a horseman carrying a hawk, a great personage seated on his throne, another in a howdah on an elephant, the spaces between the panels filled in with strapwork and with foliage intermixed with griffins, birds, and flowers.

Examples are found also in Spain of another class of Arab box, namely, those which are perforated or completely open-worked with a geometrical pattern. They are charming in simplicity, with their mounts and bands of silver or copper and the decorative lettering. But we have few of the best in our museums: none to compare

with one in the cathedral of Saragossa. Other coffers are rectangular, with sloping or roof-shaped lids. We find in the decoration the palmetto leaf, and antelopes, or birds *affrontés* or *dos-à-dos*, in groups repeated as in a pattern. There is a fine example in the cathedral of Palencia, of the eleventh century; deeply cut, but so as to present a level surface. Others, again, are of plain ivory painted with coats-of-arms and other designs, and diapered in colours and gold in the style which has already been noted in the Siculo-Arab crosiers and caskets of the twelfth and thirteenth centuries. There are two Siculo-Arab caskets at South Kensington painted and gilt with figures of saints and with Arab inscriptions. The Moorish style is found also in the decoration of some magnificent sword-hilts, and there can be little doubt that oliphants would have come into Spain in considerable quantities, and have found their way afterwards further north.

Very few of the religious figures in ivory of the later periods call for notice. Crucifixes are now and again attributed to the painter-sculptor, Alonso Cano; but though his sculpture in wood is well known, there would seem to be no direct authority for ivory carving. Nor, if we may judge from a crucifix in box wood at Kensington which is attributed to him, do we lose much. It is of the type which represents a nude human body apparently in full vigour of life, the expression of the face insipid and sentimental, the hair and beard neatly combed and arranged, and the modelling of quite ordinary character. Neither can an oblong ivory plaque in the same museum, carved in high relief with the Assumption of St. Francis and ascribed to Cano, be said to be worthy of admiration. Other statuettes of the infant Saviour, of the Virgin, and of monks and saints and bishops, are either of the poor style of the seventeenth and eighteenth centuries, or remarkable on account of the Chinese or Indian characteristics which they show.

When we remember the monuments of Spanish art, the splendid altar-pieces, the wrought-iron work, the gorgeous specimens of gold and silver smiths' work in the vessels used in the service of the altar, the vestments and embroideries, we regret the more the paucity of ivory carving. But wars and invasions apart, the amount of destruction of works of art which has gone on for centuries has been enormous. Neglect, on the one hand, did its share, and the comparatively small intrinsic value of ivory will account for much which must have disappeared. On the other hand, anything in the way of settings undoubtedly found its way speedily to the melting-pot. It is sufficient to recall the few Arab ivories which we possess, and such an example as the ivory crucifix of Leon, to feel certain that very many fine things have been lost.

There is, of course, from their geographical position and political connection, together with the similarities of national character, a considerable resemblance between the arts of Spain and Portugal, so much so that at times it becomes difficult to discriminate and rightly to assign the country of origin of certain works. Portugal suffered also the same invasion and domination of the Moors. Much, therefore, that has previously been said will apply to both countries. On the other hand, we shall have to bear in mind the Portuguese settlements in India, the results of which are especially to be remarked in the case of the use of ivory in sculpture and decoration. In the sixteenth century, after Goa was taken by the Portuguese under Albuquerque, importations of Indian art were poured by them in quantities into their own country. The style was liked, became popular, and was extensively imitated. We may leave on one side for the present the furniture inlaid with ivory in the manner which in the west is known as Certosina. But besides this, which the Portuguese affected largely and themselves manufactured to a con-

siderable extent, even in religious art the native Christians of Goa fashioned many of the statuettes and other ivory carvings which were made to order in India. Portugal had also her colony at Macao, and here again the same effects followed, not only with regard to native work, but also, to a lesser extent, perhaps, than in the case of India, from the influence of Chinese art and decoration.

A very curious example of Goa work, the meaning of which does not appear to be quite clear, is that known as the " Pilgrim" or " Shepherd" rockery. This is in the form of a mountain or rocky hill, with a spring from which a stream of water flows. Beneath are some sheep, and at the top a youthful shepherd, apparently asleep. Examples are to be found in many museums. One is in the Mayer collection at Liverpool.

A great deal of interest has lately been taken in some ivory carvings from the west coast of Africa, where the Portuguese founded a settlement in the fifteenth century. The earliest specimens which came to this country were usually classed as Goa work; but since the English expedition to Benin in 1896, which destroyed the power of the savage kings of that district, a large quantity of remarkable ivory carvings and bronzes which were brought back seems to establish the fact of the African origin of a good deal that was previously uncertain. The ivories are now, for the most part, in the British Museum.

Benin is situated on the Guinea coast, near the mouth of the Niger. Discovered by the Portuguese in the fourteenth or fifteenth century, they were followed later by the Dutch, and eventually we ourselves established trade relations there. The bronzes and brass work are very curious and interesting, and no doubt go back to the early times of the European settlement, the natives having received instruction in casting them by the Portuguese. With these we need not concern ourselves.

Neither is it necessary to do more than recall the English expedition in 1896, and the massacres of our troops which it entailed before the flight and capture of the king and the annexation of the territory to the British crown.

The ivories in the British Museum, whether from the latest expedition or from former ones, comprise a number which were no doubt the work of the early Portuguese settlers themselves; others which are purely native in design and workmanship, and others, again, copied from objects of art which the Portuguese had brought with them, or had caused to be carved by native workers under their instruction, or are of a mixed character. There are cups or covered bowls upheld by rudely executed grotesque human figures, drinking and other horns with extremely well-designed bands of interlacements in the style which we associate with Scandinavian or Celtic work—really, perhaps, one of the earliest forms of ornament resulting from the weaving of reeds and grasses. The horn in the British Museum here illustrated was of course made for the Portuguese, and probably by native workmen. The Spencer horn, in the possession of Earl Spencer, is almost identical and of similar origin. Some of the designs on the tusks are intensely reminiscent of the carvings in the architecture of the buried cities of Central America. Then, again, we have some small lions, evidently copied from Chinese kylins brought by the Portuguese. Numbers of huge tusks were brought to England by the late expedition, and are now in the museum. They are rudely carved, and have probably figured in many a dreadful Ju-ju ceremony. The details given in Mr. Roth's lately published work, *Great Benin*, are almost too horrible to contemplate. Most of the tusks were found *in situ* as doorposts and the like, and covered thickly with congealed blood. Others are evidently of a great age, and are in a very decayed condition. There is little interesting

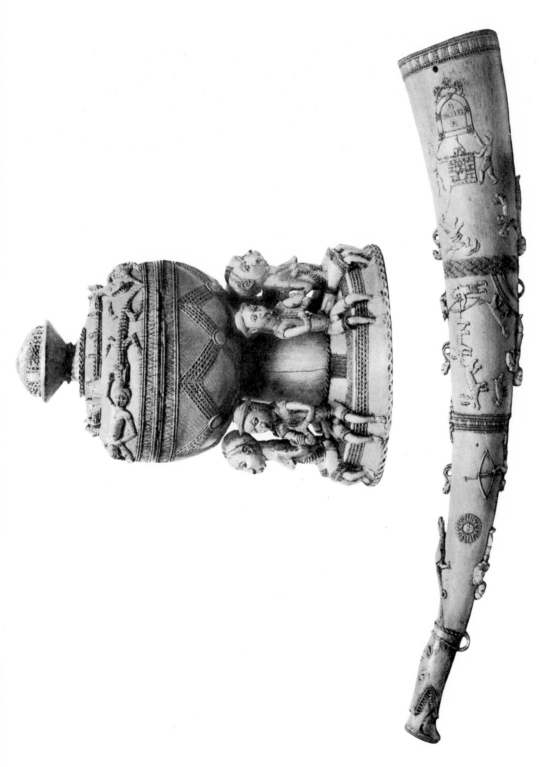

Plate 71. IVORIES FROM THE GUINEA COAST, WEST AFRICA

SIXTEENTH CENTURY

about these things, and savage art demands, perhaps, a special taste in order to be thoroughly appreciated. At the same time, the collection of ivory carvings from West Africa, which has been many years in the museum, and is evidently the result of Portuguese influence, is certainly worth attention. It includes one of the curious " Pilgrim " pieces which have been just now noticed.

CHAPTER XV

INDIA, PERSIA, ARABIA

ALMOST unconsciously we associate in our minds the art of ivory carving with India more than with any other country. The name alone brings with it the idea of the elephant, and of the tusks which furnish the beautiful material. Nor is this without reason. The quantity of ivory worked in and exported from India has for centuries been enormous. We need not again stop to consider the relative amounts of ivory which India proper and her dependencies produce, compared with those which exist in and are exported from Africa and other countries where the elephant has flourished and has been utilised in all times of which we have any history. It is, of course, certain that India being in possession of practically unlimited supplies, and her people being, moreover, endowed with natural artistic instincts, the idea of the adaptation of ivory to all kinds of decorative purposes would have been, from the first, eagerly seized upon. And in the development which followed, we shall remember India's geographical position, how this great empire has been in all ages the highway for traffic between the distant east and the west, and the influence which her arts, either in a direct manner, or filtered through those of other nations, exercised upon the art of every other civilised country. Nor could the results of this constant traffic, of the passing through these territories of the invading hordes

of Greeks and Persians, Scythians and Tartars, and, in one way or another, the influence of every other nation under the sun, have had a less important effect within the empire itself. Not so conspicuously, perhaps, with regard to purely Indian art, in the taste and for the purposes of the people, but very much and disastrously so when we consider, in the latest times, the influx of western designers, the enforced reception of western ideas and methods by the hands of her conquerors, and the vast quantity of ornamental work turned out for the European market.

Although the use of ivory for decorative purposes has been constant, and has been largely practised in India for so long a time, it has not a history which we feel called upon to follow in the same manner in which we have endeavoured to follow—or, at least, to outline—the progress of ivory carving in the west, and in the countries with which the west has been more intimately connected. For these reasons. First, with regard to both ancient and modern ivories, it might be necessary to consider at some length the indissoluble connection between the arts of India and the whole system of Hindoo mythology, which is so intimately bound up with them. Next, we could hardly avoid a constant reference to and comparison with—if not every other decorative art of India—at least the sculptural arts. To attempt this without occupying considerable space would be difficult, and without very ample illustrations would be wearisome. Lastly, we have to take into account the relations with other countries, the constantly changing conditions, the exactions of the conquering nations, and the call which has ever been made on Indian artists to satisfy the taste of, and to respond to, other feelings than their own. And it may be questioned whether, owing to these and other causes, we should be able to find sufficient examples from which to show that the system of sculpture in India can hold

a high rank at all as a fine art, according to our western ideas, and, as a result, whether we can expect a great amount of interest to be accorded to it. It need hardly be explained that we do not presume so to speak of the arts of India generally, or even of her sculpture, excepting so far as it is connected with ivory carving. All these things may very well be left in the competent hands of those who have written upon them.

When we consider the application of ivory to decorative purposes, as we find it presented to us in the great mass of objects exhibited in museums and collections, it is difficult to avoid the impression that the general character of the art is one which appeals, and could appeal, to but few amongst us. There is a sameness, a repetition, an overloading, a crowding and elaboration of detail, which become wearisome before we have gone very far. We are spoken to of things, and in a language, of which we are ignorant. We regard them with a listless kind of attention. There is nothing to rouse us. In a word, we are not interested. We feel that the artist has ever been bound and enslaved by the traditions of Hindoo mythology. We are met at every turn by the interminable processions of monstrous gods and goddesses, these Buddhas and Krishnas, Vishnus and Ramas, these hideous deities with animals' heads and innumerable arms, these dancing women with expressionless faces and strange garments. Or again, the same figures—human and yet not of our race, living but lacking any semblance of vivacity—are presented to us with monotonous repetition; with the absolute sameness and quite as little artistic value as on an ordinary wall-paper. They are thus disposed without intelligible reason. No suggestion is evoked, as in the case, for example, of the sculptures at Thebes. They are not beautiful, nor do the forms or the arrangement of them assist the decoration.

It may be said, perhaps, that the employment of

these mythological figures is not an invariable accompaniment. That is so, but the general ornament is equally monotonous. We rarely — the ivories will especially illustrate this—get away from the eternal repetition of the same kind of floral scroll which, like a weed, covers every portion of the surface to be decorated, leaving not a square inch for the eye to rest upon. And it may also be remarked that we have in this ivory sculpture no colour to help us. Nor, from the small scale, and from the technical method in which the carving is carried out, can colour, or tone of any kind, be suggested. Throughout it all there is a want of simplicity, a barbaric profusion, so that the mind is given no repose, but wanders vaguely throughout the composition. Ivory sculpture is not at its best in the display of a pattern, after the manner of a Cashmere shawl. In the oldest and finest work the case is different; but, as a rule, rarely do we find the theme of decoration less intricate and crowded, the treatment of the vegetation and floral ornament less stiff and unnatural. In his figures the Hindoo artist seems absolutely incapable—it may be reluctant—to reproduce the human form; he ignores anatomy, he appears to have no idea of giving any expression to the features. There is no distinction between the work of one man and another. Is the name of a single artist familiar? The reproduction of type is literal: one divinity resembles another, and we can only distinguish them by their attributes, or by the more or less hideous occupations in which they may be supposed to be engaged.

That the representations of personages and events relating to the Hindoo pantheon may have a special and important interest of their own cannot, of course, be denied; but they are not subjects which appeal to many of us. They have not even the charm of the Japanese folk-lore and mythology which, in the art of Japan—little intimate as may be our acquaintance with

them—still have their stories to tell, which are not so far removed from our own ideas as to prevent our delighting in them. It is difficult to understand why the Hindoo mythological system should form the staple matter of many books on Indian art in so disproportionate a manner, at least, to the questions involved in the art itself.

The impression which we derive from a general survey of ivory carving in such a collection as that in the India Museum at Kensington, than which no more comprehensive one representing Indian art could elsewhere be found, is that we have first Hindoo art proper, and next the results of the interference of the foreigner. The term interference is intentionally used, instead of influence, because in such cases especially as the conquests and occupations of the Portuguese and the British it has been imposed and forced upon the oriental temperament for political or trade reasons, rather than assimilated from choice and inclination. Of the oriental influences and varieties, the most striking are the Mogul and the Cingalese, and these, with the native Hindoo, may be said to be the dominant types. Leaving apart, for the moment, the articles made for the European market, we have no such choice of objects and decoration as that which the palmy days of ivory sculpture in Christian countries have furnished to us. We can bring forward no cups and tankards, no statuettes, no pastoral staves or other objects for religious use, no horns or weapons for the chase, and we do not understand the stories which the figures tell us as we do those of a mediæval diptych.

Our references to individual pieces must be few, in default of illustrations which a visit to the India Museum will better supply. For Hindoo art proper it may appear strange that we should go to Ceylon; but certainly we could hardly find it better illustrated than in some Cingalese plaques of the seventeenth century from the

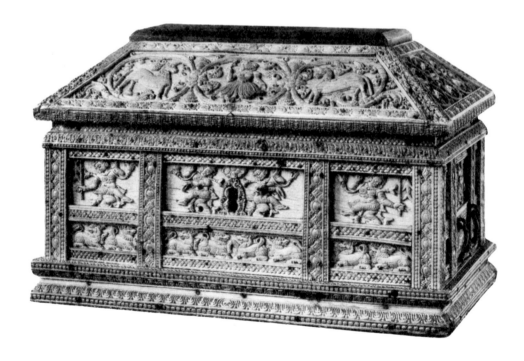

Plate 72. SOUTHERN INDIAN CASKET AND CINGALESE PLAQUES

SEVENTEENTH CENTURY

Nevill collection, of which we give two illustrations. Here we have repeated—but not in an aimless, exaggerated way—some seated mythological figures in a floral arabesque, and with floral borders of a beautiful scroll design, of bold and broad workmanship. Or we may take again, both for figures and borders, the southern Indian (Travancore) seventeenth-century casket, also illustrated; a fine and typical example in its way. Then we have the Mogul style in a small oblong casket of the seventeenth century, with a really charming and delicate floral pattern in low relief, simple, broadly treated, well executed, and entirely free from the niggling fashion too often found. No better styles than these could be mentioned; they recur frequently with more or less merit, and it would be superfluous to repeat the references.

Mention may be made, in passing, of numerous Cingalese caskets made by native Christians which have biblical subjects from European models amongst the floral arabesque Hindoo decoration. A fine Cingalese spoon, or dipper, is well known, very large, with its cocoanut-shaped silver bowl and elaborately carved ivory handle mounted with gold and jewelled. In a Benares palanquin completely covered with thick plaques of ivory we have a mixture of pure Hindoo and Mogul ornament in the borders. Some of the plaques are carved in relief with fighting elephants, lions, and all sorts of reminiscences of the styles of countries still farther east. Combs with a double row of teeth are not uncommon, and when of simple design are elegant and examples of good art. Such, for instance, is one of which the rectangular field is composed of an endless intertwisted band in open-work within a border of pierced quatrefoils. After all, there is nothing distinctively oriental in this design.

The results of foreign interference cannot be said to have been productive of good. Amongst them, the

Portuguese occupation caused the exportation and dis-
semination in Europe of a large quantity of articles of
a hybrid art, ranging from religious statuettes and other
devotional objects to articles of furniture inlaid with
ivory in the Certosina style, which are more often than
not classed as Portuguese.

It is generally admitted that Orientals have never
yet attempted with success to engraft upon their own
art, or to assimilate western ideas and models. The
results are disastrous, when, as in the cases of other
arts besides ivory carving, British influence has been
forced upon them. Without, however, straying from
our subject, perhaps no more terrible instance could be
given than the suite of ivory armchairs and a chess-
table, now in the India Museum, which were produced
at Berhampore for the great exhibition of 1851. If an
attempt were purposely made to show to what depths
of vulgarity and bad taste art could be made to descend,
together with a waste of a valuable and beautiful material,
it would be difficult to succeed better than has been done
with these astounding specimens.

It is hardly necessary to do more than chronicle the
very considerable industry in ivory carving made in
India and its dependencies for the European market.
A large and excellent collection of, in many cases,
carefully executed and, up to a certain point, beautiful
examples, is in the India Museum at South Kensington.
We are familiar with the endless variety of sandal-wood
boxes inlaid with ivory mosaic, in the well-known style
from Bombay, the tables, prayer-stools, cabinets, and
chess-boards; the large mythological groups, the elephants
and native figures, and the *ekka* bullock-carts brought
back by every traveller, and preserved under glass shades
in so many suburban drawing-rooms; the card-cases,
paper-knives, scratch-backs, knife-handles, dice-boxes,
fly-flappers, fans, chessmen, puzzles, and turnery work;
there is profusion of it, and much may be said to be

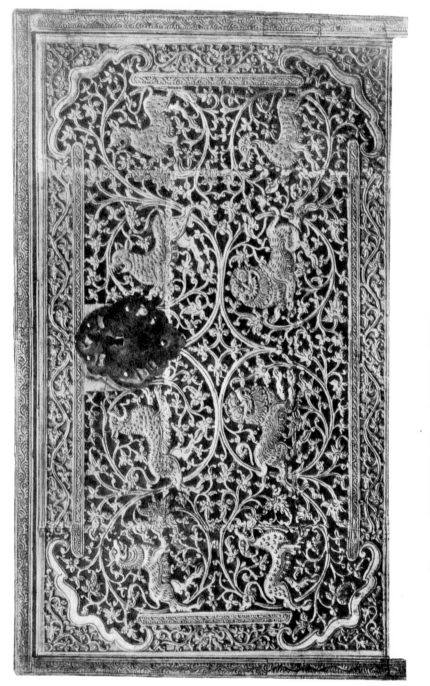

Plate 73. SOUTHERN INDIAN CASKET (MYSORE OR TRAVANCORE)
SEVENTEENTH CENTURY

extremely good. India has always been deservedly famous for such things. The best are produced mainly at Benares, Bombay, Murshedabad, Umritsur, Delhi, Travancore, and Ahmedabad; but it is hardly necessary to make distinctions, for the industry flourishes in all the great centres.

In Persia ivory seems to have been less worked than in other parts of the east, except for sword-handles. For these it was the rule, and they are also almost invariably of walrus ivory. An illustration is given, from a photograph in the Art Museum at Kensington, of a fine seventeenth-century cabinet at one time belonging to MM. Rollin and Feuardent, ascribed to Persia, but of distinctly southern Indian workmanship, perhaps from Mysore or Travancore. One cannot always be sure of the origin of ivories with a Persian character. An Arab cylindrical box of the kind has already been referred to in the chapter on ivories in Spain. Persian ivories are, at any rate, extremely rare, and there are none at South Kensington.

Arabian art in ivory is always beautiful, with an attraction peculiarly its own. There are about it a facility of execution, a breadth and firmness of touch, which are quite remarkable, and perhaps hardly sufficiently recognised. We need not again allude to work of the character of the Hispano-Moresque caskets, except to add to it another class of box, usually cylindrical, in which the whole surface is covered with a perforated diapered pattern, and always with a band of the decorative Arab lettering. Of this distinctively Saracenic type, with its system of open-worked geometrical arrangement of circles and stars, some beautiful thirteenth-century examples are in the India Museum. There is also some Turkish ivory work of a similar character.

The most interesting application of ivory in Saracenic art is one on which we cannot but regret that our space will not permit us to dwell at greater length. It is the

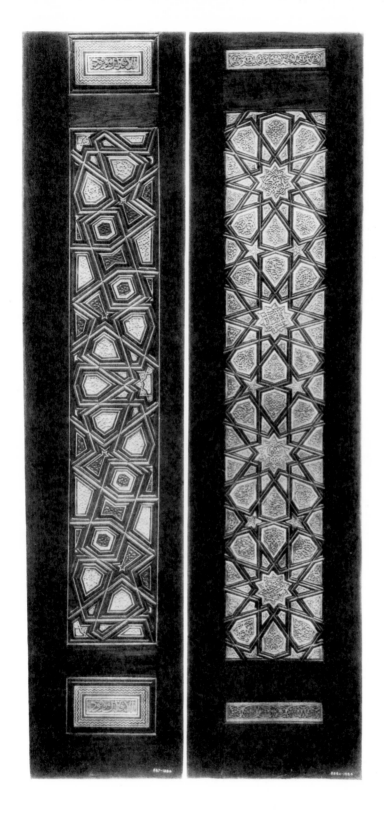

Plate 74. PANELS OF PULPIT DOORS. SARACENIC

FOURTEENTH CENTURY

inlay in geometrical designs for the panelling of doors and furniture of various kinds. Many varieties of the Mushrabeeyeh work which is so well known are inlaid with ivory. It is, in fact, a mosaic, a complicated arrangement in little hexagonal or other multi-sided panels of geometrical designs and arabesques, varying so much that hardly ever do any two exactly resemble one another. Lines of ivory are set round the carved and inlaid wooden panels or, on the other hand, ivory panels are set in borders of ebony mingled with various other woods. It is difficult to imagine any system which could lend itself better to a fertile artistic imagination than this especially characteristic Arab marquetry. The almost puzzling intricacies of the interlacing lines, the harmony of the passage from the whiteness of the ivory to the more sombre woods and jet-black ebony, the innumerable geometrical combinations, the imperceptible, yet effective, variations in level of the general surface of the design, the fine carving of the ivory incrustation, even when these inlays are quite small—all this is more striking than anything that certosina or tarsia work, with their greater regularity, can show. Both methods have, no doubt, a like origin in Persia. The magnificent *nimbar*, or pulpit, at South Kensington, is a well-known admirable example. A further development is to be found in Coptic screens, in which whole panels of ivory, carved in relief, are added : sometimes, also, thin ivory slabs, through which the light of lamps shines dimly. Most visitors to Cairo are carried off by their dragoman to the dingy and evil-smelling churches in the Coptic quarter. There, surrounded by narrow and tortuous lanes and alleys, is the tenth-century church of Abu-Seyfn, which possesses one of the finest known screens of the kind.

CHAPTER XVI

CHINA AND JAPAN

ALTHOUGH the quantity of objects for which ivory is used in China is very large, there is little to call for detailed notice, nor is it necessary to devote to them any considerable amount of space. In a general way, with very rare exceptions indeed, what we know of Chinese ivory carving is confined to those examples which are turned out for the European market, and for the most part are not intended to appeal to cultivated tastes. It would be impossible, in fact, to consider seriously as works of art what, on the other hand, it may be perfectly reasonable to admire as prodigies of mechanical dexterity and ingenuity, joined to a degree of patient application which excites our wonderment. Such, for example, are the well-known intricate puzzle-balls. Beyond this patient application there appears indeed to be nothing which demands more than the most passing notice.

As curiosities most museums possess specimens of the enormous models of villas and gardens with their paths and rockeries carried out in the style of the willow-pattern plate, and made of blocks and veneers of ivory, the trees and foliage imitated with the brilliant turquoise-blue feathers of the kingfisher, which are used also in Chinese jewellery, the water with glass or crystal, the robes of the little figures stained and coloured. In other models, allowing for the "Chinese" style, it is true that we can call to mind better and less flimsy

things. There is a certain amount of attractiveness in
the model of a *sampan*, the hull of solid polished ivory,
the passengers standing up on the deck beneath the
awning arrayed in gorgeously painted robes, the natural-
istic lilies with their stained leaves, the whole reposing
on a bed of always the same fabric with always the
same blue silk edging. With this kind of work we are
familiar, but there is in it nothing of the imagination,
the spirit, the observation, and the vitality which a
Japanese would display in his treatment of quite as
commonplace a subject. Such things are made for a
dreamer of dreams of Chinese type.

A mortar for pounding drugs of old Chinese work
is illustrated. There is a similar mortar with its pestle
in the collection at Oscott Seminary. Vessels of this
kind come probably from Portuguese settlements, where
they were used for pounding incense for church purposes.

Very curious are the ivory puzzle-balls, the outer
one having within it a dozen or more diminishing in
size down to the smallest, no larger than a pea, but
every one perfectly detached and movable, and carved
with a pierced pattern, which is not alike on any two
balls. The whole, and in addition a chain for suspen-
sion, is carved out of one piece of ivory without a join.
Some puzzle-balls are very large and elaborately carved
on the outer surface, but the best, which are uncommon,
are perfectly plain, so that there can be no suspicion of
any sort of join. It is difficult to describe the method
by which these things are made, but it may be said
shortly to consist in piercing a number of holes in such
a way as to gradually diminish to a point at the centre,
and then with a special tool to work through these
openings and carefully detach each inner ball, turning
it round as the work proceeds. It is a mistake, how-
ever, to imagine that balls of this description require
great skill to produce, or that they involve the labour
of a lifetime. The whole of the work, except the

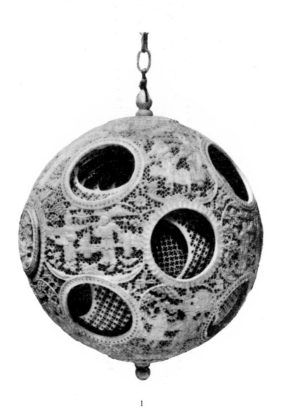

1

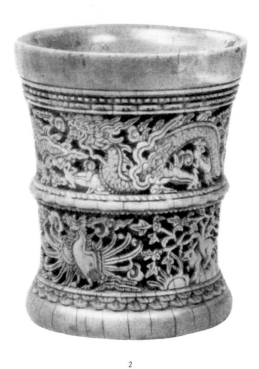

2

Plate 75. CHINESE IVORIES

1. PUZZLE BALL. 2. MORTAR. OLD CHINESE

decoration, is done in the lathe, in an eccentric chuck, and as a matter of fact it is not an unfrequent diversion of the amateur turner.

One curious example of figure sculpture may be mentioned. These are the representations of the Buddhist goddess Kwanzin, with the infant in her arms. There is a remarkable resemblance in them to the mediæval statuettes. The same twist or bend arising from the shape of the tusks is to be observed; a rosary hangs from the girdle, and even in the faces of the mother and child there is no marked Chinese character. But they are not in any way Christian work, as some imagine them to be.

The work on Chinese ivory fans, with their pierced and chased sticks and guards, is, of course, very delicate and remarkable. From them the fashion spread into Europe, and has been especially practised in France.

It is delightful to turn from the restricted ideas and cold formality of Chinese sculpture, in which there appears to be no scope for originality and absolutely no evidences of the individuality of the artist, to the personality and variety of invention which form the charm of Japanese art. It has been said, and it may be true, that all Japanese art is of Chinese origin. We shall take it as we find it. Religion, and some symbols and legends apart, the sources have in the main disappeared, and would be difficult to trace.

In dealing with ivory carving in Japan two points will be very evident. The first is that we shall be occupied almost entirely with comparatively modern art. The practice of sculpture in ivory does not go back very far. We shall scarcely go beyond the middle of the eighteenth century even for our earliest examples: for the most part they will be considerably later. Next, our attention will be directed to nothing very serious, nothing which has pretensions to do more than interest by the charm of a system of decoration applied to

objects of ordinary domestic use, but which at the same time is characterised by the extraordinary taste and talent which are innate with the Japanese, and not unfrequently bears the mark of their most distinguished artists. It has been well said by a French writer that the art of Japan is *"l'art du bibelot,"* by which is meant that though trifles only may be concerned, yet we may find art in them of the highest kind. Nowhere is this better exemplified, and in a very high degree, than in the delightful little *netsukés* and other small objects which we propose principally to notice. We shall find in them the characteristic art of Japan in miniature, with all the care, the simplicity, and idealisation which distinguish her other pictorial arts. For we shall have to recognise a pictorial quite as much as a sculptural art in a system which but a very short time ago was practically unknown amongst us. Certainly so far as ivory is concerned there were few, if any, points of similarity amongst the sculptures of the west.

In all the profusion of work of small sculpture in which the human form so prominently figures there is one aspect which seems to have no charm for the Japanese artist. We do not find amongst this people that the nude as expressive of beauty of form has any attraction. It does not appeal to them as capable of exciting pleasurable imaginative feelings, or induce them to consider the subject capable of high artistic treatment. On the other hand, nothing is more remarkable than the knowledge of anatomy, and the power shown by the Japanese artist in his treatment of such subjects as wrestlers, or where superhuman strength—in the case, for example, of demons—is pitted against that of ordinary mortals. All this is the grotesque, no doubt, but he sees in it capabilities of the exercise of imaginative faculties, where in the nude, as expressive of the beautiful, he has not been drawn towards our system of idealisation.

The use of ivory in sculpture, to which it is proposed to direct attention almost exclusively, may be divided into three classes. First, where the material is employed alone, as in the case of the miniature figures, or groups, called *netsukés*, and the somewhat larger figures of a similar character which, in many cases, are hardly statuettes. Next we may take the variety of boxes of different kinds, but more especially those peculiar to Japan known as *inros* or medicine-cases, the sword-hilts and scabbards, the pipe-cases, and other small objects of personal use or adornment in which ivory is used without addition of any other material. Lastly, there is the mixture of materials for decorative effect, the application of ivory to heighten and complete the pictorial composition in conjunction with wood, lacquer, and other materials ; and, again, the inlay or setting in ivory of other precious materials, as, for example, gold and silver, coral, and mother-of-pearl. It would be difficult to find precise analogies, in western work, of any age, for this practice. It will be seen in a subsequent chapter that the fashion of combining in sculpture ivory with other materials is again becoming usual, but this is more a following of the ancient chryselephantine system, which does not appear to have been practised by the Japanese. On the other hand, the modern fashion, for which such artists as Lalique are famous, now being taken up extensively by goldsmiths and jewellers everywhere, of using ivory and further adorning it with enamel and precious metals is, it can scarcely be doubted, a following of Japanese taste and ideas.

Apart from the merit of the design, apart from the intrinsic value of the material, a notable feature in Japanese workmanship is the conscientious and scrupulous manner in which every part is carried out. Has the workman to construct a small cabinet, a box, a piece of furniture? He does not, as with us, spend all

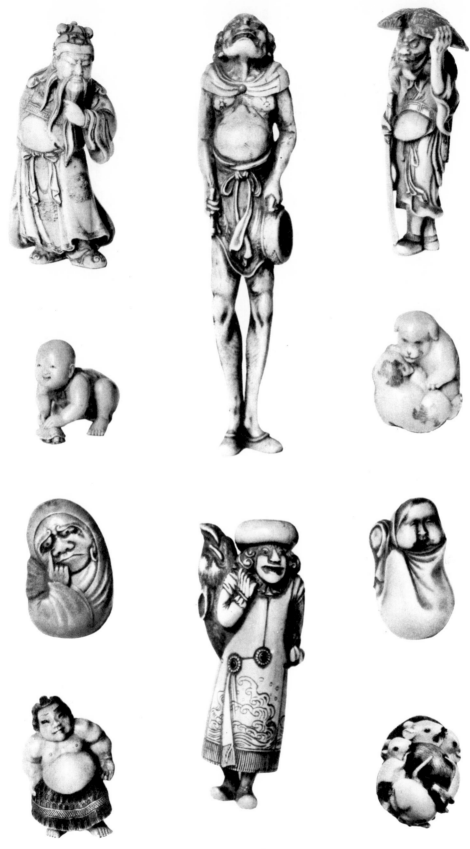

Plate 76. NETSUKÉS

(From the Collection of Mr. H. Seymour Trower)

his energy in decorating those parts only which are sure at once to be seen, leaving those which may be turned to the wall—the under parts or the interiors of drawers—rough and unfinished. On the contrary, every detail is faithfully carried out, and the artist even seems to take a pleasure in surprising us by carefully perfecting and elaborately ornamenting his work where we should least expect to find such labour bestowed. Examine the little medicine or sweetmeat boxes, with their numerous drawers and divisions. See how perfectly each part is fitted together. Back and front, inside and outside, even the backs of the tiny drawers, receive their full share of the skill of designer and workman.

The name of "netsuké" was given to a kind of toggle used as a button to secure the cords attaching the pipe, medicine, or sweetmeat case, or writing materials to the belt. We distinguish them from other little carvings when we find the two holes for the cord to pass through.

There are few things within the whole range of Japanese art which witness in so high a degree, within so small a compass, to the originality and purity of taste which distinguish these wonderful workmen. Each little group, with its studied physiognomies, its scrupulous reproductions of national costume (in those days when the national costume was universal), is a complete composition, telling a complete story. Sometimes it is an historical scene, sometimes a mythological or symbolical subject, at other times an illustration of domestic manners, a bitter caricature attacking social vices, or even the national religion. Everywhere there is the characteristic charm of Japan, and in no subjects more so than in the groups of laughing and playing children. As in the decoration of the sweetmeat-cases, it is the quaint conceit, the humour, the unexpected revelation which the artist prepares for us which so take our fancy. He has nearly always some surprise in store for us. It is impossible to avoid a kind of childish delight when one

takes up and examines one of these little objects. See, even the under part is not forgotten, but carefully made use of! And look, why, there is another head of a laughing boy within this laughing mask! And how well every part of the work fits; there is no fear of its coming unglued!

It cannot be supposed that everyone will have that knowledge of Japanese history and folk-lore which will enable him to understand all the allusions which these little carvings contain; but in so many of them the story is apparent and requires no explanatory text. They are the epitome of the history and feeling of the whole of Japan, her people, her arts and sciences, her passions, her virtues and vices, her likes and dislikes; the occupations of all, from the noble to the peasant, the fauna and flora of the country, the religion, the wonderful insight into the habits and peculiarities of animal life, examples of the love amongst all nations of the use of fables and the attribution of human characteristics to the brute creation—in short, the list might be almost indefinitely extended. Yet there is seldom anything expressed in a commonplace manner. Realistic as they may be, they are rarely wholly divested of that subtle quality which distinguishes the best art, that is, the abstract expression of an ideal.

As before remarked, the fashion of carved netsukés is of no very ancient origin. Perhaps even the custom of carrying the pipe-cases and other small articles at the girdle did not come in before about the end of the seventeenth century, at which period we date the oldest and finest examples. The earliest and best of all are, in the opinion of many connoisseurs, the wooden ones. That may be so, and of course there is a greater ease in working in this material, which yields more freely to the sculptor's tool. But ivory has its peculiarities and a charm of its own in the expression of curves and in modelling texture that such artists as the Japanese

would be quick to avail themselves of and to appreciate. Certainly there are considerations which ought—other things being equal—rather to make us prefer them to those in wood. At any rate, the caution may be given to avoid following a fashion which after all is sometimes scarcely more than a shibboleth.

Before the great revolution of 1868 the nobles, as with us in early days, were the great employers of labour and patrons of the arts, or rather, the wealthy daimios had permanently attached to their houses many of the most distinguished artists. Amongst our ivory netsukés some of the finest examples bear the signatures of the greatest of these artists, and, as with painters, it is not difficult to recognise their styles. But certain pieces and certain subjects were, after a time, extensively copied. More than this, there can be little doubt that, especially from about the end of the eighteenth century, when the fashion was at its height, and when, as a matter of fact, *ivory* netsukés first came into general use, the carving of these objects was largely taken up in an amateur way. Much of it may have been done as an occupation for spare time by all classes of the people— as a thing to *whittle*, as one may say, in idle moments —and the rich would have had their ideas and designs carried out for them. In the earlier days, and for the best work, the sculptor of netsukés was a profession by itself, and was confined to and continued in certain families. The fashion seems to have reached its greatest height in about the last thirty or forty years of the eighteenth century. A great luxury in dress and orna- ment then prevailed, added to which the practice of tobacco smoking, the habit of carrying little medicine- cases or sweetmeat-cases, and the use of ivory carving in various other ways, caused the demand for, and popularity of, objects of this description. Netsukés were, of course, made in other materials—in gold, and silver, and bronze, in lacquer, coral, crystal, amber,

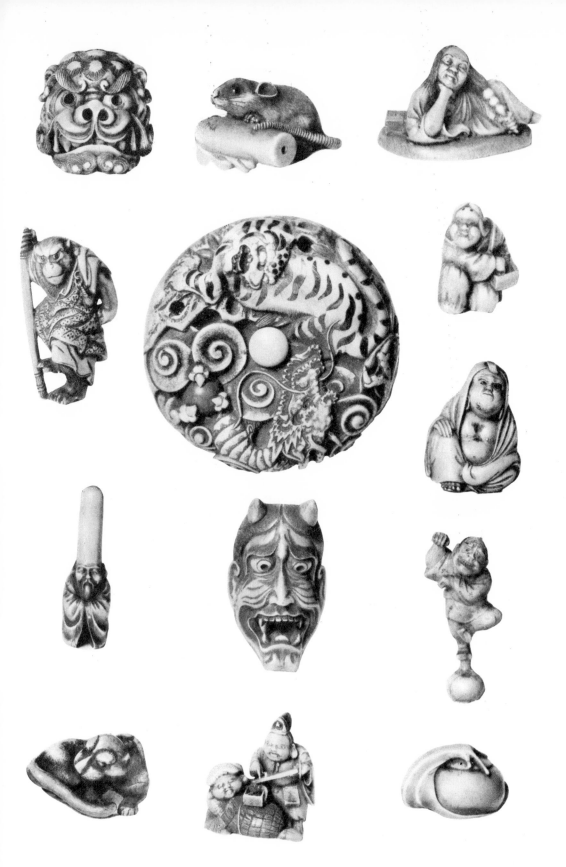

Plate 77. NETSUKÉS

(From the Collection of Mr. H. Seymour Trower)

porcelain, and so on; but the favourite and, to use a common expression, the most *correct*, were in ivory and wood, and during the best period when they were in vogue these were the monopoly of a certain category of artists which counted in its ranks the most famous masters, the greatest of whom would not disdain to acknowledge by his signature these little *chefs-d'œuvre*. The earliest ivory netsukés are of Siberian mammoth ivory. Nowadays the supply of ivory is from London.

That the netsukés and other little sculptures of the kind were highly prized is evident from the care taken to use for them only the finest description of ivory. It was in any case by no means a common or inexpensive material, but it is easy to see, in the best examples, that the artist well knew the value of the best part of the tusk, was not unmindful of the grain, and appreciated the warmth of colour of the satiny skin to which time and use would add fresh charm.

In a certain way, though on a smaller scale, the netsuké may be compared to the Tanagra statuettes. They would have served the same purpose as running commentaries on daily life and habits, there is the same strict adherence to truth, the same lifelike reproduction of expression and suggested movement. And, again, not strictly perhaps, but on parallel lines, may not the gargoyles and misereres of our mediæval churches be recalled? In a sense they are less sculptures than pictures, but they are pictures which can be seen from every point of view. Sometimes they may appear, at first sight, to be little more than clever imitations of some natural object—a shell, a fruit, a nut—so close is the resemblance that we are, for the moment, deceived; but still there is generally something which distinguishes them from commonplace imitation. The absolute fidelity to nature is apparent only.

So great is the variety of subject and the method of expressing it, in these astonishing little netsukés, that

the only way in which to attempt to give even an imperfect idea of the extent of ground which they cover must involve something in the nature of a catalogue. It may be as well to admit this, and, at the risk of tedium, to adopt it as a plan.

With the mind full of the impression produced by an inspection of such a collection as that in the British Museum, and with the recollection of many others—turning over, as it were, the leaves of a book—we find that the Japanese artist has, as a rule, seized upon the most homely and familiar subjects—things that are seen every day in the streets, in the fields—that are known to children of every age from the legends and fairy tales which are the property of no one country. Here we have the ancient system of mythology, gods and holy personages, distinguishable by their emblems or occupations: Fuzin, god of the winds, with long white beard and eyebrows, filling his sack with tempests; the divine personifications of Buddha; the goddess of the arts with a sort of four-stringed zither; ministers and emblems of the Shintu religion. Or there is a group of five blind men crawling on their hands and knees, an illustration of the story of the five blind travellers who, finding themselves at the ford of a stream, to avoid all getting wet, arrange that two shall carry the others over on their backs. Some wags passing by upset the arrangement by being carried over themselves. Hence, on arriving eventually on the other side, there is an altercation between the five blind men. Then we have a familiar street scene in times not long gone by: a nude woman squatted by a bucket washing herself with a towel. And, again, the religious mendicant—an ascetic figure seated on the ground hideous in his rags, holding in one hand a rod tipped with a tuft of paper ribbons, the Shinto emblem of purity; a skeleton half sitting, half reclining, his fleshless skull resting on a fleshless hand as he appears to consider meditatively a serpent coiled up under a lotus

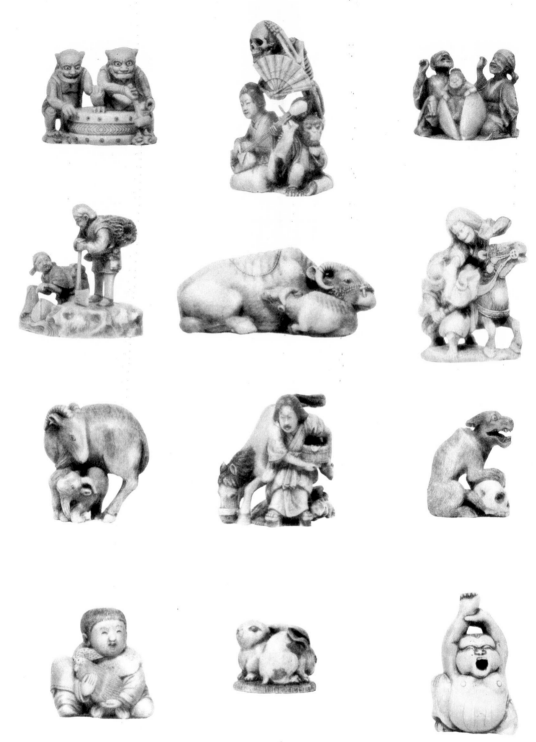

Plate 78. NETSUKÉS

(In the British Museum)

leaf; a group—more correctly, perhaps, an agglomeration —of apes gibing and grimacing at each other; a rat trying to get out of a sack full of rice, caught by the middle of the body by a piece of the sack not quite bitten through; two chickens having a dispute about a worm in a fashion not peculiar to Japan; a figure tying up a sack, with an admirably expressed difficulty of so doing; a child frightening another by means of a large mask; athletes lifting weights; a street row; a mass of people struggling together as in a football scrimmage; a figure with an immense yawn; a group of merry children at play— repeated over and over again with endless variety; a story-teller, his audience convulsed with laughter; people taking shelter under a group of trees; a working bullock lying down (a very favourite subject, with a delicate lining and filling in with black); men with outrageously long arms and short legs, and vice versa—the catalogue is endless of delightful exaggerations, of ridiculous caricature, of the expression of laughter, of sorrow, of all the emotions which affect mankind, of satire and of the instinctive atheism and real contempt for religion which is in the Japanese, notwithstanding his deities and demons, and the paraphernalia of Shintuism; of fantastical animals and astonishing hybrids and nightmares; of wonderfully realistic representations of floral and vegetable life; of the most extraordinary insight into the habits and characteristics of animals—in short, the subjects are infinite in variety and originality of conception.

Yet a little more space must be devoted to two or three among the most striking of the netsukés. Could anything in sculptural art of greater pretension exceed a little figure representing some ancient ascetic personage of the fakir type, emaciated and worn out by fasting and austerities, his parchment face, his bones covered with contracted and withered skin, the expression of vacant stupidity, and the slobbering of his senile mouth? Or, again, in the contrary spirit, the joyous little troop

[447]

of children—jumping, dancing, and playing the fool—such Japanese children with their little twinkling eyes and dimpled cheeks, their partly shaven heads with jet-black locks plastered down over the foreheads and temples; or, once more, a little girl attacked by a fowl, and the expression which shows her as more under a spell of fascination than of fright? Such things as these are meant to be handled and handed round to be admired, not huddled pell-mell in a cabinet together with hundreds of others, where the eye becomes dazed and weary, with the result that they are often carelessly passed by after a moment's hasty survey.

The medicine-cases or sweetmeat-boxes are scarcely less interesting or less various and charming in their decorative conception. Whether of metal or wood, of ivory or of lacquer, or of an extraordinarily accurate imitation in lacquer of other things, such as leather, plaited straw, or the bark of wood; made of one of these materials alone, or of several combined, they are usually of the same form and of about the same size; that is to say, a number of separate little divisions having, when closed, a flattened elliptical shape with a silk cord to confine them together. A netsuké on the cord accompanies them. The carving is generally in low relief, and sunk so as to avoid discomfort in handling. They are not always plain, but are often encrusted with coral, mother-of-pearl, lacquer, tortoise-shell, gold and silver, incorporated in the design.

It is this system of working together different materials, even the most opposite metals, which is so distinctively Japanese. To follow it in detail would far exceed our limits. So far as ivory is concerned, a brief mention must suffice, and include the panels and screens in lacquer and wood and the smaller objects such as the cases for holding the colour and implements which the Japanese use in writing. The lavish perfection of the work is extraordinary, the theme of the subject running

over the whole surface, following the curves and continuing from front to back, heightened with all sorts of effects in relief, or by inlay and the use of precious and semi-precious materials. And yet in good work all this is carried out with a quiet purpose, which is far from suggesting vulgarity. Most people are familiar with these things and the manner in which ivory is used for the faces, hands, and feet of the figures, or it may be for a gorgeous flower, a chrysanthemum or a peony, naturalistically treated and delicately stained.

It is true that the practice of combining different materials is not confined to Japan. We have seen it, for instance, in the German beggar figures. But the Japanese method is entirely original. It might almost be said that no other nation would have the power to carry it out except, perhaps, the Chinese, and in their case for the mechanical part only. It is not of the chryselephantine kind, nor do we find in Japanese art the combination of ivory with metal and goldsmith's work on a large scale, which will be noticed in a succeeding chapter on the revival of ivory sculpture in Europe in the present century. It cannot be pretended for a moment that all work of this kind is in the best possible taste or free from vulgarity. Many of the pretentious and expensive importations with which the Japanese shops in every great city are loaded are open to objection. But it is not the Japanese artist who is primarily to blame. It is his European master in Paris, Vienna, or London, and the taste which he imagines himself called upon to satisfy. These are not the things that the Japanese noble of to-day buys back again to return to his country, as he does the netsukés and lacquers that the events of 1868 caused to leave it. People are indeed fortunate who acquired examples at that time, for they are not now to be had. A word of warning will not be misplaced with regard to the frightful imitations of netsukés and other figurines in ivory which are

so common, often artificially made to look yellow and worn, as if of considerable antiquity.

Netsukés are frequently signed, and amongst their makers may, no doubt, be reckoned the most famous artists known in Japan, but for the most part little is known concerning these except their names. They are seldom, if ever, dated. In the nineteenth century designs of celebrated artists of painting, such as Hokusai, were frequently copied. Grotesque ivory figures of Chinese origin, which may be considered the prototypes of the netsuké, appeared in Japan about the end of the seventeenth century. All information is, however, very vague, although figures of this kind, which are said to be old Chinese work, turn up in Japan from time to time.

The earliest ivory netsukés date from the middle, or even, perhaps, not till the end of the eighteenth century. They continued to increase in excellence until the demands of the European market exercised an influence which, as may be supposed, caused a considerable quantity of spurious and worthless imitations to be exported. The events of 1868, however, happily brought to Europe a large number of the best specimens. The Franks collection of the British Museum, and those of Mr. Gilbertson and Mr. Seymour Trower, are amongst the most famous of the present day.

In the earliest examples we find walrus ivory frequently employed. There are specimens carved from boars' tusks, and vegetable ivory (*corozo* nut) was also used. Some are a combination of wood and ivory, and the staining of ivory was brought to great perfection in Japan. We have amongst them, also, some remarkable *tours de force*. The most extraordinary of these are the skulls and skeletons for which Asahi Giokusan (nineteenth century) was famous. There is a small skull by him in the Trower collection, the fidelity of which, on a minute scale, is so perfect that on seeing it a well-known surgeon declared that it would suffice

to illustrate a lecture. The brain-pan opens, and within every detail is absolutely correct. Another, in the Gilbertson collection, is an absolute facsimile on a reduced scale of a skull which has long been buried, and is partly decayed and eaten away. Such things, if not pure works of art, are, at any rate, marvellous curiosities.

A favourite subject is a chestnut in wood or stained ivory with perhaps a maggot crawling out from a hole in it. It may be said that work of this kind, like the faithful imitation in sculpture of lacework, shows only the skill of a clever mechanic. That is so, as a rule, but there is often a peculiar charm about Japanese imitations. They are not such a downright copy of nature as may appear at first sight, and it is consummate art when the seeming fidelity is thus put before us. Amongst other little tricks which we find are those in which the netsuké is so designed that it is extremely difficult to balance it on the feet of the tiny figures when standing upright, on account of the centre of gravity being purposely placed very high. For instance, a man holding up an enormously long gourd with a bulbous end, or a horse with his four hoofs all brought together.

For other ivory sculpture—*inros*, pipe-cases, shrines, and small objects of various kinds—the earliest specimens date from quite the end of the eighteenth century, and the finest examples of the little figurines and groups called *okimono*, which are something like netsukés, are quite modern. The same may be said of screens inlaid with ivory. There are, besides, wonderful figures of larger size, representing usually various Japanese popular types, to which it is impossible not to accord a high measure of admiration. The most famous artists for these of the present day are Asahi-Hatsu, Uttagawa, Okawa, and Kuorin. A fine figure of the Buddhist goddess *Kwannon*, perhaps the largest ever made in ivory by Ichikawa Komei, was exhibited at the Chicago

Exhibition. It shows, however, the necessary outcome of the passion for European schools which followed upon the revolution. Before the fashion of sword-wearing went out with the daimios—and it may be said, also, since that time to the present day—scabbards were made of elaborately carved ivory, but they are not esteemed and are hardly worth mention.

As so many netsukés are signed, and as it is not a difficult matter to get them deciphered, it may be useful to add a few of the best-known names and the kinds for which some artists were especially distinguished. In ivory in the eighteenth century there were Hide-masa, Ki-sui, Giokumin, Hakuunsai, Tomochika (Long-legs and Shortlegs), Toyo (groups of masks), Shigemasa, Hiroyuki, Hogioku, Ikosai, Minkoko (wild boars), Minzan, Mitsuhiro, Mitsotomo, Okatomo, Tomotada (working bullock lying down), and the Miwas, the most celebrated of all netsuké makers. It is said that five or six examples of the first Miwa exist. Besides these we have Ichimin (cattle), Tomochika, Anrakousai (holy personages), Riumin, Hogitsu (children), Hozan (children), Giokusan (skulls), Mune-tomo (monkeys), Ikkouan (rats), Hukwan (small figures), Kajitomo (mushrooms), Shiusen, Mazakadzu (monkeys, rats, and *tours de force*), Okatomo (quails), Giokusai (shells), Masafousa, and Riukei (wood and ivory conjoined). Although the most esteemed artists in wood seldom or never worked in ivory, their productions were frequently copied. There were the Miwas, Demé-Uman (masks), Tadatoshi (snails), Giokumin (tortoises), Kokei (frogs and goats), Masanao (fowls and rats), Masatami (rabbits), Tame-taka (snakes), Sokwa-Heishiro (flowers and grasses), Nobuyuki (groups). Miwa and Shibaiyama first inlaid ivory in wood about 1810. Riukei made pipe-cases, and was the first to stain ivory.

CHAPTER XVII

FURNITURE, MUSICAL INSTRUMENTS, ARMS AND
SPORTING WEAPONS, AND OTHER ACCESSORIES
OF THE FIELD AND CHASE

EVIDENCE is not wanting of the magnificence
of the furniture used in the decorations of the
palaces and houses of the wealthy amongst all
the earliest nations of antiquity. In Assyria and Egypt,
in Greece, and in Imperial Rome the most luxurious
habits prevailed, not only in the fashion and ornament
of tables, chairs, and couches, but also in the inlay of
the panelling of walls, ceilings, and doors with ivory
and stained and painted woods. In the British Museum
are six ancient Egyptian chairs of wood inlaid with
collars and dies of ivory. One is of ebony.

There are few purposes for which the use of ivory
has been more constant and more varied, and at the
same time perhaps more overlooked in general estima-
tion than that which relates to its employment in con-
junction with other materials. So far as furniture is
concerned, this implies, of course, with wood, either
by means of inlaying, or where the whole surface is
covered with solid pieces and veneers of ivory. The
subject is an extremely interesting one, which deserves
more consideration than it has hitherto received. To
enter fully into it in any detailed manner is more, how-
ever, the province of a history of furniture. For our
present purpose it will be sufficient to confine our

attention to a few brief remarks on two varieties, that is to say, upon the system of marquetry which was first introduced into Italy by the Venetians, and has become known under the name of *Certosina* work; and secondly, where ivory is used alone, as in the case of one or two suites of furniture, of which we possess some very fine examples.

The absolute origin of the simplest form of this elegant surface decoration, which consists solely of geometrical patterns and of arrangements of stars and circles, may be a little uncertain ; but, generally speaking, it is, of course, oriental. The Venetians in the middle ages carried on a considerable traffic with the east, importing large quantities of ivories, ebony, cypress, and walnut, and other woods, and they, no doubt, introduced the system from Persia and India. We have already noticed a like fashion in essentials in the case of Arabian marquetry, and even the Bombay work, which is still imported, is practically of the same nature. At a later period than its introduction into Italy the Portuguese, through their relations with their colony of Goa, still further contributed to popularise a similar method, and to flood the European market with inlaid furniture, either imported or made in Portugal. In Spain also the Moors had undoubtedly introduced many methods of oriental decoration, in which the system of inlay in ivory, mother-of-pearl, and other materials in arrangements of small discs and geometric forms was employed. Later on marquetry was extensively used in France, Germany, and Holland, and we shall find the practice of decorating such things as crossbows, saddles, and sporting weapons and accessories, as well as cabinets and caskets, by means of ivory plaques engraved with subjects in outline and afterwards filled in with black, very largely prevailing throughout Europe. In England, as regards furniture, it may be considered mainly as a foreign or imported art till late in the seven-

teenth century, when, under William and Mary, Dutch marquetry became the fashion, the older designs representing tulips and other flowers, foliage, and birds, and afterwards more elaborate hunting and domestic scenes. The most beautiful is the Italian, which we call Certosina, from the great Charterhouse (*Certosa*), or Carthusian monastery, between Milan and Pavia, which became celebrated for its encouragement of the art, and whence, no doubt, a great deal of the fine work to be seen in the choirs and sacristies of churches throughout Italy proceeded. The best examples are of the fourteenth and fifteenth centuries. At that time also, as we have seen, bone was much used in a peculiar manner for diptychs, triptychs, coffers, and caskets, and the marquetry work was employed in the framing of retables and triptychs. A good example of the latter has already been illustrated.

In its simplest form certosina work consists of geometrical patterns in ivory let into wood. An extension of the system came into vogue in Italy about the beginning of the sixteenth century, in which we have pictures formed by the use of different coloured woods, to which ivory was also added. In this method, by means of altering the direction of the grain of the wood, the lights and shades of drapery, the perspective of landscapes and buildings, and the other elements of a picture are expressed. It is especially characterised by architectural scenes, in a kind of mosaic of the angular lines of windows and doors, porticoes and columns, with a play of light and shade varying with the angle from which they are observed. In work of this kind advantage is taken of the natural tints of brilliant-coloured woods. It was very largely used for the wainscottings and backs of choir-stalls, for cabinets, panellings, chests, and wardrobes, and is more properly termed *tarsia* or *intarsiatura*. The practice continued, and is seen at its best in the wonderful French works

of such great cabinet-makers as Riesener and David, in the eighteenth century. These are mostly limited to wood marquetry alone, but ivory is sometimes used to a small extent. For this reason also a passing allusion may be made to the well-known marquetry of Boule, a combination of brass, copper, and tortoise-shell, into which stained ivory also sometimes enters.

There are few things of their kind which for simple beauty and harmony exceed an Italian chest in which the decoration is confined to the geometrical designs in ivory, with ebony mouldings, mounted on an ebony stand with twisted legs. Time has perhaps softened down the brilliant whiteness of the ivory to the mellow and indescribable tone which it acquires under certain conditions, and ages of careful polishing and waxing of the whole surface have imparted to the wood that quality which is so much esteemed. But the chief characteristic is the charm of the irregularity of the surface, and the greater æsthetic pleasure which is always derived from a not too strict adherence to absolutely correct and formal straight lines either in the design or in the execution. Such a studied carelessness is typical of the oriental artist. Whereas in western work, as a rule, every line or curve is drawn with mathematical precision, the surface is planed and sandpapered down to the utmost smoothness, and made accurately level, the ivory gleams white and cold, and the effect of the whole is lifeless and mechanical.

Ivory has also been largely used in all times for the inlay of panels, furniture, and smaller things, in a manner in which it is less perhaps the principal object than a medium for fulfilling scarcely more than the office of paper, or of providing a white background on which designs are lightly engraved, and filled in with some black substance, as in niello work.* Some ancient

* In this connection some reference may be permitted to the encaustic or burning-in method of painting of which Sir Charles Eastlake speaks in his

examples from the Scythian tombs of the Crimea, and others in the British Museum of this nature have already been noticed. The same system is carried out in much Dutch and Italian furniture, and we shall presently find it again applied in the decoration of musical instruments, arms, and sporting weapons. A fine Italian couch, and some chairs of Italian early seventeenth-century work, are in the Jones collection in the Kensington Museum. They are of ebony, inlaid with ivory, engraved with floral scrolls. Portions of the ebony framings are not in the best style, but the ivory inlay is very good in design and execution.

For furniture entirely of ivory it would be difficult to surpass the suite of which there are a table and two chairs also in the Jones collection. Furniture of this kind is extremely rare in Europe, although there can be little doubt that it has been frequently made in India after European designs, either for the palaces of the governors of the English, Portuguese, and French possessions or for those of native princes. It is surprising, indeed, that such a charming and delicate style should not be more frequently used. Such things are solid and appropriate in appearance, with no suggestion of fragility. They fetch large prices whenever they come into the market, and the scarcity or value of the material can hardly, therefore, be urged against them. The chairs and table which are here illustrated are said to have belonged to Tippo Sahib. They were, at any rate, taken from him by Warren Hastings at the capture of Seringa-

Materials for a History of Oil Painting (i. 149), where he says : " The process, according to the words of Pliny, comprehended the engraving by means of encaustic of outlines in ivory and other substances with a metal point. In this instance the expression need not be taken literally : forms burnt on ivory could not have been very delicate works of art. It may rather be supposed that the outlines first drawn on waxed ivory (for the facility of correcting them where necessary) were afterwards engraved in the substance, and that the finished and shadowed design was filled in with one or more colours, being ultimately covered with a wax varnish by the aid of heat. Works so produced must have resembled the *sgraffiti* of the Italians, and were no doubt quite as excellent."

patam and given to Queen Charlotte. They came later into the possession of the Duke of Buckingham, and were sold at the world-famous sale at Stowe in 1848 for forty-two guineas. For the table Mr. Jones gave £350 and for the chairs £600. The decoration, partly gilded, of leaves and flowers is evidently of Indian character, with a French style and feeling. A peculiarity of the chairs is that each has five legs. A couch, three tables, and four chairs of the same suite were in Lord Londesborough's collection. There are also in the Jones bequest four very elegant armchairs of ivory, or rather completely covered with ivory veneer. They are of French or English design of the eighteenth century, and in noticing them one may again wonder that ivory is not more often used at the present day for such purposes. At Buckingham Palace there is a set of two large couches and sixteen chairs in ivory, of Indian workmanship after fine Chippendale designs.

With the exception of a few isolated instances, for example, some specially designed piano cases, such as the one executed by Messrs. Broadwood for Sir Lawrence Alma-Tadema, ivory is not now much employed in the decoration of musical instruments. Time was when even unimportant objects of ordinary use received a lavish and rich ornamentation, but we now look more to utility, and are, before all things, practical. There may also be, of course, good technical reasons why musical instruments should be as free as possible from any adjunct which might tend to interfere with the primary use for which they are intended. But at least down to the beginning of the nineteenth century we shall find many examples of musical instruments into whose lavish decoration ivory frequently entered with considerable effect. From their nature the principles upon which it is used are naturally not different from those which we have been just considering in the case of furniture; that is to say, the ivory is either inlaid,

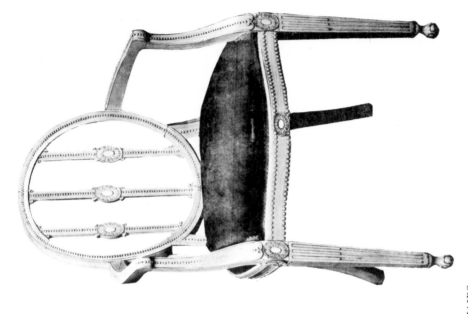

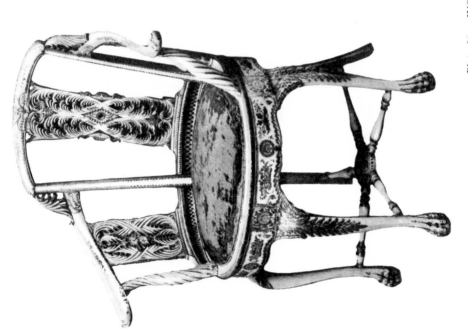

Plate 79. IVORY CHAIRS
EIGHTEENTH CENTURY
(*Jones Collection*)

veneered, or applied as sculpture. Most of the examples which we shall find in such collections as the extremely fine ones of musical instruments in the South Kensington Museum, or at the Royal College of Music, consist of the inlay of instruments of the lute or guitar kind, of the type which was in use in most European countries in the seventeenth and eighteenth centuries. No doubt at all periods musical instruments have received similar treatment in the way of decoration. Early examples are extremely rare, but we have one important instance in the magnificent specimen of a harp in solid ivory, of the fifteenth century, now in the museum of the Louvre. Apart from its high interest as an example of a musical instrument of the period, it is equally interesting as a unique example in ivory of most original beauty of design.

In general form this harp resembles others which are known in wood of about the same period. The portions remaining, for the present sounding-board is a later addition, are formed of two separate pieces of ivory. The fore-pillar is practically the natural curve of the tusk—in fact, in oliphant shape—springing from a rectangular block where it joined, at its lowest point, the sound-chest. The harmonic curve, or transverse portion, forming the top, is naturally a separate piece of ivory in an elegant curve and counter-curve. The decoration is similar throughout, with the exception of the small rectangular base-piece and of a small portion at the junction of the upright and transverse members. It consists of four semicircular channels, in each of which, all the way up, and again across to the sounding-board are disposed, at regular intervals, elegant fleurs-de-lys of an elongated form with wavy stems. They are of the character which is met with in seals and miniatures of the time of Charles VI. Alternating with these fleurs-de-lys is the monogram A🅱 in gothic characters. The base and the top of the fore-pillar are encircled by open

crowns of fleurs-de-lys. Above the upper crown at the top of the harp we have, on either side, religious subjects in compartments—the Nativity, the adoration of the Magi, and the slaughter of the Innocents—and above one of the compartments is the inscription, in Flemish, " EN BETHLEAN." The sculpture in these panels recalls the work of the diptychs of the thirteenth and fourteenth centuries, and is on an extremely minute scale.

Now, in endeavouring to trace the origin and history of this beautiful work, we are met by several considerations. In the first place—the religious subjects apart, and they are not of great consequence, as they may have been copied from diptychs or other religious objects of an earlier date—it would be difficult to find anything amongst ivory carvings with which to compare the style of ornamentation. The channelled grooves, filled in with the monograms and fleurs-de-lys, recall the architecture and sculptured monuments of Savoy of the first half of the fifteenth century. We have next to consider the initial letters A Y, and with whom they may be connected as the prince or great personage for whom this piece was made. Several explanations, more or less conjectural, have been hazarded. Certain authorities have seen in them the first and last letters of the device, "*Aultre n'aray*," adopted by Philip the Good, Duke of Burgundy, at the time of his marriage with Isabelle of Portugal in 1430. Others, again, take them to be the initials of Antoine of Burgundy, Duke of Brabant, second son of Philip the Hardy, who married, as his second wife, Ysabelle of Luxembourg, in 1409. He himself was killed at Agincourt in 1415. Of the two this would seem to be the most natural, and we may remember also that as a prince of the House of Burgundy he would bear the fleurs-de-lys of France. But there is a third attribution given by the learned M. de Champeaux in an article on the subject of this harp in the *Chronique des Arts et de la Curiosité* (No. 12, 1895). M. de

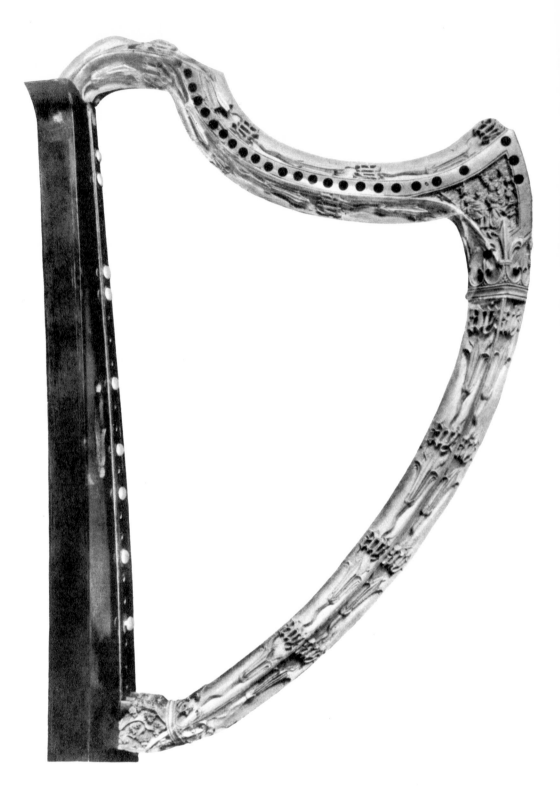

Plate 80. HARP. FLEMISH

FIFTEENTH CENTURY

Champeaux finds that the initials correspond with those of Amadeus, Count of Savoy, in the last half of the fifteenth century, and of his wife Yolande, daughter of Charles VII. Now, bearing in mind the intercourse with Flanders at this period, that many Flemish artists were attached to the courts of the princes of Savoy, that the communication with France was interrupted on account of the English occupation, that Flemish models were much used, and that quantities of objects of art were imported or sent as presents from Flanders, we may reasonably come to the conclusion that the harp is of Franco-Flemish origin, dating from the beginning of the fifteenth century, when Antoine de Bourgogne married Ysabelle de Luxembourg, to about the middle of the same century in the time of Amadeus and Yolande of Savoy. Other opinions are in favour of placing the date farther back into quite the fourteenth century, but though the style of the panels may recall the style of that period, we must remember that fashions were persisted in, and were frequently copied. For the same reason we need not place any particular stress on the fact that the costumes of the soldiers in the scene of the slaughter of the Innocents are of late fourteenth century. Still more important is it to compare the system of the fleurs-de-lys and the hatched backgrounds which are characteristic of a later period, as we have seen in some diptychs of the transition period of the art, especially in such things as the diptych representing Louis XI., which has been already noticed. We have, then, in this harp a magnificent specimen of ivory carving, absolutely unique so far as ivory is concerned, of considerable interest as a musical instrument, and probably made about the middle of the fifteenth century by a Flemish artist for Amadeus and Yolande of Savoy.

From the fragile nature of the material of which one class of musical instruments is constructed, very few indeed of early date have come down to us. Flemish

artists were renowned for their fabrication in the four-teenth and fifteenth centuries. We find frequent references to harps in the miniatures of the period and in paintings, for instance of the school of Van Eyck. It would appear that harps had usually twenty-five strings, and we have, in fact, in the Louvre example that number of holes for receiving them pierced in the transverse member. Guillaume de Machaut, in his *Dit de la harpe*, quaintly and prettily compares these strings to the twenty-five virtues which are possessed by the lady whom he honours. He says :—

> "Je puis très bien ma dame comparer
> A la harpe et son gent corps parer
> De xxv cordes que la harpe ha
> Dont rois David par maintes fois harpa."

He then proceeds to enumerate them, assigning to each string a special charm or virtue ; and if the lady possessed them all, she must indeed have been perfect.

For the connection in general of musical instruments with ivory it is hardly necessary to do more than refer to its use for the keys of organs, pianos, and percussion instruments of the kind. We find many examples in the collection at South Kensington in which ivory is used, either plain or in conjunction with gold and silver, enamel, jewels, and other precious materials. A brief mention must suffice to call attention to a few amongst many richly decorated instruments. We have, for instance, some quite charming French hurdy-gurdies of the eighteenth century. On one, which is elaborately inlaid, the head of the finger-board is the bust of a peasant girl in ivory, the dress of wood, and the handkerchief head-dress coloured. An ivory lute by the Venetian, Jacob Hesin (1586), was exhibited at the Inventions and Music Exhibition in London in 1886, and there were many more instruments, into which ivory entered, shown in that collection, the most wonderful that has ever been brought together. In

a theorbo of 1629 the whole of the belly is composed of strips and veneers of ivory engraved with subjects filled in with black. On a very long Venetian theorbo the ivory finger-board is engraved with landscapes. A German guitar, dated 1592, has the whole surface, except the sound-board, of tortoise-shell inlaid with ivory or *vice versa*, and a citerna of 1539 is of similar fashion. Cither viols, viole da gamba, and other instruments of the kind have also elaborately inlaid finger-boards and tailpieces. And, again, there are charming little pochettes, or kits, of the seventeenth or eighteenth centuries with beautifully carved heads. An eighteenth-century German flute is entirely of ivory, but of course instruments of this kind in ivory or bone must date back to unknown ages and have been in constant use in all times. Flageolets and a double flageolet are there also; an Italian *flauto dolce*, dated 1740, with an elegant design in low relief on the upper part. And so, again, for the chaunters and drones of bagpipes we find ivory constantly used, sometimes for the pipes themselves, sometimes inlaid as decoration. The amateur of beautiful musical instruments will find abundant material for admiration in the use which has been made of ivory in various ways, and the maker of modern ones might indeed, perhaps, be induced to consider more often how effectively it may be applied, not only for inlay, but also for plaques and even for the more solid portions in the case, for example, of grand pianos.

Ivory has at all times entered into the decoration of arms, and accoutrements, and weapons of the chase. Certain fragments of early Egyptian origin, and some other monuments of antiquity are known, but the general scarcity of very ancient instances of ivory sculpture of any kind will not lead us to expect to find more than a few isolated examples. Amongst these the *parazonium*, or parade sword, of the time of the Roman occupation of what is now Belgium, has been noticed. It is scarcely

necessary to do more than call attention to the very general use of ivory for sword and dagger hilts in all countries. Most of the great collections of arms possess numberless specimens, and the oriental examples range over all eastern countries from very early times to the present day.

In the middle ages the most remarkable objects for use in the field, or for the chase, to which sculptured ivory or bone was applied were the pommels or cantles of the ponderous saddles of those times. The extent of surface which was available offered a considerable opportunity for the work of the carver. We often find particulars in old inventories of the wealth of decoration lavished upon horse furniture, and the elaborate carving, gilding, embroidery, and precious stones with which it was ornamented. The monk Theophilus, whose work, *De diversis artibus*, has already been quoted, gives minute directions for the embellishment of the panels and backs of the cantles of saddles, and there were stringent regulations of the trade guilds concerning the degrees of ornament which might be applied to the different portions. For example, pure gold only might be used on the cantle, but a lesser quality, or colours, on the *arçon*. Evidently the back part of the cantle was considered the place of honour. In *Atis et Prophelias*, a romance of the twelfth century, we find :—

> " D'Ivoire furent li archon
> Bordé de pierres environ."

One or two specimens of cantles in ivory from the museum of the Louvre—for we have no examples at South Kensington or in the British Museum, and but unimportant ones even in the magnificent collection of arms at Hertford House—may be selected as typical. The first of these is Italian work of the thirteenth century ; a long-shaped plaque with rounded ends. It is carved with a spirited representation of a battle of the amazons within a border, on three sides, of foliage in deeply cut

open-work. A still finer one, and perhaps the earliest known, also in the Louvre, was formerly in the Spitzer collection. It is remarkable for the figures of two knights tilting, which form the principal subject. We derive from this piece interesting details of the armour of the period, the cylindrical helmets surmounted by conical caps, the shirts of mail, the shoulder-pieces, genouillières, and greaves, and the triangular shields—of which one bears the arms of Aragon and Sicily. Around three of the edges runs a most intricate design, in the style of the twelfth century, of interlaced foliage work, with which are mingled numerous figures—combats between men and bears, a fight between naked men, between bulls and fantastical animals, the hunting of stags and wild boars and of lions—and in the centre a large eagle with outstretched wings is carrying off a hare in its claws. The style, the composition, and the workmanship of this interesting piece are admirable. It is Italian (Sicilian) work, and, if we may judge from the arms above alluded to, made for a king of Sicily some time between the middle and the close of the thirteenth century. The saddle in the Wallace collection is a German one, entirely overlaid or plated with plaques of bone or polished stag's-horn carved in low relief with figures of a man and woman in the costume of about 1470. They hold between them a long scroll, which meanders about the whole composition, on which is a sonnet in obsolete German, which is thus translated in the catalogue :—

The Woman—
　　"I go hence, I know not where :
　　Well a day ! willingly thou art not forgotten."
The Man—
　　"I go, I stop : the longer I stay,
　　The more mad I become :
　　Thine for ever, the world over, your betrothed."
The Woman—
　　"But if the war should end ? "
The Man—
　　"I should rejoice to be always here."

There is little else which calls for attention until we come to the fifteenth century, when the magnificence of the times which preceded the full glory of the renaissance and of the two succeeding centuries caused every object of ordinary use to be covered with rich and artistic decoration. It is therefore not surprising that arms of all kinds, the weapons of the chase and other accessories for sporting purposes, should share in the general luxury of adornment. Throughout these periods ivory or stag's-horn was used in lavish profusion for the inlay of the arbalestes, or crossbows, the pistols, arquebusses, petronels, rifles, powder-flasks, powder-primers, and other things which were required for military or hunting purposes. Most people are familiar with the curious and at the same time elegant forms of the sporting guns of the renaissance period, which presented a sufficiently large surface upon which the artistic decorator could employ his skill. But without devoting special attention to many individual examples, and without a large number of illustrations, it would be difficult to appreciate their importance and the wonderful variety of decoration which are displayed in them. In the same way, however, that the museum at South Kensington furnishes sufficient examples of the earlier periods of ivory carving in general, so also we have near at hand, in the Wallace collection at Hertford House, one of the finest collections of decorative armour in the world, and from this we may draw one or two examples of the various ways in which ivory was used for weapons which will be sufficiently comprehensive. Most of the famous collections of arms and armour which have been dispersed during the last half-century have contributed their greatest treasures to the armoury at Hertford House, and the specimens are there exhibited more on account of their artistic beauty than from an armourer's point of view.

The method in which polished stag's-horn was used,

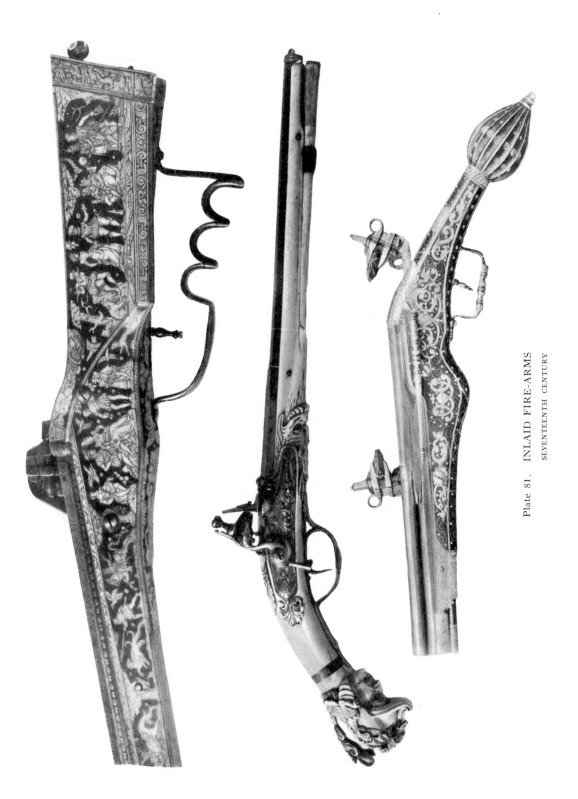

Plate 81. INLAID FIRE-ARMS
SEVENTEENTH CENTURY

not only for the engraved plaques which were inlaid
in weapons, but also for the portions which were carved
in relief, and the resemblance which this horn bears to
ivory, frequently cause the one to be taken for the other ;
and, as a matter of fact, it is rare in museums to find
any other description than ivory given to them. The
sculptured portions have, of course, the greatest interest
for us. The engraved plaques, on the other hand, are
more akin to the system of decoration which has been
noticed in the case of furniture, and, strictly speaking,
they fall within our province from the same point of
view only as the certosina work with which they have
an analogy. But it would be impossible to ignore the
charm and the interest which belong to them on account
of the subjects filled in with black in the fashion of niello
work, with which they are engraved. Very various indeed
are the pictures of all kinds which we find upon the stocks,
and upon every available portion of the surface of these
arms—pictures illustrative of manners and costumes of
the time, hunting scenes, bear and bull baiting, mytho-
logical and allegorical figures and emblems, the romances
of the period, the musketeers in their full bombasted
breeches, coats of arms, monograms, ciphers, busts,
arabesques, scrolls, masks, fantastic animals, religious
subjects—everything, in fact, is laid under contribution,
and there is scarcely one of these highly decorated
weapons which is not full of interest, and will not repay
minute examination. Charming also is the manner in
which the engraved or chased and polished stag's-horn,
or ivory, harmonises with the darker tone of the beautiful
woods of which the butts and stocks are made, and with
the elegance of the gilt and chiselled mounts. Fre-
quently the whole is still further enriched by the inlay
of gold and silver, mother-of-pearl, and other precious
materials. The arbalestes or crossbows, the elegant
wheel-lock pistols with their huge spherical pommels,
and the arquebusses of various kinds, are all inlaid

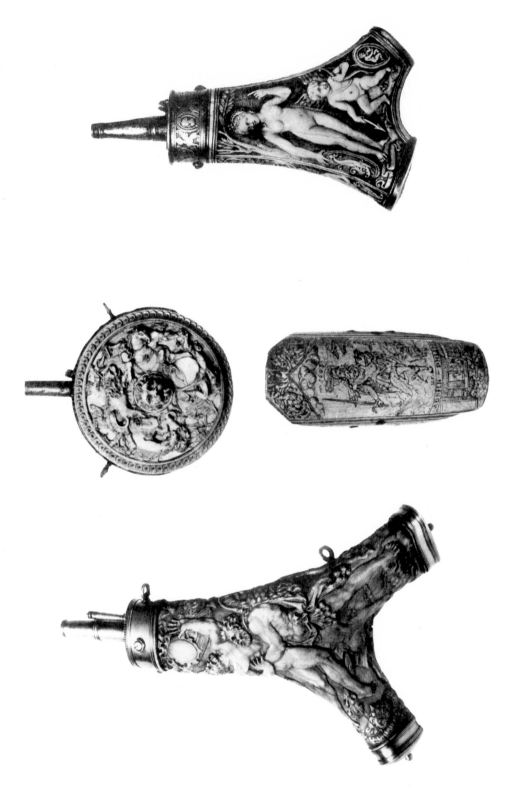

Plate 82. POWDER FLASKS AND AN ARCHER'S WRISTGUARD

SIXTEENTH AND SEVENTEENTH CENTURIES

(*Wallace Collection*)

with engraved plaques, and in addition, in many cases, the ivory or stag's-horn mountings are carved in relief. A German crossbow of the middle of the fifteenth century in the Wallace collection has a stock of walnut wood and a barrel of ivory, and is inlaid with plaques of polished stag's-horn carved with a great variety of subjects: for example, Adam and Eve in Paradise, knights in armour, shields of arms of Bohemia, Austria and Hungary, St. George and the dragon, allegorical groups, and the martyrdom of St. Catherine—a very rich decoration indeed. An arquebus and a pair of pistols in the same collection (Nos. 199, 774) illustrate very well the fine Italian work of the end of the sixteenth and beginning of the seventeenth centuries. They are most delicately inlaid with minute strap-work, with numerous small groups of horsemen, drummers, musketeers, and classical and allegorical figures. Arms of this kind are, however, endless in number and variety, and it would be impossible to follow them in detail.

The pulverins, or powder-flasks, and priming-horns are still more charming, and, so far as ivory carving is concerned, more elegant in design and workmanship. The most usual and the most characteristic are in the natural form of the stag's-horn, leaving two forked ends at the lower portions. They are generally mounted in iron, steel, or damascened work of the best style of silver-smith's work of the period. Others, and these are the finest, as a rule, are entirely of ivory and of flattened-globular and other similar shapes. The best are nearly always Italian work, and it is hardly too much to say that ivory sculpture—especially of Italy—of the sixteenth and seventeenth centuries is nowhere represented in purer taste or of better workmanship. A beautiful oblong casket of walnut wood is interesting, because it exemplifies a similar system of applied ornament in the certosina style, from which to a certain extent the decoration of gun stocks and the like was derived. At the same time

we must not forget that a like fashion prevails in the arms of India, Persia, and other oriental countries, and has been continued down to quite recent times. The casket (No. 560 in the Wallace collection) is a very fine specimen of seventeenth-century German work. The panels are inlaid with cornucopiæ, dolphins, scrolls, and fruit and flowers in stained stag's-horn and mother-of-pearl, and in addition with engraved brass, and on an oval cartouche in the centre of one side is the date and the maker's name: "Fait en Massevaux par Jean Conrad Tornier monteur d'harqueb^{isses} L'en 1630." We thus connect this kind of work with that of a no doubt celebrated decorator of arquebusses.

In connection with the use of stag's-horn instead of ivory, it may be as well to mention the engraved antlers often sent as presents by one great personage to another, more especially about the sixteenth century. Existing examples are of extreme rarity; perhaps, in all, not more than half a dozen are known. One is in the collection of Lord Tweedmouth, and the Rothschild collection at Vienna has another. The beams and tines on both are covered with engraved sporting subjects in the style of the firelocks of the period, and the polish is such that they might easily be taken for ivory. On account of the size of the pieces required stag's-horn was used also for the decoration of saddles.

Besides weapons, there are also in the armoury of the Wallace collection several other interesting objects in, or decorated with, ivory, but limits of space prevent more than a passing notice of them. Amongst them are some beautiful pommels and sword and dagger hilts, an archer's wrist-guard, inscribed "ADRIEN-PHILIPPE," and dated 1608, engraved with the interior of a blacksmith's shop; some large serving-knives and sets of knives and forks with elaborately carved handles, a very fine Flemish knife-sheath of ivory, carved with figures of King David and an amazon, walking-staves,

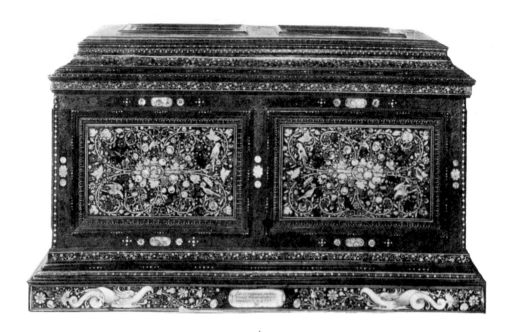

1

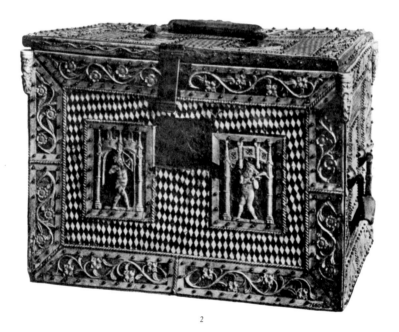

2

Plate 83. 1. CASKET. GERMAN. 2. CASKET. FRENCH

SEVENTEENTH CENTURY FIFTEENTH CENTURY

wands of office, and other minor objects. We have to leave the subject with regret, for even without departing from examples which are connected in one way or another with ivory sculpture, and allowing that the sixteenth and seventeenth centuries cannot supply us with artistic work of such high merit as the centuries immediately preceding, there is yet much of perhaps a more domestic character which is very attractive, and to a great extent beautiful.

CHAPTER XVIII

THE WORKING OF IVORY — ARTIFICIAL IVORY — COLOURING AND STAINING — FORGERIES — THE GREAT COLLECTIONS

IN a larger work than the present one much of interest might be said concerning the practical details of sculpture in ivory, the methods used by artists, and the preparation of the very great variety of applications for which ivory is used. Some of these, such as the manufacture of billiard-balls, combs, and the handles of brushes and other things of like character, are worked in a special manner differing from the processes employed with other materials. The turning of billiard-balls is an achievement which few amongst the cleverest of turners would successfully accomplish. Ivory, like wood, requires drying or seasoning, otherwise it would be liable to crack, warp, or shrink unequally. This is especially important in the case of billiard-balls. The most extreme care is necessary to obtain the nearest possible approach to absolute sphericity. They are usually, therefore, turned to the sphere for some months before they are finally reduced to the actual size required, and meanwhile are stored under the most favourable conditions for seasoning and contracting with regularity. The most perfect tusks are selected, not necessarily the largest; on the contrary, the best are made from teeth scarcely larger in diameter than the balls themselves. These are known as ball teeth, and command the highest price. Even then

there are different qualities from the same tusk, out of which perhaps not more than three of the highest grade can be made. It would seem that they are best the nearer they are to the termination of the nerve which runs through the tusk, and the smaller this is, as may often be observed in the black speck to be seen on a ball, the better the quality. About ten balls of the English size are cut from a pair of tusks, so that to supply the standing stock of one great London maker, which, it is said, amounts generally to over twenty thousand balls, would require the produce of two thousand elephants.

The artist-sculptor in ivory uses practically the same tools as the wood-carver: knives, gouges, files, saws of any kind. Great care is, of course, necessary in the selection of well-seasoned ivory, and of the character and direction of the grain. Large work is naturally roughed out by the *practicien* or pointer, in the same way as is usual in marble or other monumental sculpture.

There has always been much speculation concerning the manner in which certain very large slabs which we find amongst ancient and mediæval ivory carvings were obtained and manipulated. The fine leaf of a diptych in the British Museum, representing an archangel, measures sixteen and a half by five and a quarter inches, and is half an inch thick throughout; and amongst other large pieces it will be sufficient to mention the book-covers in the Paris National Library, which are each no less than fourteen and a half by eleven and a half inches, and there are others of correspondingly large dimensions. Such pieces could hardly be cut from the largest elephants' tusks now known, and it is conjectured that some means of softening and bending the ivory must have been practised. Then, again, there are references in ancient writers to the colossal statues of ivory, gold, and bronze, known as chryselephantine, which adorned the temples in Greece

and Rome. We learn from Pausanias particulars concerning these gigantic works, which were made by Phidias and his contemporaries at the highest period of Greek art. That of Minerva in the Parthenon was nearly forty feet in height, and the colossal Jupiter at Olympia, a sitting figure, measured no less than fifty-eight feet. It may be remembered that works of this kind were the tribute of a grateful people to commemorate the victories over an enemy who had attempted their absolute destruction. They were made, therefore, from precious spoils of ivory and gold, and enriched in every way as triumphal trophies. The faces, hands, and other exposed portions of the figures were of ivory, and the question, therefore, of the method of production has been often debated. But as no remains of these statues are known, we can only conjecture the exact part which ivory played in their formation, and the most reasonable explanation seems to be that they were simply covered with slabs or thin plates of this material, which could easily be bent round to follow the contours. The effect close by would resemble a kind of mosaic, or the leading of stained-glass windows, but at a great height, such as these statues reached, the joins would be imperceptible. The whole question has been treated with great erudition, and at considerable length, by M. Quatremère de Quincy in *Le Jupiter Olympien*, published in 1815. As befitting his subject, the book is a colossal folio, with working plans showing the manner in which ivory plates could be affixed and attached to the surfaces of objects to be decorated. An attempt made to reproduce on a lesser, though still a very large, scale the Jupiter of Phidias was made in 1855 by M. Simart, of Paris. It will be alluded to in the following chapter. It may be mentioned that a machine was invented and exhibited by M. Alessandri at the Paris Exhibition of 1855, by means of which veneers of ivory of large dimensions could be cut from the tusk. Sheets as large as thirty by a hundred and fifty inches were produced by it.

Some extraordinary recipes by which it was supposed ivory could be hardened and moulded are to be found in the works of the old alchemists. The monk Rugerus, or Theophilus, in his book on divers arts (*Schedula diversarum artium*, of the eleventh century) enjoins us to take sulphate of potass, salt, and vitriol, and to grind them in a mortar with strong vinegar, into which the ivory being placed, it can then be moulded at will. Another method, from a Sloane MS. of the fifteenth century, advises steeping in dilute muriatic acid for half a day, when it will become as soft as wax, and may be again hardened by placing in white vinegar; and another a mixture of quicklime, pounded tile, and torn tow. The latter suggests, and probably was, a method of producing artificial ivory from waste ivory dust and other materials, rather than one for softening ivory. According to Dioscorides, the root of mandragora possessed the property of softening ivory, and Plutarch speaks of boiling in fermented barley. Many of these methods have been tried, but never with success, and this is hardly surprising if we may judge from the fanciful recipes regarding other matters which Theophilus gives us in his marvellous work, and the extraordinary ingredients which delighted the alchemist and the leech of mediæval times. As a matter of fact, so far as our knowledge goes, ivory may be softened, but it cannot be again restored to its original condition. Its nature is entirely changed, and it becomes simply a kind of gelatine. From the point of view of value to art there would, after all, be little to gain.

The subject of artificial ivory, and of substitutes for that of the elephant's tusk, is not without interest. Amongst the latter some vegetable products are known, and until the recent introduction and popularity of celluloid and analogous compounds, were largely used. *Corozo*, or the fruit of the ivory palm, is a nut of ivory whiteness, which becomes very hard, and bears a singular resemblance to the true material. The

plant is low-growing, but palm-like, a native of the great forests of Peru and Brazil, and of the warmer parts of South America. The fruit hangs in clusters in an envelope like that of the Brazil nut, each pod weighing about twenty-five pounds when ripe, and containing six to nine seeds as large as hen's eggs, the albumen of which is close-grained and very hard, resembling fine ivory in texture and colour. It used to be much employed for buttons, umbrella-handles, and small objects of the kind, and it is certain that some of the older Japanese netsukés and *okimono* were made from it. It is softer and not so brittle as ivory, easy to work, and takes stain well. A method of distinguishing it from true ivory is to apply a little sulphuric acid. With ivory there is no discolouration, but with the nut, after a few minutes a rosy tint, which can be easily washed off, appears. Betel-nuts were also used as a substitute for ivory. Up to the eighteenth century ivory was employed in the making of artificial teeth, but a composition of enamel or porcelain has since taken its place. Martial speaks of a lady who had a set, but, as he says, with very little chance of passing them off as her own.

The modern methods of producing imitation ivory, besides celluloid, consist in various ways of utilising ivory and bone waste and dust by maceration with scraps of skin and leather, wool, cotton, silk, lac, and other materials, in solutions of chloride of lime, using also phosphates of chalk, gelatine, gutta-percha, plaster of Paris, and analogous substances. The residue, which forms a fluid gelatinous mass, is filtered and spread on frames, and allowed to harden in a strong solution of alum. Another and older system is by boiling potatoes in sulphuric acid, by which they become extremely hard and ivory-like in texture. Bonzoline billiard balls are now very well known, and by many players preferred to ivory ones, on account of their elasticity, and because they are not so liable to shrink or warp. A new

discovery, that of the product called *Gallalith*, now being commercially worked at Hamburg, is too recent to allow of more than passing notice. It is used as a substitute not only for ivory, but for horn, tortoise-shell, amber, and coral. It takes a high polish, is easily turned, and is not inflammable. Preparations of caseine are said also to be largely used in France.

What are known in art museums as Fictile ivories are, of course, imitations of the original works rather than actual substitutes. It would be difficult to exaggerate their teaching value. From this point of view they are practically equal to the originals themselves. The South Kensington Museum possesses a series of considerably over a thousand, but unfortunately no additions appear to have been made to it since about thirty years ago. It is a pity that every known ivory of any importance is not included. No works of art lend themselves more easily to reproduction, so that at a small cost and with little difficulty an absolutely complete collection could be made. The great importance of ivory sculpture in the history of art, not only of the periods when other arts were in a flourishing condition, but also of times of which we possess no sculpture and even hardly any pictorial examples, requires no insisting upon; but obvious as it is we may doubt whether the fact has been sufficiently recognised. Although only plaster casts, fictiles need not be put away in dark corners or placed at such a height from the ground that, without a tall ladder, it is impossible to examine them.

It is by no means a difficult process to make fictile copies of ivory carvings of almost any kind. Ordinary gutta-percha is heated and mixed with sufficient wax to prevent it hardening too rapidly on cooling. Enough of this preparation for the cast required is then softened in nearly boiling water until it is about the consistency of well-kneaded putty. The ivory receives first a thin coating of a weak solution of soft soap and is then covered

with this composition, which is pressed with the fingers until it has entered into and filled up every portion of the carved surfaces. Being very pliable, no danger to the original need be apprehended. If there is much undercutting or fragile open-work, of course these portions should be protected and the resulting cast finished subsequently by hand. The mould, when quite cold and hard, is easily removed and a cast made from it in fine plaster of Paris in the usual way. The plaster is then dipped in melted stearine, from which it acquires an ivory-like surface, which will take water-colour without difficulty if it is desired to make a still more faithful reproduction of an ancient and perhaps discoloured original. The simple white and stearined casts are, however, much to be preferred. It must, of course, be admitted that plaster reproductions of this kind are fragile, and it would be a considerable improvement if a moulding material of the nature of bonzoline could be substituted.

A good deal of attention has lately been given to the question of forged antiquities and the systematic manufacture of spurious works of art. This is no new industry, but has been practised for centuries, and we find reference to it in ancient classical writings. It is hardly within our province to follow the subject generally. It will suffice to say that no department of art has been free from the attention of the clever forger. He has tried his hand, and successfully, with paintings, engravings, sculpture, goldsmith's work, enamels, ceramics, everything, in fact, that is envied and collected by the art-loving connoisseur. Possibly it may not be altogether an unmixed evil, for it serves at least the purpose of increasing our knowledge and care. It may even be said that no expert, no collector of note has escaped, but that at one time or another he has bought valuable experience which perhaps he would have acquired in no other way. When we recall the wonderful productions of such a great

artist as Bastianini, or of Roukomovski who made the tiara of Saitaphernes and other pieces of goldsmith's work in which the highest authorities believed until the very last moment—until, in fact, the modern artist revealed himself—we shall be prepared to expect that ivory sculpture could produce similar examples. It is at least satisfactory that forgeries of importance are more rare amongst old ivories than in other departments of art. There have been, so far as we are aware, few in our great public collections in England which can be pointed to or have even been suggested. Probably every fine example of such things as consular diptychs, book-covers, and the most important mediæval ivories is well known, their history and possessors may be traced with accuracy, and the appearance of anything of the kind which might hitherto have remained in obscurity would—internal evidence apart—entail a strict examination of the circumstances under which it had so long lain hidden.

The manufacture of spurious paintings and sculpture is almost a recognised industry in Italy. Vienna and Amsterdam have produced notable examples of objects in the precious metals, and the discoveries of the marvellous Scytho-Greek goldsmith's work in the tombs of the Crimea no doubt instigated the clever imitator of these things to produce the work which, after having deceived the most learned authorities, has been so recently exposed in Paris. The attention that ivories have received has probably been from such modern centres of the industry as Geislingen and Erbach, in Germany.

In many cases of forgeries it may happen that parts of an object may be genuine while the rest is false, but with ivories we have hitherto been met by no such difficulties. No imitator has yet dared to produce for us a consular diptych in the original precious setting with which, there can be little doubt, those destined for presentation to distinguished personages were mounted,

although the field for invention would be all his own. No one has reconstructed a shrine or reliquary of the thirteenth century with its rich belongings.

Ivory forgeries are often artificially aged by steeping in tobacco or liquorice juice, burying in dunghills, by wearing next to the skin and frequently rubbing, and in other ways. Even the cracking and disintegration are imitated without much difficulty.

It is strange how often the forger of antiques gives himself away in some minor particulars. We shall see this presently in the case of a well-known spurious consular diptych. In regard to diptychs generally, the fashion of the hinges, and the method in which the ivory is prepared to receive them, often furnish valuable tests. It has, of course, to be admitted that forgeries of all kinds have been, and still are, executed by most skilful artists. There are no more notable examples than the *quattro-cento* terra-cotta busts in the Kensington Museum, whose maker was perhaps equal in power and knowledge of his subject to those whose work and feeling he imitated. Their artistic quality alone would baffle the expert, and in such instances we can only rely on comparatively insignificant details to put us, in the first place, upon the track of suspicion. Nothing is more curious than the revulsion of feeling which ensues on conviction.

Some remarks on a few typical, or supposed spurious ivories will not be without interest. It will be noticed that although it is not unlikely that many others are in circulation, the number of those of any importance which have been detected is extremely few. There can be no safeguard against imitations which would be in some cases not difficult to make, except the intimate acquaintance with the style and spirit of the period affected, which only long and careful study of such things can give. Signatures of artists are almost wholly wanting, inscriptions, and the guide which the style of lettering affords are not very common, we have nothing to correspond with

hall-marks, and the quality of ivory is the same now as it was in prehistoric days.

The *Leodiense* consular diptych, one leaf of which is in the Kensington Museum, the other at Berlin, was formerly preserved in the cathedral at Liege. It was there when described by Wiltheim, in his *Diptychon Leodiense*, published in 1659, and an engraving of it forms the frontispiece to his book. This engraving is fairly accurate, and is interesting from the fact that it was made before the Kensington leaf had lost a not inconsiderable portion of the right-hand lower corner. The diptych disappeared in the troubles of the French Revolution, and was lost sight of for some time. Its subsequent history is uncertain, but, at any rate, early in the year 1864 the leaf which is now at Kensington, and at that time in the possession of Mr. Webb, was exhibited and described by the late Sir Augustus Franks, at a meeting of the Society of Antiquaries. In the summer of the same year Mr. Franks, to his surprise, found what purported to be the entire diptych at the museum of the Porte du Hal, at Brussels. He was well aware of the existence of the Berlin leaf, and, of course, of the one just mentioned. By his advice the ivories were taken out of the wooden frames in which they were fixed and carefully examined, with the result that their spurious nature was at once made evident. Amongst other indications, the first glance on removal from the frames showed that the surfaces of the backs of the leaves had not been lowered in the usual way to receive wax for writing on. It appears that the authorities of the museum had purchased the forged diptych, for which they had given no less than £800, from a dealer at Liège, without sufficient examination, and under the impression that they had acquired a treasure of exceeding rarity. In the sequel the dealer was compelled to refund the amount paid, and the clever forger had to quit the country to avoid imprisonment. The imitation was confiscated, and is still in the hands of the

Brussels authorities. M. Eudel, in his amusing and somewhat imaginative work, *Le Truquage*, has, of course, something to say on the subject. He describes the ivories as being framed in ebony cases with fine and elegant mouldings. The fact is that the wood in which they are firmly encased is of ancient-looking and worm-eaten oak, with metal mounts and hinges to correspond. On examining the diptych one is at once struck by the greater depth to which the ivory is carved than is the case with the genuine leaves, or with most examples of consular diptychs. From various minor details also, such as the curls of the consul's hair, or the fashion of the curule chair, which correspond accurately with the imperfect representation in Wiltheim's work, there can remain no doubt that it is from this that the copy was made. It has been given an appearance of age, and the surface is considerably rubbed. It must be admitted that it is extremely well executed, especially in the lower portion, which represents scenes in the circus. Had the forger taken originals for his inspiration, it would have been far more difficult on *prima facie* grounds to decide against its being a genuine duplicate of a consular diptych, for replicas of such things were undoubtedly made for distribution as presents. As a clever copy it has a certain value as an interesting and very near reproduction in ivory of the diptych before a portion had been broken off and lost.

Mention may be made, under all reserve, of copies of the diptychs of Flavius Clementinus now in the Liverpool Museum, and of Areobindus in the Trevulzi collection at Milan, formerly in the Possente collection at Fabriano, which was dispersed late in the last century.

The question of the genuineness of the *Vierge ouvrante* in the Louvre has already been noticed (page 230). We have no information as to the exact reason which led the authorities of the museum to the conclusion that it is a forgery, and it would be presumptuous on

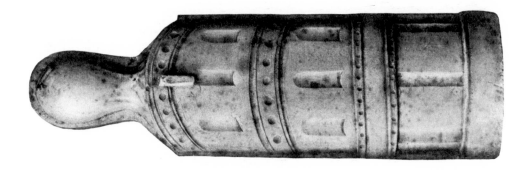

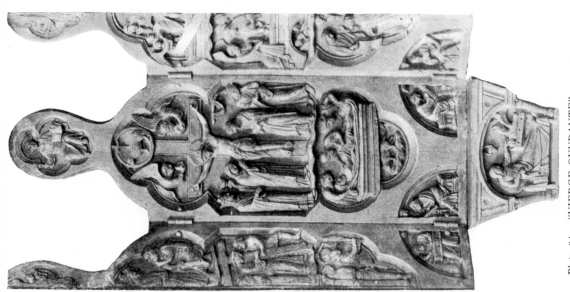

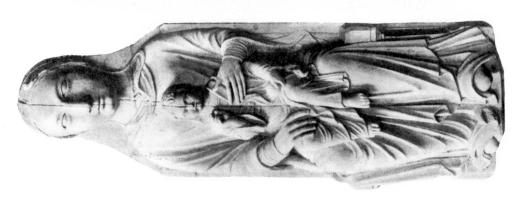

Plate 84. "VIERGE OUVRANTE"

(In the Louvre)

the evidence only of the cast from this piece or from the photographs to express a decided opinion on the subject. The treatment of the figure itself and of the groups within it do not greatly differ from the Boubon image. The Virgin holds the Child upon her knee, His right hand raised in benediction ; and in the representation of the crucifixion the allegorical figures of the sun and moon are placed in a quite unusual manner, that is to say, the sun is on the left instead of on the right. The cartouche of the Lamb, plastered as it were on the upper arm of the cross, is altogether inexplicable. If a forgery, the question arises whence the sculptor obtained the model from which he drew his inspiration. It could scarcely have been in its entirety from the Boubon image, for it would appear certain that the central portion of this had been lost sight of for more than a century. On the other hand—although no particulars exist amongst the papers of the Hugonneau-Beaufet family—it seems that the fragment which they possessed was sent to Paris about the year 1830 to be repaired. The whole matter is of considerable interest and importance, and perhaps the last word has not yet been said regarding the authenticity—in whole or in part—of the "monster" of the Louvre or of the figures at Lyon and at Rouen.

The learned M. Didron, in the *Annales archéologiques*, to which he has contributed so much valuable archæological lore, throws doubt on the authenticity of several ancient ivories which are accepted in various museums. Amongst them are the tablet representing the Virgin and Child and the companion-piece, the first of which we have described at length (page 130), and with these he includes the great book-covers in the Paris Library, the covers of the *Codex Ebnerianus* in the Bodleian, and eight Byzantine ivories in the Berlin Museum, which it is unnecessary to specify here as we have made no previous reference to them. In addition he doubts the genuineness of the

Byzantine plaque of the Emperor Otho and his wife Theophano, in the Cluny Museum. Of course the Emperor Otho plaque is not so fine as that of the Greek Evangelistarium, certainly of the eleventh century, in the Paris Library, which it so much resembles. The design is almost identical on both, but while the execution of the Romanus and Eudocia example is careful to a degree, the other is by no means equal in workmanship. Still, it need not follow that all these are forgeries in the sense of being made to deceive, even should they not be of the epochs assigned to them. They may be genuinely made copies, or partly copies, and with regard to the Emperor Otho plaque it is certainly mentioned as existing in their time by the two learned Benedictines, Martène and Durand, in their account of the *Voyage Littéraire* which they made in 1717. It requires no great stretch of imagination to conjecture that monastic artists would from time to time more or less accurately copy plaques or other objects in ivory in their possession. They would probably also sometimes mix two styles, and therefore cause an appearance of anachronism which, when not too flagrant, is calculated to puzzle the archæologist of later times. We cannot avoid thinking that M. Didron not unfrequently describes objects and founds opinions from engravings or casts rather than from originals. Certainly he did so in the case of the Bodleian Greek Testament. The cast of the ivories in the covers reproduces also part of the very poor modern silver work in which they are set.

An early chapter in this book was devoted to prehistoric ivory carvings, and it must be said that there has been a not inconsiderable output of spurious things of the kind which profess to have been discovered in Swiss lake dwellings and in the caves of the Dordogne. The St. Germain Museum possesses an interesting collection of forgeries, and to this the reader may be referred. The

best genuine examples, including those noticed in our second chapter, are also in this museum, and we may be contented with the authority of the learned curator.

The colouring of ivory is a subject which may be looked upon from two points of view: on the one hand, in relation to the change which takes place under certain conditions, and involves, more properly speaking, the discoloration of the material; and, on the other, with regard to the artistic propriety of using colour in sculpture generally. Both are points of sufficient interest to justify at least some passing attention.

It is difficult to account in all cases for the discoloration or bleaching of ivory, and for the organic changes which disintegrate the substance, and cause it to assume an aspect totally different from its natural condition. We find this especially illustrated in the case of ancient ivories, such as the Nineveh fragments, which have lain buried for a considerable period, and have undergone, perhaps, in addition, the action of heat, but not to such an extent as to cause them to exfoliate. It is analogous, no doubt, to the decomposition of glass, which flakes and becomes iridescent in various degrees, according to the nature of the soil in which it has been buried, the exclusion of air, and the substances which the object contains, or with which it has been brought into contact. The Nineveh and other very ancient ivories present an appearance which few people would dream of associating with this material. Some are entirely like ebony, others resemble fossil wood, basalt, boxwood, slate, sandstone, and even opal. The gelatinous substance must have shared in the changes, for where this is wanting, nothing but the bony structure is left. Again, where ivory, such as the mammoth remains of all countries, has been buried for unnumbered ages, it becomes, under certain conditions, veritable turquoise. Where no very great length of time has elapsed, however, it is not always easy to account for the variety of discoloration which takes place. A

piece of a casket in the British Museum, and a fragment of a figure found in London, and both no older than the thirteenth century, resemble much more nearly box-wood than ivory, and the Archangel diptych in the same collection is in a somewhat similar condition. The Arab casket at Kensington has the appearance of plaster or darkened alabaster. The Passion plaques of the seventh century, which have been described, are of a reddish chestnut hue. The Downside crucifix is of a fine mahogany colour for the most part, and in more or less variety this is not unusual, and, as has already been remarked, is far from unpleasing. Many other instances of what may almost be called vagaries might be mentioned, but the above will suffice. A simple method of producing the reddish or chestnut colour on ivories is to give a coating of oil; then to apply friction by means of the lathe and a piece of rag; and, finally, to expose to the sun for a few days.

It is generally considered that exposure to light has the effect of bleaching ivory, but the crucifix just mentioned has been so exposed for at least a hundred years. On the other hand, most of the mediæval ivories in the Wallace Museum, for example, are in a most extraordinary state of fine preservation. The most delicate portions, such as hairlike spears and other projecting parts, are perfect, and the ivories themselves are as purely white as the day they were made. And yet their preservation for four or five centuries is probably due to their having been kept in cases and carefully stored away. We know, from the examples which have come down to us, that most beautifully stamped cases of *cuir-bouilli* were specially made to contain very fine diptychs and other mediæval ivories. Ivory from the tusk of a young animal remains white longer than that of older ones.

There are, of course, artificial methods of bleaching ivory, to which it is hardly necessary to do more than

refer, for no one would think of tampering with what may be called the *patina* of a fine ivory. The dipping in turpentine and exposing to sunshine during three or four days is said to be practical and harmless.

The colouring of ivory statuettes and groups, and of diptychs, triptychs, and other things of the kind, was usual in the middle ages, and, in addition, they were often gilded. The group of the Coronation of the Virgin in the Louvre is a charming example, the faces and hands delicately tinted, and the robes diapered with a pattern. Sometimes the whole of a group, except the flesh tones, was gilded, as we find in an example of which an illustration has been given (plate xxxix.); or the hair only is gilded, and this with good effect. We must not hastily conclude that colouring in sculpture is barbarous or vulgar. With regard to marble, we know that the works of the greatest Greek sculptors, of Praxiteles or Phidias, were often coloured. An argument against the use of colour is that it is not legitimate to mingle two arts; but, nevertheless, this is done, not only in sculpture, but in the graphic arts. The reply is that no hard-and-fast rule can be laid down, and that a great artist cannot be bound by trammels of the kind. He may throw them over, as the dramatic poets threw over the dramatic unities. It is sufficient to remember that the general feeling of mankind has, in all ages, called for the practice. It has received the sanction of the designers and makers of the most beautiful decorative work of Greece, of Egypt, of Assyria, of mediæval times, of the painted monumental figures of the renaissance, of the pure Japanese taste, and now in recent years it is practised by the best of those who have assisted in the revival of ivory sculpture, to which our next chapter will be devoted. The great test is the reserve, discrimination, and restraint, which are of importance to preserve it from the suspicion of vulgarity, and it must not be purely imitative. We do not wish

to produce a pictorial effect, and to forget that it is sculpture. There are certain necessary proprieties and distinctions to be observed. Such distinctions are not arbitrary, but are the result of the observation and conclusions of ages. The province of sculpture is to represent by form, and this, and not the convention of perspective, must predominate. Few need to be told nowadays that it is not within the province of painting to raise certain portions of a picture, as one sees, for example, in the not uncommon representations of dead game hanging from a nail on a wall. Coloured wax-work is inferior as sculpture, because it approaches too nearly nature, and yet is never so true as to deceive in reality. It is impossible, also, to quarrel with those who oppose the painted statuettes of Spanish art, even if the carving or colouring should be by an Alonso Cano or a Montañes, or by the skill of the best painters of the time.

That the Japanese should excel in the practice of staining ivory is no more than we should expect from an artistic people, possessed of such refined taste. We find, perhaps, stained ivory more usual in their netsukés, okimono, and inlaid lacquer work, than the use of colour laid on, and it is evident that they are acquainted with methods which are unknown to ourselves. The engraving of such things in light lines filled in with black is also remarkable in refinement and delicacy.

It has become increasingly more difficult to acquire fine specimens of ancient and mediæval ivory sculpture, because so many great collections have been broken up and dispersed by private sale or by auction during the last fifty years. The most remarkable examples from these have been bought by the museums of the great capitals, and there is little chance that they should ever again come into the market. The British, South Kensington, and the Wallace Museums have in this way added to their collections, the two first at prices which

[493]

were ridiculously low compared with those which specimens of the highest class will realise nowadays.

The British Museum was singularly deficient in ivories until in the year 1856 it purchased the greater part of the then unrivalled collection of the late Mr. William Maskell. More than two-thirds of those which the museum now possesses, and certainly a large number of the most important, had previously been collected by him. Besides those to which reference has been made in the present volume, other noteworthy pieces now in the museum are a Byzantine plaque of the ninth century representing the raising of Lazarus, some admirable thirteenth and fourteenth centuries Burgundian plaques in open-work, very many varieties of chess and draughts men, an extremely fine Italian triptych in bone, of large dimensions, and many mediæval caskets and mirror cases. The South Kensington Museum was principally enriched by numerous purchases from the very large and important collection of the late Mr. John Webb, and by some of the finest examples from the equally important treasures dispersed at the Meyrick, Soltikoff, and Spitzer sales. The Liverpool ivories are chiefly due to the munificence of Mr. Joseph Mayer, who bequeathed to the museum the famous Fejérváry collection which he had acquired *en bloc*. The mediæval ivories at Hertford House are not many in number, but, as would be expected, they are all of fine quality, and without exception remarkable for their extremely fine condition.

The ivories in the Ashmolean at Oxford were collected by Elias Ashmole more than two centuries ago, and have received hardly any additions since that time. They number nearly twenty pieces, and they possess an additional interest from the fact that they are all of English workmanship. There are a chessman and two remarkable draughtsmen, statuettes, diptychs, and plaques of the fourteenth century, a crozier head, a

mirror case, and the thirteenth-century seal of the archdeaconry of Merioneth. An English draughtsman is in the Cambridge Fitzwilliam Museum and also a curious plaque of our Lord and the Blessed Virgin with Latin inscriptions in Anglo-Saxon characters. The Bodleian Library at Oxford possesses three fine book-covers and an Italian bone triptych.

Other existing English collections of note are the Sneyd at Keele Hall, brought together by the late Rev. Walter Sneyd, the Gambier Parry, the Fitz-Henry and the Salting (now in great part in the loan collection of the Kensington Museum), the Morrison, Goldsmidt, and Rothschild. The collections of the late Mr. George Field and Mr. R. Goff, who exhibited largely at the famous loan exhibition at Kensington in 1862 and were remarkable for post-renaissance work, especially in the style of Fiammingo, have since been dispersed. The greater part of Mr. Webb's fine ivories, numbering some 160 pieces of the highest quality, and including the beautiful *Meretense* (Symmachorum) leaf of diptych, was also shown at that exhibition. The very fine Gibson-Carmichael collection which included the famous *Vierge ouvrante* of Boubon came under the hammer so recently as the year 1902. Oscott College, besides the crucifix already described, possesses several interesting ivories, especially those which have come to it through its connection with the Portuguese and their colonies. Amongst them is an old Chinese pestle and mortar, similar to that at Kensington, already illustrated (plate lxxv.); a curious turned cup used, according to Portuguese custom, in giving water to communicants; a charming Madonna and child, probably Italian eighteenth-century work; some figures by native Christians of the Portuguese colonies, and a very curious grace-cup, with cover, mounted in silver and carved with sacred subjects.

In Italy the Vatican Museum is unrivalled for classical

[495]

statuettes and for examples—amongst the very few in existence—of antique ivory sculpture and for early Christian caskets and other work, besides a large number of very important Byzantine and mediæval ivories, both religious and secular. Other interesting pieces in Rome are at the Minerva and Barberini libraries and in the museum of the Collegio Romano, and the Museo Kircheriano has a number of early Christian caskets. Ravenna possesses in the cathedral the famous chair of Maximianus and several interesting examples in the public museum. Bologna has two important collections at the University and in the municipal museum. Milan is rich in examples at the Duomo, the Brera Museum, and the Trevulzi palace, and the basilica of San Ambrogio has an important early Christian diptych. Reference has already been made to the ivories at Monza. The Naples Museum has several classical examples, and in Florence the Carrand collection at the Bargello is most important. To the above it must suffice to name Lucca, Novara, and Aosta, which possess leaves of consular diptychs. Several museums in Italy are remarkable for Byzantine caskets in the style of the Veroli at Kensington.

The Bibliothèque Nationale of Paris has eight consular diptychs, or leaves of diptychs, and the famous Charlemagne chessmen. The Louvre is remarkable for Nineveh, Egypt, and other antique ivories, for charming mediæval statuettes of the Virgin, and other pieces of a large collection of mediæval ivories, not to be matched elsewhere, amongst them the group of the coronation of the Virgin, the descent from the cross, and the Savoy harp. There is also the fine and very large Poissy retable. The Cluny Museum is scarcely less rich, and the city of Paris has lately come into possession of the famous collection of M. Dutuit, of Rouen. The museums at Lille, Reims, Chartres, Lyon, Orléans, Dijon, and Narbonne possess more or less important collections

and specimens, and in addition the cathedrals of Reims, Laon, Troyes, Angers, Sens, and Nancy include historic ivories in their treasuries, and the same may be said of churches at Auch, Avignon, and Mareuil-en-Brie.

In Brussels all the ancient and mediæval ivories have been transferred to the Musée du Cinquanténaire at the Exhibition buildings. The most important amongst a not very numerous collection are the Stavelot combs, a diptych of the ninth century, a reliquary of the twelfth century in the shape of a Romanesque church, and an Italian casket in the style of the Veroli at Kensington.

In Germany the principal ivory collections are at the Kunstkammer and Royal Library in Berlin, the Dresden green vaults, and the Bavarian National Museum at Munich. There are, besides, the ducal and grand-ducal museums, amongst others, at Karlsruhe, Darmstadt, and Gotha, and in all the German museums ivory sculpture of the seventeenth and eighteenth centuries is profusely represented. Combs of historical interest are to be found in the cathedrals and churches at Bamberg, of St. Ulrich at Augsburg, at Elbingen, Osnabruck, and Quedlinburg. In Austria it is curious to note the number of pastoral staves which are preserved in monasteries: among them those of Admont in Styria, of Altenburg, Göttweitz, Kloster Neuburg (Vienna), Raigern, Nonnberg and St. Peters (Salzburg), and Swetl. Other great collections abroad are the Basilewski, now in the museum of the Hermitage, St. Petersburg, the collections of the Rothschilds, and, in France, those of Baron Oppenheim, of Count de Valencia, and of MM. Cottreau, Corroyer, Boy, Garnier, Aymard, and Bardac.

CHAPTER XIX

THE NINETEENTH CENTURY AND THE PRESENT DAY

IT will come as a surprise, perhaps, to many people to hear that in this present twentieth century sculpture in ivory can be considered worthy of any consideration, or, to put it otherwise, that it is practised by artists of distinction. They will be aware of the neglect into which the art had long fallen, and although the use of ivory for such prosaic things as billiard-balls, paper-knives, the backs of brushes, and other objects of utility which we are accustomed to see in shop-windows is well known, it would appear to be almost entirely forgotten as a material for serious sculpture. It is true that Dieppe is still famous as a centre of ivory carving, that crucifixes and figures, fansticks and nick-nacks from thence are abundant enough, that Chinese and Indian productions fill a void of a certain kind, and that modern Japanese figures of a better type than the latter command comparatively high prices. But it is also true that, for one cause or another, ivory carving has been neglected—it would not be right to say despised—for many years by great sculptors in marble and bronze. It was relegated to the position of an industry, and during the three centuries or more which have gone by since, as has been shown, ivory sculptors occupied a position inferior to none amongst those who practised what have been called the minor

arts—a misnomer, for they are often lesser only in point
of size—during all this lapse of time the immense out-
put of the beautiful material was restricted in its use
either to objects of utility upon which it was not thought
worth while to lavish decoration of any kind, or—so far
as public taste is concerned—was only good enough for
the manufacture of that which we know by the terms
"articles de Paris" or *"de Dieppe"*: bazaar or chimney
ornaments with pretensions to nothing beyond prettiness.

Yet, speaking principally of the preceding century
to our own, even while the art slumbered, isolated
examples from the hands of capable artists appeared
from time to time at the exhibitions of the salons and
academies of the great capitals of the world. Now and
again a figure or two might be observed at the Royal
Academy, or some modest attempt at decorative work
managed to insinuate itself at an arts and crafts exhibi-
tion. But they are not the fashion; they attract some
desultory attention, are acquired by a discerning col-
lector, disappear, and are forgotten by the public at
large. Fashion, of course, has much to do with neglect
of the kind, and to this must be added the conservatism
of the authorities of our great public collections. In
London not one of our permanent museums exhibits
an example of modern ivory sculpture—with one excep-
tion. There is in the South Kensington Museum an
ivory parasol handle: French art of the middle of the
nineteenth century. We have no museum like the
Luxembourg at Paris, there is no fashionable lead, and
the encouragement of ivory sculpture would appear not
to be within the terms of the Chantrey bequest.

At universal exhibitions—certainly up to that at
Paris in 1900—ivory carving has been classed with
leather-work, brush-ware, basket-work, and a number
of other industries. So that to deepen the irony a dis-
tinguished sculptor (Moreau-Vauthier was such a one
at the exhibition of 1887) who might find himself placed

on the jury of the division would be called upon to adjudicate on the decorative sewing of a boot or the value of a carved meerschaum pipe, while a leather merchant would pronounce on the merit of a piece of sculpture. It is little wonder then that artists of distinction declined to exhibit under such conditions and that the public should remain in ignorance. Nor, again, is this general ignorance lessened by the fact that it often happens that the work in ivory of our best sculptors goes straight from the studio to the galleries of those for whom it has been executed without having acquired the publicity of the salon or academy of the year.

However this may all be, it is certain that it is very little known that the most distinguished amongst our sculptors have been accustomed to work in ivory. Some general account of the position in which the art now stands may not be, therefore, without interest or advantage. Further than this, it will be attempted to show that a real renaissance and a revived interest in ivory sculpture have taken place within recent years which bid fair to raise the state into which it had fallen and to regain for it the position which it had ceased to occupy during the last three centuries.

Up to about the last quarter of the nineteenth century ivory carving seems to have been principally in the hands of the leading gold and silver smiths—such great houses, for instance, as Froment-Meurice or Falize, in Paris—who employed in their workshops, no doubt, the best talent they could find to carry out ideas which they considered suitable to the public taste of the period. The most important, perhaps, amongst those who then worked was Augustin Moreau-Vauthier, who enjoyed a considerable reputation and had numerous pupils and followers. The carvers of the Dieppe school were also prominent, and there will be occasion to allude again to some of these, for they belong also to the century which

has just begun. We find in 1854 two statuettes—a Venus and a dancing Bacchante—executed by Froment Meurice for Prince Anatole Demidoff, modelled by Feuchères, and carved in ivory by Soitoux. Belleteste made copies of such things as the groups of the "Four Seasons" at Versailles and there is a figure of an old man dying, by his pupil Meugniot, in 1829, in the museum of the Louvre. Pradier, who died in 1852, is credited with many ivory figures, and about that time the portrait medallions of Desrieux showed that that fashion had not yet gone out. By Baron Triqueti also, to whom is due the carving of the high altar at the Invalides, we have a large figure in the British Museum. The Louvre has also a St. Theresa, by the elder Rosset of Dieppe. In Italy Giuseppe Maria Bonzanigo (1740–1820) had a large following. He carved also in wood, and is distinguished principally for microscopic work, flowers, fruit, bracelets, boxes, and the like. There is a medallion portrait by him, in the Louvre, of the Empress Marie Louise. Moreau-Vauthier, amongst other things, exhibited at the Paris Salon in 1881 a "Fortuna," in 1885 a figure personifying painting, and in 1889 a bust of which the goldsmith's work in gold, silver, and damascened iron, and set with topazes and tourmalines, was by the Maison Falize. The Luxembourg galleries acquired his excellent "Gallia," and it seems that there was at the time a strong and reasonable remonstrance because it bore not his name, but that of the commercial house. He died in 1893.

There is, of the last century, one important piece which calls for special notice, because it was an early attempt to reintroduce that system of the combination of ivory with precious materials which is usually termed chryselephantine sculpture. In the revival of ivory carving, to which attention will presently be devoted, the tendency to this description of work and its use by our best sculptors in preference to the employment of ivory

alone is remarkable. It is sufficient to state the fact without inquiring whether we should wish it otherwise. The direction which the revival may take may well be left to the sculptors.

The reconstruction on a reduced scale of the famous gigantic figure of Minerva—one of the great chryselephantine statues by Phidias described by Pausanias— was exhibited at the Paris Exhibition of 1857. It was designed by M. Simart and made by Froment Meurice to the order of the Duke de Luynes, no doubt inspired by the descriptions and directions given by Quatremère de Quincy in his *Le Jupiter Olympien.*

In the best age of Greek art the mixture of material was undoubtedly common. Decoration was applied, or let in, to goldsmith's or other metal work. Ivory was inlaid with these materials as they themselves were inlaid with ivory. In Donatello's time he practised the method himself. Bronzes were gilded, eyes of glass, enamel, or ivory were let in. From Pausanias we hear of the famous ivory chest of Cypselus sent as an offering to the temple at Olympia about 600 B.C. It was of cedar covered with ivory and with small figures, in five rows, of gold, illustrative of mythical stories and legends. Quatremère de Quincy in his *Jupiter Olympien* gives us a reconstruction of this casket, after the description of Pausanias. Phidias and his contemporaries made several gigantic statues. The Athene and others were seen by Pausanias in the second century A.D., and they probably existed for two centuries more, until the gold they contained was melted down to make the vessels and ornaments of the newly established religion. There is an existing letter of Julian the apostate, who mentions that he had seen them. The account given by Pausanias of the Athene is rather vague, but we gather that the flesh was of ivory, the drapery and armour of gold. In her right hand the goddess held a Victory, four cubits high, and every part of the

gold was worked and embossed. The eyes were of marble, perhaps some semi-precious stone, such as *lapis-lazuli*. The dimensions of the great Jupiter have already been given. Several other ivory or chryselephantine statues at Corinth, Mycenæ, and Ægina are mentioned by Pausanias and other ancient writers. Amongst them are a wooden statue of Minerva, of which the hands were of ivory; a Venus by Praxiteles; a Castor and Pollux, and other deities at Sicyon and Argos; the Hours, a Themis, a Diana; an Endymion entirely of ivory except the robe; an ivory throne with a sitting figure of a virgin, near Tritia in Achaia, and a table of ivory. We learn also the names of some of the sculptors—Phidias and Praxiteles, Polycletus, Endoos of Athens, the brothers Medon, Dorycleides, a Hebe by Naucydes, a Minerva by Endius.

Simart's reproduction of the Minerva of Phidias was of ivory and silver, nearly nine feet in height, the face, neck, arms, feet, the head of Medusa on the shield, and the torso of Victory of ivory; the lance, helmet, and serpent of bronze, and the tunic and shield of silver, *repoussés* and chased. The silver work was executed by Duponchel. The figure is described by Labarte, in his *Histoire des Arts industriels*, who says, " M. Simart, who has executed it, has shown himself to be a worthy interpreter of Phidias, and has, by deep study, reconstructed it in the true spirit of antique art."

The revival of ivory carving in quite recent times, to which allusion has been made, is due in great part to Belgian sculptors. It is fitting that it should be so, for to Flemish artists, both at home and in other countries, we owe probably much of the finest work of the middle ages; and in the seventeenth century they were also, as has been shown, immeasurably ahead of others, whatever the general condition of the art may have been. The decline in the use of ivory by sculptors in later times, when the plastic arts had advanced in

other directions, may perhaps have been due, in some measure, to the scarcity of the material, the high price, and the consequent falling off in the number of *praticiens* who were capable of working it from the sculptor's model.

The acquisition of the Congo State by the King of the Belgians, and the large amount of ivory imported into the Antwerp market, inspired the king, on the recommendation of M. van Eetevelde, Secretary of State for the Congo, with the happy idea of the encouragement of a long-neglected art. For this purpose tusks of the finest description were placed at the disposition of the leading sculptors, and the desire of the king was well known that efforts should be made to revive the use of ivory for sculpture, both alone and in conjunction with other materials, and also for furniture, for caskets, and other decorative objects. The response was immediate and gratifying, and the first results were exhibited at the International Exhibition at Antwerp and at the succeeding one at Brussels in 1887. From these a selection was made and is now permanently installed at the exhibition of the Congo State in the Belgian capital. It is unnecessary to trace the further steps which ensued. It will suffice to give some particulars regarding the work of the most prominent Belgian artists who contributed. In so doing it will not be within our limits to refer except in the briefest manner to the artists themselves or to the place which they hold as sculptors in other materials.

No less than forty Belgian sculptors exhibited ivory sculpture at the Brussels Exhibition of 1887. At their head was Julien Dillens, who has, perhaps, the greatest reputation amongst all the artist sculptors of Belgium. His T'serclaes monument is well known, and his statuary work—bas-reliefs, fountains, groups, and figures—has been acquired by the State, and adorns the capital and other cities in the kingdom. Amongst other sculpture

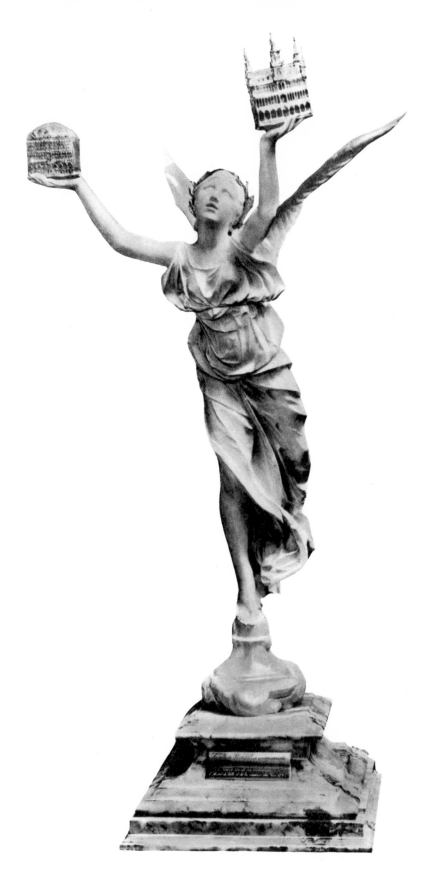

Plate 85. "LA GLOIRE." BY JULIEN DILLENS

in ivory he contributed to the Brussels Exhibition a fine bust of Minerva in ivory and bronze, "Allegretto" —a charming nude figure very far removed from the banality which is too frequent in similar themes—and an allegorical figure, "La Gloire," which is here illustrated. And besides his own contributions it is but right to record that Dillens has been in the forefront of the revival in his encouragement of others and in the interest which he has taken throughout in the movement.

The name of Constantin Meunier is also too well known in the world of sculpture to necessitate more than the briefest reference to his admirable figures of simple models, more especially those of field labourers and miners. In such things, besides the cultured artist one recognises the keen observer of popular types, the pathos and truth to nature which he gives to the humblest subjects. Not less distinguished is the work in ivory which he appears to have taken up with enthusiasm and with a real love of the material. Not only so, but so far he has been contented to use the ivory alone, with no assistance from the mixture with other substances. From another point of view we are still more indebted to him, on account of the subjects he has chosen, for in his crucifix and in his "Christ entombed" —admirable in their poetry and simplicity—he shows us that we need not fear that a true devotional spirit in the treatment of such things has died out : nor can we doubt that the sculptor has at his disposal themes which, rightly used, are surpassed by no others and are capable of enlisting the sympathy and admiration even of the least religiously inclined. The wonder is that they are not more frequently selected and that minor artists especially should not appreciate their value higher than the tiresome repetitions of characterless *académies* to which we are too much accustomed.

In Meunier's crucifix we have a nearly nude figure, the drapery simple and admirably disposed, the arms

almost straight. It is, in many ways, a new interpretation of this very difficult theme—a theme which is so rarely successful. The expression of the face, full of suffering, is yet not painful, but resigned. Nothing is forced, and it is absolutely free from any mannerism. Such things are, however, difficult to describe with justice unless aided by an illustration, and it must suffice to record it.

In Charles Van der Stappen we have another Belgian sculptor of universal reputation. His "Sphinx de Silence" is the first of the important pieces of chryselephantine work which we have to notice. The tendency to use ivory in this way is one which will frequently call for incidental remark in our account of modern ivory carving. It may be that Van der Stappen was one of the first— if not the first—to revive the problem. In the "Sphinx" we have a bust with a somewhat juvenile expression, one hand, with fingers extended, placed at right angles to the lips, as if to implore or to indicate silence. The face and visible parts of the neck and bust are carved from a fine block of ivory of beautiful grain and of considerable size, but, notwithstanding the size, it was necessary to use another piece for the back of the head. The helmet and armour are of silver gilt, *repoussés*, and of excellent design and execution. There is little need to add to the praise which has been given to this fine piece. The harmony of the arrangement, the masterly modelling of the ivory, and, in addition, the general decorative effect, are quite sufficient to justify the remarks which have been made concerning the revival in Belgium of ivory sculpture.

Fernand Khnopff is well known as a painter in the modern art world. His contribution to the collection of ivories is in the nature of a fragment, for we have a face only in ivory with small wings, and wreaths surrounding it, of bronze.

The "Venusberg" of Egide Rombaux is somewhat

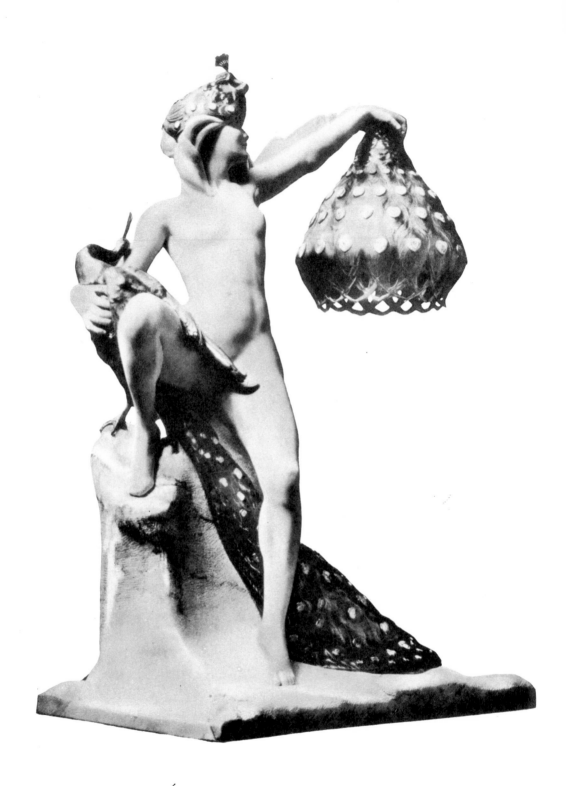

Plate 86. "FÉE AU PAON." BY PHILIPPE WOLFERS

IVORY, SILVER-GILT, OPALS AND TRANSLUCENT ENAMELS

of a *tour de force*, considering the restrictions imposed by the form of a tusk. These he has cleverly surmounted in his group of three nude women struggling together, with outstretched limbs.

Phillippe Wolfers is a leading Brussels goldsmith who has a considerable reputation also as a sculptor. We have from him, as we should expect to have, some delightful examples of ivory carving in conjunction with gold and silver, marble, onyx, enamel, and precious stones. There are few things in art, perhaps, more difficult to combine without a suggestion of vulgarity, but the work of Wolfers has nothing of the character of that which bears the stamp of the commercial atelier. It is delicate, refined, and personal, because as a true artist he designs and executes himself. To use the language of the bookbinder's craft, he is his own forwarder and finisher. Of this chryselephantine work we have from him a "Juno" or a "Fée au Paon" in ivory, silver gilt, marble, translucent enamels and jewels, and he has taken also a tusk in its entirety, which is upheld, as it were, by a swan in bronze in such a manner that the neck and wings of the bird embrace it. Mention must also be made of the elegant ivory and jewelled combs and hairpins which he has designed and executed. In his "Twilight hair ornament" we have one of his favourite subjects—a bat treated symbolically, with the membrane and outline of the wings delicately indicated.

Charles Samuel, also a leading Belgian sculptor, contributed to the ivory exhibition a semi-draped figure, "Fortuna," delightfully poised, and bearing a cornucopia in silver and gold, an example also how the most can be made of a tusk. His other ivory works are a draped figure, in the act of running, in ivory and silver-gilt; "Nèle," a bust in ivory and wood; "Les lis"; and "Dawn."

Alphonse van Beurden is perhaps better known, as an ivory sculptor, in England than in his own

country. In 1896 he exhibited at our Royal Academy a "Bacchante," in 1898 a bust, and in 1899 "The Snake Charmer."

A brief enumeration must suffice for other examples of ivory sculpture by Belgian artists. Amongst them are an excellent small bust—a " Psyche," a replica of a marble—by the late Paul de Vigne ; a "Calvaire," by Henri Boncquet, exhibited at the Paris Salon in 1899 ; the "Chrysis," a statuette with charming drapery from waist to feet, by Godefroid Devreese ; a portrait statuette, by Thomas Vincotte ; a marriage coffer in ivory and bronze, and a full-length " Dead Christ," in ivory and wood, by A. de Tombay. Other names are Paul Dubois, Craco, de Rudder, Jespers, Lefever, A. des Enfans, J. Dupont, Weygers, J. Geleyn, Pierre Braecke, and Lagae.

It was not long before the influence of the Flemish revival made itself felt in Paris. The end of the nineteenth century had seen a general renaissance of the decorative arts, and what is known as *l'art moderne* had been created. Artists of all kinds confined themselves no longer to one particular branch of art. They began again to take advantage of everything which could add beauty to objects made for the most utilitarian purposes. New fantastic forms were invented to correspond with new fantastic requirements. No doubt the modern style has sometimes been carried to extremes. It was inevitable that it should pass through a period of extravagance and exaggeration ; indeed, in all new departures exaggeration is at first almost a necessity. Thus it came about that casting around, as it were, for new fields to occupy, and the lead having been given, it was found that sufficient material existed to organise an exhibition of the revived art of ivory carving. This was done—on a modest scale, perhaps, and with little blowing of trumpets—in the spring of 1903, at the Musée Galliéra in Paris, with complete

success if we may judge from the standing of the sculptors who exhibited and the interest taken by the public. A limitation was made restricting exhibits to the last and present century. It is true that very little previous publicity was given, and French art was almost exclusively represented. But a beginning, at least, was made.

As a matter of fact it cannot be said that the profession of ivory sculptor alone exists. We shall find amongst those who practise it nearly always a diversity of talent. They are painters, designers, enamellers, gold and silver smiths, and in the first place marble and bronze sculptors.

At this special exhibition there was, of the older Dieppe school, a really original head of a fisherman, by the elder Graillon, and a group of the "Visitation," in which the draperies are excellently treated, by Félix Graillon. A nude "Phryne," by Vever, and a "Frileuse," by Scailliet, were remarkable, and still more so the "Charmeuse," by Caron, an essentially Parisian type— a graceful figure, in which the delicate character and satiny surface of ivory is singularly appropriate in conjunction with the snake in bronze, which is held up and entwines itself around the figure. Another group, "Le Lion amoureux," is by Gardet. The nude figure reclines, resting her head against that of the lion, while she holds a paw in one hand and clips the claws with the other. Amongst other notable figures were the "Young girl of Boussada" by Barrias and the "Chrysis Victrix" by Allouard. In the Salon of 1902 a crucifix had already been exhibited by Eugène Bourgoin and a "Phœbe" by Delacour, and in that of 1898 a fine group of "Leda and the Swan" and a St. George in bronze and ivory by Ferrary, and a "Japanese girl" in jade and ivory by René Foy.

But amidst a host of minor work which cannot now be followed in detail there are at least three sculptors of

eminence, to some of whose work more particular attention must be given. They are Jean Dampt, Théodore Rivière, and Madrassi. From such an artist as Dampt one would expect nothing less than his beautiful group, "Paix du Foyer." It is in ivory and wood, a homely group of a woman seated beneath a dais, a cat nestling up to her, and a dog leaning familiarly against her. The treatment is decorative, and very admirable are the contrasts of the grain of the wood against the lighter tonality of the portions which are carved in ivory. The figure itself is in ivory, the mantle which covers her, the dog, and the cat of wood. Another delightful and well-known group by the same artist is his "Raymondin and Melusine." It is executed in ivory and steel. A knightly figure in full armour, the vizor of his helmet raised, draws to him a young girl, who, her eyes closed, lifts her face to his kiss. The pose is charming; the contrast of the slim figure, which is in ivory, with the steel arms which tenderly embrace her, the mailed hand against the soft cheek, every line and fold in this group—small as it is—are arranged with great art. In the Salon of 1902 we had, by Dampt, the delightful group, "La Jeunesse" and the "Comtesse de Béarn," a bust in wood and ivory. More commonplace and less striking is the nude figure, "Femme couchée." The girl is reclining, hiding her face with one arm and raising the other with a lily in her hand.

The position of Théodore Rivière as a sculptor is well known, but it is less well known, perhaps, that it is not only recently that he has occupied himself with ivory carving, in which, like so many others, he would seem to prefer the intelligent mixture of precious materials. His "Jeune fille de Carthage" is an arrangement of ivory and white marble, the ivory for the flesh, the marble for the simple drapery. In "Salammbô" we have a majestic figure in ivory, entirely nude but for the thick draperies in bronze, which she has, as it

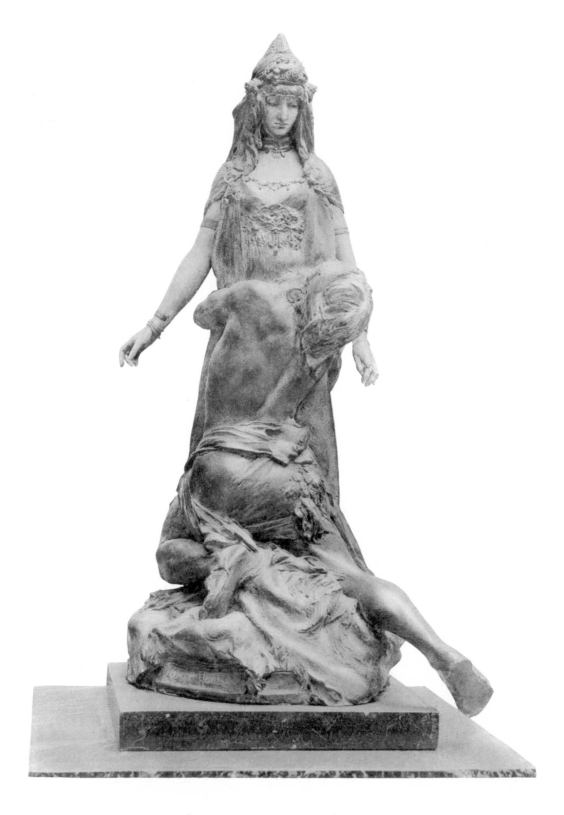

Plate 87. "SALAMMBÔ CHEZ MATHÔ." BY THÉODORE RIVIÈRE

were, thrown back from her, surrounding her in heavy folds. The modelling is firm and decided, the contrast of the ivory used for the flesh and part of the drapery, with the more sombre bronze, remarkable. Nor could praise be too freely given to the important group, "Salammbô chez Mathô." It is now in the Luxembourg. Other groups and figures by Théodore Rivière are a "Fra Angelico" in ivory, stone, and marble, the "Vierge de Sunnam" in ivory, marble, and goldsmith's work, the "Brodeuse Arabe," a portrait statuette of the Countess Récopé and a "Loïe Fuller" dancing. Madrassi has a full-length figure in two materials, "La Reconnaissance," the ivory used for the face, bust, and arms, and a "Théodora"; and another excellent portrait figure is by Reymond de Broutelles.

At a first exhibition it is of course inevitable that a considerable quantity of inferior work should find admission. With a new departure, as it were, there is certain to be a tendency to accept anything, merely because it happens to be in ivory. This was especially to be noticed in the case of the productions of commercial houses. The public calls for exuberant display, it is fond of richness and complication, of all sorts of materials mixed together without discernment, and the great goldsmiths' establishments supplied these things in profusion. The same criticism must apply to the greater number of the pretentious adaptations of ivory to jewellery, to combs, hairpins, fans, and the like. There is also the tendency to use ivory reduced to transparent fineness. This is seen, for example, in a fan, the sticks and guards formed of butterflies with outspread wings. Ivory is the last material to be used for such attempted realism. But among the crowd of articles of adornment or for toilet use an important exception must be made. It will suffice to say—though the temptation to go farther is difficult to repress—that such a great artist as Lalique was represented. A few

years ago he was unknown, but it is now unnecessary to add a word to the reputation which he has achieved. That his exquisite taste, his refinement, and his creative power should turn to ivory is of course certain. Nothing less than a dissection of the jewelled ornaments which his marvellous originality has conceived and executed could do justice to his work and to the possibilities which may arise from it. This is more than the space at our disposal will permit. But those who are acquainted with it will be as well able to judge for themselves the importance which it may have in the history of ivory sculpture. Nor can the name of Boutet de Monvel, who has used ivory in many charming designs, be omitted.

We come now to England, and if it cannot be said that we can produce an extended list of workers in ivory, on the other hand it will be admitted that those whose work remains to be noticed are in the first rank amongst our sculptors. No pretension is here made to compile a complete list.

The pages of the catalogues of the exhibitions of the Royal Academy during the last ten years or so of the nineteenth century—it would be hardly necessary to go farther back—will show, from time to time, solitary instances of art in ivory. We shall find in 1896 the work of the Belgian sculptor Van Beurden, and again in the two following years, when there was also a "Despair of Cleopatra," by Richard Garbe. In 1899 we have the group by Harry Bates, in 1900 Frampton's "Lamia," in 1901 the frieze by Lynn Jenkins, and "Andromeda," by Clovis Delacour. In 1893 Gérôme, who was an honorary Royal Academician, had exhibited his life-size "Bellona" in ivory and bronze. Now and again there are minor ornamental works, such as a lady's belt in ivory and silver, and some medallions by Garbe, or, in 1897, a mirror frame by the Countess Fédora Gleichen. And we may suppose that other

things would have gone direct from the artist's studio into the hands of the purchaser. In any case, it must be admitted that the list is not a lengthy one. But if not extensive, it makes up, as has been said, in quality.

In noticing English ivory sculpture we shall be again struck by the predilection for using it in conjunction with other materials. Again, also, we shall find amongst the artists the diversity of talent that distinguishes them not only as clever statuary sculptors, but skilled as painters and enamellers, in gold and silver smiths' work, or in the execution of bas-reliefs, plaques, and medals. It is hardly surprising that the decorative character of the mingling of materials should appeal to this versatility of genius. It is a difficult method to handle, but we know that in the use of metal or in adding colour or jewellery such an artist as Frampton, for example, will not offend by vulgarity. He does not appeal to purely sensuous feelings. There is no question of trickery or attempt to deceive, nor will the effect be tawdry or claptrap. And, then, how charmingly applicable is such a system—more than marble or bronze—to small sculpture! In the leaning towards modernity could anything be more suggestive than the introduction of portrait figures of everyday life or the poetic ideals such as the labourers and miners of Constantin Meunier? We cannot help thinking of the Tanagra figurines, but can there be any reason why the contrasts and tonalities of the flesh and draperies should not be harmoniously translated by the mingling of ivory with wood and metals? It is another question from that of colouring, and while it must be admitted that both are of too extensive a nature to be strictly within the scope of the present work, the allusion to them will be pardoned.

The work of George Frampton requires but little introduction. He is an all-round craftsman who astonishes us by the variety and fertility of his invention. He

appears to be completely unshackled by the traditions of the past and the usages imposed by convention. It has been said that he has been influenced by the study of Donatello. That may be, but in the main it must be seen that he goes to nature. There is, after all, an emancipation from tradition and precedents which is in itself logical and by no means a renunciation. Throughout all his work we find the note of simplicity and exact knowledge, the intuition which knows when to be lavish and where to stop. In the mingling of materials Frampton has already given us numerous examples in his other work. We need only recall his St. George in bronze, agate, and mother-of-pearl, his panels, or his figure of Dame Alice Owen in bronze and marble.

The bust of " Lamia," now in the possession of Mr. William Vivian, which is here illustrated, is an example of modern ivory carving which it is pleasing to be able to give. The face, with its studied serenity—cryptic, snake-like—is carved in life-size from a fine block of beautifully grained ivory. The quaint head-dress and arrangement of the hair in nets projecting on either side of the face, in the style which was fashionable in the reign of Richard II., the dress and covering of the shoulders and neck are of bronze, through openings in which ivory is again used for the flesh. The head-dress is jewelled, and so also is the elegant breast ornament, with opals, and the patina of the bronze should be noticed.

For the same reasons of variety in his work one is not surprised to find that Alfred Gilbert has applied himself to ivory carving. He also is a goldsmith, notably in the case of the fine epergne which he made for the late Queen. Neither, indeed, has he disdained lesser work, such as the designing and executing of necklaces and other objects of jewellery. He seems to revel in richness of decoration. Of his ivory, or mixed ivory work, the Vivian collection possesses two excellent

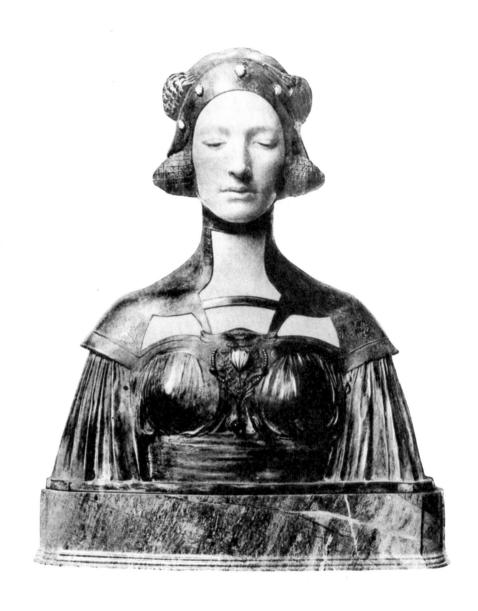

Plate 88. "LAMIA." BY GEORGE FRAMPTON, R.A.
(In the Collection of Mr. W. Vivian)

examples. One is a bust of a bishop in gilt and jewelled bronze and colour, the aged and wrinkled face of ivory. The other, also coloured and gilt, is a figure of St. Elizabeth, the roses, in accordance with the well-known legend, escaping from the folds of her cloak. Both are repetitions of the figures on the Clarence memorial, but not exact copies. The bishop was to have been full length, but Gilbert changed his mind.

In Mr. J. Lynn Jenkins we have a young sculptor who has executed a number of works for public institutions, in several of which he has availed himself of ivory as a medium. He has used it in a charming manner in the frieze which he made for the offices of Lloyd's Registry; mainly for the faces and hands of the figures, which are decoratively placed in bronze panels with scrolled edges amongst the main theme—in bronze and variously coloured materials—of galleys rolling on the waves.

Mr. Vivian possesses also two admirable figures in which ivory is mainly or partly used. The first, "Mors Janua Vitæ," is by the late Harry Bates. Life is represented by a delightfully modelled nude figure of a girl, the winged Death of bronze. And in "Launcelot and the Nestling" we have one of two companion statues by W. Reynolds-Stephens, the other being "Guinevere and the Nestling." Launcelot is a knightly figure in armour. In his arms lies a charming naked baby, which he holds with extreme tenderness as he looks down on it with smiling features. The base of the group is decorated with the symbolism which seems dear to the artist—rough branches on which doves are standing at intervals. It was exhibited at the Royal Academy in 1899.

Mr. A. G. Walker is another well-known English sculptor who has worked in ivory. Mr. Alexander Fisher has contributed caskets, tankards, and decorative

objects to various exhibitions, and Mr. W. Goscombe John, A.R.A., has executed some small work in this material.

The imperfection of the foregoing account of the present condition of ivory sculpture must be, to a great extent, admitted. There has been as yet but one not very widely known exhibition. Existing work is scattered in various collections, and it has been thought best to include that only of which there has been opportunity to acquire personal knowledge. For this reason particulars regarding Germany, Italy, and other foreign countries have not been included.

It is true that in order to justify the expectation of a revival of ivory carving we can as yet show comparatively few great names amongst a crowd of mediocrities and of more than indifferent work. But everything must have a beginning. Sufficient time has hardly elapsed to show the effect of the direct encouragement by the state in Belgium, of the exhibition in Paris, and of the work of such men as Dillens and Dampt and Frampton. We can hardly expect that a revival can come from scattered exhibits from time to time, and until more forcible attention is drawn to the question it would no doubt be premature to base hopes for the future. A great deal depends on the trend of fashion—in a word, of patronage. The most that can be said is that in the same way that modernity in art has through this achieved at least notoriety, so also in the case of a return to ivory for sculpture it cannot be dispensed with. When those who have the means can detach themselves from the collecting only of the antique, when the patronage of art becomes less applied to the profit mainly of the dealers, a step which is necessary will have been taken. It is useless to ignore this fact. The profession of sculpture especially demands in many ways expense. Under other conditions in the middle ages, as we have seen, men of the highest talent were

contented to allow their individualities to remain hidden. Public rewards and exhibitions were unknown to them. It is more difficult for the artist, nowadays, to sacrifice his material interests. Those whose works in ivory have been alluded to are, in the first place, great sculptors in marble. They naturally, in another direction, have regard to public requirements.

It may be questioned if even the Belgian sculptors worked solely for love of the material—much as they esteemed it—and not, rather, simply because the government of the Congo had placed in their hands, with a definite object, the superb tusks which came from that colonial possession. The result was to produce a certain movement in the desired direction and to show that a school of ivory sculpture could easily be formed, but that support was necessary for a prolonged existence. It was bounty-fed in fact, and through the apathy or want of tangible recognition on the part of those whose protection is essential in all the arts it was almost strangled at its birth. The public admired, the success was undeniable; but it was a *succès d'estime.* More than this is required. Undoubtedly from time to time the sculptor will use ivory as his medium. It is a delightful material to work, attractive, delicate, and graceful in results; grateful in every way to the artist. It bears to monumental sculpture something of the relation that miniature painting bears to the art of painting on a large scale. No new or special knowledge is required. Any sculptor can work it. What is essential is the creation of the model, to be afterwards reproduced in ivory. But still more essential are patronage and a market, and these at a figure worthy of a great artist. All this must be conceded. It cannot be denied that ivory sculpture since its most glorious days fell into bad hands and got a bad name. It is from the productions of the workshop that it has been judged. To the public, nowadays, carving in ivory

suggests China or India; nothing more. People will pay for industrial art what it is worth, but it is not at such a price that a sculptor of reputation can work. Nor should it be forgotten that from the point of view of the qualities of the material it costs as much to execute a statuette in ivory, a foot or so in height, as to produce a life-size statue in marble. No longer does the church encourage good art in the figures and statues of religious edifices. Images of quite another order take the places of the charming statuettes of the Madonna and the groups representing sacred subjects which mediæval art has given to us. When, also, we remember the large sums obtained for a Veroli casket, for ancient Byzantine, or mediæval caskets, or for a "Vierge de Boubon," we cannot help thinking what a great modern artist could produce of this kind if he were offered adequate inducement. Nothing could be more appropriate for presentation caskets than a simple one of ivory, deriving its principal value from the work of a sculptor of distinction; nothing more worthless than the hideous productions of the silversmith's shop, upon which the choice of a corporation so often falls to honour foreign potentates and distinguished guests.

A few points arise in connection with modern ivory carving which may be not without interest to notice. A minor one, perhaps, is the question to what extent the ivory should be polished. Its peculiar sheen and mellow colour are especially characteristic, but in certain instances the artist reduces these, and prefers a matt white surface which it is difficult to distinguish from marble. It need hardly be said that absolute polishing is not advisable. As an example of an excellent mean the smooth surface of the "Lamia" bust may be given.

Another thing which can hardly escape attention is the greater popularity of chryselephantine work, or the use of ivory as a secondary material. Looking back,

and following the history of the art as it has been attempted in these pages, it is difficult to know exactly what inference to draw, or the reason for the preference. More interesting still would it be to be able to explain why two such arts as ivory and wood carving, which in the past produced such masters, fell into disfavour. The popularity of a certain kind which the latter enjoys at the present time induces the question why great sculptors hold aloof. Minor arts they may be, but they are arts which have given us the mediæval ivories, the busts and groups of Dürer and of Riemenschneider, the canopies, stalls, and figures of the choirs of cathedrals, and the roodbeams of the churches, inferior in nothing but in mere size to the architecture and statuary in stone or marble within and without. The answer to this has, perhaps, just now been hinted at. May it not be said that if the renaissance of such things has not yet actually taken place, there are hopeful signs that it may come at any time? Neither the material nor the men are wanting. That in the case of ivory the one is worthy of the other, no one will have the hardihood to deny.

A LIST OF IVORIES TO WHICH REFERENCE IS MADE IN THE PRECEDING PAGES

THEIR ORIGIN, DATE, DIMENSIONS, AND THE COLLECTIONS IN WHICH THEY ARE NOW TO BE FOUND

NOTE.—It is intended that this list should serve to supplement the General Index, in which details which may here be gathered are therefore omitted.

Measurements in the case of diptychs are given of the diptych closed.

DESCRIPTION.	ORIGIN.	DATE OR CENTURY.	SUBJECT OR CHARACTER OF DECORATION.	APPROXIMATE DIMENSIONS IN INCHES.	COLLECTION.	PLATE.	PAGE.
Slabs and fragments	Dordogne	Prehistoric	Various	Fragment	St. Germain Museum	II.	43
Reindeer antler	"	"	Ibex	"	"	I.	52
Slab of mammoth ivory			Elephant	"	Jardin des Plantes	I.	48
Slab	Thaingen	"	Reindeer	"	Constance Museum	—	51
Slab	Dordogne	"	Glutton	"	St. Germain Museum	—	"
Reindeer bone	"	"	Woman and horse's head	"	Piette	—	52
Box	Egyptian	4000 B.C.	Plain	"	Louvre	—	55
Panel[1]	Nineveh	980-634 B.C.	Cartouche of Auben Ra	"	British Museum	III.	61
Plaque	"	"	Man with lotus	"	"	IV.	66
Fragments	"	"	Various	"	"	IV.	66
Fragments	Egyptian	1st dynasty	"	"	Various	—	69
Statuette	Roman	"	Penthea	H. 15	Cluny Museum	—	72
Fragments	Scytho-Greek	3rd "	Engraved	Fragments	Hermitage Museum	—	72
Tablet	Etruscan	3rd B.C.	Diana and stag	$1\frac{1}{8} \times 4$	Liverpool Museum	—	73
Fragment	Roman	—	Head of a woman	H. 6	Vienne Museum	—	73
Mirror handles	Mycenaean	7th B.C.	Arimaspes slaying Gryphon	Fragments	British Museum	—	73

[1] Birch thinks of 22nd dynasty.

Figure	Greek	2nd or 3rd	Tragic actor	Fragments	City of Paris	—	74
Fragments[1]	Roman	—	Various	"	British Museum	—	74
Fragments[1]	"	—	"	"	B. and other municipal m.	—	75
Parazonium[2]	"	—	Plain	"	Brussels Museum	—	75
Plaques, etc.[3]	Coptic, etc.	5th to 8th	Crosses, etc.	"	Various	—	75
Consular diptychs:—							
M. J. Philippus	Roman	248 A.D.	Circus games	11¾ × 4¾	Liverpool Museum	VII.	85
M. Aurelius	"	308	Apotheosis	11 × 5	British Museum	VI.	85
Unknown	"	3rd	Circus games	11⅓ × 4½	Brescia Museum	VII.	85
Probianus	"	322 A.D.	Consul	11⅘ × 5	Berlin Museum	VII.	87
Probus	"	406	Emperor	11 × 5	Aosta Cathedral	—	88
Fl. Felix	"	428	Consul	11½ × 5½	Paris Library	—	88
Valentinian II.	"	380	Emperor	13 × 6	Monza Cathedral	XI.	89
Fl. Ætius	"	454	Consul	11 × 5¼	" "	—	89
M. Boethius	"	487	"	13½ × 5	Brescia	VII.	90
Valentinianus	"	505	"	13 × 5	Berlin	VI.	90
Areobindus	"	506	Circus games	13 × 5	Basilewski	VIII.	90
Fl. Clementinus	"	513	"	15 × 5	Liverpool Museum	—	92
Justinian	"	516	Foliage	15 × 5¼	Paris Library	VII.	92
Fl. Anastasius	"	517	Consul	14 × 5⅓	Kensington Museum	V.	92
Probus	"	518	"	14¾ × 5	Paris Library	—	93
Philoxenus	"	525	Circles and busts	15 × 5½	Paris Library	VII, VIII.	95
Orestes	"	530	Consul	13 × 4⅖	Kensington Museum	V.	95
Unknown	"	5th or 6th	"	12½ × 5½	Novara Cathedral	VIII.	176
Basilius	"	534	"	13½ × 5	Uffizi	VIII.	96
Full list of consular diptychs		—	—			—	
Statuette	"	5th or 6th	Consul	H. 6.	British Museum	—	109
Leaf of diptych	"	2nd or 3rd	Bacchante	11¾ × 4¾	Kensington Museum	IX.	98
Leaf of diptych	"	"	Priestess	11¼ × 4¾	Cluny Museum	—	100
Diptych	"	3rd	Æsculapius and Hygieia	12½ × 5⅘	Liverpool Museum	X.	103
							105

[1] Found in England.　　[2] Found in Belgium.　　[3] Found at Sakkara and Akmin.

1 Maskell Collection.
4 The "Brescia" casket.
2 The diptych of Rambona.
5 2. Formerly in Abbey of Lorsch.
3 *Cfer.* plaque, 9th, 10th c. in B.M.
6 Bone plaque.

		Century	Subject	Dimensions	Location	Plate	Page
Figures on reliquary	Rhenish	12th	Figures	Various	Kensington Museum	—	159
Book covers¹	Byzantine	,,	Scriptural	9 × 6	British Museum	XXIII.	162
Chair arm (?)²	,,	,,	Foliage, etc.	2½ × 2	Formerly in Meyrick	XLIV.	162
Plaque	,,	7th to 9th	Holy coat	5¼ × 10¾	Treves Cathedral	—	163
Eland's antler	,,	9th	Scriptural	L. 32	Basilewski	—	163
Panagia	Russian	17th		D. 4¾	Vatican	XXIV.	166
Plaque	,,	16th	Glorification of B.V.M.	4⅛ × 3⅜	Soane	,,	168
Plaques of throne	,,		Mythological	Various	Kremlin	XXV.	168
Plaques	Russo-Byzantine	11th and 12th	The Saviour	,,	Brit. and Ken. Mus.	XVI.	—
Plaques of chair	Byzantine	11th			S. Peter's, Rome	XXV.	170
Plaque of reliquary	Carlovingian	10th		5⅝ × 3⅛	Kensington Museum	—	172
Plaques³	Roman	4th or 5th	Mythological	Various	Aix-la-Chapelle	—	177
Leaf of diptych⁴	,,	6th	Consul	6½ × 4	Kensington Museum	—	178
Diptych⁴	,,	,,	,,	14½ × 5½	Monza Cathedral	{VIII.– XXVI.}	178
Book-cover	French	9th	Ceremonial	2½ × 2¼	Paris Library	—	182
Plaques	,,	10th	,,	—	Louvre	—	183
Book-cover	,,	11th	,,	—	British Museum	—	183
Leaf of diptych	,,	9th	,,	11 × 4½	Frankfurt Library	XXVI.	183
Leaf of diptych	,,	,,	,,		Formerly Spitzer		183
Box	German	10th to 12th	Life of a saint	2⅝ × 2⅜	Kensington Museum	—	184
Statuette⁵	Italian	14th	Virgin and Child		Pisa Cathedral	—	195
Pax⁶	French	15th	SS. Roch and Sebastian	H. 4	British Museum	—	195
Pyxis	Arab	11th and 12th	Lines and circles		St. Gereon, Cologne	—	197
Casket	French	13th	Saints and shields of arms	13¼ × 6½	Kensington Museum	—	197
Plaque	French	14th	Open-work saints	5¾ × 4½	,,	—	197
Panels	Burgundian		The Passion	Various	,,	XXVII.	198
Casket	English	15th	Life of B.V.M.	4 × 8	,,	XXIX.	198
Book-cover⁷	French	14th	Thirty minute panels	6 × 4¼	British Museum	XXVIII.	204
Diptych	English	,,	The Passion	8¼ × 5	Kensington Museum	XXIX.	206
Diptych	,,	—	The Passion, etc.	,,	,,	—	208

¹ The Melisenda book-covers. ² The cast, only, at Kensington. ³ On pulpit in cathedral. ⁴ Palimpsest.
⁵ Attributed to Giovanni Pisano. ⁶ Inscribed "Jehan Nicolles," supposed name of artist. ⁷ Maskell Collection.

Description	Origin	Date or Century	Subject or Character of Decoration	Approximate Dimensions in Inches	Collection	Plate	Page
Diptych	English	14th or 15th	Figures	8 × 4	Salting	—	208
Plaque	French	15th (?)	Virgin and Child, etc.	4 × 3	Kensington Museum	—	208
Triptych	"	13th	New Testament scenes	7¾ × 8½	"	xxx.	210
Triptych[1]	English	14th	Sacred subjects	6½ × 8	British Museum	xxxi.	211
Leaf of diptych[1]	"	"	B.V. and St. John	4½ × 4½	"	"	211
Leaf of diptych[1]	"	"	Coronation B.V.M.	"	Louvre	"	211
Diptych	"	"	Life of the Virgin	5¾ × 2¾	Kensington Museum	—	211
Diptych	"	"	The Passion	10½ × 4⅞	Escalopier	—	213
Diptych	French	"	Gospel scenes	6⅝ × 4½	Kensington Museum	—	213
Diptych	"	"	The Passion	6 × 3½	Louvre	—	213
Leaf of diptych[2]	"	14th	New Testament scenes		British Museum	—	213
Statuette	"	"	Virgin and Child	7¼ × 2	Kensington Museum	—	214
Statuette	English	"	"		British Museum	—	214
Plaque	"	"	Subjects in circles	4½ × 4	Salting	—	214
Tablet	"	"	Crucifixion		British Museum	—	214
Plaque	"	15th	Henry VI.	9½ × 3¾	Liverpool	—	214
Plaques, diptychs, etc.	"		Various		Ashmolean	—	214
Diptych	French	14th	The Passion	12¾ × 4½	Kensington Museum	xxxii.	214
Diptych	"	"	V. and Child and Crucifixion	6¼ × 4½	"	"	216
Diptych	"	"	Virgin and Child	12 × 12	"	xxxiii.	217
Shrine	"	"	"	8¾ × 6½	"	xxxiv.	219
Shrine	"	"	"	13½ × 7	"	xxxiii.	219
Diptych	"	"	New Testament scenes	7 × 5	Fitz-Henry	xxx.	219
Diptych	"	"	The Passion	10¼ × 4½	Kensington Museum	—	219
Leaf of diptych	"	"	Virgin and Child	4 × 4	Rev.Ethel.Horne,O.S.B.	xxxiv.	—
Leaf of diptych[3]	"	13th or 14th	Crucifixion		Wallace	xxxv.	222

[1] The Grandisson. [2] Found at Mansfield. Another of the same school, probably of Siena, lately acquired by Mr. Pierpont Morgan, is in the Loan Collection at South Kensington.

[3] The very large and splendid retable of Poissy, in the Louvre, is well known.

Object	Nationality	Date	Subject	Size	Location	Plate	Page
Retable	Italian	14th	Gospel scenes	27½ × 17¼	Kensington Museum	XXXVI.	223
Statuette	French	13th	Virgin and Child	H. 8¼	" "	—	225
Statuette	"	14th	"	H. 14	Formerly Barker	XXXVII.	225
Statuette	English	"	"	24 × 6	British Museum	—	226
Statuette	French	13th	"	H. 15	British Museum	—	228
Triptych[1]	French	13th	"*Vierge ouvrante*"	H. 15	Louvre	LXXXIV.	229
Triptych[1]	"	"	"	"	Lyon Museum	—	229
Triptych[1]	"	"	"	"	Rouen Museum	—	229
Triptych	"	"	"	H. 18	Formerly Carmichael	XXXVIII.	230
Plaque	Flemish	15th	Virgin fainting	5 × 4	Kensington Museum	XL.	235
Group[2]	German	"	St. George and Dragon	H. 6	Salting	—	235
Group	"		"		Wallace	—	235
Group	French	13th	Coronation of B.V.M.	H. 10	Louvre	XXXIX.	235
Figure	"		St. Joseph		G. de Rothschild	—	236
Statuettes	"	13th and 14th	Virgin and Child		Louvre	—	238
Group	"	14th	Coronation of B.V.M.	H. 3	Kensington Museum	XXXIX.	238
Diptych	Flemish	15th	Dormition and Crucifixion	2 × 2	Wallace	XXXV.	239
Group	French	13th	Deposition	H. 12	Louvre	Frontispiece	240
Plaque	Byzantine	10th			Formerly Spitzer	—	241
Group	French	13th	Annunciation		Langres Museum	—	242
Statuette	"	"	Virgin and Child		Villeneuve-les-Avignon	—	242
Plaque	Flemish	15th	Deposition	D. 4	Kensington Museum	XL.	242
Situla	German	10th to 12th	Figures	7 × 5	Aix-la-Chapelle	—	243
Situla	Italian	10th	"	7 × 5	Milan	—	243
Flabellum case[3]	French	9th	Foliage, figures, etc.	H. 36	Bargello (Carrand)	—	245
Flabellum (fragment)[4]	"		Capital of column, etc.	H. 2	British Museum	—	245
Flabellum handle[5]	French	12th	Figures and animals	4½ × 1½	British and Kensington	XL.	244
Flabellum handle[5]	"	"	Months of year	4½ × 1⅛	British Museum	—	245
Flabellum handle	"	"	Arabesques, figures, foliage	9 × 1½	Cluny Museum, Paris	—	245
Paxes	Various	8th to 10th	Various	H. 5	Kensington and others	—	247
Memento mori	German	13th to 15th	Human life		Kensington Museum	XL.	247

[1] Authenticity doubtful. [2] Formerly in Magniac. [3] The flabellum of Tournus. [4] Maskell Collection.
[5] Part of handle in British Museum in shape of capital of a column, with figures, monkeys, etc. Another part has figures of the twelve apostles, etc.

DESCRIPTION.	ORIGIN.	DATE OR CENTURY.	SUBJECT OR CHARACTER OF DECORATION.	APPROXIMATE DIMENSIONS IN INCHES.	COLLECTION.	PLATE.	PAGE.
Tablets	French	14th	Various	—	Kensington Museum	—	249
Casket[1]	Italian	15th (?)	Cherubs	L. 23	Florence, Duomo	—	249
Sceptre[2]	Carlovingian	9th	Sceptre of Charlemagne	$6\frac{1}{2} \times 2\frac{1}{2}$	Aix-la-Chapelle	—	253
Tau	N. Europe	11th	Arabesques and figures	5×2	Rouen Museum	—	258
Tau (?)[3]	"	"	Signs of zodiac, etc.	—	Kensington Museum	XLI.	260
Tau	French	"	Lion attacking horse		" "	—	260
Tau[4]	"	12th	Scrolls with figures	$5\frac{5}{8} \times 1\frac{3}{4}$	" "	XLI.	260
Tau[5]	N. Europe	11th	Acanthus, as on head of a column	—	Maestricht Cathedral	—	277
Tau[6]	"	12th	Crucifixion, figures, lions' heads	5×2	Deutz, church at	—	277
Tau	"	"	Arabesque with figures	5×3	British Museum	XLI.	277
Tau	"	"	Serpents, men struggling, archangel, etc.	$6\frac{3}{8} \times 2\frac{1}{4}$	Kensington Museum	XLI.	261
Taus, List of[7]	—		Foliage, medallions	6×3	Basilewski	—	261
Crosier	"	13th	Serpent and lamb	6×4	Convent, Namur	—	262
Crosier	"	"	"	"	Ashmolean	—	262
Crosier	Italian	12th	"	"	St. Gregorio, MonteCelio	—	262
Crosier	Siculo-Arab	13th	Serpent's head, figures and busts	"	Salting	—	263
Crosier[8]		13th	Serpent and lamb	60 × 5	Kensington Museum	—	263
Crosier[9]	French	"	Double subject	$8\frac{1}{4} \times 4\frac{7}{8}$	" "	XLII.	263
Crosiers[10]	Various	13th and 14th	"		Kensington and others	XLII.	265

[1] Casket of the holy "cingolo."
[2] An ivory sceptre in English regalia.
[3] A fragment, probably head of ordinary staff.
[4] Schaepkens describes as the "canne" of St. Servais.
[5] Tau of St. Herebert.
[6] Found at Alcester, 1903. Exhibited at the Society of Antiquaries by the rector of Alcester before it was acquired by the museum. The story told at page 200 is therefore hardly likely to be true.
[7] See list, page 214.
[8] The whole staff.
[9] The Soltikoff crosier.
[10] Crosier head in British Museum, ox of St. Luke within serpent volute, 12th century; another, French, with the crucifixion, 14th century; another, Italian, with ram, eagles, and a small animal within volute, 14th century.

Item	Origin	Century	Subject	Size	Location	Plate	Page
Crosier	English	14th	Double subject	8 × 5	Howard of Corby	—	266
Crosier[1]	German	13th	Serpent and lamb	—	Hildesheim Cathedral	—	266
Crosier[2]	"	12th	Serpent, Annunciation	—	Bamberg Cathedral	—	266
Crosier[3]	Rhenish	11th	Plain	—	Cologne Cathedral	—	266
Crosier[4]	French	11th	Serpent and cockatrice	5 × 4	British Museum	—	266
Crosier[5]	English	13th	Serpent and man	5 × 3	"	—	267
Crosier[6]	French	11th	Scriptural	—	Pontoise	—	267
Crosier[7]	"	12th	Translation of saint	—	Arles	—	267
Crosier[8]	Italian	14th or 15th	Bishop, angels, etc.	8 × 5	Salting	—	267
Fragment[9]	"	14th	Pietà and Agony in Garden	3 × 3	B.M. Maskell Collect'n.	LII.	267
Crosier	French	18th	Rococo	10½ × 6½	Kensington Museum	—	268
Crosiers, List of[10]	—	—	—	—	—	—	—
Comb[11]	English	11th (?)	Foliage and lions	4½ × 3	Durham Cathedral	—	272
Comb[12]	French	"	Foliage, etc., notched	4¾ × 5½	St. Etienne, Sens	—	272
Comb	German	9th (?)	Crucifixion, angels, notched	4⅞ × 7¼	Cologne Museum	—	272
Comb[13]	Carlovingian	7th (?)	Persian character	—	"	XLIII.	273
Comb[14]	Oriental	10th		—	"	—	273
Comb[15]	French	"	Doves and grapes	5 × 4	Malonne	—	273
Combs	Carlovingian	9th to 11th	Foliage and birds	6 × 5	Nancy Cathedral	—	274
Comb[16]		"	Floral arabesques	5 × 4	Brussels Museum	—	274
Comb	English	"	New Testament scenes	—	Abbey of St. Hubert	—	274
Comb[17]	"	13th	Leaf work and figures	8 × 3¼	Hardwicke Court	XLIII.	274
Comb[18]	German	12th	Scroll work, notched	6 × 5	British Museum	—	275
List of combs		11th			Quedlinburg	—	276
Crepitaculum[19]	Italian	12th	Figures, gospel scenes	15¾ × 6	Basilewski	—	282
Casket[20]	Byzantine	11th	Mythological	15 × 6	Kensington Museum	XLIV.	286
Casket	German	"	"	6¼ × 3¾	Brussels Museum	—	286
Casket	"	"	Interlaced work	—	Kensington Museum	—	287
Casket[21]	Northumbrian	11th or 12th	Runic inscriptions	9 × 5	British Museum	XLV.	287

[1] Of Bishop Otho. [2] Of St. Otto. [3] Of St. Annon. [4] Of St. Bernard. [5] Of the Abbot of Peterborough.
[6] Of St. Gautier. [7] Of St. Trophimus. [8] With its case of *cuir-bouilli*. [9] Part of group in a volute of crosier. [10] See list, page 215.
[11] Of St. Dunstan. [12] Of St. Lupus. [13] Of St. Herebert. [14] Of St. Berthuin. [15] Of St. Gauzelin.
[16] Of St. Hubert. [17] Maskell Collection. [18] Of Henry II. [19] A flabellum case (?). [20] The Veroli casket. [21] The "Franks" casket.

DESCRIPTION.	ORIGIN.	DATE OR CENTURY.	SUBJECT OR CHARACTER OF DECORATION.	APPROXIMATE DIMENSIONS IN INCHES.	COLLECTION.	PLATE.	PAGE.
Casket	N. Europe	—	Like the "Franks"	—	Bargello, Florence	—	288
Casket	„	11th or 12th	Calligraphic animals	5×5	Brunswick Museum	XLV.	290
Casket¹	German	10th or 11th	Interlacements	$10\frac{1}{2} \times 5$	Bav. Nat. Museum	—	292
Casket	N. Europe	„	„	24×11	Cammin Cathedral	—	292
Casket	French	14th	Romance scenes	$10 \times 4\frac{1}{4}$	Kensington Museum	XLVI.	295
Marriage coffer	Italian	15th	Pyramus and Thisbe, etc.	$H12\frac{1}{2} D12\frac{1}{4}$	„ „	XLVII.	299
Casket	English	—	Hawking party, etc.	$5 \times 2\frac{7}{8}$	„ „	—	299
Mirror case	French	14th	Castle of love	D. $5\frac{5}{8}$	„ „	—	300
Mirror case	„	15th	Tournament, etc.	D. $5\frac{1}{2}$	Wallace Museum	XLIX.	301
Mirror cases	„	14th	Various	—	Kensington Museum	XLVIII.	299
Mirror cases	„	14th	Various	—	British Museum	—	299
Fragment²	French (?)	14th	Knights in armour	5×3	British Museum	—	301
Mirror³	„	16th	Costume of Louis XII.	H. 8	Louvre	—	304
Toilet combs	Roman	1st to 4th	Various	—	British and L'pool M.	—	304
Toilet combs	Italian and Engl.	14th and 15th	„	—	Kensington Museum	L.	306
Writing tablets	Northern	9th to 12th	Interlaced work	3×2	British Museum	—	309
Scribes' rests	French and Ital.	14th and 15th	Figures on top	L. 10	Kensington Museum	—	310
Tenure horns⁴	English	11th, etc.	Various	—	Various	—	311
Horn	Northern	11th	Byzantine	$24 \times 5\frac{1}{4}$	Kensington Museum	LI.	312
Horn	French	16th	—	—	„ „	„	—
Horn	German	15th	Hunting scenes, etc.	26×5	„ „	„	314
Horn	Northern	11th or 12th	Scroll work and deer	—	Soc. of Antiq., Scotland	—	314
Seal	Anglo-Saxon	—	Figures	—	British Museum	—	315
Handle of seal⁵	Italian	14th	Bishop and archangel	3	„ „	—	315
Seal	English	—	St. Alban	—	„ „	—	315
Rosary ring⁶	„	14th	Knobs and bosses	—	Waterton	—	315

¹ Casket of Cunegunda. ² Part of valve of mirror case. ³ Shield shaped with handle. ⁴ The Ulphus, Carlisle, Bruce, Blackburn, etc., horns.
⁵ Formerly in Gherardesca. ⁶ Waterton considered it Irish.

Figure for crucifix	Byzantine	10th	Figure of our Lord	7½ × 5¼	Kensington Museum	—	326
Cross	Scandinavian	—	Sacred subjects	11½ × 9	Copenhagen Museum	—	326
Crucifix	Byzantine	11th	Foliage, interlacements, arabesques	—	Madrid Museum	—	326
Arms of cross	"	"	—	—	Louvre	—	327
Fragment	—	—	Figure of our Lord	H. 6	Kensington Museum	LII.	329
Fragment	English	12th	" "	—	Guildhall Museum	—	330
Crucifix	German	17th	—	—	Munich	—	331
Crucifix	Flemish	"	—	H. 18	Comte de Grunne	—	331
Crucifix[1]	French	"	—	—	Avignon Museum	—	332
Crucifix	Flemish	1681	—	—	Tours	—	334
Crucifix	German	17th	—	H. 19	Downside Abbey	LIII.	336
Crucifix	"	"	—	H. 30	Oscott College	—	337
Crucifix[2]	Italian or German	"	Spanish, perhaps, as regards colouring and treatment of the hair and beard. For that matter the sculptor may have followed some Spanish models	H. 20	S. James's, Spanish Place London	LIV.	337
Crucifix	German	"	—	H. 24	British Museum	—	339
Crucifix[3]	"	17th	—	—	Vienna Museum	—	339
Crucifix[4]	German	"	—	—	Florence Museum	—	339
Crucifix[5]	"	"	—	—	Brunswick Museum	—	339
Crucifix[6]	"	"	—	—	Frauenkirche, Munich	—	339
Plaque	"	10th to 12th	The Flagellation	2 × 2	Formerly Sneyd	—	340
Plaque[7]	"	16th	"	6 × 5	British Museum	—	340
Triptych	Florentine	"	The Deposition	—	Florence Museum	—	342
Triptych	"	"	Gospel scenes	24 × 14	Louvre	LV.	342
Group	Flemish	"	Virgin and Child	H. 8	"	LVI.	342
Group	French	14th	" "	H. 10¾	Kensington Museum	"	—
Triptych	"	"	Louis XI. "	—	Louvre	—	344

[1] By Guillermin.　[2] Cfr. the crucifix called of Charles-Quint in the chapel of the Pères de l'Assomption, Paris.
[3] By Petel.　[4] By Barthel.　[5] By Permoser.　[6] By Bendel.　[7] Maskell Collection.

[533]

DESCRIPTION.	ORIGIN.	DATE OR CENTURY.	SUBJECT OR CHARACTER OF DECORATION.	APPROXIMATE DIMENSIONS IN INCHES.	COLLECTION.	PLATE.	PAGE
Plaque	Italian	15th	St. Sebastian	$9\frac{5}{8} \times 4\frac{3}{4}$	Kensington Museum	—	344
Plaque	Flemish (?)	17th	Dead Christ and angels	9×6	British Museum	LVII.	345
Plaque[1]	German	1616	The Temptation	6×4	"	—	345
Memento Mori[2]	"	16th	Skull, etc.	—	"	—	345
Memento Mori	French	15th	"	—	Liverpool Museum	—	347
Rosary Beads	Flemish	16th	Various	—	Louvre	—	347
Sceptre	French	17th	"Main de Justice"	25	Londesborough	—	358
Powder-horn[3]	"	16th	A cupid and seahorse	—	Louvre	—	—
Figure	German	"	Psyche	5	"	—	352
Figure	"	"	Young Girl and Death	6	Bav. Nat. Museum	—	352
Plaque[4]	"	"	Last Judgment	6	Vienna Museum	—	354
Group[5]	"	"	Allegorical	—	"	—	355
Grace cup	English	12th (?)	Plain	—	Howard of Corby	—	359
Figure	Italian	—	Hercules	6	Wallace (?)	—	360
Statuette	Italian (?)	17th	Virtue and Vice	—	Cluny	—	360
Plaque	Italian	"	Conversion of Saul	—	Bav. Nat. Museum	—	362
Plaques[6]	Flemish	"	Youthful Bacchanalians	$4\frac{1}{4} \times 6$	Kensington Museum	LVIII.	365
Plaques[6]	"	"	Diana and nymphs	$4\frac{1}{2} \times 6\frac{1}{2}$	"	—	365
Figure[6]	"	"	Cupid	—	Green vaults, Dresden	—	365
Plaque	German	"	David and Bathsheba	8×5	Wallace.	LIX.	366
Tankard[7]	Flemish	"	Nymphs and satyrs	H. 6	Jones (S.K.M.)	LX., LXI.	369
Cup and cover[7]	"	"	"	—	Vienna Museum	—	370
Tankard[7]	"	"	"	—	Karlsruhe Museum	—	370
Plaques[8]	"	"	Nymph and boys	11×5	Cluny	LXII.	373
Plaques[9]	"	"	Various	—	Brunswick Museum	—	374
Coin cabinet[10]	German	"	Mythological	32×18	Bav. Nat. Museum	{LXIII. LXIV.}	377

[1] By Angermair. [2] By Harrich. Maskell Collection. [3] Style of Jean Goujon. [4] By Steinhards.
[5] By Maucher. Maskell Collection. [6] Attributed to Duquesnoy. [7] By Fayd'herbe (?). [8] By Van Opstal. [9] By Van Bossuit. [10] By Angermair.

Object	Origin	Century	Subject	Size	Locality	Plate	Page
Plaque¹	German	17th	Holy Family	—	Bav. Nat. Museum	—	377
Plaque¹	„	„	Virgin and saints	—	„	—	377
Plaque²	„	„	St. Jerome	—	„	—	378
Group³	„	„	Adam and Eve	—	Berlin Museum	—	378
Group³	„	„	St. Jerome	—	Vienná Museum	—	378
Tankard⁴	„	„	Mythological	H. 12.	Kensington Museum	—	379
Salt⁴	„	„	„	„	Chérémèteff	—	379
Clock⁵	„	„	Nymphs and satyrs	„	Karlsruhe Museum	—	379
Rosewater dish⁶	„	„	Mythological	36 × 24	Berlin	—	380
Ewer⁶	„	„	Horses, men, etc.	12	Hohenlohe	—	380
Groups⁷	„	„	Centaurs, etc.	H. 8	Bav. Nat. Museum	—	380
Figure	„	„	Dance of Death	H. 9¼	Kensington Museum	—	381
Cups⁸	„	„	Turned work	H. 9	„	LXV.	381
Hunting-horn⁹	Italian	16th	Arabesques	L. 24	Rothschild	—	384
Plaques¹⁰	French	18th	Various	—	Holbourne (Bath)	—	384
Beads	„	„	Piqué with gold	—	Wallace	—	385
Medallions¹¹	„	„	Portraits	—	British Museum	LXVI.	387
Plaque¹²	English	16th	Satirical	—	„	„	387
Plaque¹³	German	17th and 18th	Hunting scene	3¾ × 4½	„	LXVI.	387
Tobacco graters	Various	16th and 17th	Various	L. 5	Kensington and Wallace	LXVII.	388
Knives and forks, etc.	„	18th	Various	—	Kensington and various	—	390
Fans	„	„	„	—	Various	—	390
Model	N. Europe	16th	Yakuts' camp	—	British Museum	—	391
Hat¹⁴	W. African	18th	Plaited strips	—	„	—	391
Chains	Archangel	—	Minute work	—	Kensington Museum	—	391
Chessmen¹⁵	N. Europe	11th or 12th	Various	H. 4	British Museum	{ LXVIII. / LXIX. }	400
Chessman	Anglo-Saxon	—	King	—	Paris Library	—	403
Chessmen	Oriental	—	Various	—	—	—	403
Chessmen	N. Europe	12th	King	—	—	—	—

¹ By Angermair. ² By Petel. ³ By Kern. ⁴ By Strauss. ⁵ By Elhafen. ⁶ By Maucher. ⁷ By Rauchmiller.
⁸ By Heiden and Senger. ⁹ Formerly in Fountaine. ¹⁰ By Voyez (?). ¹¹ By Le Marchand and Cavalier.
¹² Formerly in Meyrick Collection. ¹³ Maskell Collection. ¹⁴ Formerly belonged to Glover family. ¹⁵ The Lewis Chessmen.

DESCRIPTION.	ORIGIN.	DATE OR CENTURY.	SUBJECT OR CHARACTER OF DECORATION.	APPROXIMATE DIMENSIONS IN INCHES.	COLLECTION.	PLATE.	PAGE.
Chessman[1]	N. Europe	11th or 12th	Bishop	H. 4	British Museum	-	402
Draughtsmen[2]	Byzantine	„	Various	2½	„	LXIX.	408
Draughtsmen	„	11th to 13th	People playing draughts	„	Kensington Museum	„	409
Draughtsmen	English	10th	S. Martin	„	Ashmolean	-	409
Box	Moorish	„	Foliage, birds, etc.	4 × 3	Kensington Museum	LXX.	413
Casket	Saracenic	„	Various		Sens Cathedral	-	413
Casket	„	„	Persian character	6 × 3	Kensington Museum	-	414
Caskets[3]	Siculo-Arab	12th or 13th	Figures of saints, etc.	7 × 4	„	-	415
Plaque[4]	Spanish	17th	St. Francis	9 × 5½	„	-	415
Group[1]	W. Africa	16th	"Shepherd" rockery	H. 6	Liverpool and Brit. M.	-	417
Horns and bowls[5]	„	15th and 16th	Various		British Museum	LXXI.	418
Horn	„	„	„		Spencer	-	418
Plaques[6]	Cingalese	17th	Arabesques	H.7¼,L.11½	India Museum	LXXII.	427
Casket[7]	Indian	„	Figures, etc.		„	„	427
Dipper[8]	Cingalese	„	Foliage, etc.	L. 15	„	-	427
Palanquin	Indian	„	Animals, etc.		„	-	427
Furniture	„	19th	Various		„	-	428
Casket	„	17th	Scroll work, lions, etc.	8 × 5	Formerly Feuardent	LXXIII.	430
Boxes	Arab	13th	Openwork		India Museum	-	430
Marquetery	Saracenic	-	Inlay		Kensington Museum	LXXIV.	430
Mortar	Chinese	-	Dragons, etc.	H. 3	„	LXXV.	434
Mortar	„	-	„		Oscott	-	434
Puzzle-ball	„	-	Lacework	D. 3	Kensington Museum	LXXV.	434
Netsukés	Japanese	18th and 19th	Various		Seymour Trower	{ LXXVI. LXXVII. }	440
Netsukés	„	„	„		British Museum	LXXVIII.	440

1 Maskell Collection. 2 Formerly in Magniac. 3 A curious Siculo-Moresque casket in Town Hall, Bodmin.
4 Ascribed to Cano. 5 Arms of Ferdinand and Isabella. 6 Nevill Collection.
7 Formerly in Meyrick. 8 Knife-handles of similar style in Bargello (Carrand).

Item	Origin	Date	Description	Size	Location	Plate	Page
Couch and chairs	Italian	17th	Ebony inlaid ivory	—	Jones (S.K.M.)	—	459
Chairs and table[1]	Indian	18th	French style	—	,"	LXXIX.	459
Furniture	Indian	"	English style	—	H.M. the King	—	459
Harp	Flemish	15th	Fleur-de-lys, etc.	—	Louvre	LXXX.	460
Musical instruments	Various	16, 17, 18th	Various	—	Kensington Museum	—	465
Saddle	Italian	13th	Foliage and figures	20 × 10	Louvre	—	466
Saddle	German	15th	Figures and scroll	—	Wallace	—	467
Arms		16th and 17th	Inlaid	—	,"	LXXXI.	468
Powder-flasks	Italian	"	Various	—	,"	LXXXII.	472
Casket	German	1630	Inlaid	10 × 8	,"	LXXXIII.	472
Antlers	"	16th	Engraved	—	Tweedmouth and Rothschild	—	473
Wristguard	French	1608	Blacksmith's shop	2 × 1	Wallace	LXXXII.	473
Serving-knives, etc.	Various	16, 17, 18th	Various	—	,"	—	473
Figure[2]	French	19th	Minerva	9 feet	Troyes Museum (the model is here)	—	478
Statues[3]	Greek	—	Various	—		—	503
Forgeries		—		—		—	485
Triptych	French	19th	"Vierge ouvrante"	—	Louvre	LXXXIV.	485
Modern work	French and Ital.	"		—		—	501
Figure[4]	Belgian	"	"La Gloire"	—	City of Brussels	LXXXV.	501
Crucifix[5]	"	"		—	,"	—	501
Bust[6]	"	"	"Sphinx"	—	,"	—	502
Head[7]	"	"		—	,"	—	502
Group[8]	"	"	"Venusberg"	—	,"	—	502
Group[9]	"	"	"Fée au Paon"	—	Private collection	LXXXVI.	509
Combs and hairpins[10]	"	"	Various	—	,"	—	509
Figures[10]	"	"	"Fortuna," "Dawn," etc.	—	City of Brussels	—	509
Figures[11]	"	"	Bust and the "Snake Charmer"	—	Alfred Mosely	—	504
Figures	"	"	Various	—	Various	—	504

[1] Others of same suite in Soane Museum. [2] Simart's chryselephantine. [3] Ancient chryselephantine.
[4] By Dillens. [5] By Meunier. [6] By Van der Stappen. [7] By Khnopff.
[8] By Rombaux. [9] By Wolfers. [10] By Samuel. [11] By Van Beurden.

Description.	Origin.	Date or Century.	Subject or Character or Decoration.	Approximate Dimensions in Inches.	Collection.	Plate.	Page.
Figure[1]	French	19th	"Charmeuse"	—	Private collection	—	511
Group[2]	,,	,,	"Paix du Foyer"	—	,,	—	512
Group[2]	,,	,,	"Raymondin et Melusine"	—	,,	—	512
Group[3]	,,	,,	"Salammbô"	—	Luxembourg	LXXXVII.	514
Figure[4]	,,	,,	"La Reconnaissance"	—	Private collection	—	514
Toilet objects[5]	,,	,,	Various	—	,,	—	515
Toilet objects[6]	,,	,,		—	,,	—	515
Figure[7]	,,	,,	"Bellona"	—	,,	—	515
Bust[8]	English	,,	"Lamia"	—	Vivian	LXXXVIII.	517
Figures[9]	,,	,,	Bust of bishop, St. Elizabeth	—	,,	—	519
Frieze[10]	,,	,,	Galleys	—	Lloyd's Registry	—	519
Figure[11]	,,	,,	"Mors Janua Vitæ"	—	Vivian	—	519
Figures[12]	,,	,,	"Launcelot and the Nestling"	—	,,	—	519

[1] By Caron. [2] By Dampt. [3] By Rivière. [4] By Madrassi. [5] By Lalique. [6] By Boutet de Monvel.

[7] By Gérôme. [8] By Frampton. [9] By Gilbert. [10] By Lynn Jenkins. [11] By Bates. [12] By Reynolds-Stephens.

Note.—The Londesborough and Sneyd collections, referred to in the text, are now dispersed.

BIBLIOGRAPHY

(Sufficient only of the titles for identification is given)

Akermann, J. Y. *Remains of Saxon Pagandom.* 1855.

Alcock, Sir R. *Capital of the Tycoon.* 1863.

 „ „ *Art and Art Industries in Japan.* 1878.

André, M. *Notice sur une cassette d'ivoire . . . Bayeux.* 1871.

Audsley, G. A. *The Ornamental Arts of Japan.* 1882–4.

Auguin, E. *Hist. de la cathédrale de Nancy.* (Lit. combs.) 1882.

Aus'm Weerth, E. *Kunstdenkmäler . . . in den Rheinlanden.* 1857–60.

Aymard. *Album photographique d'archéol. religieuse.* 1857.

Bandini, A. M. *In antiquam tabulam eburneam sacra.* 1746.

Bandurius, A. *Antiquitates imperii Orientis.* 1711. (Cons. dipts.)

Barbier de Montault, Abbé X. *Bibliothèque Vaticane.* 1857.

Barbier, L. N. *Esquisses historiques sur l'ivoirérie.* 1857.

Barraud et Martin. *Le bâton pastoral.* 1856.

Becker and Hefner-Alteneck. *Kunstwerke des Mittelalters.* 1852–7.

Benedictines. *Voyage littéraire de deux Bénédictins.* (Martène et Durand). 1717.

[Berlin museums.] *Beschreibung der Bildwerke der christlichen Epochen. Die Elfenbeinwerke.* 40 plates. 1903.

Bertolotti, A. *Artisti belgi ed olandesi in Roma nei secoli* 16 *e* 17. 1880–85.

Bianconi, G. *Pettine d'avorio intagliato.* (Combs, secular). 1839.

Bingham, J. *Antiquities of the Christian Church.* (New ed., 1880.)

Bock, F. *Das heilige Köln.* 1858.

Bode, W. *Denkmäler der Renaissance Skultur Toscanas.* (600 fol. plates.) 1892.

[Bologna.] *Osservazione di una frammento di tavoletta antica d'avorio stimata consolare.* Bologna, 1775.

Bossuit, F. van. *Cabinet de l'art de la sculpture executé en ivoire.* 1727.

Bretagne, M. *Sur les peignes liturgiques.*

Bugati, G. *Memorie storico-critiche . . . sopra un di dittico d. chiesa . . . di Milano.* 1782.

Buonarruoti, F. *Osservazioni sopra . . . vasi.* (Illustrates three ivory diptychs.) 1716.

Bürkner, R. *Geschichte der kirchlichen Kunst.* 1903.

Cahier et Martin. *Mélanges d'archéologie.* 1847–56.

Carter, J. *Specimens of Ancient Sculpture.* 1780. (New ed. 1838.)

Cerf, Abbé. *Histoire de N. D. de Reims.* 1861.

Chabouillet, A. *Catalogue général . . . cabinet de médailles.* 1867.

" " *Description sommaire des monuments exposés . . . à la bibliothèque impériale.*

Champeaux, A. de. *Les travaux d'art executés pour Jean . . . duc de Berry.* (The Poissy retable.) 1894.

Charles, Abbé R. *Un diptyque d'ivoire du xive siècle.* 1881.

Chennevières, Ph. de. *Notes d'un compilateur.* 1858.

Cicognara, L. *Storia della scultura.* 1823.

Clinton, H. Fynes. *Fasti Romani.* (List of consuls.) 1845–50.

[Copenhagen]. *A Guide to Northern Archæology.* (Ed. by Earl of Ellesmere.) 1848.

Courajod, L. *Catalogue de la donation Ch. Davillier.*

Cust, L. *Ivory Workers of the Middle Ages.* 1900.

Darcel, A. *Catalogue raisonné . . . Basilewsky Collection.*

Dart, J. *Canterbury Cathedral.* (Appendix.) 1726.

Denon, V. *Monum. des arts du dessin.* (Diptych of fifth or sixth century.) 1829.

Dibdin. *Bibliographical Tour.* (Consular diptychs.) 1821.

Didron, A. N. *Iconographie chrétienne.* 1845.

" " *Annales archéologiques.* 1844, etc.

Didron, E. *Etude sur les images ouvrantes.* 1870.

Donati, S. *De' dittici degli antichi, profani e sacri.* 1753.

Doppelmayr, J. G. *Hist. Nachricht von den Nürnbergischen Künstlern.* 1730.

Doublet, J. *Hist. de l'abbaye de S. Denis.* (Charlemagne Chessmen.) 1625.

Dragoni, Abbé B. *Sul dittico eburneo . . . nel Museo Ponzoni.* 1810.

Dresser, C. *Japan: its Architecture, Art, etc.* 1832.

Ducange, C. D. *Ceraculum diptychorum.*

" *Glossarium med. et inf. Latinitatis.* 1840–50.

Du Meril, E. *De l'usage de tablettes de cire.* 1861.

Dunlop, J. *History of Fiction.* 1845.

Durand, G. *Rationale divinorum officiorum.* 1459.

Du Sommerard, E. *Les arts au Moyen-âge.* 1838–46.

BIBLIOGRAPHY

Erbstein, J.	*Konigl. grünes Gewölbe zu Dresden.*
Eudel, P.	*Le truquage.* 1903.
Fol, W.	*Catalogue du musée Fol.* 1874.
Förster, E.	*Geschichte der Deutschen Kunst.* 1851–60.
Forster, H. R.	*The Stowe Sale Catalogue.* (Priced and annotated, S.K.M.) 1848.
Garrucci, R.	*Storia dell' arte christiana.* 1881.
Gaussen, A.	*Portefeuille archéol. de la Champagne.* (Comb of S. Loup.) 1861.
Goldschmidt, A.	*Frühmittelalterliche Elfenbeinsculpturen.* 1903.
Gonse, L.	*L'Art Japonais.* 1883.
„	*L'Art gothique.* 1890. (Louvre coronation group.)
Gool, J. van.	*Nieuwe Schoubourg der nederlantsche Kunstschilders.* 1750.
Gori, A.	*Thesaurus veterum diptychorum.* 1759. (See Passeri.)
Graesse, J. G. T.	*Guide de l'amateur . . . monogrammes . . . des ivoiriers.* 1871.
Graeven, H.	*Typen der Wiener Genesis auf Byzant. Elfenbein-reliefs.* 1900.
„	*Frühchristliche . . . Elfenbeinwerke.* 1898.
Graz (Exhibition).	*Kunstg. arb. Austellung.* 1883. (Reliquary).
Grovand de la Vincelle.	*Recueil des monum. ant.* (Diptychs.)
Guénebault, L. J.	*Dictionnaire iconographique.* 1845.
Guenin.	*Histoire de l'abbaye de Tournus.*
Hagenbuch, J. C.	*De diptycho . . . Boethii . . . epistola epigraphica.* 1749.
Hahn, F.	*Fünf Elfenbein-Gefässe des frühesten Mittelalters.* 1862.
Heideloff, C. A. von.	*Die Ornamentik des Mittelalters.* 1843–52.
Heider, G. von, and Eitelberger, R. von.	*Mittelalterliche Kunstdenkmale.* (Appendix, Oliphants.) 1856–60.
Hertfelder, B.	*Basilica S. Udalrici in Augsburg.* (Combs.) 1627.
Holtzapfel, C.	*Turning and Mechanical Manipulation.* 1847.
Hübner, E.	*Die antiken Bildwerke in Madrid.* 1862.
Huish, M.	*Japan and its Arts.* (Netsukés.)
Jacquemart, A.	*Histoire du mobilier.* 1876.
[Japan.]	*Report of the Japanese Commission.* Paris Exhibition. 1900.
Julliot, G.	*Trésor de la cathédrale de Sens.* 1886.
Käntzeler, P. S.	*Eine Kunst-Reliquie des zehnten Jahrhunderts.* 1856.
Kanzler, Barone R.	*Gli avori . . . Vaticana.* 1903. (Photographs.)

BIBLIOGRAPHY

Kramm, C. *De levens en werken der Hollandsche en Vlaamsche Kunstschilders.* 1856.

Kugler, F. T. *Kleine Schriften.* 1853.

Labarte, J. *Histoire des arts industriels.* 1864.

Lacroix, P. *Les arts au moyen âge.* 1869.

Lartet, E., and Christy, H. *Reliquiæ Aquitanicæ.* 1875.

Layard, A. H. *Nineveh and its Remains.* 1850.

Lee, J. E. *Isca Silurum.* Illustrated catalogue of the museum at Caerleon. 1862.

„ *The Lake Dwellings of Switzerland.* (From the German of F. Keller.). 1872.

Leich, J. H. *De diptychis veterum et de diptycho Card. Quirini.* 1743.

Lenormant, C. *Trésor de Numismatique et de Glyptique.* 1834–46.

Lièvre, E. *Les collections célèbres.* Collection Sauvageot. 1866.

[Lille.] *Catalogue of Exhibition in 1874.* (36 ivory crucifixes.)

Lind, C. *Ueber den Krummstab.* 1863.

Linde, A. van der. *Geschichte und Litteratur des Schachspiels.* 1874.

Louandre, C. *Les arts somptuaires.* 1857.

Lowrie, W. *Christian Art and Archæology.* 1901.

Lubbock, Sir J. (Lord Avebury). *Pre-historic Times.* 1865.

Lübke, W. *Grundriss der Kunstgeschichte.* 1860.

„ *Die Mittelalterliche Kunst in Westfalen.* (Charlemagne comb.) 1853.

Mabillon, J. *Annales Ordinis Sancti Benedicti.*

MacColl, D. S. *Glasgow Exhibition,* 1903.

Madden, Sir F. Lewis Chessmen. (In *Archæologia,* vol. xxiv.). 1832.

Madrazo, P. de. *España artistica y monumental.* 1884.

Maes, J., and Weale, W. H. J. *Album des objets d'art.* 1864.

Maffei, S. *Museum Veronense.* 1749.

Magri, D. *Hierolexicon.* (See sub *pecten.*)

Maigne, W. *Manuel . . . de l'ivoirier.* [Manuels Roret.] 1889.

Mantuani, J. *Tuotilo und die Elfenbeinschnitzerei . . . zu S. Gallen.* 1900.

Marguet, A., and Dauphinot, A. *Trésor de la Cath. de Reims.* 1867.

Marriott, W. B. *Vestiarium Christianum.* 1868.

Martène, E. *De antiq. eccles. Ritibus.* (Eccl. dipts.) 1736.

Martigny, J. A. *Dict. des antiq. chrét.* (Diptychs.) 1865.

Maskell, W. *Ivories Ancient and Mediæval in the South Kensington Museum.* 1872.

BIBLIOGRAPHY

Maze-Sencier, A. *Le Livre des Collectionneurs.* 1885.

Ménard, L. and R. *Tableau historique des Beaux Arts.* 1866.

Meyer, W. *Zwei antike Elfenbeintafeln der Staats-k. Bibl. in München.* 1879.

[Michael Angelo.] *Lettre adressée à Madame la Comtesse de . . . à l'occasion d'un crucifix en ivoire sculpté par Michel-Ange que possède cette dame, par Courtois.* Paris, 1845.

Millin, A. L. *Voyages.* (Diptychs.) 1802–6.

Molinier, E. *Histoire générale des arts.* 1896.

 „ Wallace Collection. *Meubles et objets d'art.* 1904.

Montfaucon, B. de. *L'Antiquité expliquée.* 1729.

Mortillet, G. *Le Préhistorique.* 1883.

Mozzoni, I. *Tavole cronologiche della storia della chiesa.* 1856–63.

Munich National Museum. *Meisterwerk der Elfenbein-Schnitzerei.* (Photos only.) 1882.

Müntz, L. T. E. *Histoire de l'art pendant la renaissance.* 1889–95.

 „ „ *Le musée d'art du xviij*e *siècle.* 1902.

Nagler, G. K. *Künstler-Lexikon.* 1870–78.

 „ „ *Die Monogrammisten.* 1858–79.

[Nuremberg.] *Photographieen aus dem germanischen Museum.* 1865.

[London : Society of Antiquaries] *Vetusta monumenta.* 1747.

Obernetter, J. B. *Kunst-Schätze aus dem Bayerischen Museum.* (Photographs only.)

Oldfield, E. *Catalogue of fictile ivory carvings sold by the Arundel Society.* 1855.

Palustre, L. *Mélanges d'art et d'archéologie.* (Crucifix by Faistenberger. 1889.

Passeri, G. B. *In Monumenta sacra eburnea a clariss. A. F. Gori.* 1759.

Pelliccia, A. A. *De Christianae Ecclesiae . . . politia.* 1777–81.

Perkins, C. C. *Tuscan sculptors.* 1864.

Perrot G. et Lasteyrie. *Monuments et Mémoires.*

Pitt-Rivers, A. H., Lieut.-Gen. *Antique Works of Art from Benin.* 1900.

Plumier, C. *L'art de tourner.* 1701.

[Possente Collection.] *Catalogue de la collection.* 1880.

Pulszky, F. *Catalogue of the Fejérváry ivories.* 1856.

Quatremère de Quincy, A. C. *Le Jupiter Olympien.* 1815.

Ranke, C. F., and Kugler, F. J. *Beschreibung der Schlosskirche zu Quedlinburg.* 1838.

Read, C. H., and Dalton, O. M. *Antiquities from Benin.* 1899.

BIBLIOGRAPHY

[Record Office.] Seventh Report. 1846. *Inventories of Churches in 6th Year of Edward VI.*

Reusens, E. H. J., Canon. *Eléments de l'archéologie chrétienne.* 1885.

Rock, D. *Hierurgia.* 1851.

„ *The Church of our Fathers.* 1849–53.

Rohault de Fleury, C. *L'Évangile. Études iconographiques et archéologiques.* 1874.

„ „ *La Messe.* (Ritual plaques.) 1883.

Rosenberg, M. *Alte kunstgew. Arbeiten . . . zu Karlsruhe in* 1881.

Roth, H. L. *Great Benin.* 1903.

[Russia.] *Antiquités Russes.* (Fol. plates only.) 1850–2.

Sabatier, J. *Notions sur l'iconographie sacrée en Russie.* 1849.

Salig, C. A. *De diptychis veterum.* 1731.

Sauzay, A. *Musée de la renaissance. Série A., Ivoires.* 1863.

Schaefer, G. *Denkmäler der Elfenbeinplastik in Darmstadt.* 1872.

Schaepkens, A. *Trésor de l'art ancien en Belgique.* 1846.

Scharf, G. *Art Treasures at Manchester.* 1857.

Scherer, Ch. *Elfenbeinplastik seit der Renaissance.* 1903.

„ „ *Studien zur Elfenbeinplastik.*

Schlosser, J. von. *Album ausgewahlter Gegenstande.* 1901.

„ „ *Elfenbeinsattels . . . des mittelalters.* In *Jahrbuch der Kunsthistor. Samml. des Kaiser hauses.* 1894

Schwarz, C. G. *De veterum diptychorum.* 1717.

„ „ *Diss. de vetusto quodam diptycho cons. et eccles.* 1742.

„ „ *De libris plicatilibus veterum.* 1717.

Siebold, P. F. von. *Nippon.* (Japanese ivory-, bronze-,and wood-carving.)

Somborn, A. *Die Elfenbein und Beinschnitzerei.* 1899 (Industrial statistics.)

[Spitzer collection.] *La Collection Spitzer.* (Illustrated catalogue). 1890.

Stephens, G. *Runic Monuments.* (Franks casket.) 1866–8.

Steuerwaldt, W. and Virgin, C. *Die mittelalt. Kunstschätze zu Quedlinburg.* (Comb of Henry I.) 1856.

Stuart, J., and Revett, N. *The Antiquities of Athens.* 1825.

Stuhlfauth, G. *Die altchristliche Elfenbeinplastik.* 1896.

Texier, Abbé. *Recueil des inscriptions du Limousin.* (Ivory tau.) 1851.

Teuber, J. M. von der. *Vollstandiger Unterricht Drehkunst.* (Turnery.) 1730.

Theophilus. *Essai sur divers arts.* (French translation of the mediæval work by C^te de l'Escalopier.) 1843.

BIBLIOGRAPHY

Turner, D.	*Catalogue of Works of Art in the possession of Rubens.* 1830.
Vanderpoel, A.	*Notice sur la vie de Lucas Fayd'herbe.* 1854.
Venturi, A.	*Storia dell' arte Italiana.* 1901.
Vert, Claude de.	*Explication des cérémonies de l'Eglise.* (Lit. combs.)
Vöge, W.	*Beschreibung der Bildwerke der christlichen Epochen.*
Vögelin, S.	*Das Zürchensche Diptychon . . . Areobindus.* 1829.
Waring, J. B.	*Art Treasures at Manchester.* 1857.
Wauters, E.	*Sculpture en ivoire et les ivoiriers flamands.* 1895.
Weltmann, A.	*Le trésor de Moscou.* 1861.
Westwood, J. O.	*Fictile Ivories in the S. Kensington Museum.* 1876.
Wexelberg, C. F.	*Bronzes, tablettes en ivoire, etc.* (Plates only). n.d.
Wieseler, F.	*Das Diptychon Quirinianum zu Brescia.* 1868.
Willemin, N. X.	*Monuments Français.* (Lewis and other chessmen.) 1806–39.
Wilson, D.	*Prehistoric Archæology and Annals of Scotland.* 1851.
Wiltheim, A. de.	*Diptychon Leodiense.* 1659.
Winckelmann, J. S.	*Geschichte der Kunst des Altherthums.* 1764. [English translation by G. H. Lodge. 1881.]
Wyatt, Sir M. D.	*Address at the Crystal Palace on Ancient Ivory Carving.* 1855.
„ „	*Notices of Sculpture in Ivory.* 1856.

INDEX

INDEX

INDEX

INDEX

INDEX